DESIGNING FOR THE ARTS
Environments by Leslie Cheek

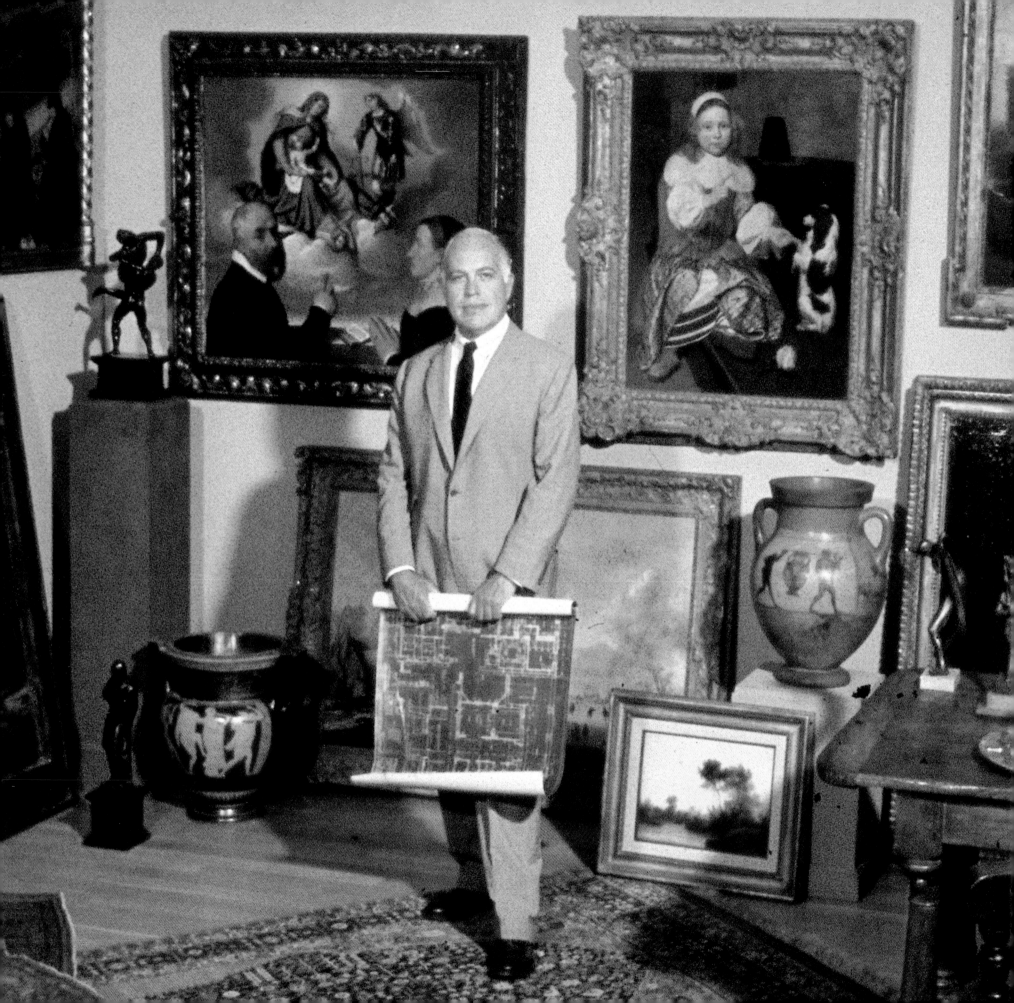

DESIGNING FOR THE ARTS

ENVIRONMENTS BY LESLIE CHEEK

A Photo Essay
with text by K. Richmond Temple

Foreword by J. Carter Brown
Afterword by Guy Friddell

Published by
THE SOCIETY OF THE ALUMNI
of
THE COLLEGE OF WILLIAM AND MARY
Williamsburg, Virginia

First American Edition
Copyright © 1990 Society of the Alumni
College of William and Mary
Williamsburg, Virginia 23187

Library of Congress Card Catalogue Number: 89-064205

ISBN 0-9615670-1-5

Printed in Hong Kong by Overseas Color Printing Corp.
Design by Geary, Flynn & Crank, Inc., Richmond, Virginia

Dust jacket and overleaf photograph: Leslie Cheek with objects from the collection of the Virginia Museum of Fine Arts, circa 1965

DEDICATED TO MY PARENTS

The pineapple design in this book was created by Leslie Cheek in the 1930s, when his mother asked him to style some stationery for her use at Cheekwood. Later, in emulation of his ancestors who had small pineapples placed on their carriages, Cheek had this traditional symbol of hospitality attached to the doors of his automobiles.

Contents

Foreword

As one of our country's most forward-thinking museum directors and as an architect and designer, Leslie Cheek has brought order, civility and imagination to diverse environments. His designs for exhibition spaces, homes, visitors' centers, classrooms and gardens convey a coherent stylistic vision and an acute sensitivity to the needs of the individual.

In the museum field, Cheek's work was undertaken in service to an idea of lasting importance—that a carefully planned, well-managed art museum could be an agent for enriching contemporary life. Leslie was fortunate to begin his career at about the same time that personal leisure time was increasing. The art museum, it is worth remembering, had long catered to and been supported by a select group of connoisseurs. Undoubtedly this would have continued had not political, social and economic forces compelled museums to embrace wider audiences. His gift was to help motivate these institutions to entice a skeptical public, and Leslie's greatest contribution was to combine his love of architecture and stage design in making art museums livelier *public* places.

Today, people from every segment of society routinely visit art museums not only to experience a variety of permanent and changing exhibitions, but also to attend lectures, enjoy film and performing arts series, and even to dine and to shop. When Cheek started out in the mid-1930s, all this was years in the future. But—and this is crucial—Leslie was among a small and influential group of visionary museum directors who grasped the potential of the art museum as a civilizing agent for all of society, and he joined them in bringing about this critical transformation.

Part I of Mr. Temple's book richly illustrates Leslie's methods as presenter, teacher, innovator and promoter. As a dramatizer of museum exhibitions Cheek was unique. I remember vividly my first visit some thirty years ago to the Virginia Museum, where I was startled by the explicit theatricality of the installations. The Medieval Hall, which has since been dismantled, was a particularly striking example of the use of artificial lighting to dramatize and highlight exhibition space. Tapestries from the period and battle flags decorated the walls and hung from the ceiling. In the center of the large gallery was a plumed knight mounted on a tall steed, both in full battle armor. Medieval ecclesiastic music was barely audible in the darkened room. Frankly, the effect was delightfully spooky, and like other museumgoers I became a time-traveler to the Middle Ages.

As innovator, Cheek rarely shied from trying something new—costumed guards, specially focused and recessed lighting systems, movable walls, the traveling Artmobiles, a museum theatre, and more—were brought to bear in the quest for the visitor's attention. Some of Leslie's practices, particularly the use of vignetted spotlights—Lusklites, they were called, after their designer Carroll Lusk—provoked consternation among many of us in the museum world. But unquestionably, the "sensuround" galleries had their impact on the public. Few can dispute, furthermore, that the Artmobiles were an innovative service that enriched the lives and piqued the interest of many who otherwise would have had to trek great distances to enjoy original works of art.

As a teacher Cheek experimented with a succession of techniques to familiarize museumgoers with the societal and historical contexts in which various artists lived and created. The Orientation Theatres were breakthrough interpretive devices that found imitators elsewhere.

Leslie was also a master at keeping the museum before the public eye. Experience with the theatre undoubtedly

introduced him to the powers of advertising and public relations, and he used these with telling effect to promote the arts. One of his cleverest ideas was the scheduling of an exhibition on modern architecture to celebrate the completion of a new "International Style" office building in Richmond. An architect himself, Leslie knew of no better way to excite interest about a structure than to have people wander around it, touch it and discover it at their own pace. Accordingly, on a clear October evening, guests were driven to the site where they happily explored the handsome building. This carefully planned event not only deepened the public's appreciation for contemporary design, it also brought the museum widespread media attention.

The subject of architecture brings me to another point. More than one person has observed that Leslie is a man of the theatre, but this is only partially true. Leslie is, at bottom, an architect, and by remembering this we fully understand what makes him tick. Fittingly, Part II includes a selection of the many projects for which he was either principal designer or consultant, and their inclusion adds to appreciation of his work in museums. Only one trained in architecture could have conceived successfully the remarkable installations that recreated, as needed, the atrium of a Roman villa, the courtyard of a Renaissance palazzo, the Great Hall of an Elizabethan country house and a drawing room in a mansion of the antebellum South. Experience and studies in stage design heightened the realism of these settings, and working out the most minute details gave him infinite pleasure.

His innate feel for the modernist revolution in architecture and his own puckish sense of the unexpected combined with particular success in his design of his own quarters as a young teacher, inside a traditional Colonial Williamsburg structure. Also intriguing are those drawings and renderings that reveal not only Leslie's keen sense of scale and his talent for accommodating structure and site, but also his whimsical, light-hearted side. The "Lion Fountain" built to his specifications for his Richmond residence is one example of his evident joy in creating decorative touches to surprise and delight us. Another is his dining table, designed in the 1930s, with exchangeable center panels and lighting systems.

Ever attentive to the smallest detail, Leslie Cheek has also demonstrated his ability to take on larger design challenges. The Beaux-Arts principles to which he was exposed at Yale University are nowhere more evident than in his wondrously complex plans for Skylark Farm in Virginia's Blue Ridge Mountains.

The environments that Leslie Cheek designed harken back to times more congenial to civility, grace, fine manners and, indeed, romance, elements of the good life that often have been undermined by the seemingly unrelenting pace of modernity. In the face of rapid unsettling change, Leslie has given us welcome oases to reawaken our sense of enduring values and our faith in human imagination. Parke Rouse's admirable *Living by Design* and now Richmond Temple's book complete the story of how one gifted designer has responded to our times with an imaginative vision and irrepressible energy. Together they are a fitting tribute to a good friend, a helpful adviser and a fearless innovator whose career—one should say careers—evidence so much of interest for succeeding generations.

J. CARTER BROWN
Director
National Gallery of Art, Washington, D.C.

Author's Note and Acknowledgements

Living by Design, the predecessor of this work, took—as biographies customarily do—a chronological approach in telling the life story of Leslie Cheek, one of our century's most innovative museum administrators. Cheek was also a designer, and this sequel completes the study of his life by focusing on specific design projects and museum installations that absorbed his interest over a lifetime of creativity. This book, then, is intended to provide details that *Living by Design* either treated cursorily or omitted owing to the stylistic limitations imposed by the strict biographical narrative. The two books are companions, the earlier one dealing with the "who," the "when" and the "why," this one examining the "what he did," and "how he did it." Read together, they provide an understanding of the prolific output of a multi-talented American.

Designing for the Arts is a photo essay, composed almost exclusively of illustrations rather than narrative text. The pictures speak for themselves and are collected in two parts: Part I has as its central theme Leslie Cheek as a builder of audiences for the fine arts. The first six chapters examine techniques he employed to make the arts understandable to and enjoyable for greater numbers of people. Part II largely leaves behind the world of museums to focus on Cheek as architect, interior designer and consultant for numerous public and private projects, including houses, instructional facilities and historic sites. The two sections are connected by the characteristics that distinguish all of his work: a passion for the drama implicit in the arts, a capacity for infinite detail in carrying out any scheme large or small, and a personal style that combines elegance and humor.

The author wishes to acknowledge with deep gratitude the cooperation of Leslie Cheek, Jr., who gave unrestricted access to correspondence, photographs, drawings and other documents essential to the completion of this project. Many of the illustrations are published herein for the first time. Every effort has been made to provide reproductions of the highest quality. In some instances, however, this proved impossible owing to the deteriorated condition of the original photograph, color transparency or drawing.

The author is particularly grateful to Mrs. Alfred Friendly, Jr., who conducted virtually all the research for Part I. Mrs. Dorothy S. Nielsen, Mr. Cheek's private secretary since 1969, was an invaluable aid in many ways great and small, as was the staff of the Society of the Alumni of the College of William and Mary, the publisher of this book. I reserve my largest thank you for Mary Tyler Freeman Cheek. No author has had a more effective editor, and I am truly appreciative for her patient and generous assistance.

The following organizations and individuals provided various materials, including illustrations: the Virginia Museum of Fine Arts, the Richmond Public Library, the Virginia State Library and Archives, Richmond Newspapers, Inc., Richmond Memorial Hospital, the John F. Kennedy Center for the Performing Arts, the United States Air Force Academy, Christopher Little, Mary M. Jacoby, Nathaniel Lieberman, Park Tower Realty of New York, Richard W. Cheek and Mrs. B. Warwick Davenport.

I wish to single out the contributions of Geary, Flynn & Crank, Inc., Robert W. Stewart, A.I.A., and Dennis McWaters. As designer, Geary, Flynn & Crank, Inc. has made this a more effective and attractive book by providing useful counsel with copy editing, proofreading and graphic styling. Architect Robert Stewart's beautiful renderings provided illustrations where no others existed. His unique artistry has brought to light views of the numerous projects (completed and uncompleted) on which he collaborated with Leslie Cheek. Without the aid of Dennis McWaters this book could not have been created. As photographer, he made hundreds of prints and transparencies for the illustrations that are the heart and soul of this study.

And last, but hardly least, I wish to thank my dear wife Mary Stuart Watson Temple for her moral and inspirational support as I labored on this book from February 1988 through November 1989. While she was a full-time student earning her M.B.A. at Duke University, she was always available for guidance, pep talks and understanding. —K.R.T.

PART I

BUILDING AUDIENCES FOR THE ARTS

Introduction

Leslie Cheek was a master-builder of audiences for the arts who believed the art museum had a central role to play in counteracting many of the dehumanizing aspects of modern civilization. Convinced that most art museums tended to be exclusive and dull, Cheek dedicated his life to making art interesting and understandable to greater numbers of people. He fervently believed that art museums could become vibrant cultural centers for educating, entertaining and uplifting those who were indifferent to or intimidated by museums. For more than thirty years the imagination and zest with which he pursued his ambition left audiences dazzled. More often than not, his critics were astonished, and in some instances angered, by what they viewed as his penchant for showmanship, but the general response was increasingly enthusiastic.

Part I of this book deals with Cheek's efforts to build larger audiences for the arts. Training in architecture and stage design, combined with an innate flair for promotion, enabled him to democratize the arts in ways few had attempted before him. Through dramatically staged exhibitions and new interpretive techniques, he made encounters with art enjoyable, educational and unforgettable. The following six chapters will present major principles and aspirations that formed the basis of Leslie Cheek's work in the museum field. They may be briefly summarized as follows:

1. Presenting the Arts

With a relentless attention to detail and an unerring sense of style, Cheek presented a series of exhibitions that were consciously designed to pique the curiosity and stir the imagination of the museum-going public. To persuade people of all ages and backgrounds to taste the pleasures of the fine arts, he created dramatic settings that recalled the historical past vividly to life.

2. Interpreting the Arts to Educate the Public

Cheek designed exhibitions as educational devices, and spoke as an unseen professor through information panels, automated slide presentations and other interpretive instruments.

3. Combining Static and Performing Arts

At heart, Leslie Cheek is a man of the theatre, enthralled by its magic throughout his life. Investing the museum with this power seemed to him the most compelling means to lure the public to the pleasures of the arts. "Theatre," he wrote, "perhaps because of the fact that it must have living actors to exist, tends to give life to cultural ideas or periods that otherwise would remain uninteresting to many." Elements from the theatre, often including living actors, enlivened and enriched many of his installations. One of his most significant contributions was the incorporation of a

theatre within the museum building itself. Drama, music, dance and film were scheduled to enhance objects in the galleries, bringing all of the arts together under one roof.

4. TAKING ART BEYOND MUSEUM WALLS
A comprehensive and ongoing public relations program formed a major part of his philosophy of museum management. All of the media were involved in promoting the museum, including radio, television, newspapers, magazines and film. The Virginia Museum's public relations chief, as well as Cheek and other members of his staff, traveled throughout the state to lecture and to participate in arts programs on a regular basis.

An agency of the state, the Virginia Museum was established in the 1930s with a legislative mandate to "promote throughout the Commonwealth education in the realm of art." The most enduring and original of Cheek's devices for carrying out this directive was the Artmobile, a gallery on wheels that brought original paintings and sculpture to every corner of Virginia in elegantly installed security. Artmobile visits were in turn supported by a statewide network of Chapters and Affiliates, which were also hosts for visiting lecturers, craftsmen, actors, musicians and dancers.

5. THE MUSEUM AS TASTEMAKER
Cheek's vision of a vibrant, vital museum included more than the lively display of the plastic and performing arts. He wanted to respond to the human longing for an atmosphere of elegance and beauty that transcended and enriched the ordinariness of daily life. The art museum was to be everyone's "great house," where the entertainment of guests involved all of the good things of life: beautiful surroundings, fine food and wine, flowers, music, and warm hospitality. A popular magazine from the 1960s aptly called the Virginia Museum an "Élegantarium."

The following six chapters comprising Part I constitute but a sampling of Leslie Cheek's comprehensive and imaginative methods for infecting a larger audience with enthusiasm and deeper appreciation for the fine arts.

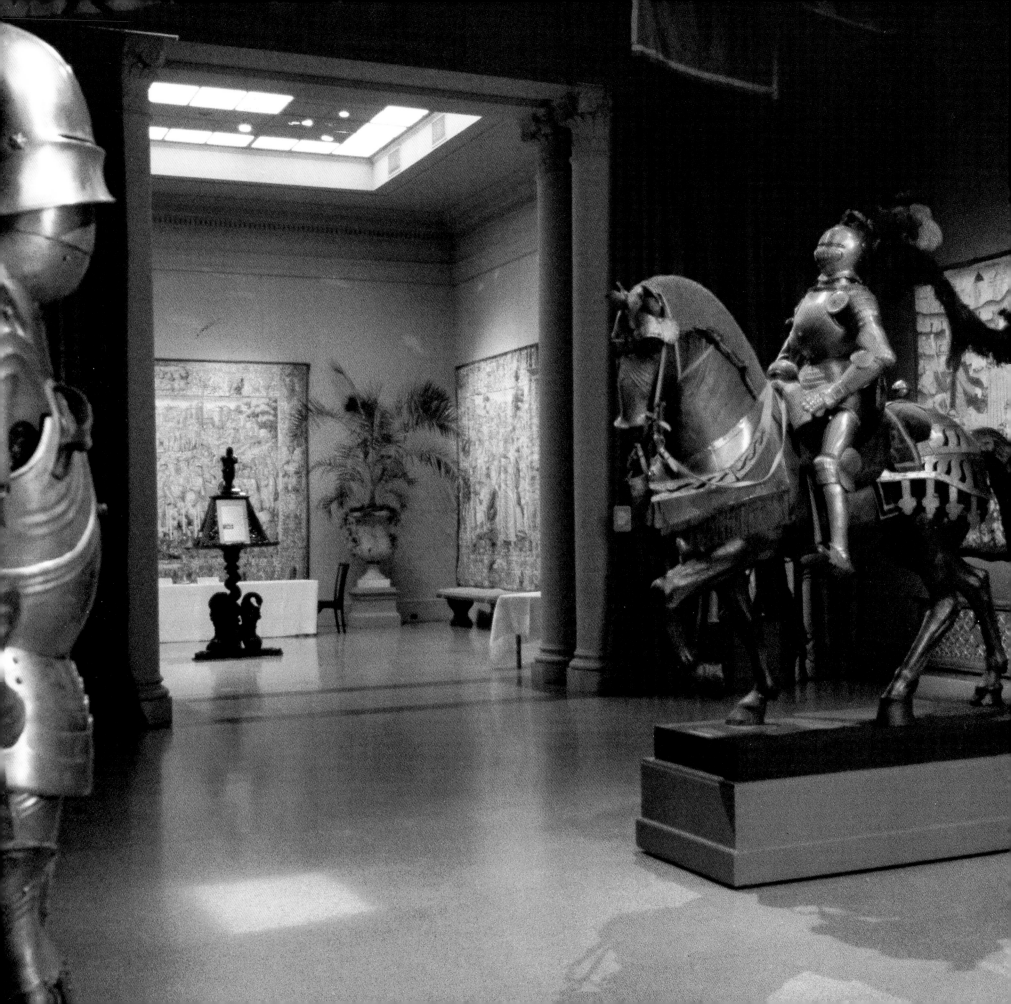

CHAPTER I

Settings for the Arts

The Medieval Hall at the Virginia Museum (shown here circa 1962) exemplified Cheek's deeply rooted commitment to dramatic presentation of an historic setting to enable the visitor to feel as well as see the environments that shaped the art of the past. Training in architecture and stage design served Cheek well in devising these settings for the arts.

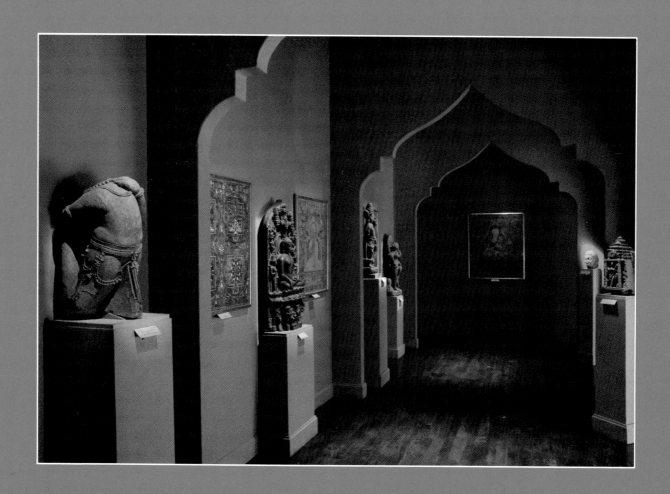

Leslie Cheek's museum installations have made a major contribution to the art of effective display. Dramatic settings for the arts were essential because, as he saw it, visitors needed help understanding art. "It is in its installations," he explained in a 1940 address to the Association of American Museums, "that the civic museum speaks directly to all its visitors. Installations must be more than mere pedestals, walls and catalogue numbers: installations must unfold the dramatic story of the objects organized into a visual experience."

With his exceptional visual talent, Cheek was convinced that art could be made more accessible in displays that recreated its historical context. An object or group of objects displayed in a gallery unaccompanied by interpretive background gave the uninitiated no means to relate to the unfamiliar, and was therefore intimidating. Placing works of art in settings of their time and place in history made them not only more comprehensible but also attractive.

To Cheek, then, the truly effective display—one that grabbed the visitor's attention while making art approachable and understandable—appealed to all the senses. As an audience-builder who had to compete with the pervasive power of television and the cinema for the public's growing leisure hours, he felt that his only option was to make museum displays irresistibly attractive and engaging. Having sought the visitor's interest through a sensual appeal, Cheek believed that he or she would be drawn to further acquaintance with the arts, and he hoped, to incorporate them into daily life. To guide audiences in this growth, and to sustain awakened interest, it was the responsibility of the museum to provide continuing experience in the various cultures and forms of art through the dramatic presentation of regularly changing exhibitions.

For *The Arts of India and Nepal: The Nasli and Alice Heeramaneck Collection* (1967) visitors walked through small temples at the Virginia Museum, the tops of which were ornamented with Islamic arches. Walls were perforated screens in the Mogul style, with many of the objects set in decorative niches.

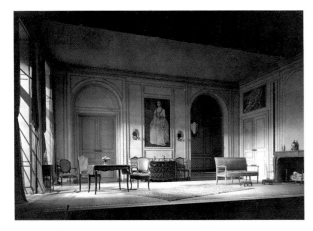

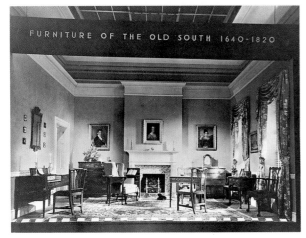

ABOVE: Cheek's training and experience as a stage designer were key to his museum settings. Compare his 1930 design for Noël Coward's *The Marquise* with the installation for *Furniture of the Old South*, which he designed at the Virginia Museum in 1952.

RIGHT: *Habiliments for Heroines* (1952) examined feminine dress as social art. Sixteen literary heroines selected from well-known novels modeled fashions from 1752 to 1952. Cheek designed settings of the period for a series of mannequins individually created to match in appearance the ladies described by the authors. Here, Becky Sharp serves a midnight brandy to a group of admiring gentlemen, from William Thackeray's *Vanity Fair* (1848).

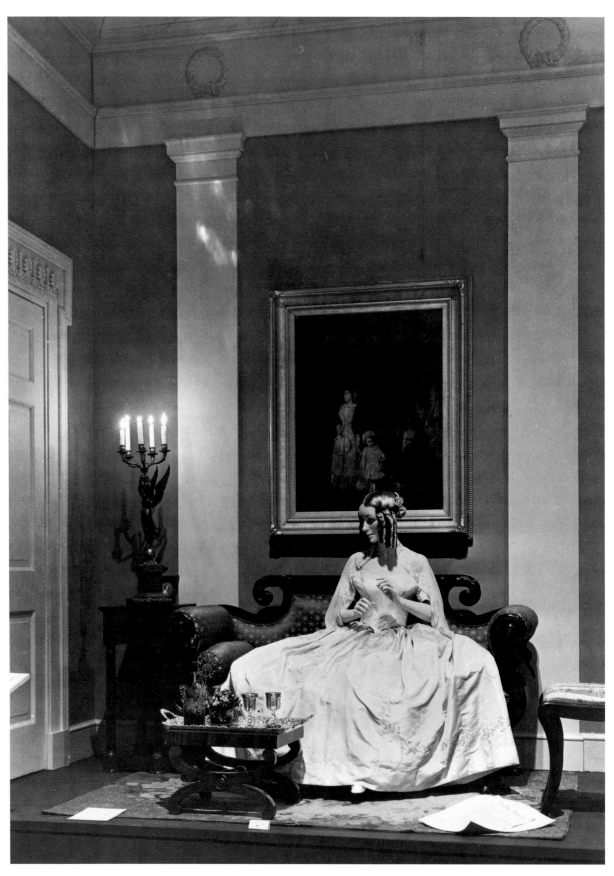

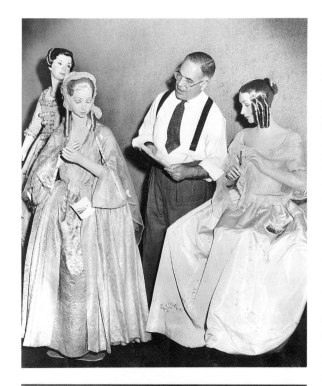

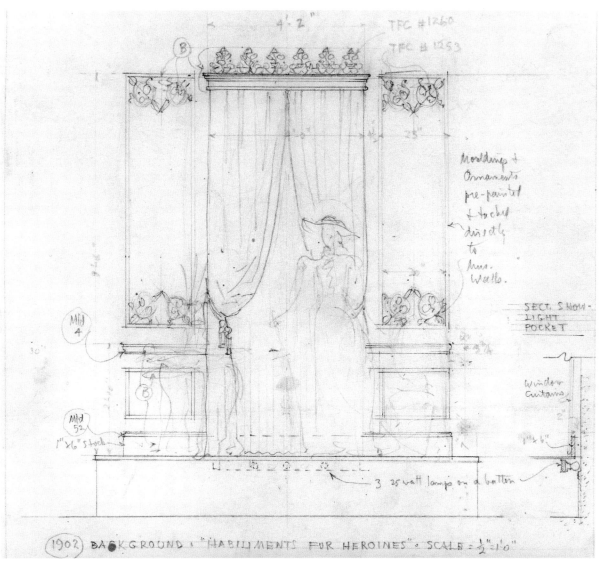

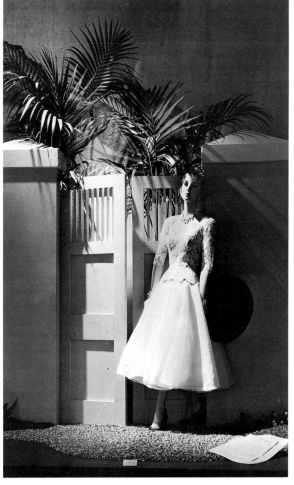

ABOVE LEFT: Check inspects the mannequins specially made for the exhibition by Mary Brosnan, whose New York atelier was internationally renowned. Each heroine was carefully crafted and dressed to resemble the author's description.

ABOVE: Cheek's pencil sketch of the vignette for *The Wings of the Dove* (1902) by Henry James.

LEFT: Couturier Pauline Trigére provided this costume for Elsi Metellus, chief character in *My Son and Foe* (1952) by Josephine Pinckney. Elsi was shown leaving an elegant cocktail party on the fictional Caribbean island of St. Finibar. As part of the exhibition, Trigére was invited to speak at the museum where she lectured on contemporary fashion design. Her remarks were broadcast by a local radio station.

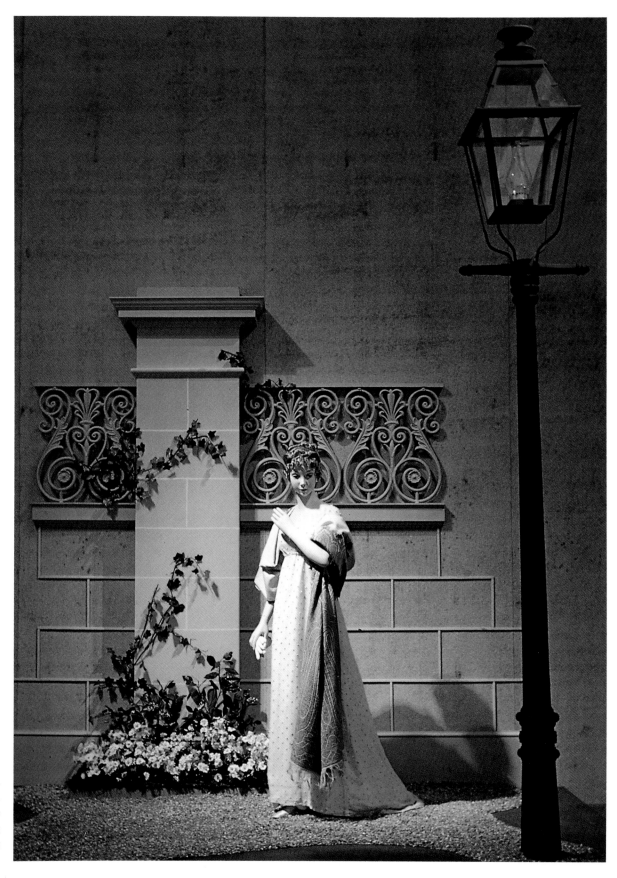

With *Habiliments*, Cheek's quest for accuracy was characteristically thorough. To provide appropriate background for Elinor Dashwood of Jane Austen's *Sense and Sensibility* (1811), he bought a section of cast-iron treillage from a New Orleans foundry to suggest a balcony above the discreet heroine.

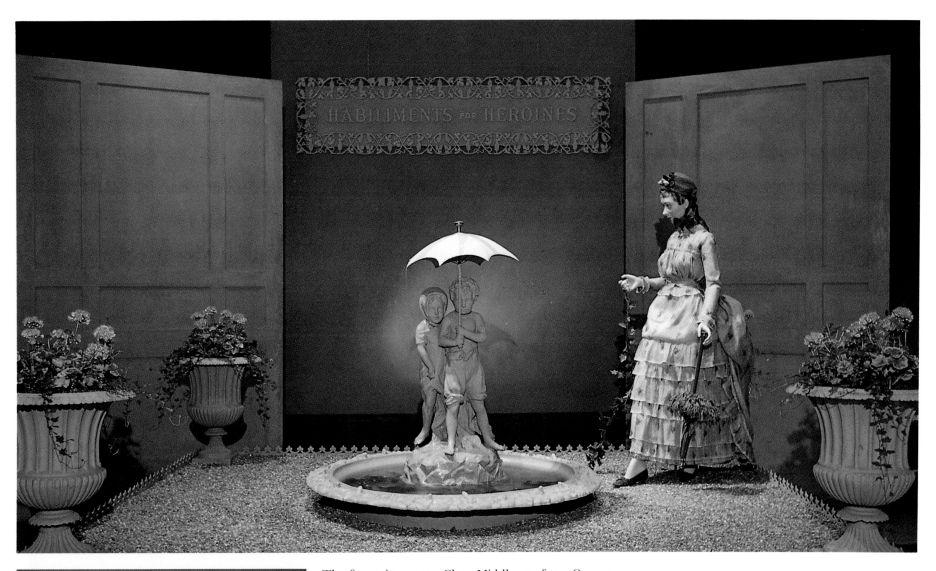

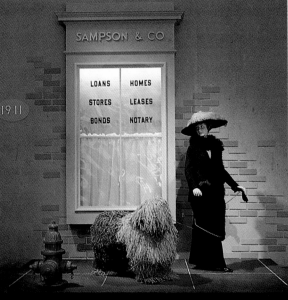

The fountain next to Clara Middleton, from George Meredith's *The Egoist* (1879), actually spouted water, and the fire hydrant in the scene from Henry S. Harrison's *Queed* was borrowed from the City of Richmond's Utilities Warehouse.

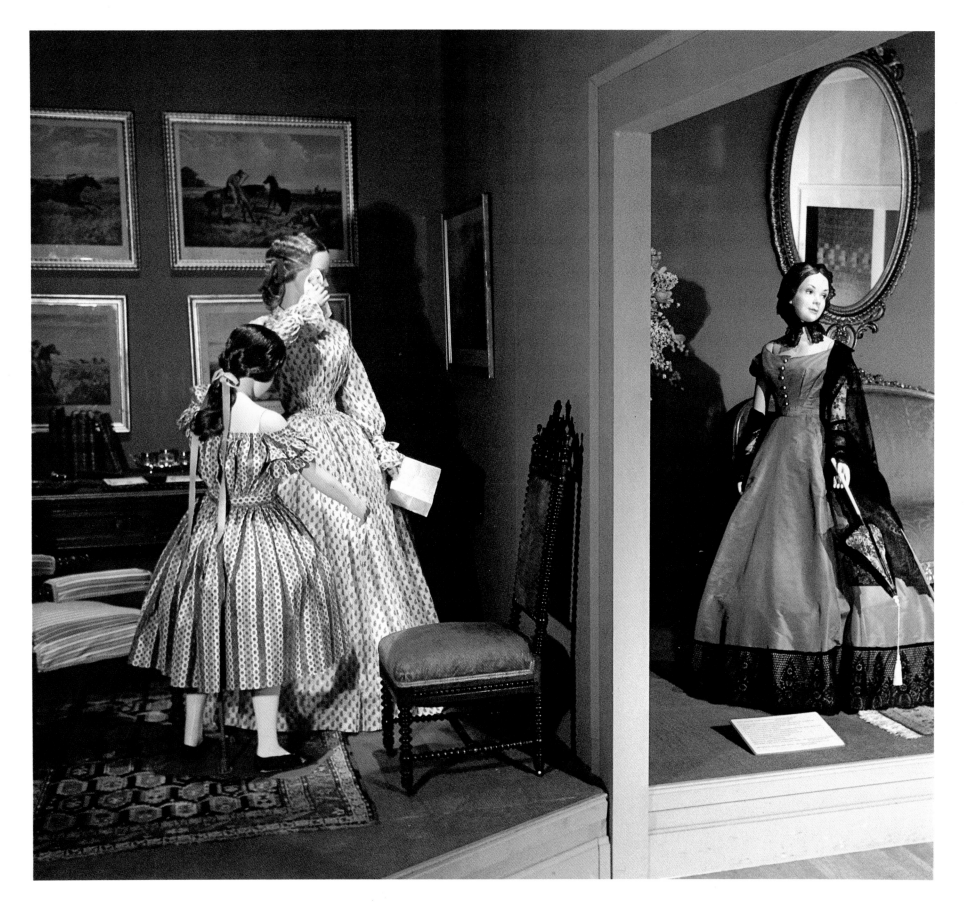

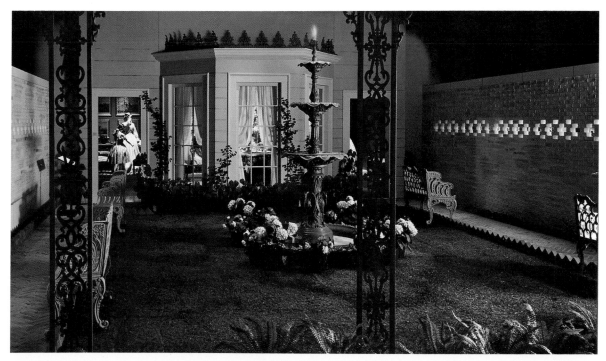

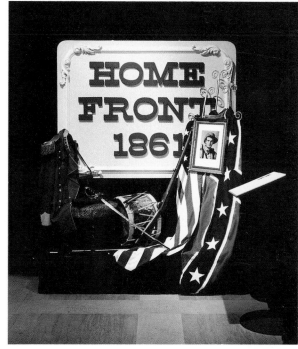

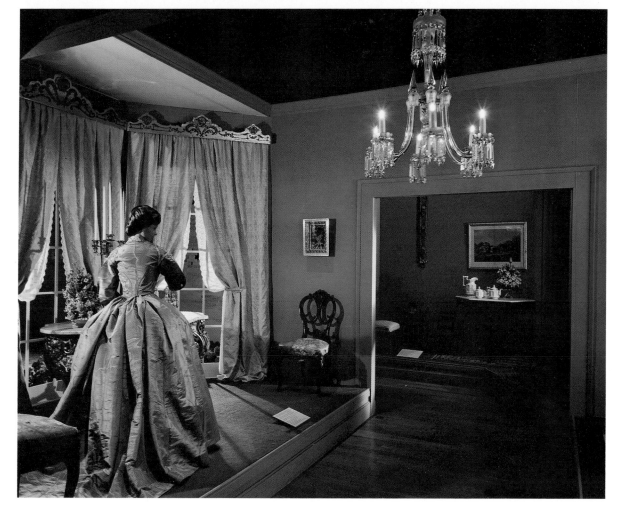

OPPOSITE PAGE AND LEFT: *Homefront, 1861* (1961) surveyed American taste on the eve of the Civil War. Objects from the museum's own collections and elsewhere were arranged in galleries around this simulated city park, complete with splashing fountain and brick promenade. Through embrasures in the walls visitors could see photomurals of houses, public buildings and private gardens that epitomized antebellum style. In the background is the room titled "Modes and Manners" that displayed fashion and decorative arts.

ABOVE: The gallery entrance to *Homefront* stirred the public's imagination about America at the time of the Civil War.

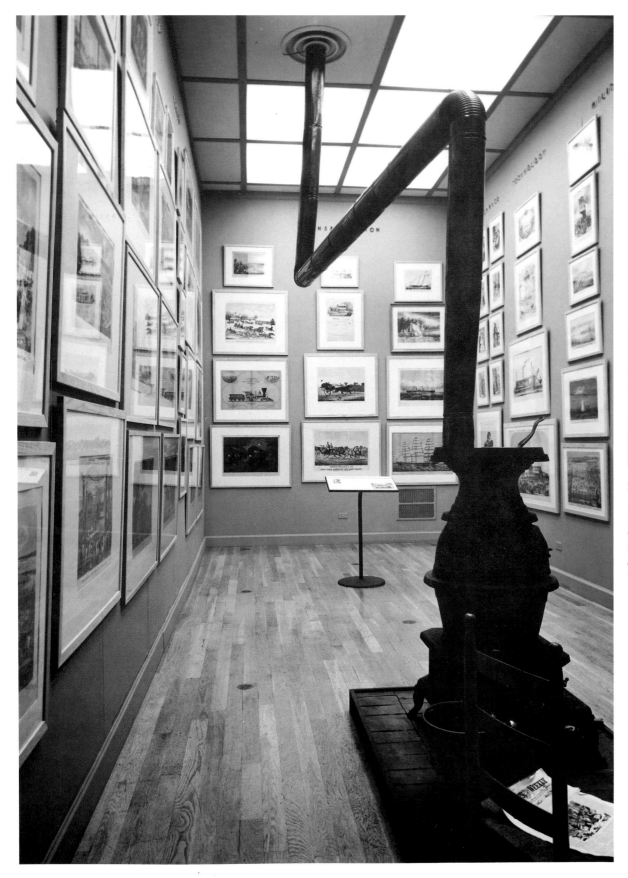

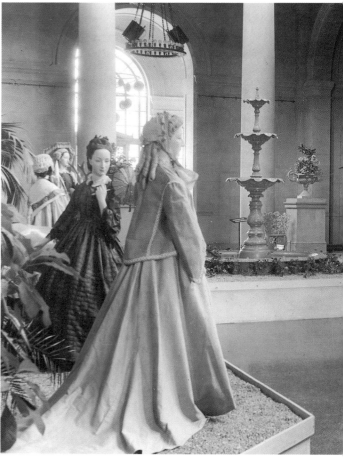

LEFT: One of the most delightful aspects of *Homefront, 1861* was this recreation of a period "Sales Room," its pot-bellied stove filled with what seemed to be actual embers. Here were hung some 100 lithographs by the inimitable Currier and Ives, whose work is a pictorial catalogue of life as it was before tragedy struck the Union.

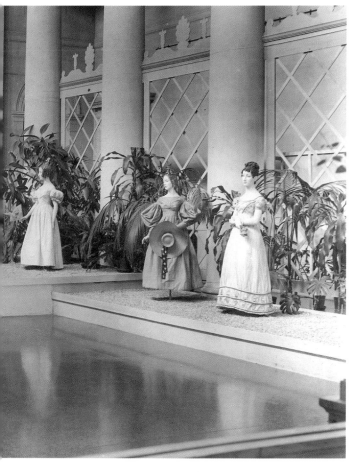

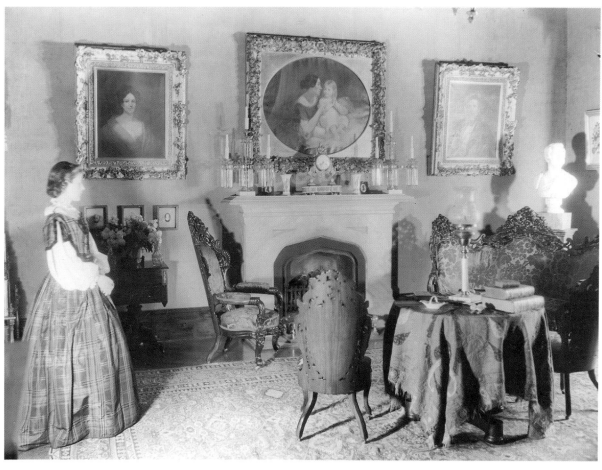

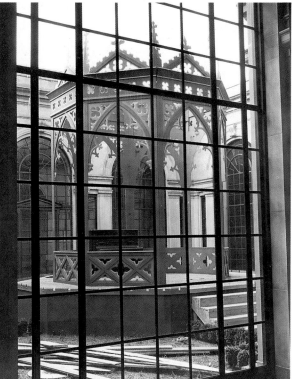

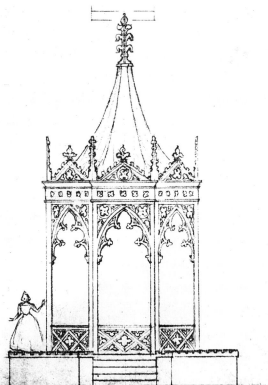

ABOVE LEFT: A precursor of *Homefront, 1861, Romanticism in America* was also an examination of antebellum culture. Like its latter-day version, the 1940 installation at the Baltimore Museum for *Romanticism* included appropriately costumed mannequins and a cast-iron fountain.

ABOVE: A recreated 19th century parlor in *Romanticism in America*. Costumed museum volunteers helped bring the Victorian age to life.

LEFT: Cheek's drawing for the Gothic-style bandstand used with *Romanticism in America* (1940). The bandstand, shown here under construction, was erected in the central court of the Baltimore Museum and contributed to the 19th century atmosphere of this memorable exhibition.

ABOVE: Visitors to the Virginia Museum's Egyptian Gallery (opened in 1961) climbed this gently inclined ramp, its dark walls covered with gray paint impregnated with sand to simulate rough stone. At either side of the ascent stood small platforms with spot-lit sculptures and canopic jars. Papyrus fragments and stone paintings were mounted behind these. Barely audible music selected to represent ancient Egyptian song added to the sense of mystery. At the end of this ramp loomed an oversized granite sculpture of King Senkamanisken—its black form also dramatically lit from above.

RIGHT: The woman at the far end of the Egyptian Gallery's upper-level concourse peers down a glass-covered shaft to see the replica of a IX-XI Dynasties tomb with a mummy and scattered objects left by robbers. The scene was an exact recreation of a photograph taken in Egypt by a team from the Boston Museum of Fine Arts in the late 19th century. The contents of the tomb were bought from the Boston Museum and reassembled in Richmond.

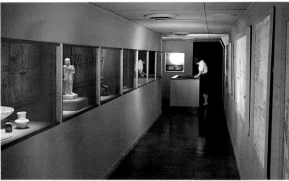

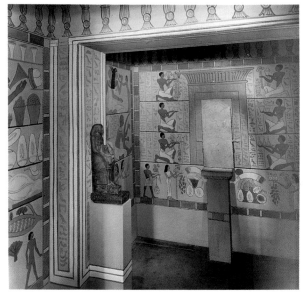

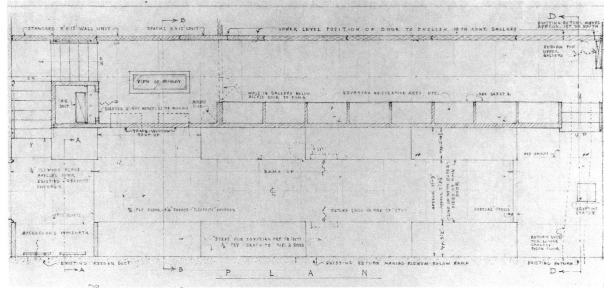

ABOVE: The "Land of the Pharaohs" inspired this tomb-like structure that Cheek built as a children's museum in the Baltimore Museum basement in the early 1940s. Youngsters eagerly entered to gaze at the colorful scenes painted on massive, cement walls.

BELOW: The Egyptian Gallery at the Virginia Museum under construction in 1960. Looking down the ramp, the door opens onto the Mediterranean Court.

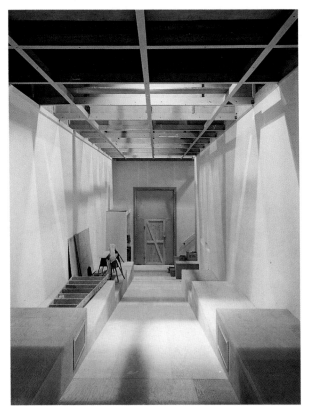

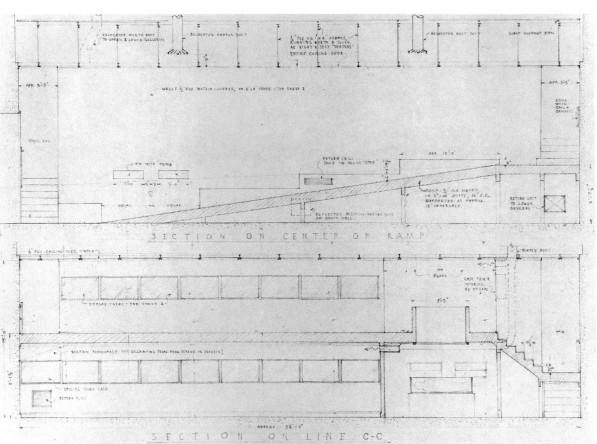

Details from Cheek's original architectural drawings of the Egyptian Gallery (circa 1959). The challenge posed by narrow spaces was met by installing the gallery on two levels—the lower-level ramp and an adjacent upper-level passage. The project was made possible through the generosity of Mrs. James H. Parsons of Richmond.

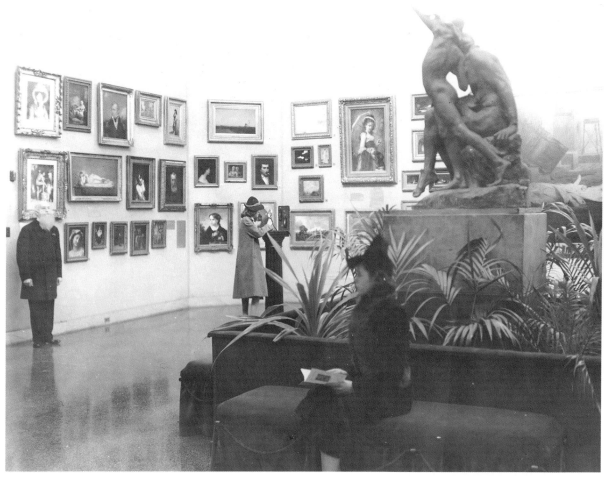

ABOVE RIGHT: Occasionally Cheek relied on humor to establish context. *Modern Painting Isms and How They Grew* (1940) was more than an assemblage of Surrealism, Impressionism, Cubism, Primitivism and Expressionism. The foundation for the display was laid by first inviting visitors to enter this recreated 19th century Salon, complete with red plush seats. Old-fashioned academism was represented with scores of paintings hung closely together covering the walls. To complete the scene, Cheek put false whiskers on one of his guards and dressed him in a 19th century frock coat. This gentleman prowled about the gallery as if on patrol at the Louvre during the reign of Emperor Louis Napoleon.

RIGHT: After viewing the Salon, visitors proceeded to separate galleries that featured the various "Isms," such as Cubism with works by Picasso, Gris, Braque and others. At the end of the tour Cheek installed a self-styled "Bury-the-Hatchet" room, with comfortable seating as well as books borrowed from Baltimore's Enoch Pratt Free Library. Here visitors who either admired or loathed modern art were supposed to reconcile their differences.

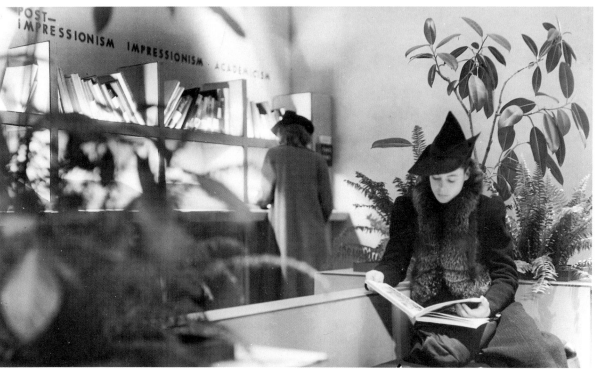

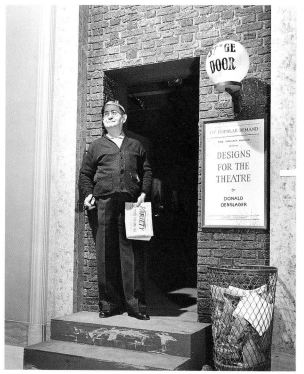

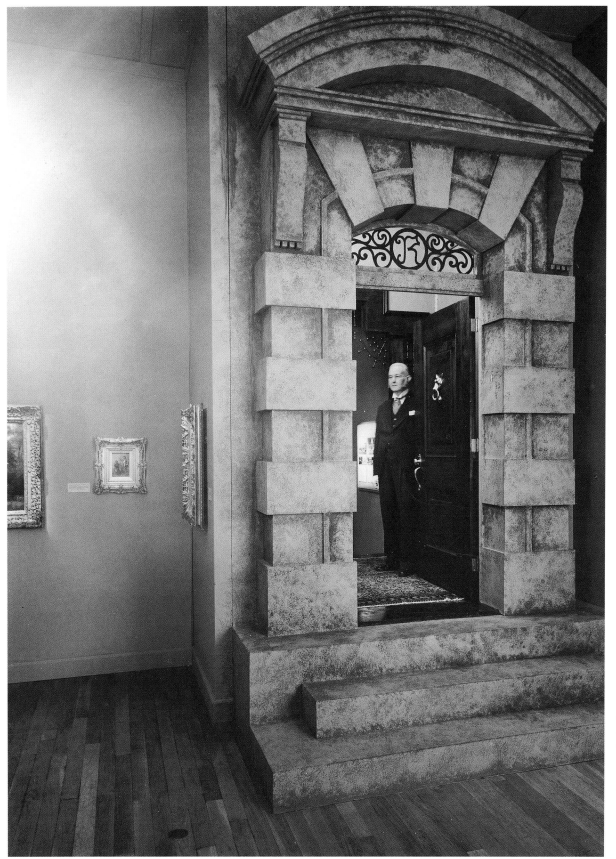

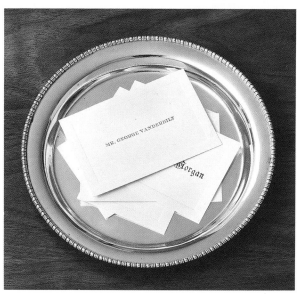

Similarly at the Virginia Museum, guards were pressed into service, once as a watchman—(top) *Designs for the Theatre by Donald Oenslager* (1958)—and as a butler (left)—*The Tastemakers* (1952). It was all part of Leslie Cheek's desire to make art museums lively and entertaining. "Art should be fun," was his oft-repeated byword. The turn-of-the-century butler who greeted visitors to *The Tastemakers* carried a tray (above) bearing the calling cards of some of New York's wealthiest citizens. This entrance to the exhibition was designed to resemble one of the grand townhouses that once lined Fifth Avenue.

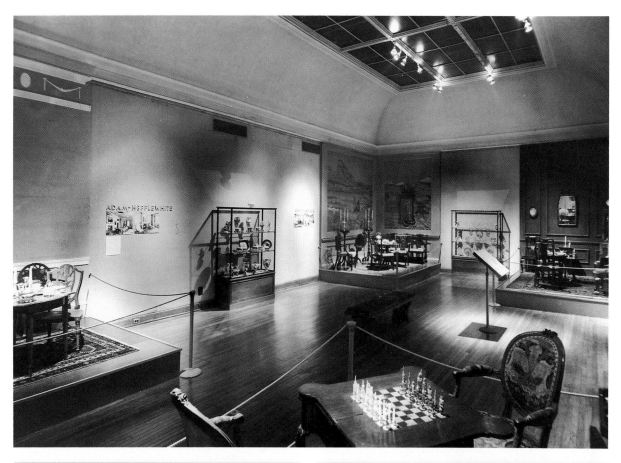

RIGHT: *Georgian England* (1940). Cheek found John Russell Pope's design for the interior of the Baltimore Museum of Art a restrictive one. The galleries were poorly lit by skylights—a problem Cheek tried to rectify by covering them with black paper and using spotlights instead. Load-bearing walls made it difficult to arrange more intimate gallery space. Later, at the Virginia Museum of Fine Arts, he introduced flexible systems for lighting and for partitioning the gallery spaces.

BELOW RIGHT: Cheek used bold lighting throughout his career to entice the public, arouse its interest and make art less intimidating. *Sculpture and Carl Milles* (1940) was the first comprehensive exhibition of the work of the famous Swedish artist. Cheek described the installation in a letter to his wife dated November 28, 1940: ". . . The Sculpture Hall was really a dream in its great height of blue gauze hung in folds, and looking very much like mist falling in sheets, lighted as it was by blue-green lights from the back. The fountain figures were lighted in pink and straw from concealed sources. This room is a success and should be, for it represents endless hours of effort—the curtains, the lighting, the bases, the repairing and painting of the casts taking many days to accomplish. We did the lighting over three times to get it right! I only wish you could see it, for never has such a thing been in a Museum—it is really breath-taking [sic] in its dramatic delicacy—especially the mysteriously lighted figures as seen through folds of gauze."

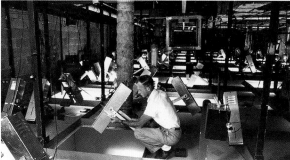

ABOVE: Cheek's long-standing fascination with lighting led him to search for new methods of refinement and control. In the early 1950s, with the help of consultant Carroll B. Lusk, Cheek developed the "Lusklite" system for the Virginia Museum. A vast improvement over the spotlights then commercially available, Lusklites provided more precise focus of the intensity, color and shape of the light projected. Lusklites had another advantage—they could be concealed and aimed through apertures cut into ceiling panels. Here a workman is in the crawl space above the ceiling in one of the loan galleries at the Virginia Museum (circa 1960). He is carefully inserting a tinted gel into one of the Lusklites to create just the right effect in the room below.

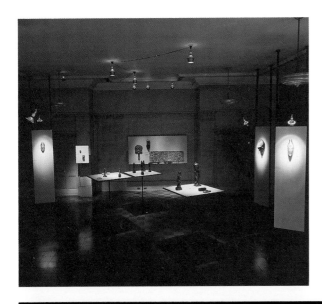

LEFT: Compared with other museums where works of art were often difficult to see, the Virginia Museum displayed objects in such a way that they appeared to be sources of light in themselves. Cheek's novel lighting made the walls recede and the art stand out as the focus of attention in the dramatic settings for the arts that he devised. *Sculpture from Africa* (1953) and the Italian Gallery, Virginia Museum, circa 1962.

BELOW: At the Virginia Museum, Cheek's imaginative use of lighting created experiences few would forget, among them *Treasures of Tutankhamun* (1963). In this gallery, consciously designed to induce claustrophobia, single objects were placed under glass on freestanding pedestals. These were individually illuminated by intense, vertical shafts of light. One observer remembered that the objects seemed to defy gravity and hover magically in midair.

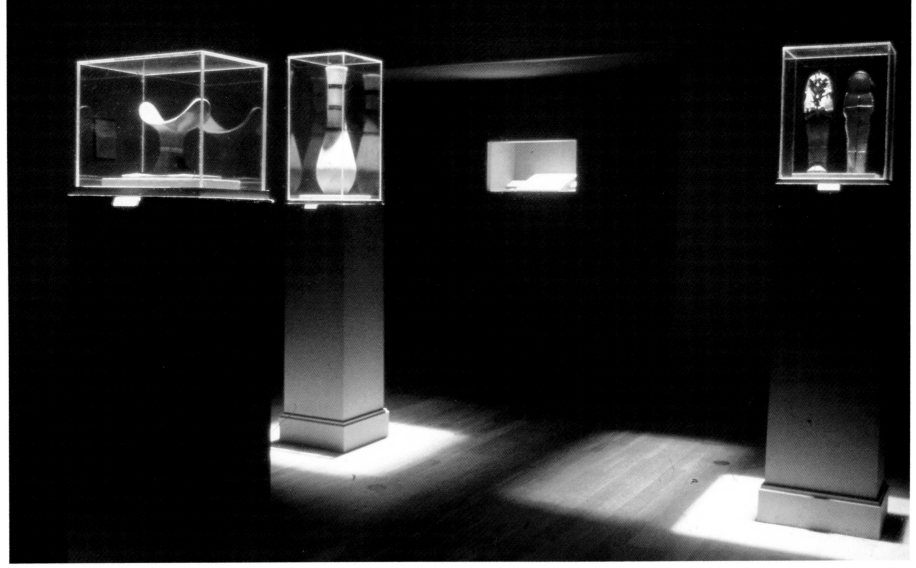

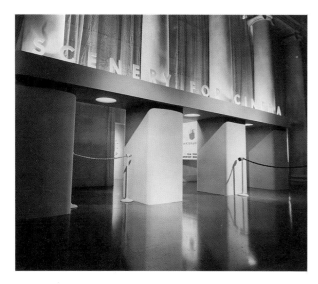

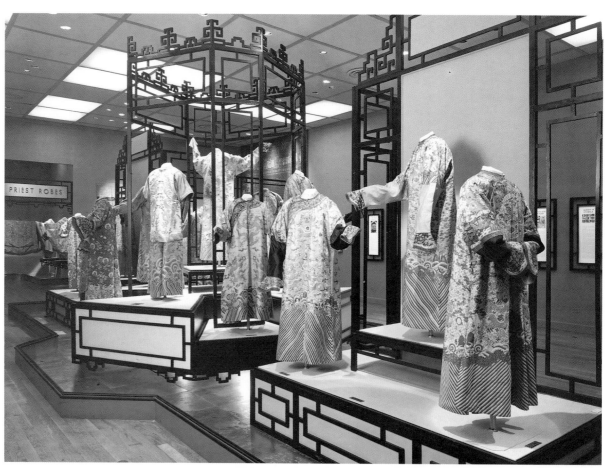

ABOVE: The gallery entrance to *Scenery for Cinema* (1940) suggested a movie marquee. Passing through it, Baltimoreans were invited to imagine that they were attending a star-studded "Opening Night" in Hollywood. To make art more approachable for museumgoers, Cheek frequently placed such contextual devices at the starting points of his installations. He believed that conventional museum displays failed to attract the public.

RIGHT: Dramatic techniques for audience building included not only complete environments, such as the Egyptian Gallery, but also nuances of design that enhanced temporary installations. Architectural detail, for example, was an effective means of establishing settings for the arts. Cheek and the professional designers on his staff included decorative features intended to coincide with the public's shared mental imagery of a particular culture or era. For an exhibition of Chinese silks—*Robes from the Forbidden City*—held at the Virginia Museum in 1959, for example, the loan gallery was fitted with lacquered trelliswork that characterized the Chinese vernacular. A year later, a display of black-and-white photographs of Japanese architecture was enhanced through a full-sized replica of a traditional Japanese garden with simulated pool, a teahouse and bright red tori—each, again, recognizable elements that enhanced the public's appreciation for unfamiliar subject matter.

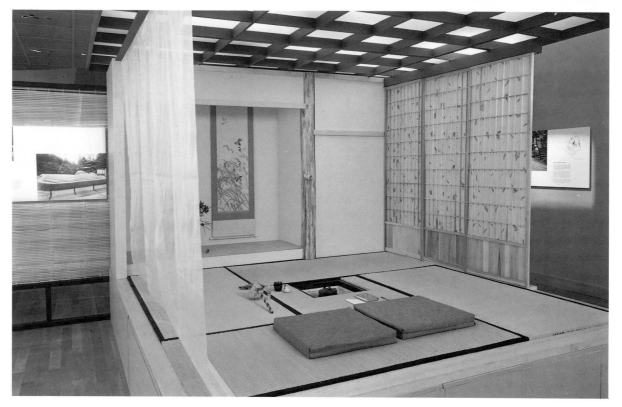

Simulations of Tudor-era strapwork and leaded windows enhanced the installation for *The World of Shakespeare* (1964), the most comprehensive collection of Elizabethan art ever assembled in the New World. The museum workshop created the windows from specially selected sheets of textured acrylic that had been faintly tinted. "At a close distance you couldn't tell that the windows weren't authentic," said Harry Robertson, museum staff member from 1961 to 1965, who assisted with the installation. Comprising 175 objects, the exhibition was organized and circulated by the Detroit Institute of Arts and included four portraits from the private collection of Queen Elizabeth II of Great Britain.

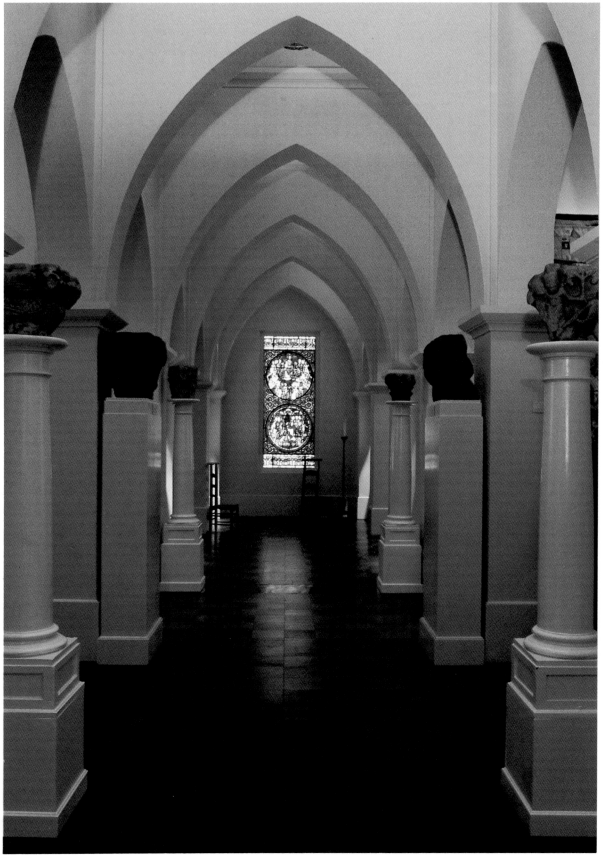

ABOVE: *Arts of India and Nepal* (1967) showcased the creative efflorescence of the subcontinent before its discovery by European explorers.

LEFT: A cloister-in-miniature—the Medieval Gallery at the Virginia Museum, circa 1967. The stained glass in the background once graced England's historic Canterbury Cathedral.

Cheek directly engaged the interest of museumgoers by placing art in historic context or through the clever manipulation of color, sound and even smell. **ABOVE:** For example, red silk fabric, like that selected for the Virginia Museum's Russian Gallery, evoked the magnificence of the Romanoffs. **ABOVE RIGHT:** The gray hues in *Medieval Treasures* (1964)—an Artmobile exhibition—suggested the stonework of Europe's unforgettable Gothic cathedrals. **RIGHT:** Color might even suggest particular geographical regions of the world, as with *The Greek Line* (1962), an exhibit of the Virginia Museum's important collection of Attic vases. The rich, hot ochre in the background repeated the color of the Eastern Mediterranean soil from which the vases had been fashioned millennia before.

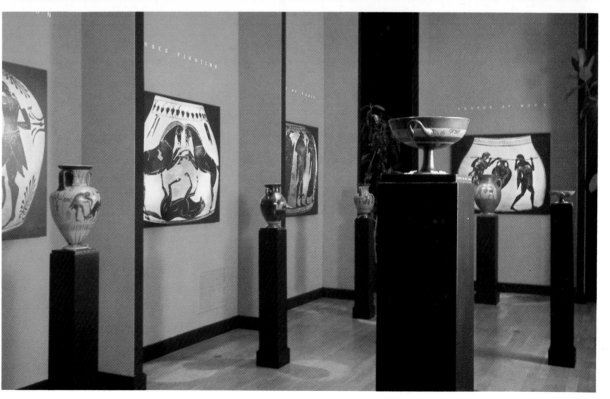

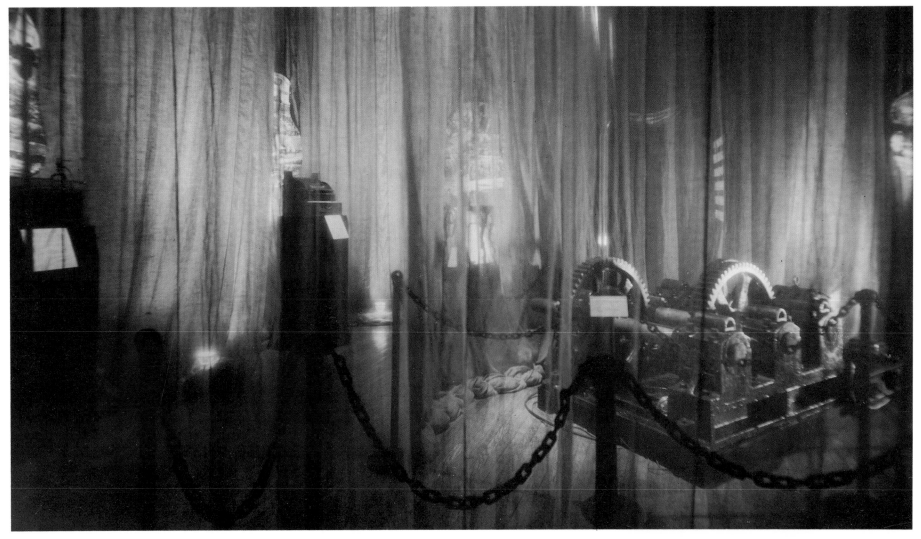

ABOVE: The suitable historic context could be created—the proper mood set—not only through the careful placement of architectural details, or the precise selection of color, but also through the imaginative introduction of sound. For *Design Decade* (1941), devoted to modern industrial design, Cheek installed this huge, clanking machine in the Baltimore Museum of Art. The ungainly contraption, which startled elderly visitors more accustomed to silence in a staid museum, was intended to symbolize the noise and grime of early industrialism. The gauze curtains pictured here were frequently used to break up the large gallery spaces at the Baltimore Museum. **RIGHT:** Later at the Virginia Museum, Cheek installed a sound system as up-to-date as the new Lusklites. Machines such as these piped music into the exhibits: in the Oriental Gallery, the dulcet tinkling of triangles; in the Eighteenth Century Gallery, chamber music; and in the Twentieth Century America Gallery, the atonalities of Bartok. The same sound system, incidentally, carried the recorded cries of seagulls into the galleries for *Homer and the Sea* (1964), thus evoking the nautical themes that characterized so much of Winslow Homer's work.

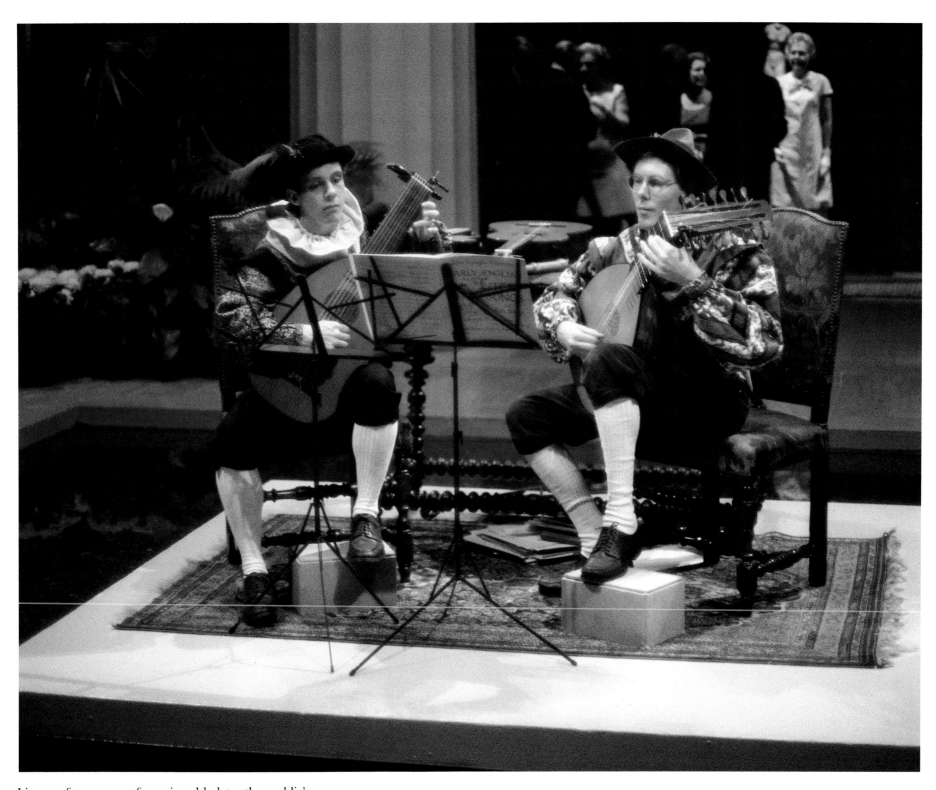

Live performances of music added to the public's enjoyment of the arts. *Festival Designs by Inigo Jones* (1968) exhibited costume and scenery designs for Stuart masques, accompanied at the opening by music of the period performed by a group of costumed instrumentalists.

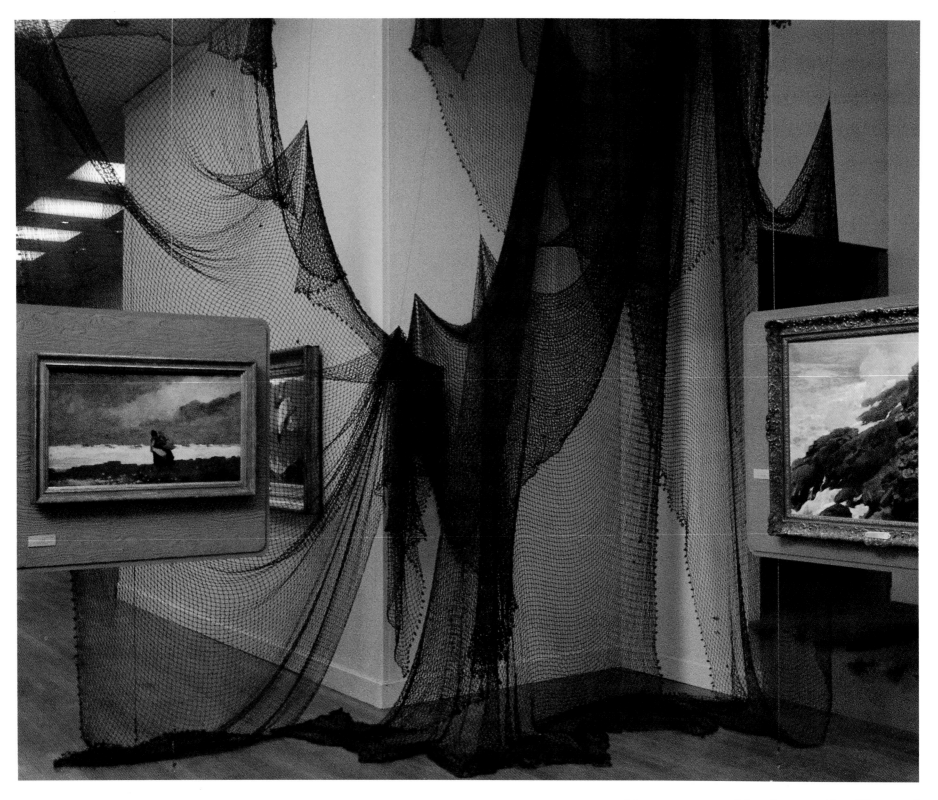

Not everyone agreed that the sense of smell increased one's pleasure in art, but Cheek thought that it did. For *Homer and the Sea* (1964) the pungent odor of tar—used as a sealant for ships' hulls in the 19th century—wafted through the exhibition.

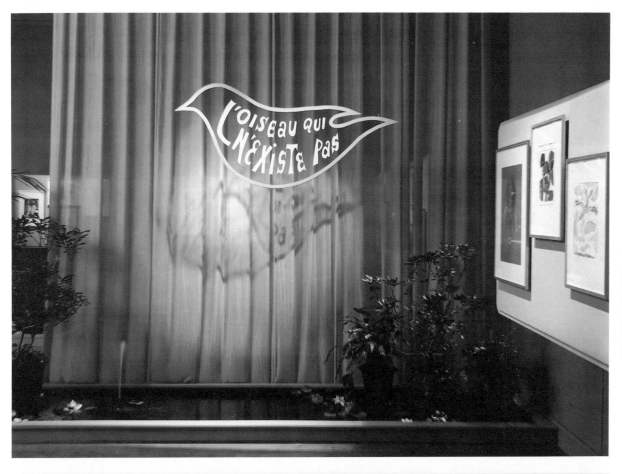

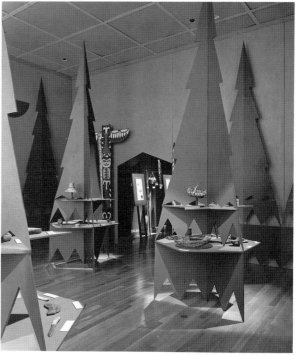

LEFT: Cheek's "sensuround" approach reached its zenith in *L'Oiseau Qui N'Existe Pas* (1964), which took its name from the 1956 Claude Aveline poem. This exhibition presented more than 100 paintings, sketches, watercolors and gouaches depicting Aveline's imaginary fowl. The works by such modernists as Cocteau, Villon, Masson and Campigli were loaned by Paris' *Musée Nationale d'Arts Moderne.* For what surely must have been his most fanciful installation, Cheek transformed the Virginia Museum's Loan Gallery into a paradisiacal garden, where the illustrations were suspended among three large, rippling pools equipped with multi-colored underwater lights. Lavender draperies and Debussy's music added to the dream-like atmosphere. On opening night, a harpist—resembling a bird-woman of classical mythology—plucked her instrument on an island that floated in the pool in the Mediterranean Court. Museum guards donned long-beaked bird masks, and the air was suffused with the scent of exotic perfumes and the recorded cries of birds.

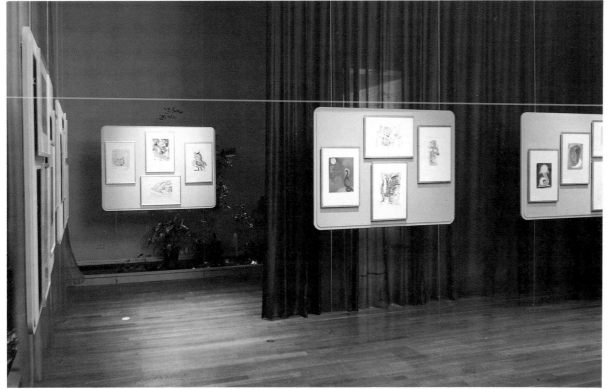

ABOVE: Pine scent evoked the great coniferous forest ranges of British Columbia in *Native Art of the Northwest Pacific Coast* (1954). "There was a masculine [aftershave] smell then available in the men's department at the local department store" Cheek says, recalling the display. "So, I asked them to ask the manufacturer to give the museum large quantities of the stuff. The store had electronically operated atomizers, so I borrowed one or two of these to place inconspicuously in the exhibition."

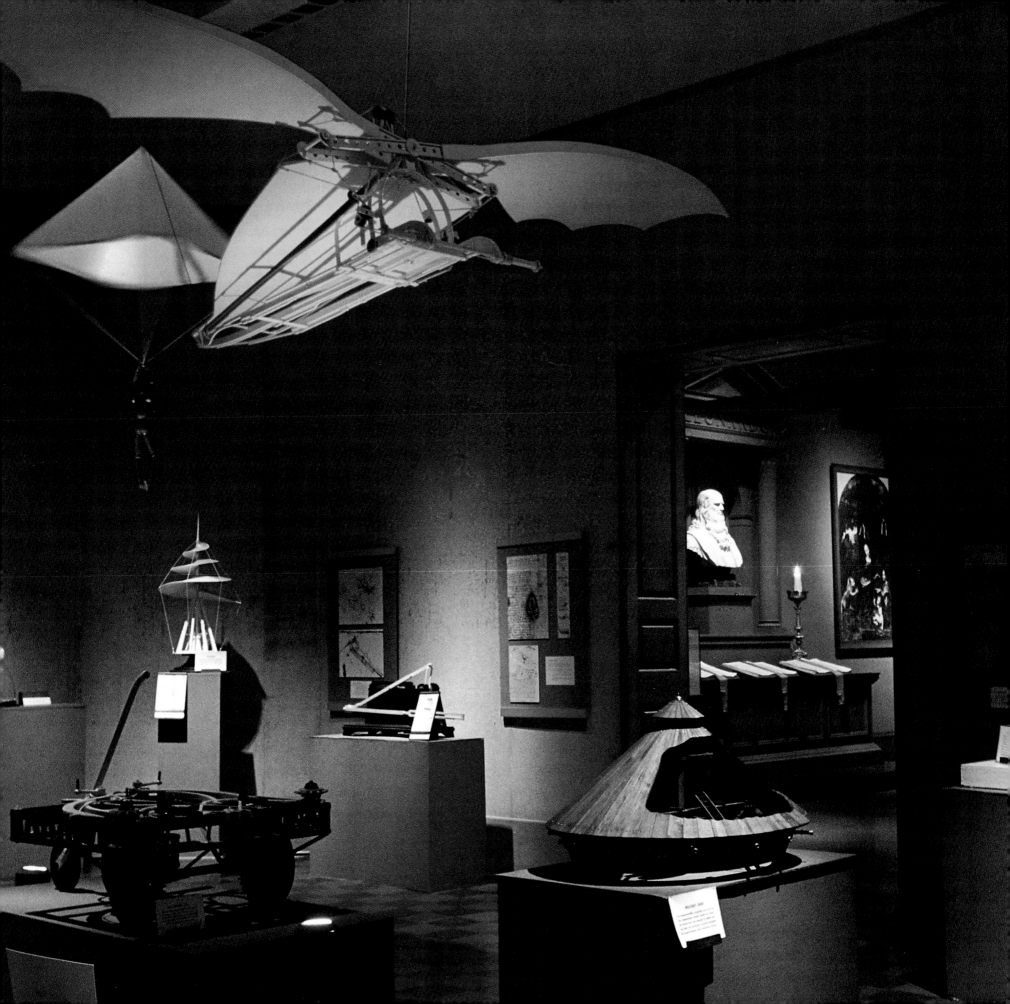

CHAPTER II

Interpreting the Arts

Models were an important feature of *The Genius of Leonardo* (1951), one of Cheek's favorite exhibitions at the Virginia Museum.

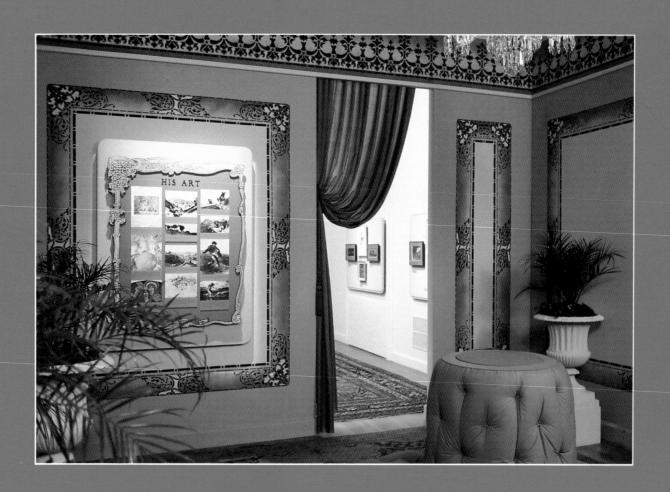

Historical settings in museum display afforded a highly effective method of placing art in meaningful contexts. While Cheek's installations were highly evocative, dramatic and visually dazzling, they also had a pedagogical aspect. His consistent use of explanatory wall panels, books, models and photomurals provided easily assimilated instruction throughout his career. From the 1950s, he enlarged his repertoire with an increasing number of automated slide presentations. These amplified the possibilities of the goals he had set for himself. He wanted people to learn without being conscious of doing so, and he wanted them to enjoy the process. His innovations culminated in the widely hailed Orientation Theatres.

As Cheek explained in 1940, "The exhibitions devoted to the arts of the past should be as complete surveys as possible of the particular era, including background information necessary for an intelligent understanding." The public's enjoyment of the arts, then, required no specialized knowledge; museumgoers, regardless of their sophistication, should be able to walk into a gallery, tour it and leave with greater understanding of, and appreciation for, what they had seen. Cheek came to believe that the fullest and easiest comprehension resulted when the visitor interacted in some manner with the display— by pressing a button to activate an automated slide show, or casting a ballot for a favorite painting.

It was through a wide variety of interpretive techniques that Leslie Cheek made a lasting contribution to the development of museums as centers of learning as well as of genuine enjoyment of the fine arts.

For a Virginia Museum exhibition devoted to Elihu Vedder, the 19th century American visionary painter, background information was available on both "The Man" and "His Art." *Paintings and Drawings from Elihu Vedder* (1966).

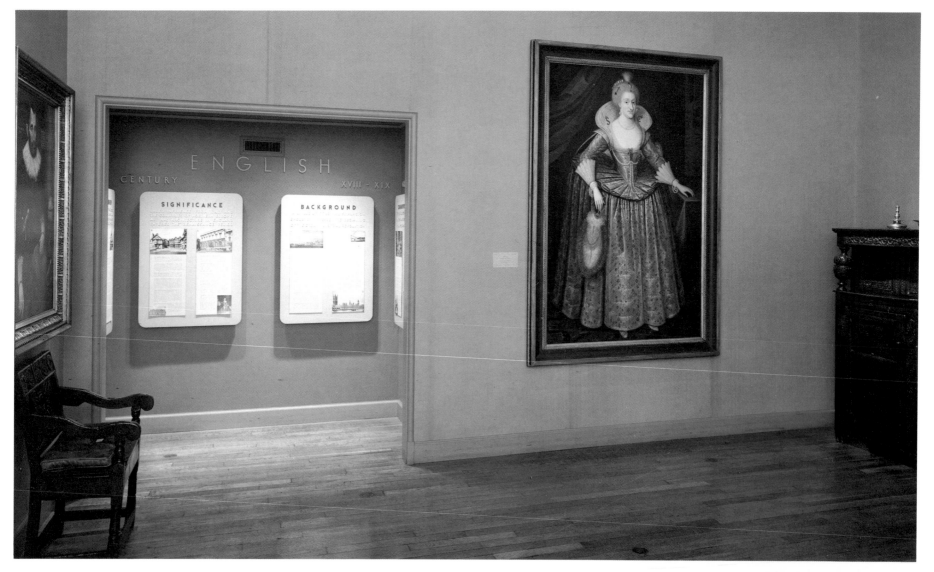

ABOVE AND RIGHT: Alcoves presenting introductory material were often at the entrances to exhibitions. The English and Italian Galleries at the Virginia Museum, shown here circa 1962, afford examples of this method. Note that the information panels titled "Background" and "Significance" feature not only textual material but stereoptical viewers as well. These provided visitors with a glimpse of historic sites.

OPPOSITE PAGE: Cheek's detailed drawings for information panels for the French and Medieval Galleries at the Virginia Museum (1954). Included are positions for spotlights, colors for woodwork and trim, as well as specifications for both type size and style for all lettering on the panels. In jest, Cheek has written just above the viewfinders beneath "French Art": "The art of France is one of pure bunk, and if you try to read all of this, you are crazy and are very curious, too. So, please stop."

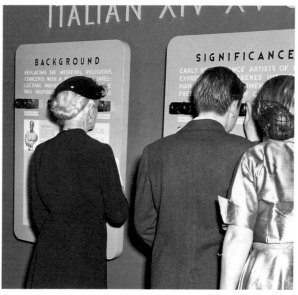

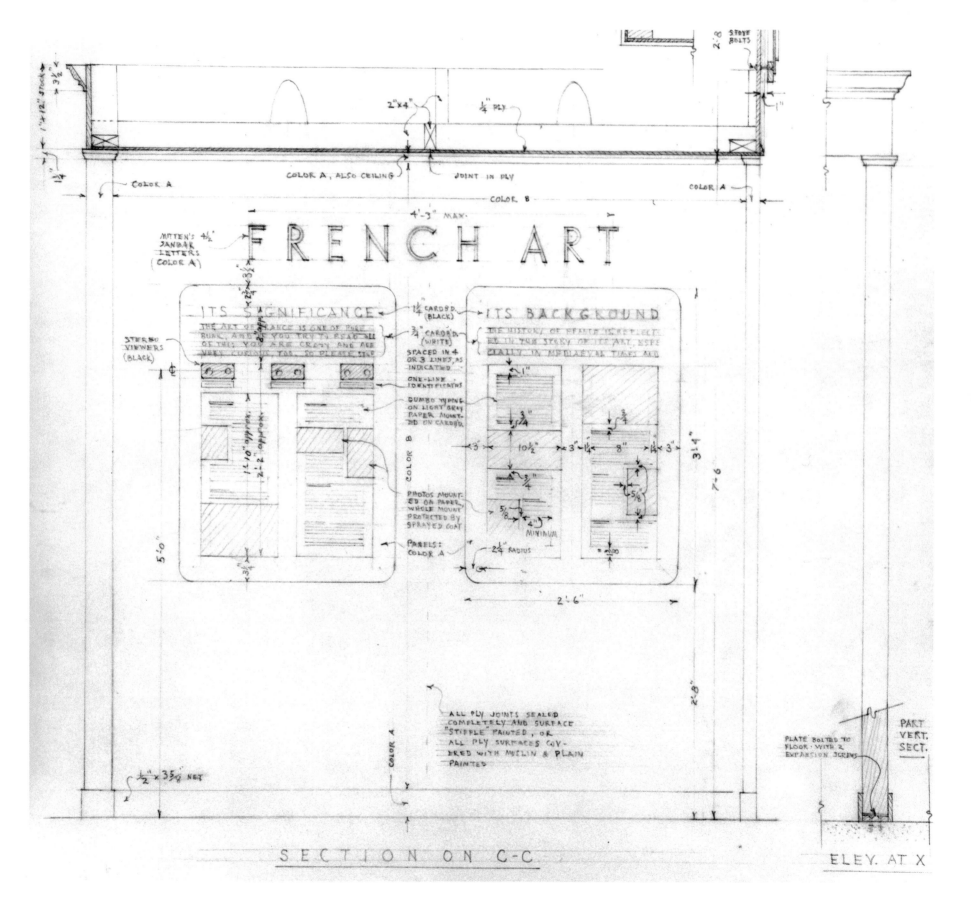

FRENCH ART

ITS SIGNIFICANCE

THE ART OF FRANCE IS ONE OF PURE
BUNK, AND IF YOU TRY TO READ ALL
OF THIS YOU ARE CRAZY AND ARE
VERY CURIOUS TOO, SO PLEASE STOP

ITS BACKGROUND

THE HISTORY OF FRANCE IS REFLECT-
ED IN THE STORY OF ITS ART, ESPE-
CIALLY IN MEDIAEVAL TIMES AND

S E C T I O N O N C-C

ELEV. AT X

BELOW: Alternatively, introductory information was conveyed not only in pavilions but in galleries that visitors had to traverse in order to enter an exhibition. In the 1940 display devoted to Swedish sculptor Carl Milles (the installation is described in the previous chapter), visitors received a mini-lecture on the history of sculpture. This small entrance room was outfitted with photographs, detailed labels and some representative original works that surveyed 4,000 years of sculpture. Armed with such information, museumgoers were better able to place Milles' contemporary works in historical perspective.

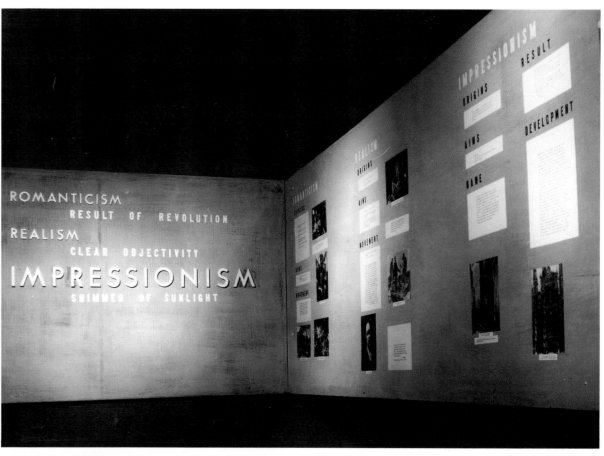

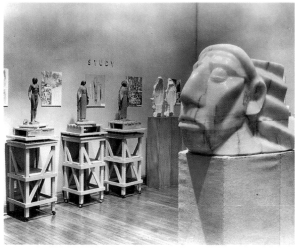

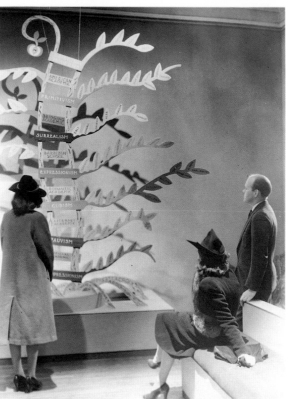

ABOVE: Cheek was convinced that background material made the fine arts more understandable to a public largely ignorant of but not averse to learning about cultural history. Hence his career-long devotion to wall-mounted information panels such as these used in *Modern Painting Isms* (1940).

LEFT: He also devised this "tree of modern art" to explain the relationship of artists (their names painted on the branches) to schools of painting.

RIGHT: Information panels were a Cheek trademark, such as these on the history of weaponry for *Again, Arms and Armor* (1941). "We have found catalogues a nice luxury," he said, "but not really needed—as well-designed and written wall labels seem to satisfy the information needs of the majority of our visitors."

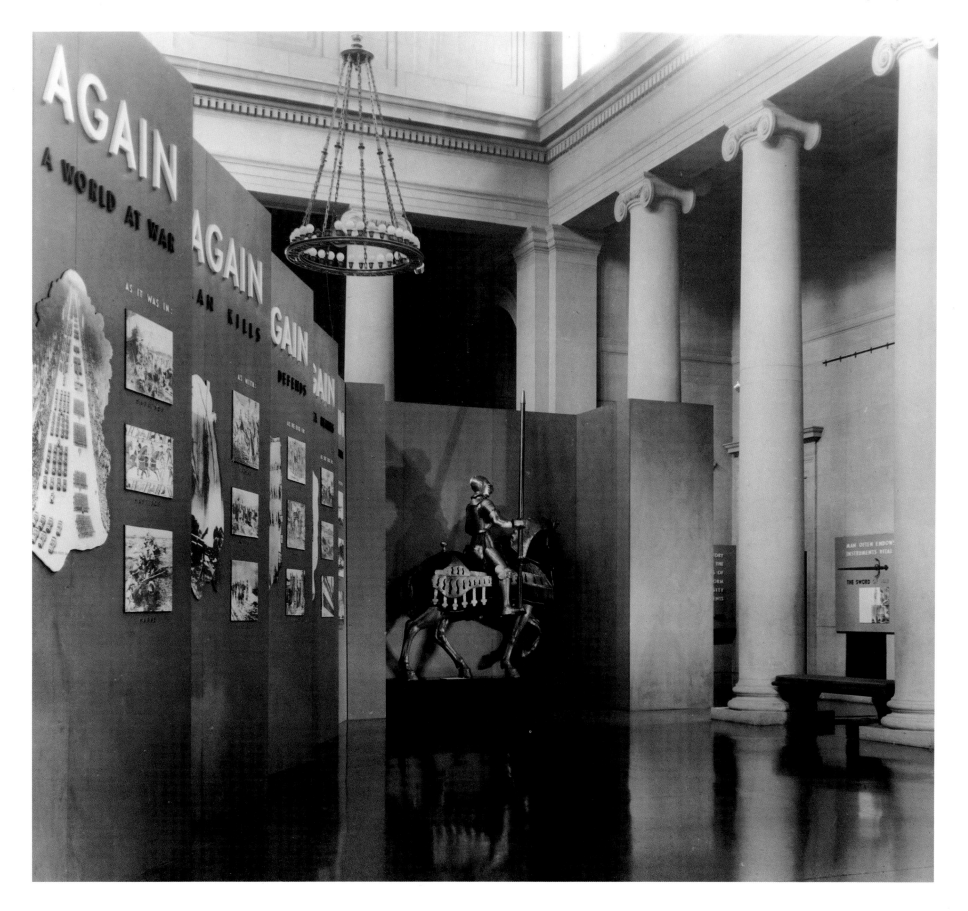

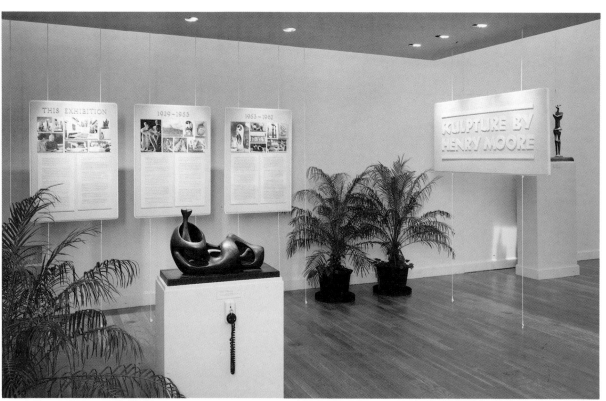

ABOVE: Background material relating to 18th-century European art was conveyed on this panel, in the Neo-Romantic style. *Les Fêtes Galantes* (1957). **RIGHT:** Also shown, panels for *Sculpture by Henry Moore* (1965) and *Georgian England* (1941).

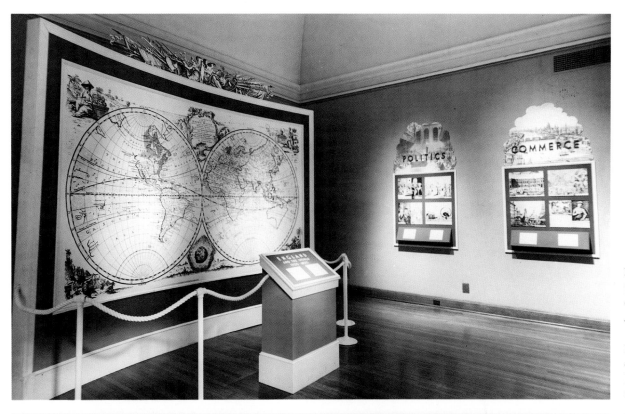

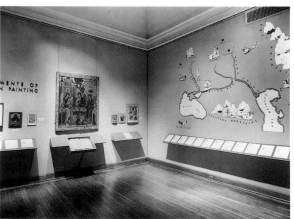

LEFT AND BELOW: Maps frequently served as interpretive aids, like these from the Baltimore Museum exhibitions *Georgian England* (1941), *Romanticism in America* (1940) and *Russian Icons* (1940).

BOTTOM RIGHT: In 1957, designer Richard Erdoes created this fanciful chart for *England's World, 1607*. Erdoes' distinctive map illustrated various world cultures that influenced the seafaring English.

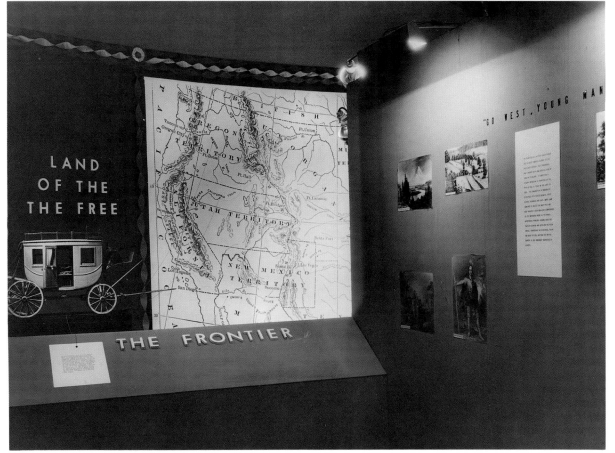

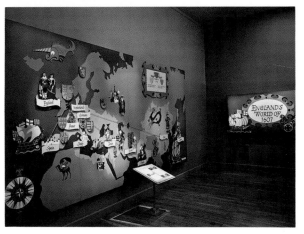

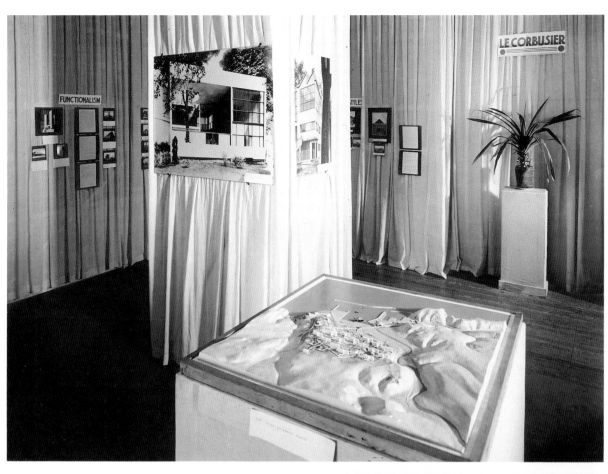

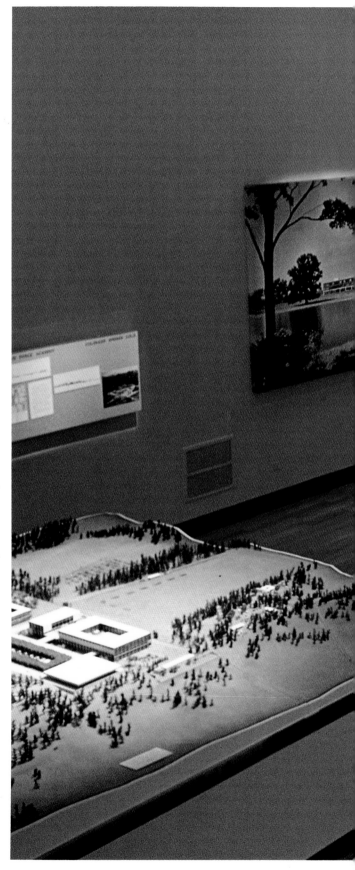

ABOVE: Exhibitions devoted to architecture recur throughout Cheek's long career in the arts. *Modern Architecture by Le Corbusier* (1937) was an exhibition borrowed from the Museum of Modern Art. Cheek combined photomurals, information panels and models in this display at the College of William and Mary. Students were thrilled by this first appearance of "Corbu" in the restored Colonial town.

RIGHT: Some twenty years later models formed the centerpiece for *The Architecture of Skidmore Owings and Merrill* (1958). A so-called "Information Terrace" at the entrance to the installation familiarized museum-goers with developments in American architecture.

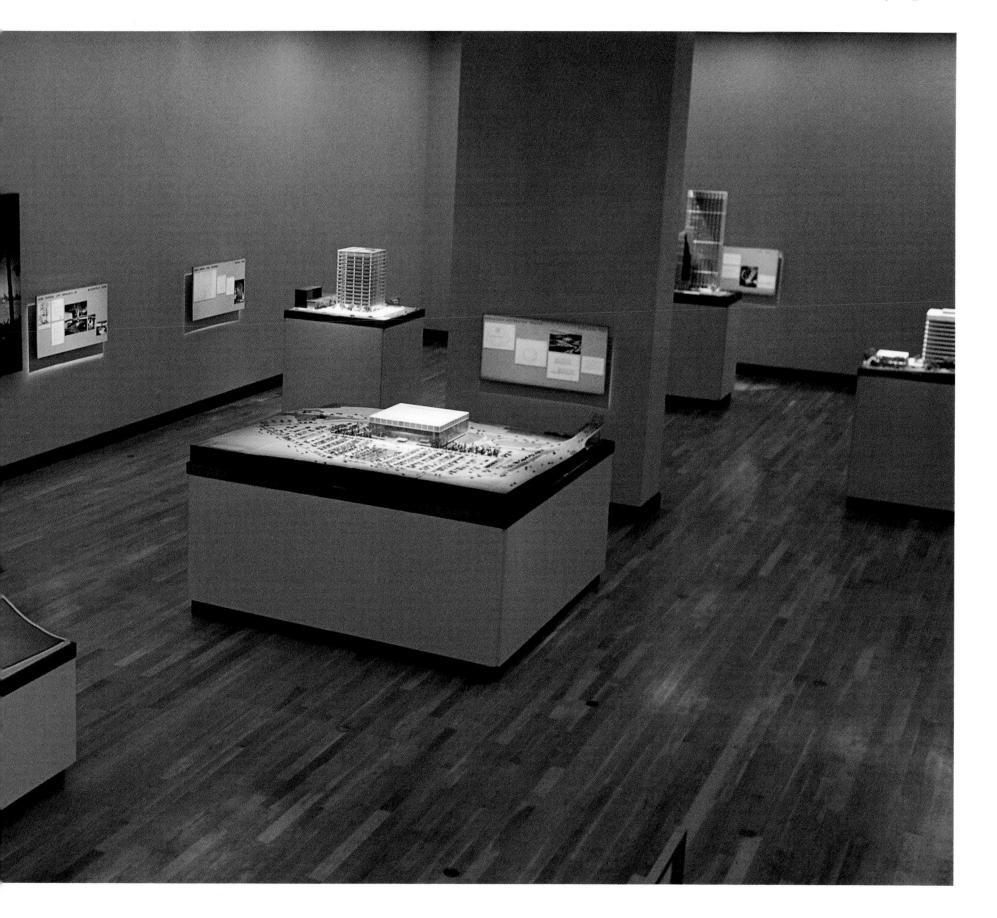

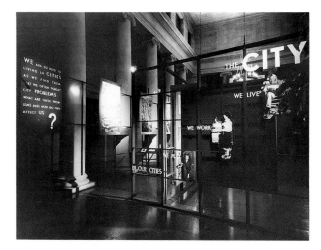

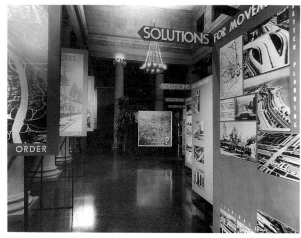

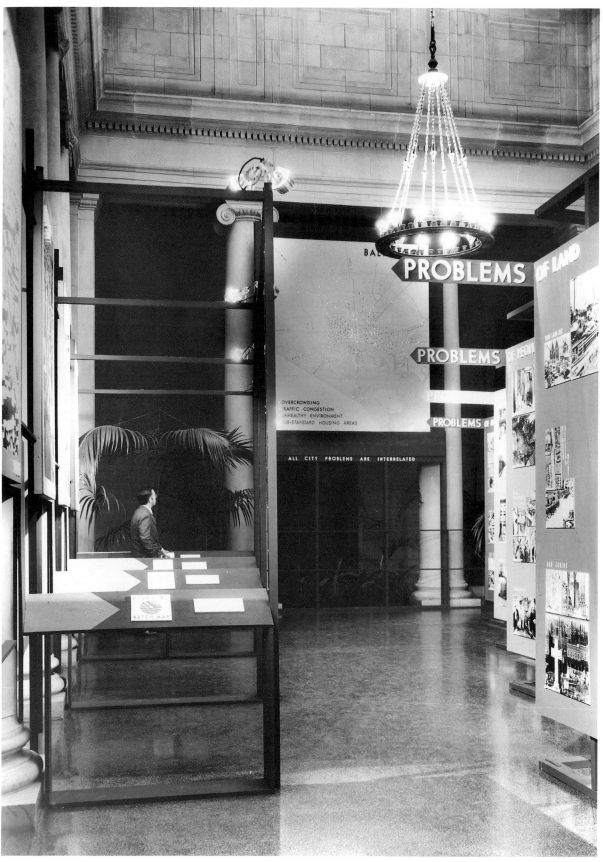

ABOVE: *The City* (1940) alerted Baltimoreans to the challenges and opportunities posed by America's evolving urban culture. The exhibition fulfilled one of Cheek's goals to make museums lively institutions that addressed contemporary urban problems.

RIGHT: The introductory section of *The City* featured an electronic map depicting pre-World War II Baltimore. By pressing the buttons (on the tables at left), museumgoers activated a series of colored lights that indicated areas that were overpopulated or unhealthy, as well as others plagued by substandard housing or bewildering traffic snarls. Panels (at right) brought attention to urban problems concerning people, land-use planning and transportation; other panels at the conclusion of the installation proposed innovative solutions.

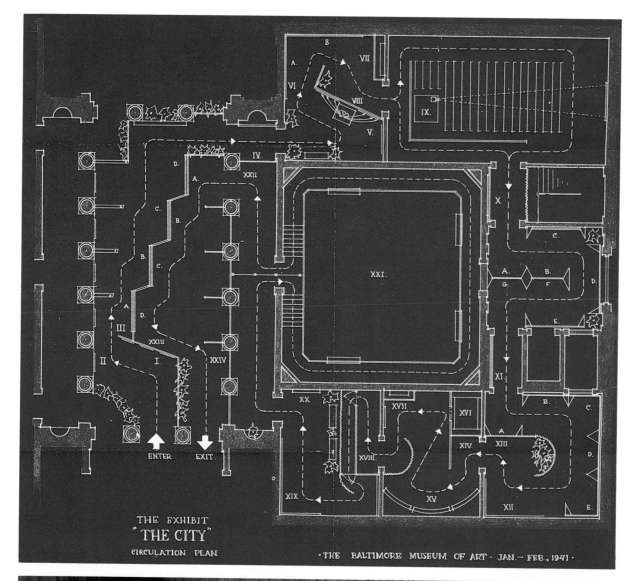

THE EXHIBIT
"THE CITY"
CIRCULATION PLAN

·THE BALTIMORE MUSEUM OF ART· JAN.~FEB., 1941·

LEFT AND BELOW: Characteristically, Cheek's circulation plan for *The City* carefully plotted the pathway museumgoers were to follow. Note how the exhibition begins and ends with areas where textual material and photomurals predominate. The layout shows how visitors were first presented with urban problems, exposed to displays concerning the changes cities underwent through the ages and then were asked to ponder alternative solutions before leaving the exhibition. **BOTTOM LEFT:** The large room at the center displayed a section of Norman Bel Geddes' breathtaking "City of 1960," which had thrilled visitors to the 1939 New York World's Fair. The model predicted cities free of urban blight, with vertiginous skyscrapers and uncongested superhighways.

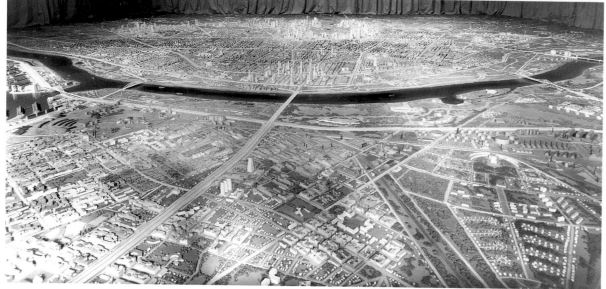

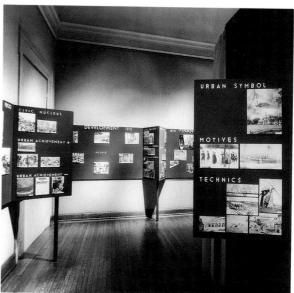

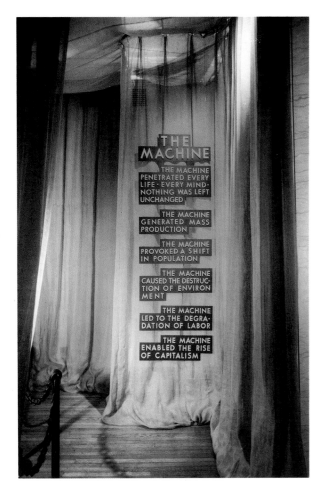

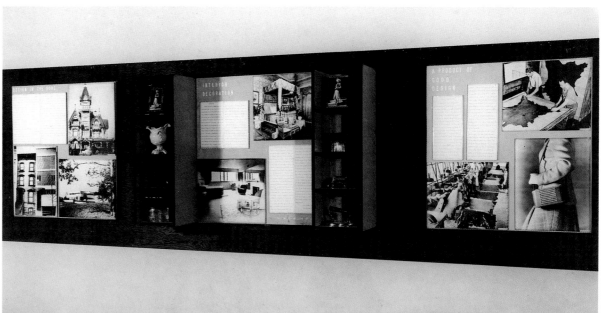

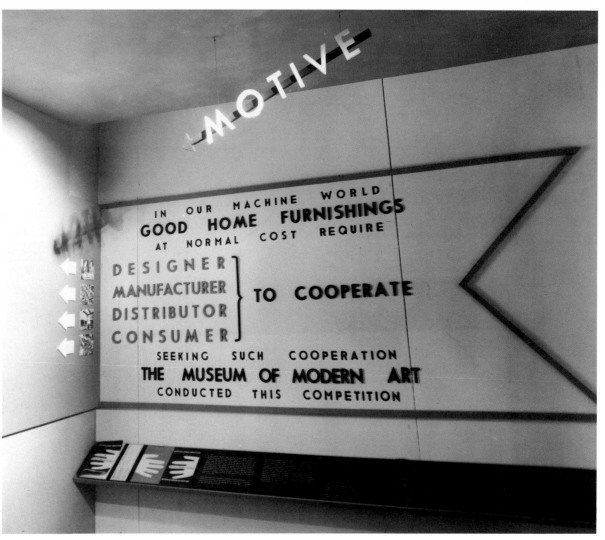

The panels in these views reveal Cheek's concern with the impact the Machine Age was having on modern life. Several exhibitions held at the Baltimore Museum focused on this topic, including (clockwise from above) *Design Decade* (1940), *Art Begins at Home* (1940) and *Organic Home Furnishings* (1942). Cheek believed that increased dependence on machines and mass production techniques threatened to dehumanize contemporary living. He envisioned art museums as oases of culture that could restore balance, grace and perspective to the inner lives of his fellow citizens.

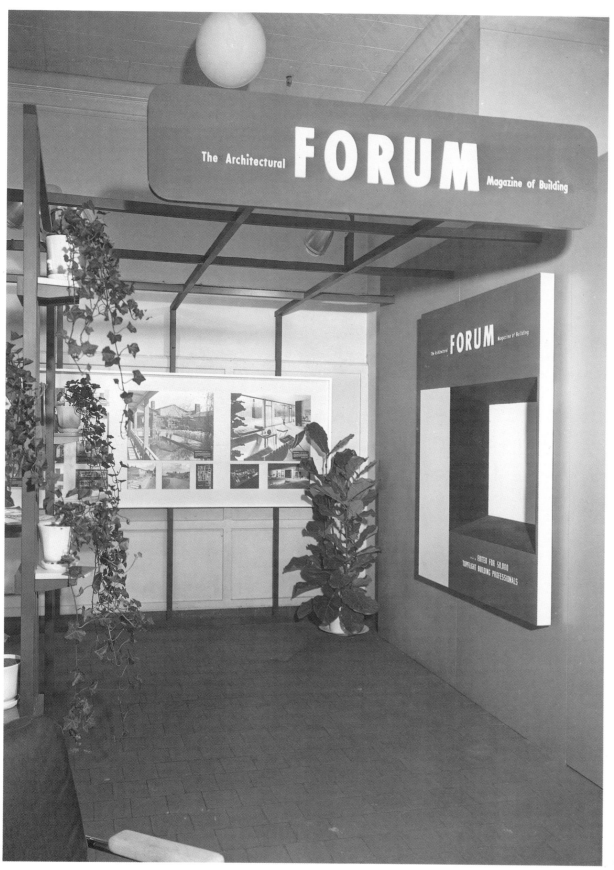

Later in his career, Cheek turned to automated slide presentations to communicate essential background material. In fact, the first time he used this technique was for an exhibition he assembled in 1946 to build circulation for *Architectural Forum* magazine, where he was an associate editor from 1945 to 1946. The slides were projected onto the white square in the Mondrian-inspired panel, mounted at the right.

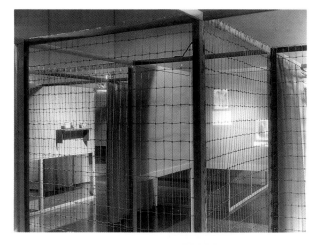

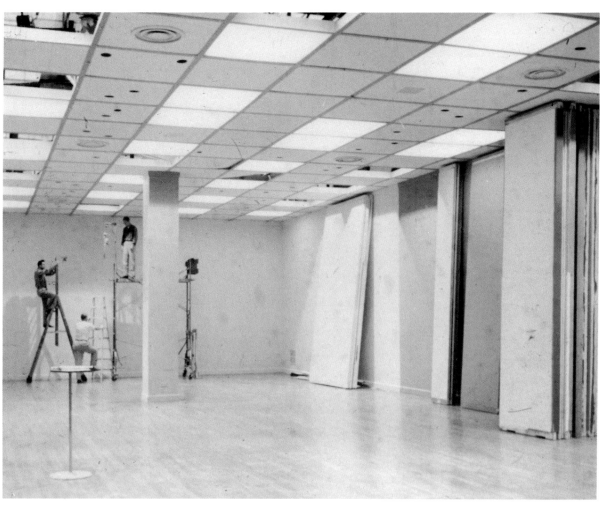

Cheek's galleries were characterized by carefully established pathways that led the public through predetermined groupings of material that corresponded to the chapters of a textbook or the logic of a lecture. The object was to organize the installation in the most orderly manner that the gallery space permitted. At the Baltimore Museum Cheek was bedeviled by large, high-ceilinged galleries and fixed, masonry walls. He introduced greater flexibility and established more manageable, more intimate exhibition spaces with temporary partitions—as with *Art of the Medici* (1939) or *Romanticism in America* (1940). **TOP LEFT:** Perhaps the most unusual of these space-creating and traffic-directing devices were the wire barriers he used in *Art Begins at Home* (1940). **ABOVE LEFT:** As with the gauze curtains in *Sculpture and Carl Milles* or the latticed screens or plants in other exhibitions, the wire allowed the visitor to glimpse what lay ahead while remaining within predetermined pathways. **ABOVE AND RIGHT:** Later, at the Virginia Museum (above), Cheek introduced so-called "movable walls," full-length panels that could be configured into virtually any arrangement desired.

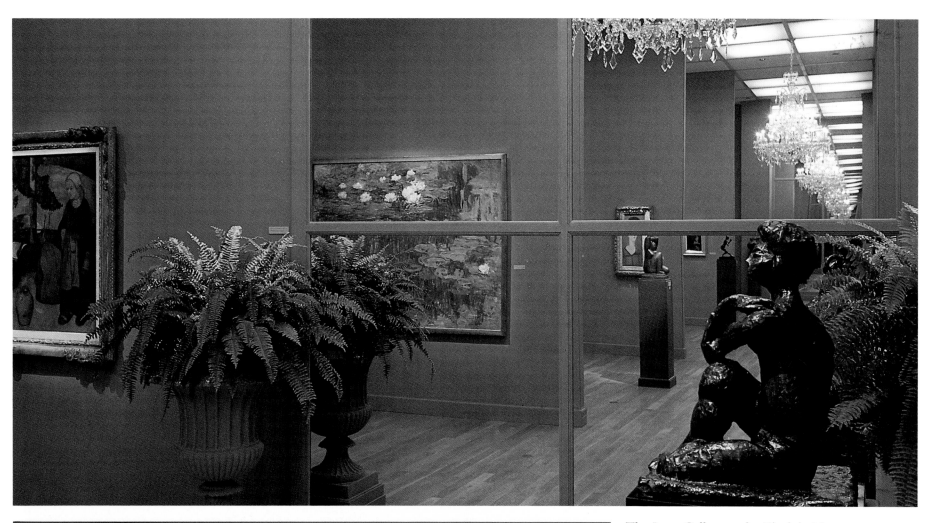

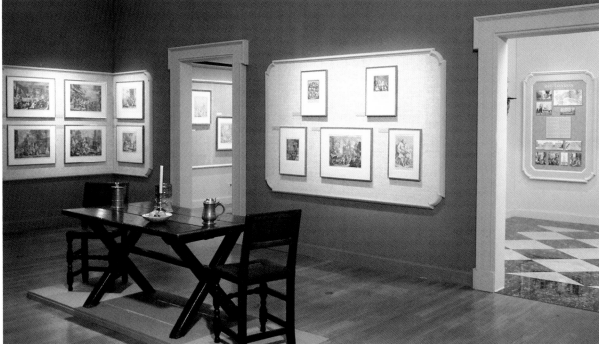

The Loan Gallery at the Virginia Museum was transformed for *The Aldrich Collection* (1959) and *William Hogarth* (1967).

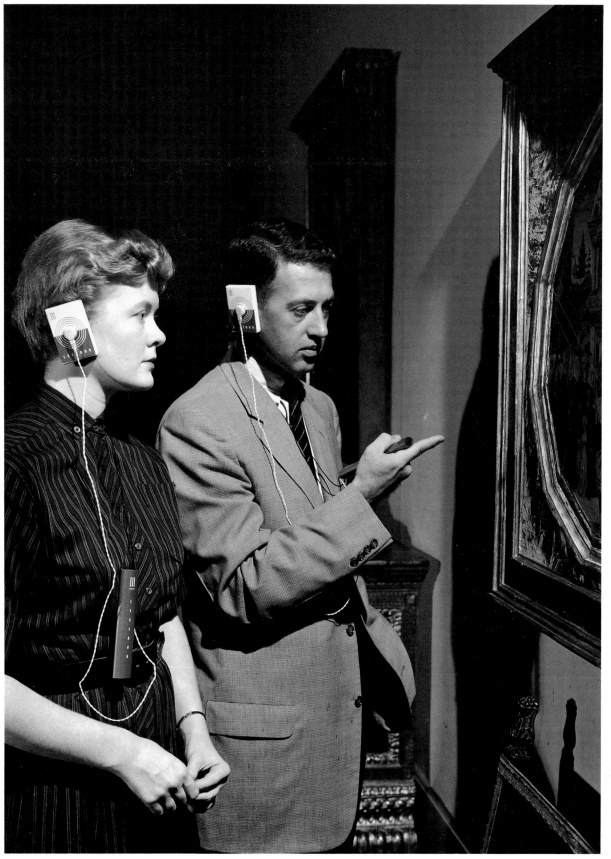

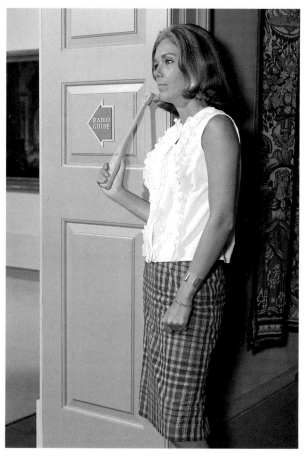

LEFT: Cheek was in the vanguard of innovators with his introduction of recorded interpretive talks in the galleries. Beginning with the 1959–60 season, the Virginia Museum became one of only five American institutions to offer patrons "LecTour" devices. Available in the Dutch, French, Oriental and Early Italian galleries, the sets rented for twenty-five cents to museum members, thirty cents to non-members. "Lec-Tour" was a small transistor receiver worn on the ear. Hand-held receivers aimed at designated points picked up signals from a hidden radio that broadcast art history lectures every ten minutes. With a later version of "LecTour" the receiver was worn about the neck of museum patrons.

ABOVE: Cheek employed a different system of electronic guides at the first major exhibition of British art held in the United States, *Painting in England, 1700–1850* (1963). The mammoth collection of 400 paintings, watercolors and drawings from the collection of Mr. and Mrs. Paul Mellon filled thirteen of the museum's major galleries. Obviously, such an assemblage of art threatened to overwhelm even the most seasoned connoisseur, so the museum distributed hand-held receivers—called "Radio Guides"—that transmitted brief commentary in each gallery.

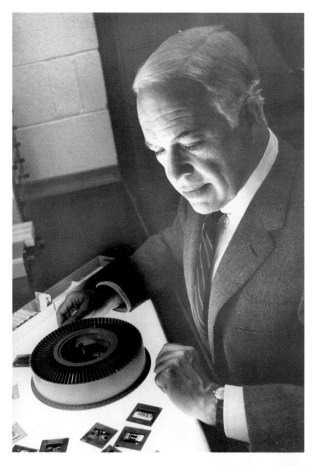

LEFT: Leslie Cheek uses a light table to select slides for the Virginia Museum's Orientation Theatres (1968). Staff members journeyed around the globe photographing some of the world's greatest art and architecture for use in the small theatres. One of Cheek's finest interpretive innovations, the Orientation Theatres were situated at the entrances to galleries, and provided a restful place for museumgoers to pause while listening to twelve-minute, automated slide presentations on cultural history.

BELOW: Prior to the opening of one of the few exhibitions devoted to modern sculpture that he presented while in Richmond—*Sculpture by Henry Moore* (1965)—Cheek asked, "How many times have we stood before a great work of art and wished we could hear the artist tell us his personal thoughts about it?" To that end, staff member Marie Louise Pinckney was dispatched to England to interview the renowned sculptor. Here, Pinckney records Moore's observations at the artist's home. Later, museumgoers were able to listen to Moore via hand-held receivers.

CHAPTER III

Taking Art Beyond Museum Walls

From Lusklites to labels, from pedestals to programming, the Artmobile was indeed a miniature Virginia Museum. *Art Before Columbus* (1961) featured objects from pre-Columbian cultures in Mexico, Central and South America.

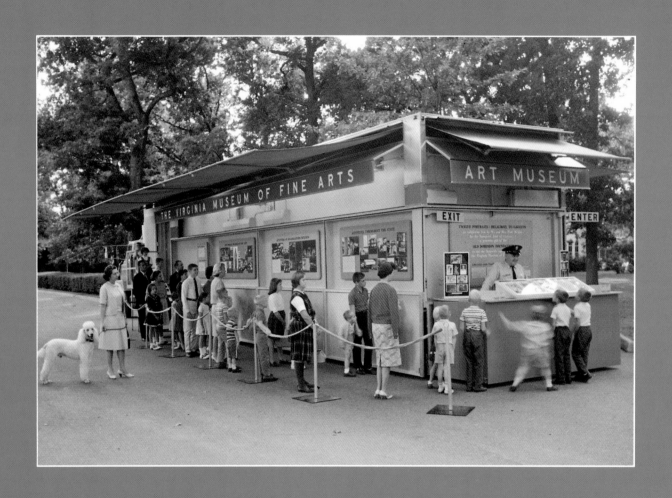

Leslie Cheek readily confesses that his most difficult challenge at the Virginia Museum of Fine Arts was fulfilling the legislative mandate that the museum serve audiences throughout the Commonwealth. Certainly, he had faced no such responsibilities before in Williamsburg. Nor had he been required to take art beyond the museum walls in Baltimore, though in early 1942 he had organized a few stage productions for the entertainment of troops billeted at nearby military encampments. No other museum in the United States had the kind of statewide responsibilities assigned the Virginia Museum. In seeking to meet this unique public obligation, Cheek added yet another dimension to his role as popularizer of the fine arts in America by developing the world's first art gallery on wheels—the Artmobile—and devising a statewide confederation of cultural organizations to bring the arts to greater numbers of people.

More than twenty years after Leslie Cheek retired from the Virginia Museum, his art services programming for the state lives on. Artmobiles ply the countryside and continue to bring the excitement and education that only direct encounters with original artwork can provide. Boxed collections of prints and photographs are circulated, accompanied by videotaped lectures, rather than the earlier slide presentations. But the practice of taking art beyond the walls of the museum endures as a lasting tribute to Cheek.

Mary Tyler Cheek and family dog "Chammy" wait for friends to complete their tour of Artmobile II in September 1962.

RIGHT: Unbeknownst to Cheek, a motorized gallery had been tried before in Richmond in the 1930s. The Richmond Academy of Arts used a small trailer to show paintings by local artists to prospective buyers in the greater metropolitan area. In contrast to this rather primitive undertaking, Cheek based his idea on the mobile libraries and health clinics that were then beginning to find wider use in various parts of the country. Cheek's museum on wheels comprised a tractor cab that hauled a trailer remodelled as a fully functioning, free-standing art gallery.

BELOW: Not content with simply perpetuating the museum's well-established methods of circulating art displays, Cheek devised a unique solution: a mobile, fully self-contained gallery. If people found it difficult to get to the museum, the museum would come to the people. This original drawing for the Artmobile was executed in 1950.

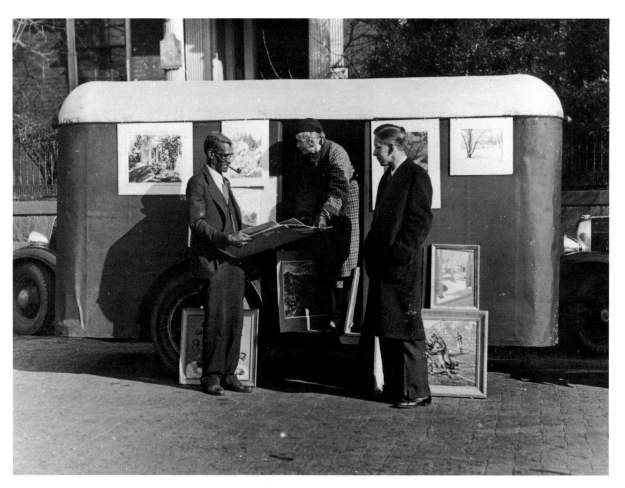

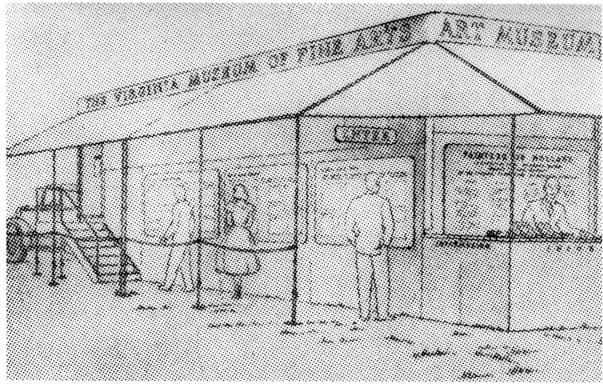

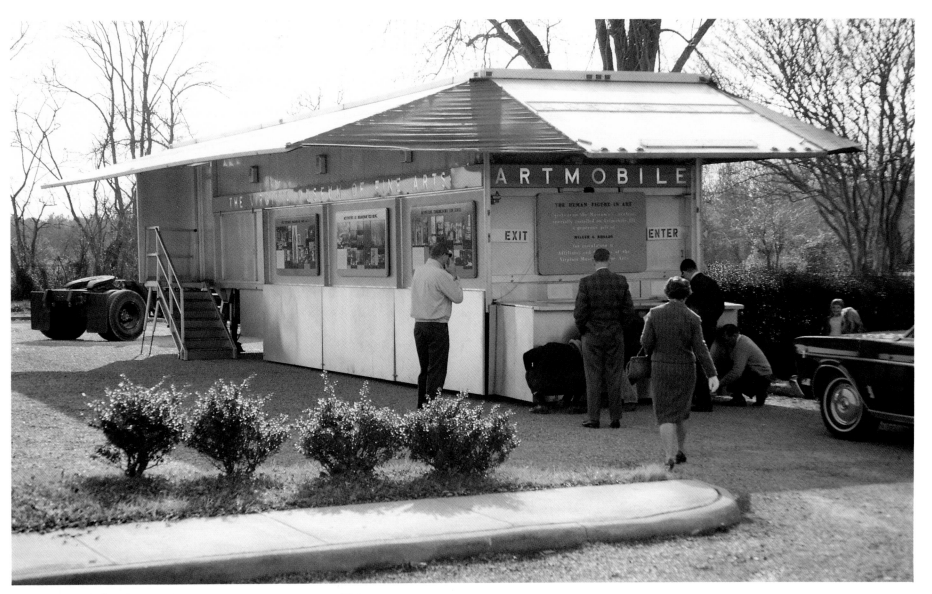

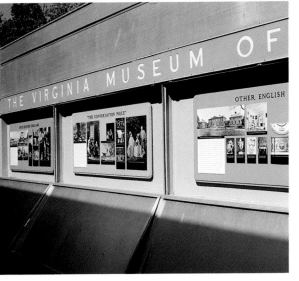

ABOVE: The Fruehauf Corporation of Detroit fabricated the special trailer, which together with its Chevrolet cab weighed more than five tons. From the ground to its top the van measured 11 feet in height, and 34 feet in length. With side panels opened outward and an information booth added, the vehicle stretched 51 feet long and 22 feet wide.

LEFT: The tractor and trim for the polished aluminum trailer were painted a special "artmobile blue." In fact, this shade of muted metallic blue was used frequently by the Virginia Museum for exhibitions because both black and white lettering was found to show up well against it. This view reveals how side panels were lowered to reveal exhibition information. As they stood in line, members of the public could find background data on what they were about to see inside the Artmobile.

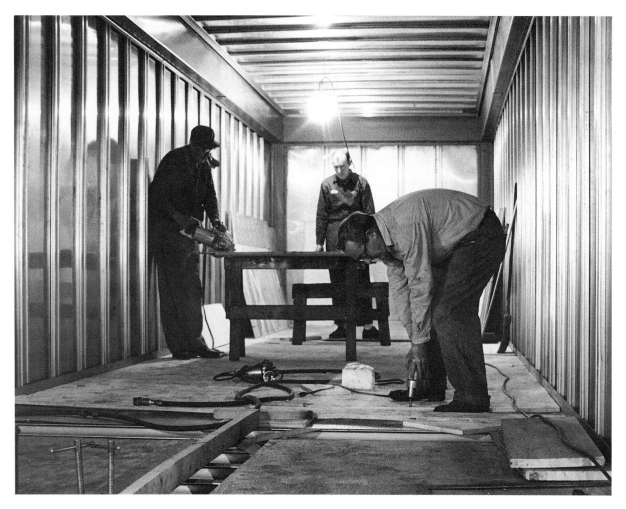

ABOVE: The "galleries" within the Artmobiles consisted of plywood walls covered with monk's cloth and floors of rubber tiling. Special clamps and brackets kept objects from bouncing around as the vehicle negotiated the Commonwealth's highways. At the first hint of fire, carbon dioxide sealed in twin, pressurized cylinders would be automatically released. (The museum was guaranteed that this fire-protection system posed no threat to artworks.) Here workmen are shown inside Artmobile II, launched in 1962.

RIGHT: The two exhibitions shown here demonstrate how the Artmobiles' sophisticated lighting system allowed for the careful control of illumination. Cheek believed paintings should be presented to appear like sources of light in themselves.

FAR RIGHT: Artmobile I seems right at home next to one of Virginia's antebellum courthouses.

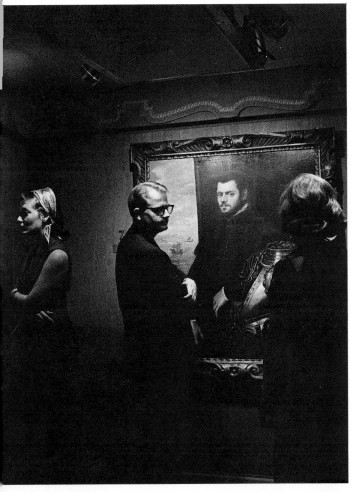

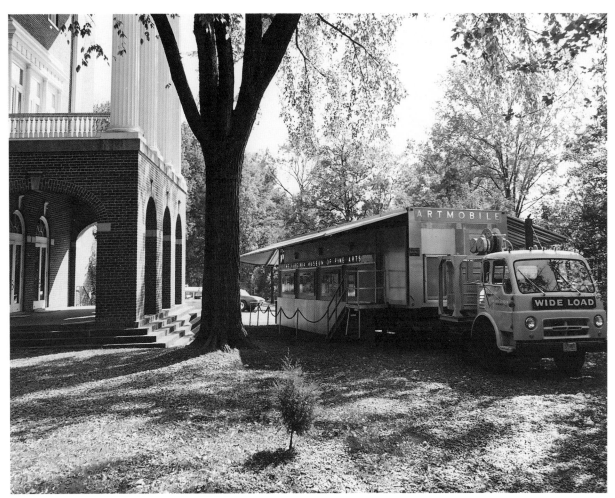

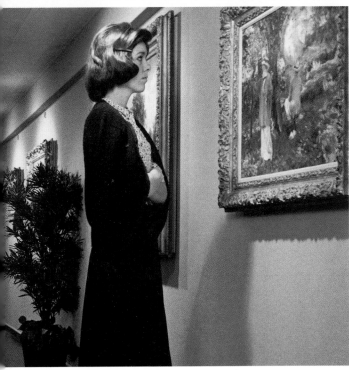

BELOW: *Age of Elegance and Grandeur* (1967), Artmobile II and *The Williams Collection* (1965), Artmobile II and *Twelve Masters: Delacroix to Gauguin* (1962)

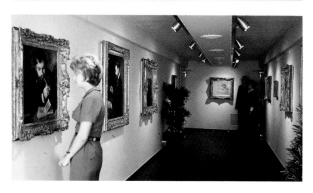

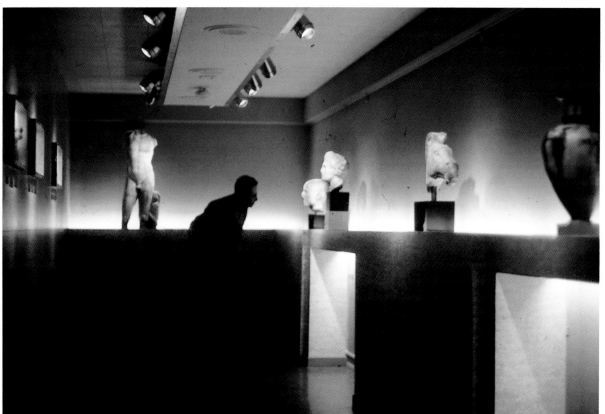

CLOCKWISE FROM ABOVE: *American Folk Art* (1968), *Art from the Ancient World* (1962), *The Guggenheim Collection* (1967)

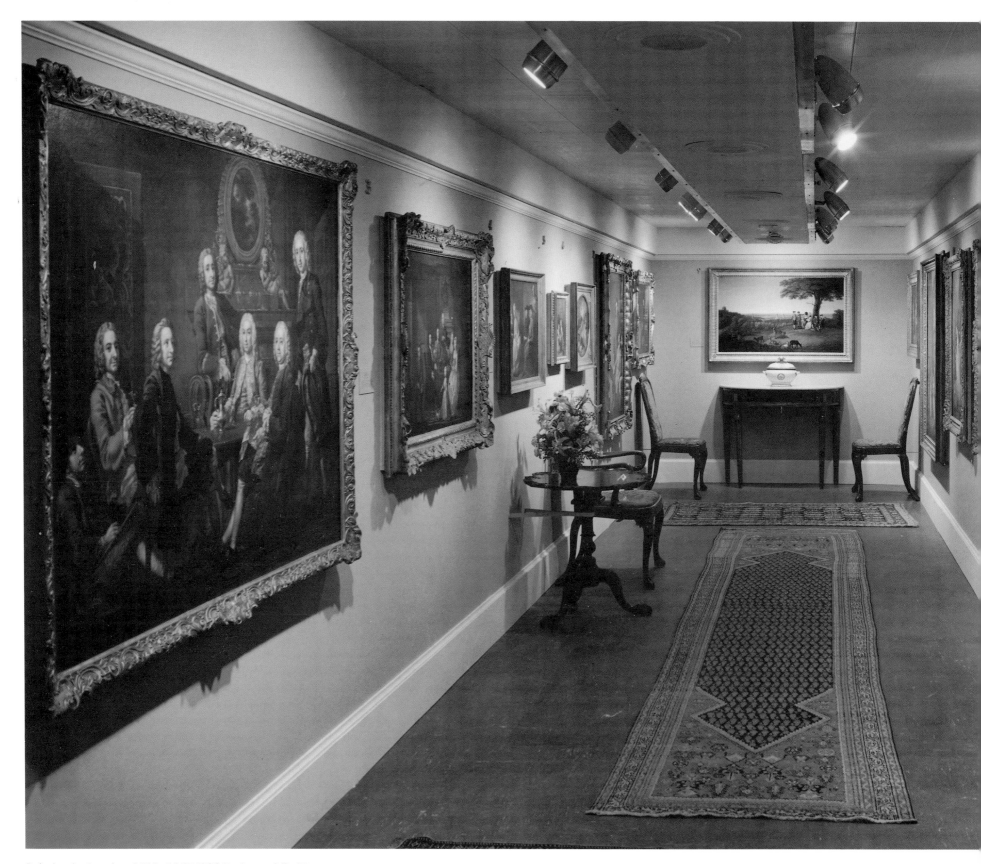

Painting in America, 1815–1865 (1964), Artmobile II

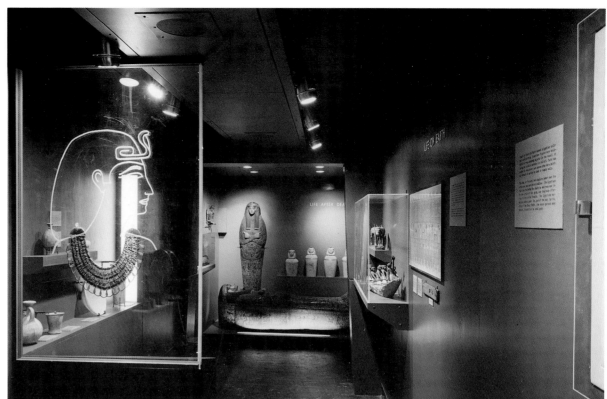

Art from Ancient Egypt (1955), Artmobile I

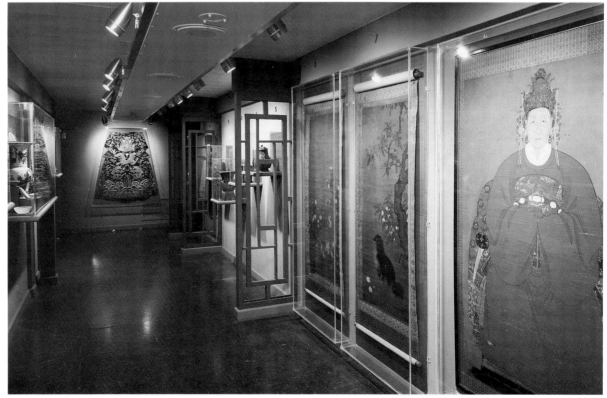

Dragons and Dynasties (1963), Artmobile II

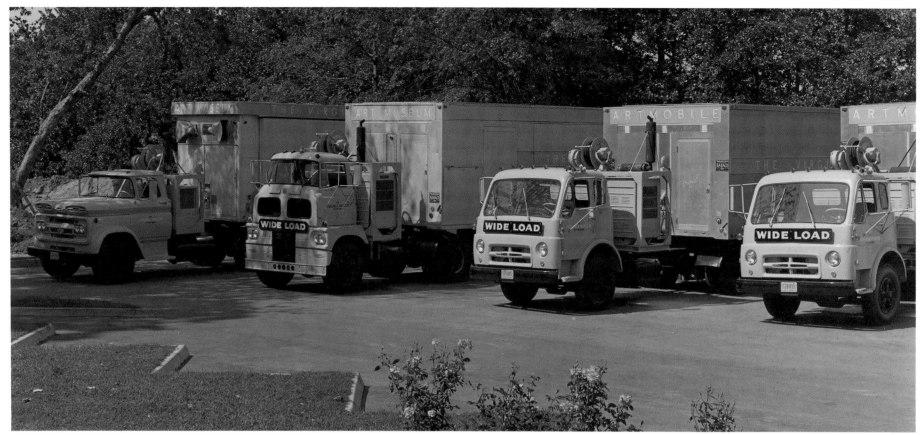

ABOVE: When Cheek retired in 1968, four Artmobiles were crisscrossing Virginia and bringing fine art to almost every community in the Old Dominion. From county fairs to church parking lots, from school playgrounds to courthouse greens, the galleries on wheels brought many Virginians face to face with art for the first time. A rare photograph of the four Artmobiles together.

RIGHT: Leslie Cheek (fourth from the left) with guests at the gala opening of Artmobile II at Middleburg, Virginia, 1962. The world's second gallery on wheels was made possible through the generosity of Mr. and Mrs. Paul Mellon of Upperville.

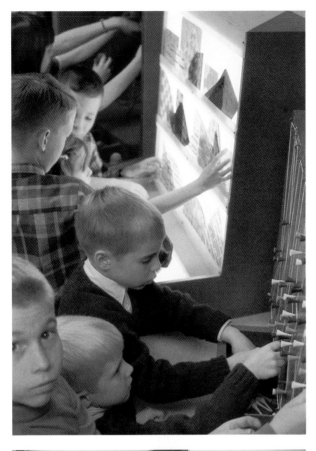

LEFT: Cheek originated the "Craftsman-in-Residence Program" that also expanded audiences for the arts. In tandem, weavers and potters came to Richmond for one- or two-year periods. Besides working and teaching at the museum's Robinson House Annex, these craftsmen traveled to the Chapters and Affiliates lecturing, demonstrating and teaching in such areas as weaving, dying and pot-throwing.

BELOW: A naturally reticent man, Cheek overcame his hesitancy before crowds to become an effective spokesman for the arts. A state-supported operation, the Virginia Museum required public advocacy, and for twenty years Cheek was its tireless champion. Here, Cheek addresses a gathering at the Williamsburg Affiliate, 1967. He introduced the Chapter and Affiliates system in 1961 as another means to take fine art beyond the walls of the museum.

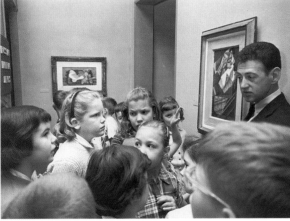

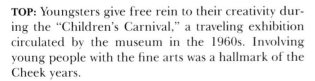

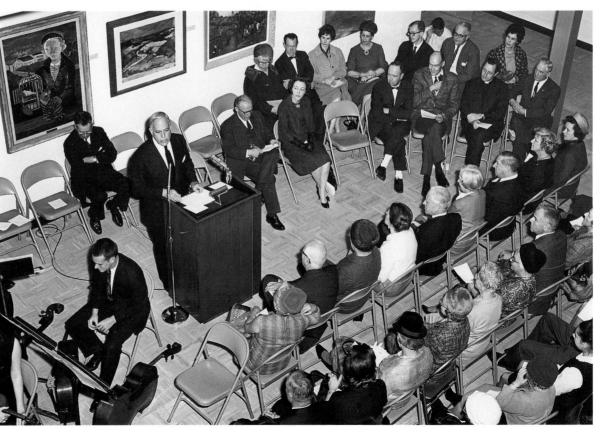

TOP: Youngsters give free rein to their creativity during the "Children's Carnival," a traveling exhibition circulated by the museum in the 1960s. Involving young people with the fine arts was a hallmark of the Cheek years.

ABOVE: On just about any given day, the museum played host to hundreds of children representing public and private schools from across the state. Here, museum staff member William Gaines tries to unravel the mysteries of modern painting for a group of curious youngsters.

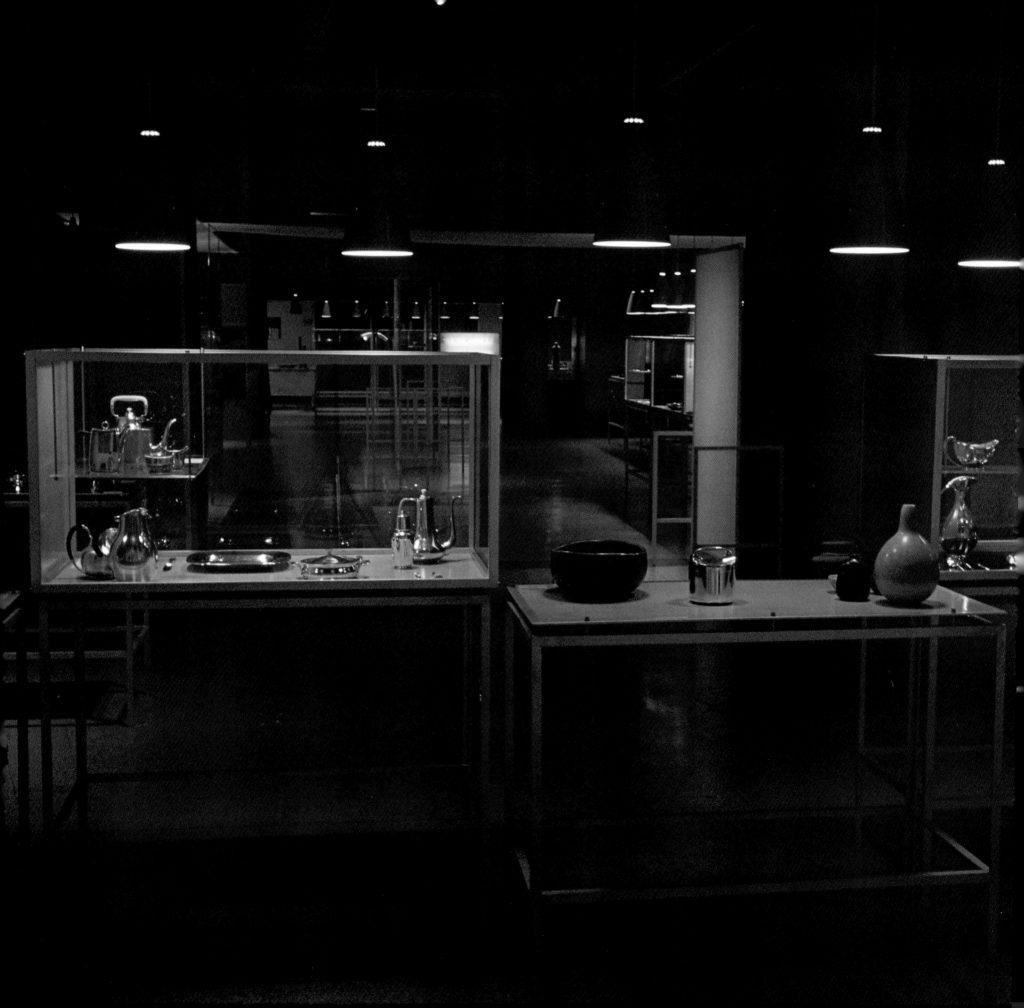

CHAPTER IV

Art for Better Living

At the Virginia Museum *Design in Scandinavia* (1954) was one of the most ambitious exhibitions of its time—an international *tour de force* that featured 700 household objects from Norway, Denmark, Sweden and Finland.

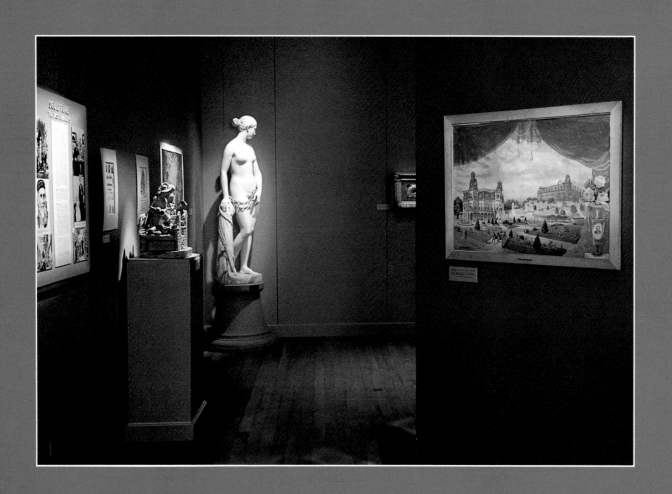

Modern mass production has not only come to symbolize the accelerated tempo of contemporary life; it has in many ways cheapened and vulgarized that life. Our so-called "Century of the Common Man" has brought with it cultural homogenization and cultural relativism that have virtually eliminated standards of refinement.

From the earliest phase of his career Leslie Cheek was convinced that a democratic society where science and machines held sway could achieve the highest standards of taste only if the visual sense could be awakened and sharpened. Traditionally art galleries and museums had been the designated keepers and transmitters of mankind's collective cultural past. In Cheek's view, a twentieth century museum could no longer afford to remain a mere repository of artifacts; it had a critical role to play as a *tastemaker* in our age of technology and anomie. For him, artful design was not a frill but an essential ingredient of the good life.

The balanced programming he introduced first in Baltimore and elaborated later in Richmond brought his audience face to face with what he believed were exemplars of elegance. In a series of exhibitions ranging from household furnishings to stage settings, from Gilded Age salons to modern engineering and architecture, from the artifacts of Elizabethan England to 20th-century Scandinavia, the highest quality of design as he saw it was showcased.

In describing one aspect of the modern museum's activist role as tastemaker, Cheek was once quoted as saying: "I sometimes think that museums will become the preservers of hospitality. As more people take the quick way out in serving meals, it becomes more important for museums to continue the traditions of heavy silver on the table, flowers in abundance, with the prettiest girls in town wearing low-cut dresses as they ladle the punch." By consciously creating installations that emphasized sound design and by incorporating gracious hospitality and civility into museum programming, Cheek contributed to the modern museum's emerging role as an arbiter of stylistic clarity and good taste in daily life.

The Tastemakers (1957) examined the ebb and flow of American stylistic preferences between the mid-nineteenth and mid-twentieth centuries. Pictured is Hiram Powers' *Bound Slave,* which caused a sensation when first unveiled in the *ante bellum* era.

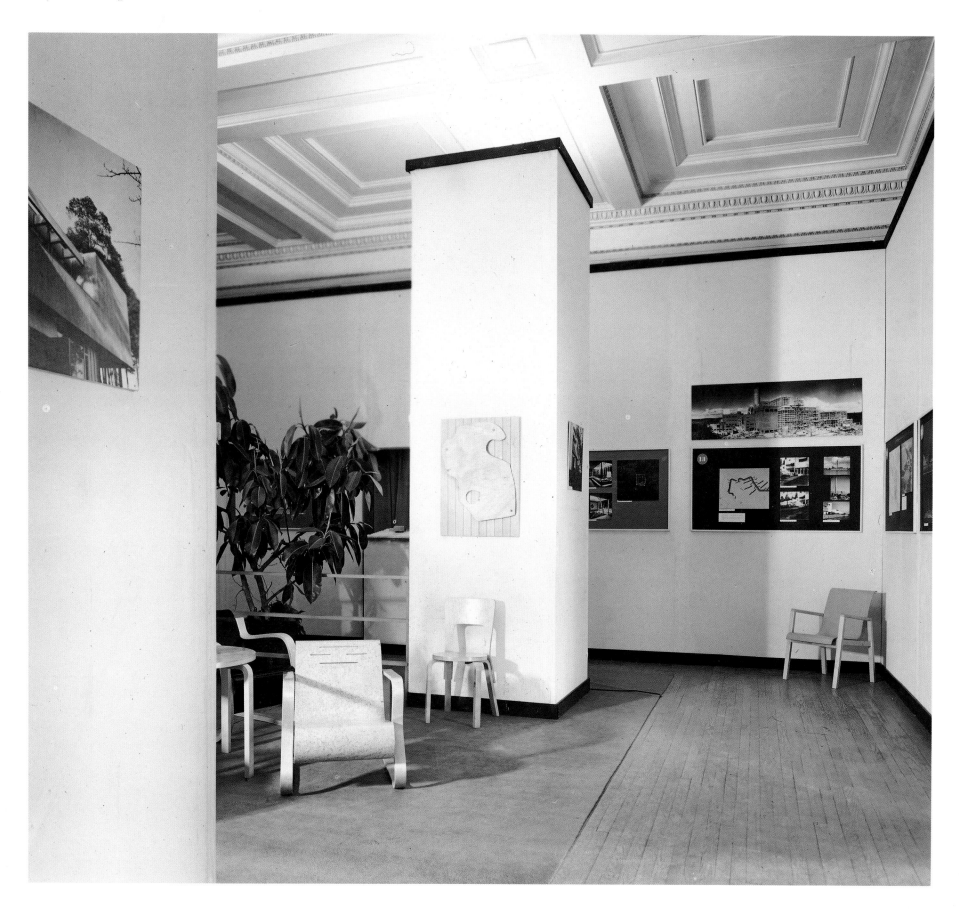

LEFT: *Alvar Aalto* was an early "tastemaking" exhibition held at the College of William and Mary (circa 1938). The display featured architecture and furniture by the noted Finnish designer. It was circulated by the Museum of Modern Art.

BELOW: At the Baltimore Museum Cheek began his assault on the inelegance he found in much of modern life. The controversial *Art Begins at Home* (1940)—an effective synthesis of Cheek's talents as pedagogue and stage designer—presented a wide range of well- and ill-designed, affordable household objects. Its purpose was to persuade the public that everyday objects from clocks to toasters could—and *should*—be manufactured with a high standard of taste.

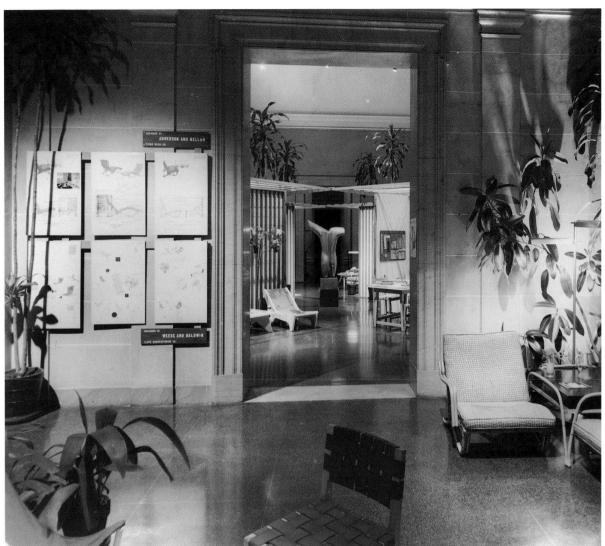

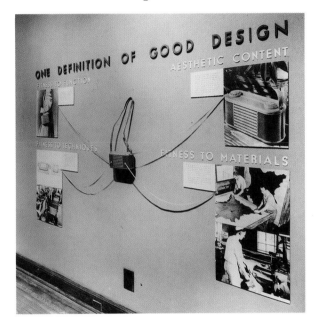

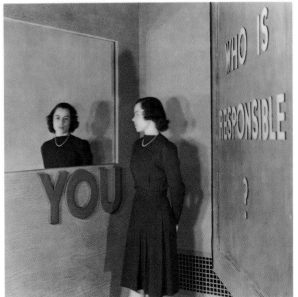

ABOVE: *Organic Design in Home Furnishings* (1942) was among the last exhibitions Cheek presented in Baltimore before he went off to war. Originated by the Museum of Modern Art, it displayed submissions in a competition for comfortable, beautiful and durable furniture. Featured were original drawings and models, as well as finished products by leading designers Walter Dorwin Teague, Charles Eames, Donald Deskey and others.

LEFT: *The City* (1940), a visual essay on the past and future of urban life, invited involvement on the part of visitors. Cheek installed a panel at the end of the exhibition with a boldly lettered challenge: "Who is responsible?" Visitors saw the answer: their own reflection in a mirror and a single, oversized word: "YOU."

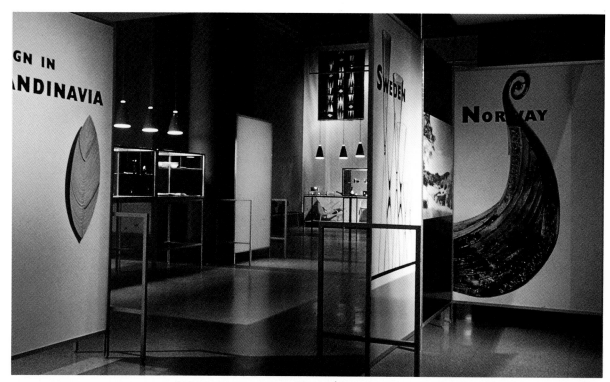

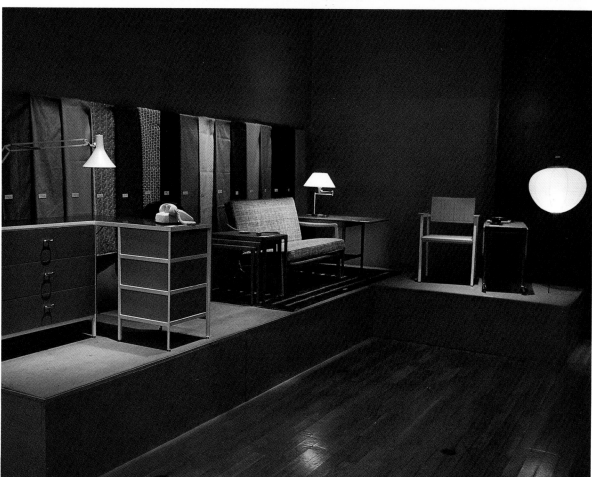

ABOVE: The entrance to *Design in Scandinavia* (1954) evoked northern Europe's seafaring past and its path-breaking role as an innovative source of elegant everyday objects in the twentieth century.

BELOW: *Design in Scandinavia* traveled for three years to museums throughout North America. It was complete in itself with cases, installation and lighting, ready to be put in place with minimum effort. Furniture, glass, china, silver, ornaments and utensils in dazzling variety demonstrated Scandinavia's remarkable achievement in influencing the manufacture of beautifully designed and functional objects for daily home use.

LEFT: Cheek's ongoing preoccupation with elevating popular taste was also evident in *The Tastemakers* (1957). Inspired by Russell Lynes' erudite and witty book of the same title, the exhibition set out to show the public the capricious course of American taste. With the home as focal point, examples of architecture, sculpture, painting and decorative arts formed a panorama of styles that had flourished and faded since 1840. Like the book, the exhibition was in three sections: Public Taste (1840–1876), Private Taste (1877–1913) and Corporate Taste (1914–1957).

BELOW: The layout for *The Tastemakers*. It, too, reflected Cheek's concern that museumgoers follow a pre-arranged path throughout an exhibition.

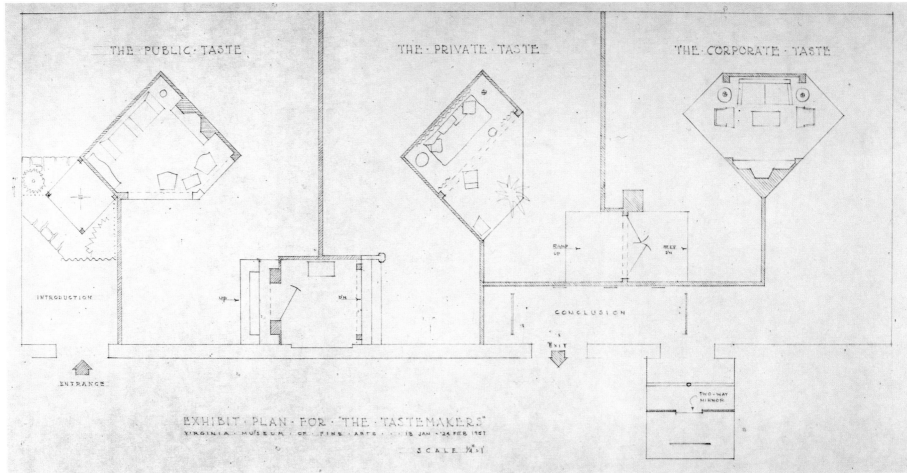

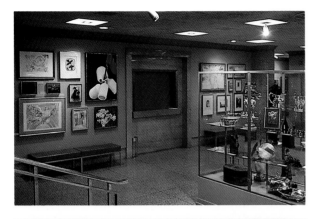

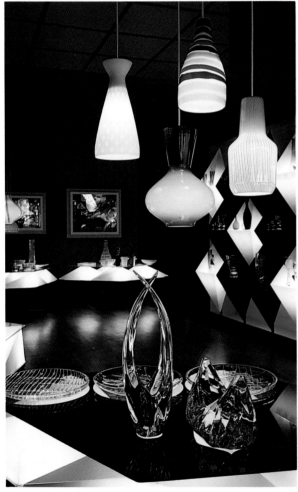

CLOCKWISE FROM TOP: Other tastemaking exhibitions included: *Collectors' Opportunity* (1968), *The Family of Man* (1956) and *International Contemporary Glass* (1960)

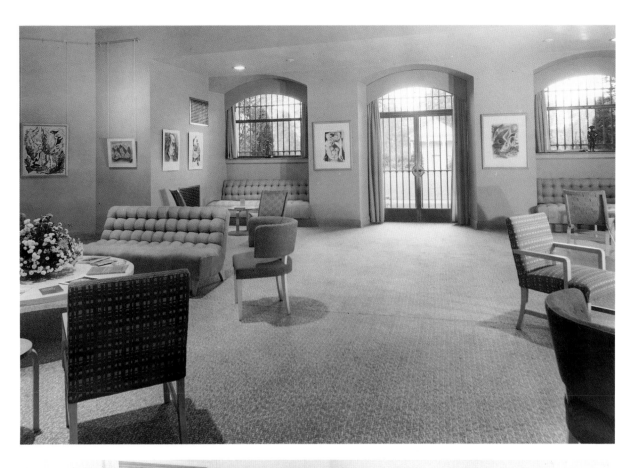

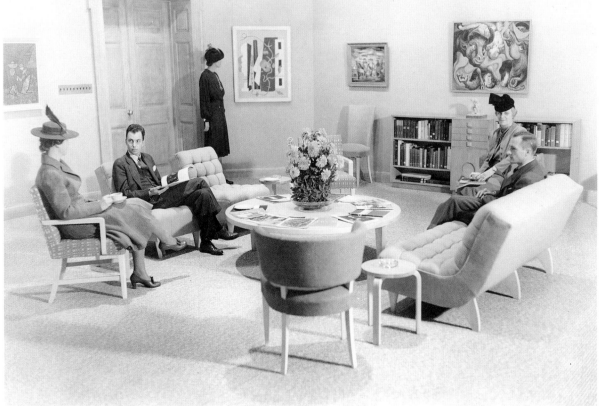

In pre-World War II Baltimore, Leslie Cheek was inspired by the Museum of Modern Art to set aside space where members could meet, read, have a cup of tea and view small exhibitions arranged expressly for their enjoyment. Handsomely furnished with the latest contemporary designs, this Members' Room, with fresh flowers and understated comfort, offered Baltimoreans a respite from an increasingly disordered world.

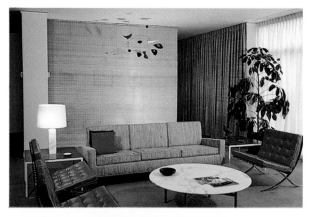

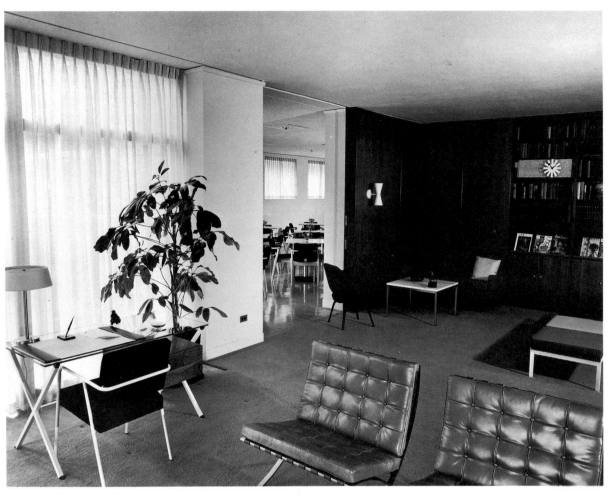

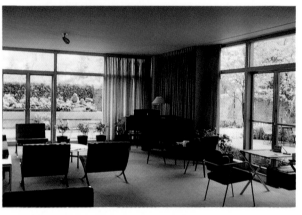

Later in Richmond, Cheek repeated his Baltimore experiment when he incorporated plans for a Members' Suite in the Virginia Museum's new Theatre Wing that opened in 1954. Internationally famous decorator Florence "Shu" Knoll created a model living room with Saarinen and Mies furnishings, handwoven Scandinavian fabrics, and paintings by Campigli, Maillol, Braque, Dufy and Picasso.

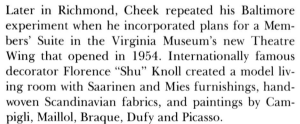

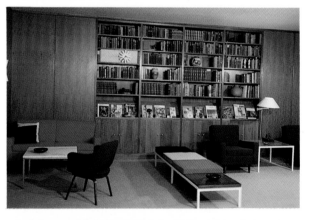

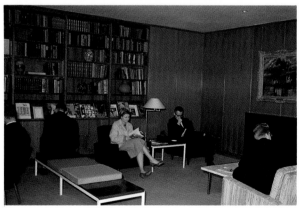

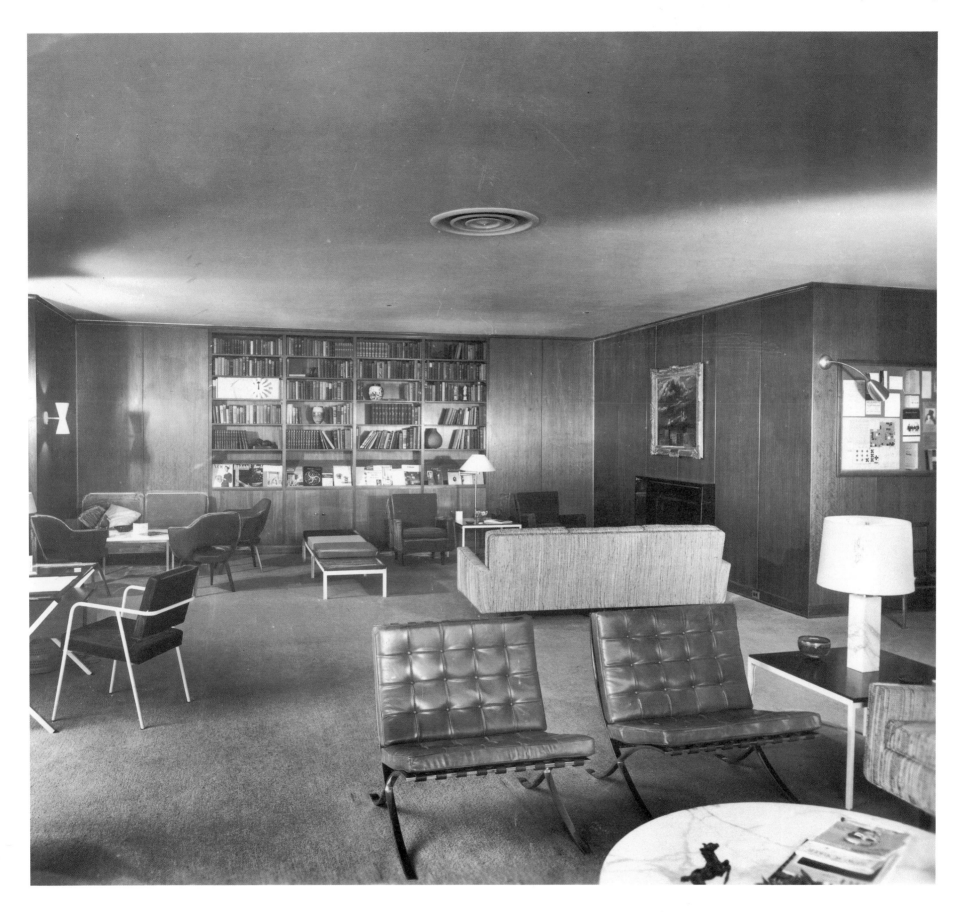

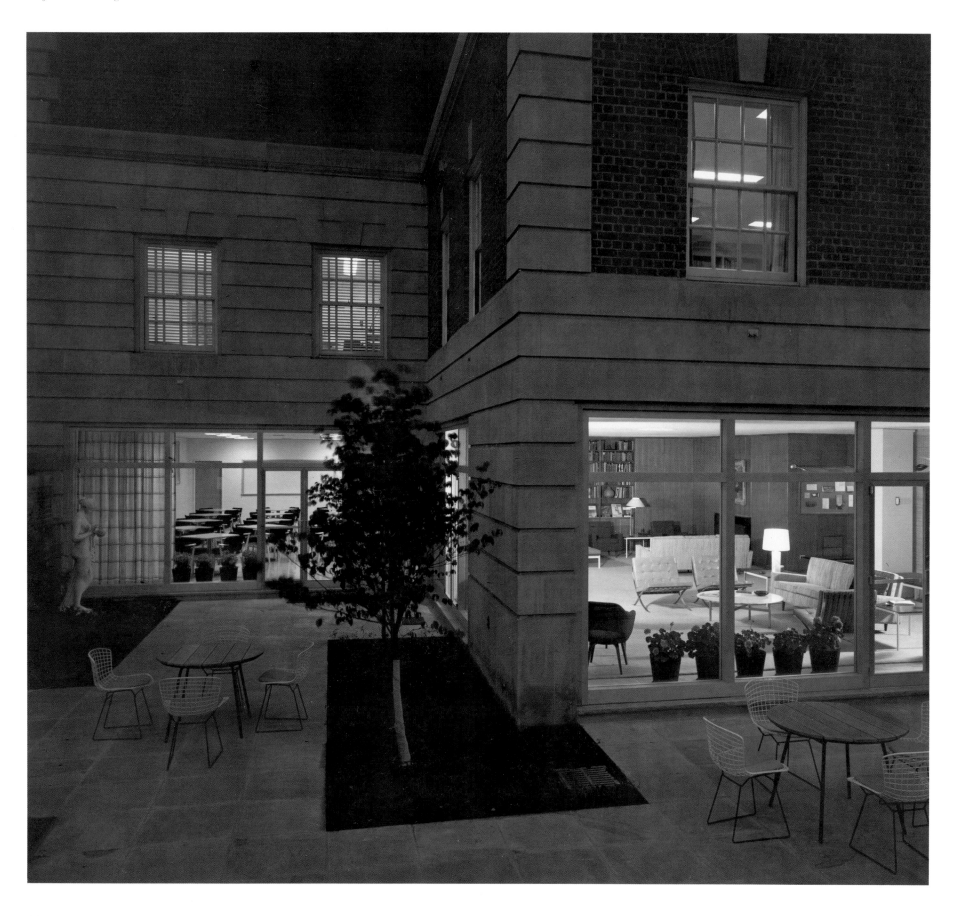

LEFT: Someone once called the Virginia Museum "an Élegantarium" because under Cheek's guidance it became a laboratory for gracious living. The Members' Suite viewed from the Sculpture Garden, circa mid-1960s. **BELOW:** This elegant coromandel screen was the centerpiece of the Knoll-designed Theatre Lobby.

ABOVE: Adjacent to the Members' Suite was the Refreshment Room, where luncheon was served to members and their guests. Diners had a choice of eating inside, where fourteen tables seated fifty-two patrons, or outside in an intimate, walled Sculpture Garden. Waitresses, usually college students, were dressed in prim yellow-and-white striped pinafores.

ABOVE: With predictable panache, Cheek secured the culinary services of Erwin Faller, former chef to Emperor Haile Selasie of Ethiopia. Faller's menus, which changed with the seasons, were popular with Richmonders, who savored such then unfamiliar dishes as *Omelets Chasseur, Blanquette de Poulet au Riz* and *Fricandeau à la Hongrois*.

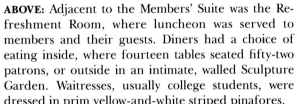

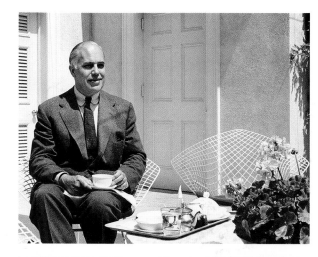

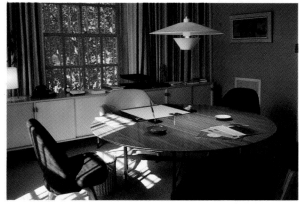

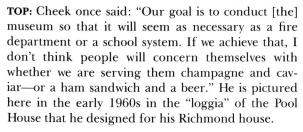

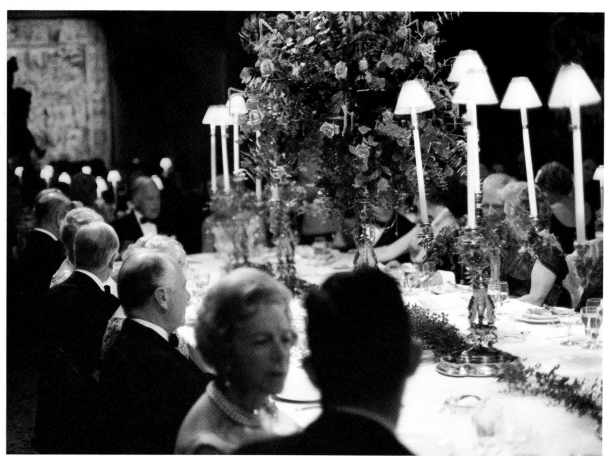

TOP: Cheek once said: "Our goal is to conduct [the] museum so that it will seem as necessary as a fire department or a school system. If we achieve that, I don't think people will concern themselves with whether we are serving them champagne and caviar—or a ham sandwich and a beer." He is pictured here in the early 1960s in the "loggia" of the Pool House that he designed for his Richmond house.

ABOVE: Leslie Cheek's office at the Virginia Museum was designed by Knoll and Associates of New York. Its contemporary furnishings reflect his admiration for modern Scandinavian style: functional, elegant and comfortable.

RIGHT: Dinners for The Fellows (top) or receptions for members of the Chapters and Affiliates were among the most elegant events at the museum. They helped introduce new standards for gracious living to the Commonwealth.

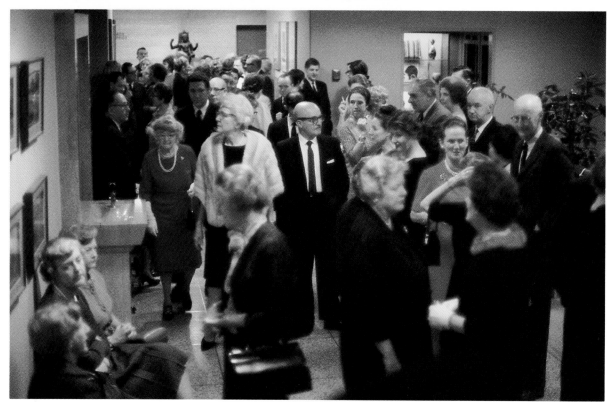

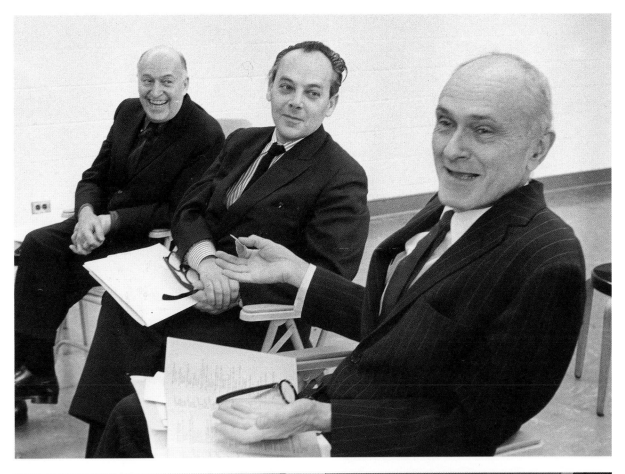

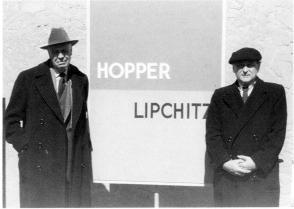

ABOVE: The museum also fulfilled its role as taste-maker through the "Virginia Artists Series." These biennial exhibitions invited entries from artists in the Commonwealth to be judged by distinguished professionals. Among the nationally and internationally prominent jurors were painter Edward Hopper and sculptor Jacques Lipchitz, who participated in 1953.

LEFT: The museum also sponsored the biennial "Virginia Architects, Designers and Photographers" exhibitions. Judges in 1964 were painter Gyorgy Kepes, photographer Ivan Dmitri and architect Philip Johnson. Other judges in these competitions included Louis Kahn, Edgar Kaufmann, Jr., Charles Eames and Bert Stern.

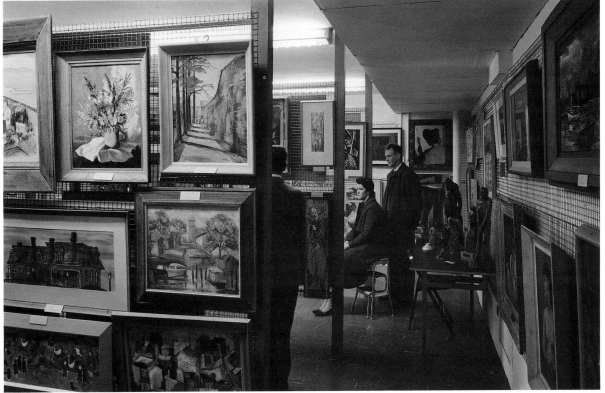

Cheek initiated the "Loan-Own Program" in 1953. For a nominal fee, museum members could rent paintings, sculpture, weavings and ceramics for three-month periods. They could also purchase original works through the museum without paying a commission. The system made it easy for museum members to experience the pleasure and excitement of living with art in their own homes. In this view members, aided by a museum volunteer, make selections from the "Loan-Own" collection, circa mid-1960s.

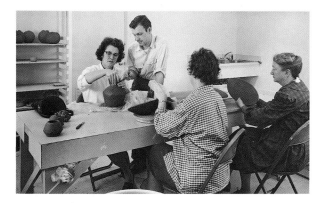

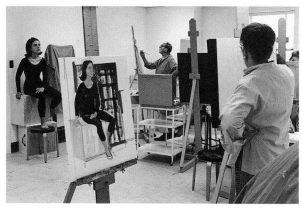

ABOVE: Adult art courses—such as these in ceramics and painting—were important ingredients in the Virginia Museum's mission as tastemaker for larger publics. Many of these classes were conducted at the museum's Robinson House Annex.

BELOW: Comely young ladies were frequently called on to serve thirsty art-lovers. Cheek's opening night parties for Virginia Museum exhibitions were highlights of Richmond's social season. These two volunteers at *The Tastemakers* served the "new" cocktails that first appeared in the "dry" 1920s.

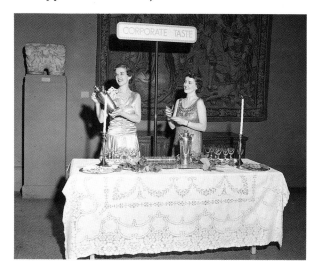

LEFT AND ABOVE: Among the gala parties held at the museum during Cheek's tenure were the annual Viennese Balls. In the 1960s these helped raise money for the Museum Council, one of several important support groups Cheek organized as director. These photographs, taken in 1966, highlight the skill and imagination that designer William Ryan applied in transforming the museum into a romantic palace.

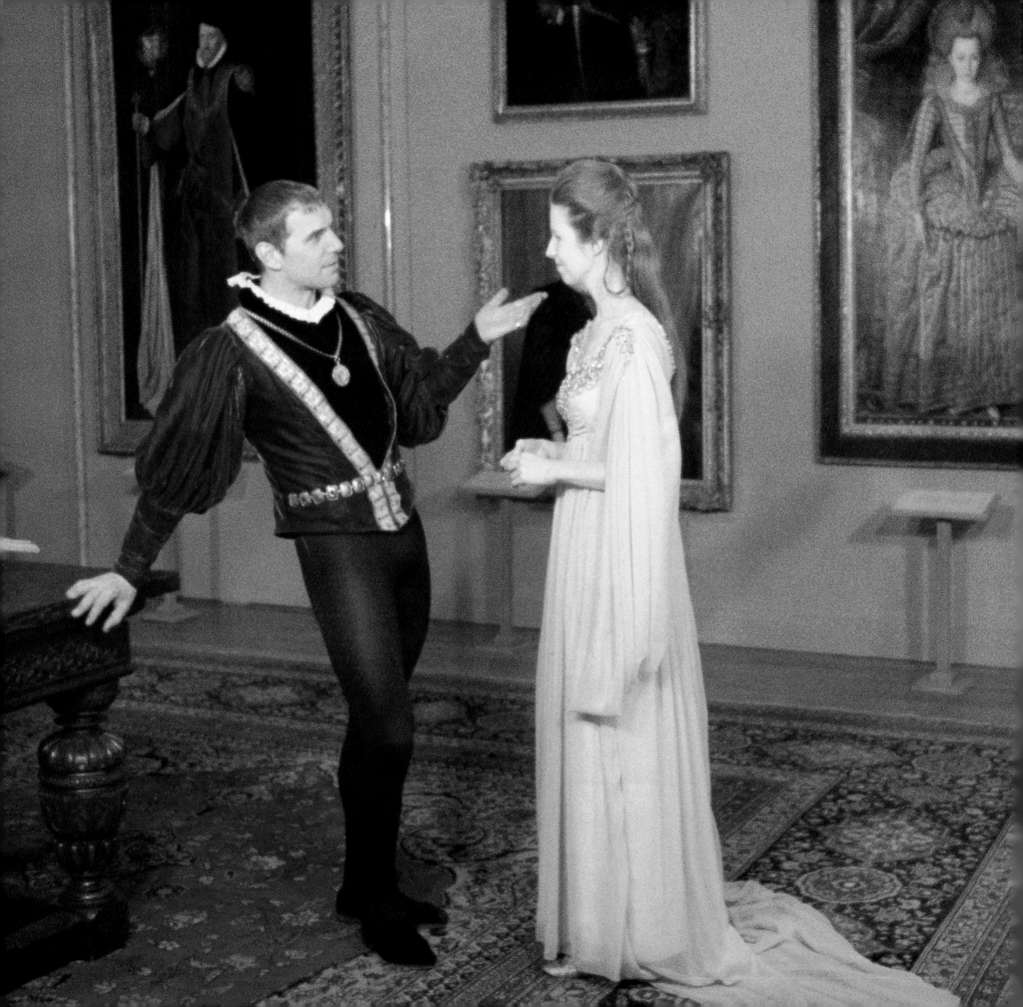

CHAPTER V

Interpreting the Arts Through Drama

One of the galleries for *The World of Shakespeare* (1964) provided a fitting backdrop for Ophelia and Hamlet to enact a scene from the Virginia Museum Theatre's accompanying production.

According to Sherman Lee, former director of the Cleveland Museum: "Leslie's a theatre man, and his attitude towards art is that it's like actors who were recalcitrant and had to be dealt with. Art had to be tolerated; it had to be lit, cared for. His collections were not all that strong, so to make up for this, he added show biz. It was as if it were a play with a willful and determined director forcing his way on the material."

The theatre, with its glamour, music and dance, remains at the center of Cheek's persona. He is enthralled by the stage and its settings, costumes and actors, and the world of fantasy they combine to create. Writing to his sister in 1935 about her growing interest in the theatre, he told her: "It has long had an inexplicable fascination for me. There is a kick to be obtained there which I have never experienced elsewhere."

For him, the dramatic arts remain the most communicative and the most easily grasped by the public. Inevitably, as we have already seen, his installations were most often stage sets for the display of the static arts. As early as 1938, Cheek wrote of the theatre: ". . . It is most universal in appeal—the most easily attractive and the most readily understood. . . . If genuine enthusiasm could be won for the theatre, the ice would be broken, for here come together practically all the arts. . . ." He envisioned inviting theatre-goers to mingle with art during intermissions—an idea he carried out at the Virginia Museum two decades later, and this innovation drew high praise.

Not surprisingly, he was convinced that live theatre could facilitate understanding of the varying forms of painting and sculpture through the centuries. As he observed late in his career, "The dynamic arts of the theatre, combining as they do so many of the more static arts, can be truly important in regional museum activities." His effort to merge the static with the dramatic arts under the roof of the museum was not without disappointment. Despite difficulties, he nevertheless remained steadfastly faithful to his vision.

Through the Virginia Museum Theatre's versatile performing arts program, Cheek was at last able to convert his personal pleasure into a public benefit by uniting the visual and the static arts in the modern museum.

Cheek scheduled several museum exhibitions devoted to the art of stage design. *Designs for the Theatre by Donald Oenslager* (1958) included a full-sized reconstruction of the noted designer's sets for *The Constant Wife*. Oenslager, who had been one of Cheek's professors at Yale, had a lasting influence on Leslie's museum career.

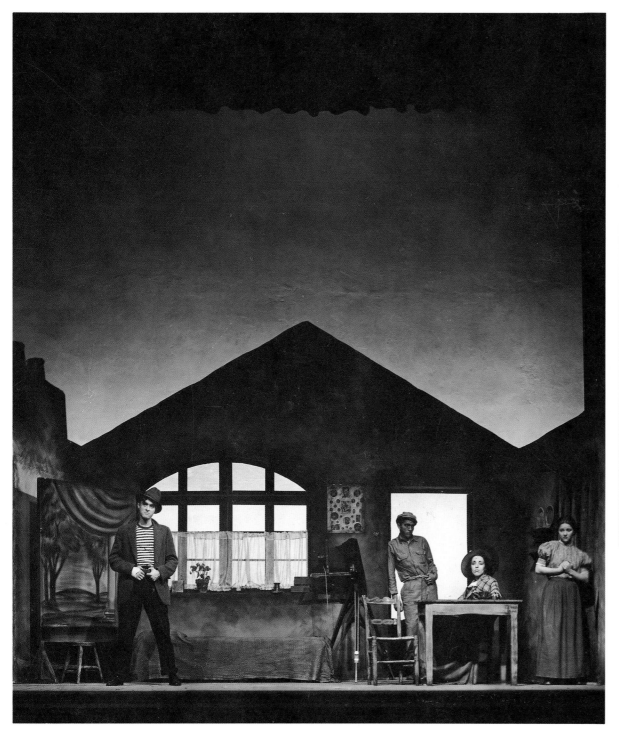

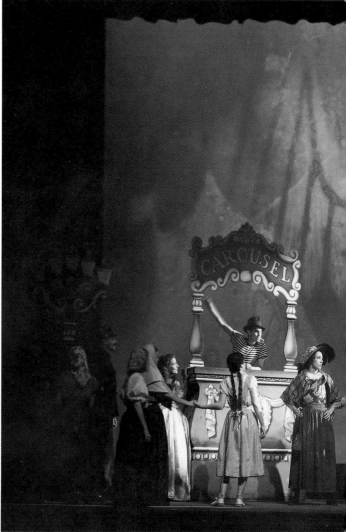

At the College of William and Mary plays, such as *Liliom* (above and left), *Death Takes a Holiday* and *The Lying Valet*, were staged in old Phi Beta Kappa Hall where facilities were limited. As founding chairman of the Fine Arts Department, Cheek initiated an ambitious program of dramatic performances that became an important addition to the College's growing curriculum. Pictured are two scenes designed by Cheek from *Liliom* by Ferenc Molnar (1938). Williamsburg was dazzled by sets such as these for the "Carousel Scene" and "The Studio."

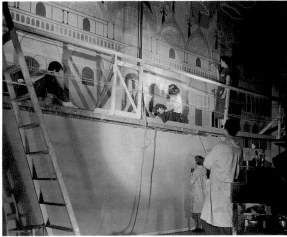

Students contributed to the success of the College's flourishing theatre program. Here volunteers labor on the elaborate sets and costumes for *The Gondoliers*.

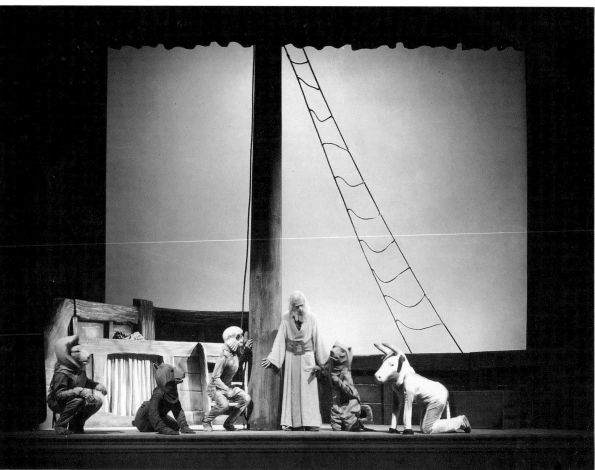

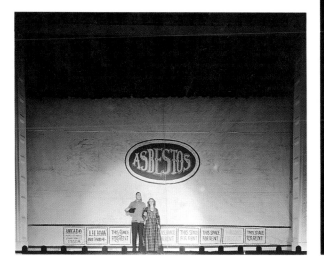

ABOVE: *American Architecture of the Nineteenth Century* (1938), a collection of photographs and prints of noteworthy buildings, was accompanied by the single performance of a nineteenth century review. The heavy "fireproof" asbestos curtain of the period fell with a loud thud after being rolled up from the bottom. Later in Baltimore and Richmond, Cheek would perfect the use of the performing arts to enhance public understanding of art exhibitions.

RIGHT: Other plays for which Cheek was responsible at William and Mary included André Obey's *Noah* (top) and Gilbert and Sullivan's *Mikado*, with sets for the latter painted by Leonard Haber.

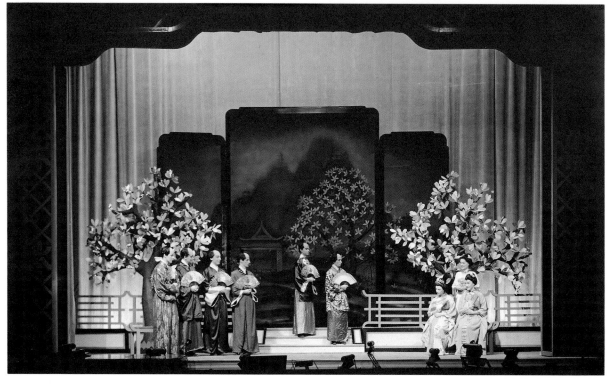

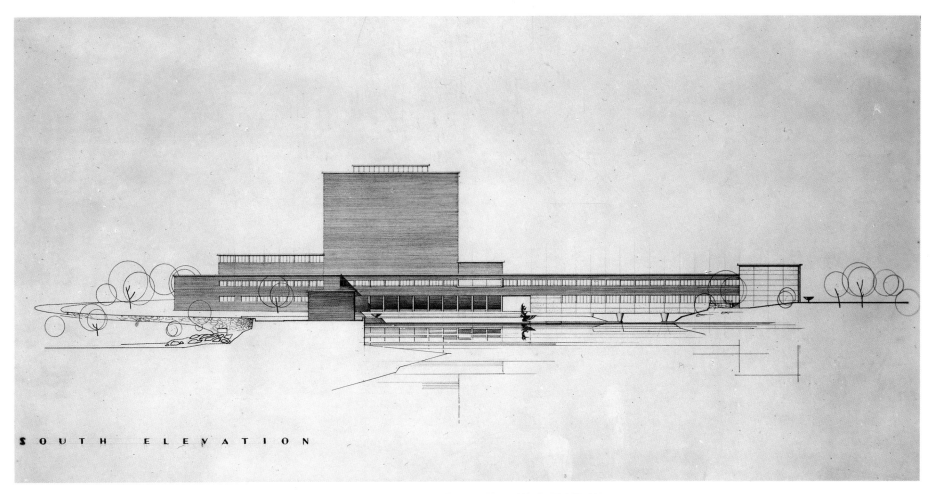

SOUTH ELEVATION

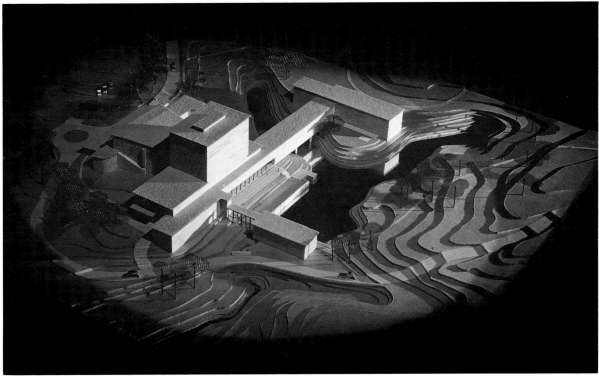

Cheek's dream of bringing William and Mary to the forefront of arts education in the United States culminated in the College's selection in 1939 as site for the American National Theatre and Academy's proposed National Festival Theatre. Shown are views of Eero Saarinen's winning design in the competition that involved some of the world's most talented architects. Had it been built Saarinen's modern design would have contrasted sharply with the College's distinctive Colonial style. Plans for the complex were abandoned following the outbreak of World War II.

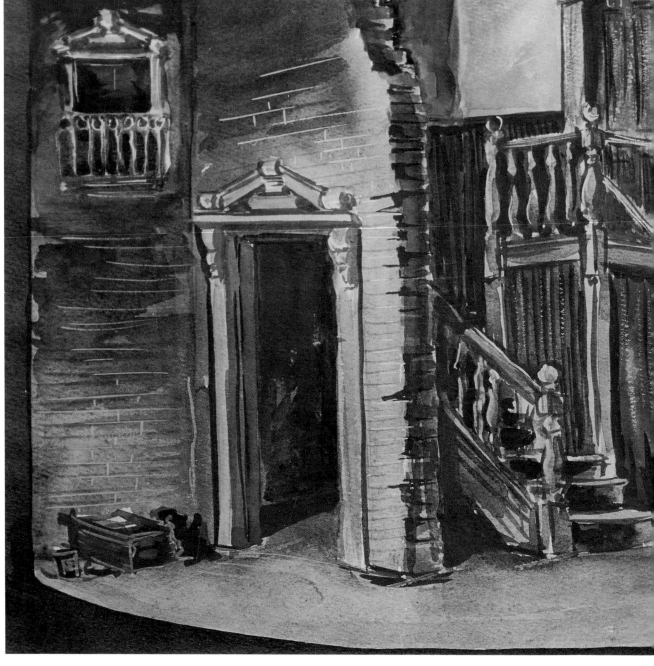

TOP: In Baltimore, a ballet was commissioned to accompany the Milles sculpture exhibition. Its premiere on November 22, 1940, shattered high hopes; it was a disaster. The inexperienced Estelle Dennis Concert Group danced awkwardly, and ill-fitting costumes drew muffled laughter from the audience. Following the recital, an embarrassed Cheek hastily dashed off a letter to his wife: "... The whole thing was a flop— and a loud one. . . . The fault was partly my own for not attending a complete rehearsal. . . . I am so discouraged that I am about through with the theatre idea for good. Nothing we did in Williamsburg was as poor as this!"

ABOVE: Undaunted by the "Marriage of Rivers" fiasco, Cheek tried again to unite the static with the active arts. *Scenery for Cinema* (1942), the exhibition devoted to the art of moviemaking, included performances of Eugene O'Neill's *Anna Christie*. Cheek invited visitors to compare the museum's set designs with those that had been used in making a commercial film based on the play, examples of which were displayed in the galleries.

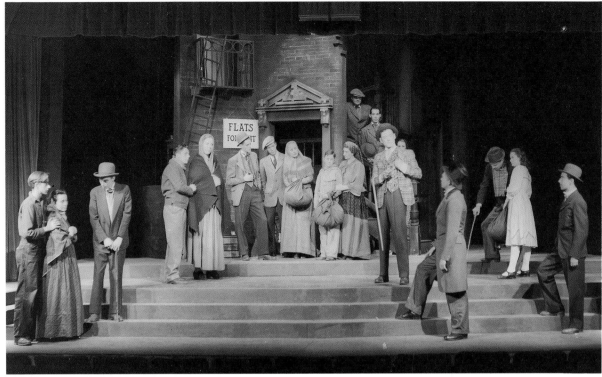

LEFT AND ABOVE: Performances of *One Third of a Nation* coincided with *The City* (1940). At first the Baltimore Museum's board of trustees refused to present Arthur Arent's controversial play, which conservatives thought vaguely Marxist. A wave of protest—orchestrated by disappointed volunteer actors and actresses—eventually forced the board to reverse its decision. The play was performed on a revolving platform designed by the museum's Albert Heschong. The entire set turned on small wheels Cheek improvised from dismantled roller skates. Pictured are Heschong's drawings and his set.

BELOW: A scene from *The Long Voyage Home* in a series of one-act plays by Eugene O'Neill, staged at the Baltimore Museum in late 1940.

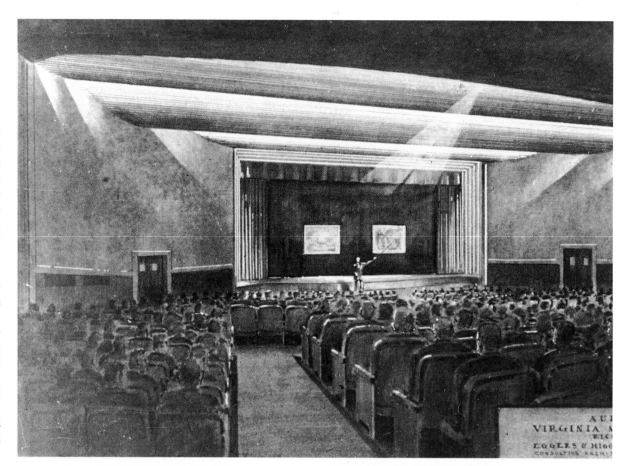

RIGHT: When he arrived at the Virginia Museum in 1948, Cheek found this preliminary drawing for an auditorium to be added to the building at a future date. Recalling his frustrations with inadequate facilities in Williamsburg and Baltimore, he was determined that any expansion would include the most up-to-date theatre. It was part of Director Cheek's long-range vision to transform the museum into a multi-faceted cultural center.

BELOW: As this sectional plan discloses, Cheek persuaded the museum's Board of Trustees to include a modern theatre in the addition it approved in 1951. When, however, Virginia's legislators balked at funding what they regarded as a frivolous enterprise, Cheek completed the project with a gift from the Old Dominion Foundation. 1. Auditorium, 2. Stage, 3. Below Stage Traps, 6. Lighting Space, 7. Sound and Light Control, 8. Projection Room, 9. Light Space, 10. Orchestra Lift, 11. Theatre Lobby, 19. Permanent Collection (e.g., Egyptian Gallery), 20. Mediterranean Court, 21. Loan Gallery.

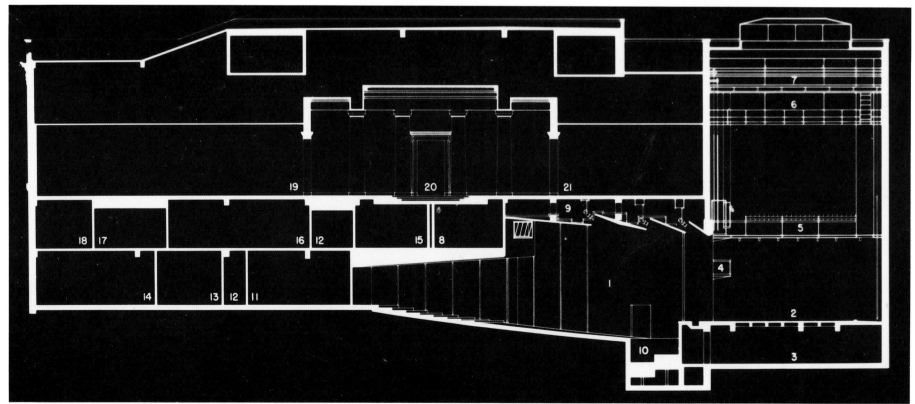

ABOVE AND LEFT: The entrance to the Virginia Museum's North (or Theatre) Wing, which opened in 1954. The style and sophistication of the new wing was exemplified by the Theater Lobby, designed by New York's Knoll and Associates. On many memorable opening nights this Lobby, now no longer in use, was the setting for elegantly dressed Virginians enjoying a new museum experience.

ABOVE: Cheek was involved in virtually every detail of the Museum Theatre's operations. Here he examines a model of the set for *Carousel* in 1960. Looking on are actor Hansford Rowe, Assistant Museum Director Muriel Christison, Public Affairs Director William Morrison and Administrator William Rhodes. Sets for the popular musical were executed by staff member William Ryan.

RIGHT: For the first dozen years of its operation, the Virginia Museum Theatre was run by a professional staff that directed a host of enthusiastic volunteers. These tireless devotees of the stage did everything from building sets and creating costumes to manning spotlights. In 1967 a grant from the National Endowment for the Humanities enabled the theatre to become a thoroughly professional company. Here a rehearsal is in progress.

BELOW: A volunteer technician makes a final check of the Museum Theatre's sophisticated lighting and sound system. For many years the Virginia Museum could proudly boast having one of the nation's finest theatre facilities.

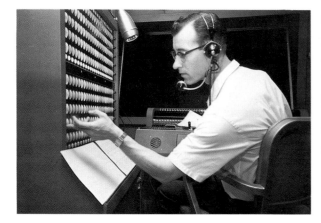

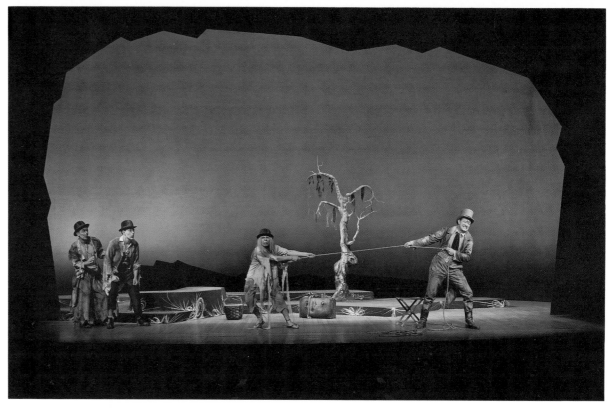

Avant-garde productions, including Karel Capek's *R.U.R.* and Samuel Beckett's *Waiting for Godot* (illustrated), were among the broad range of drama in the Museum Theatre's repertory.

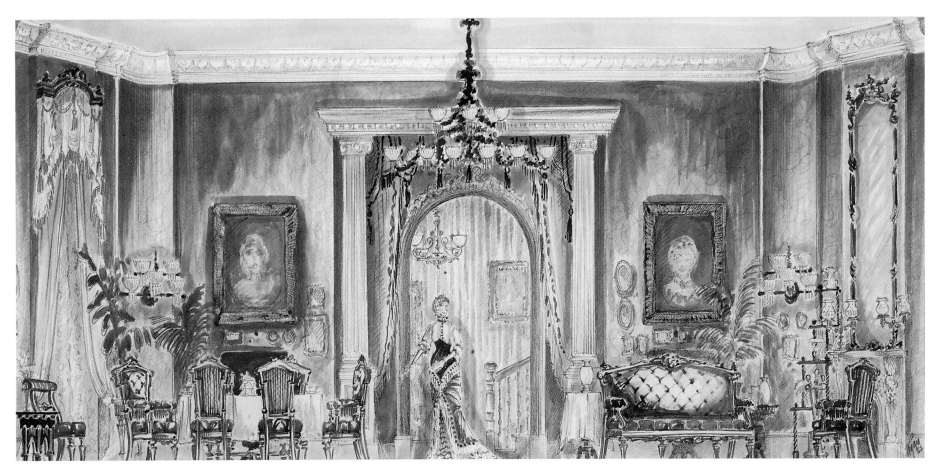

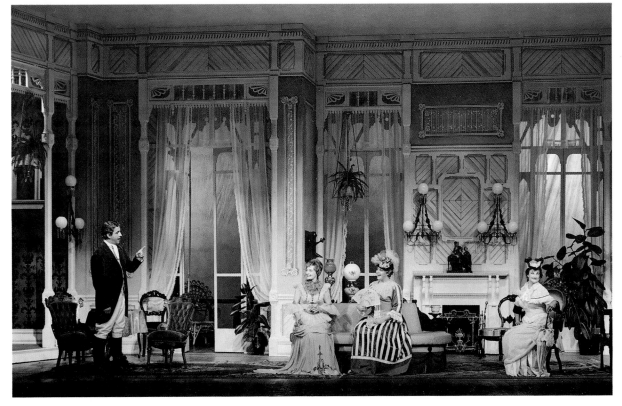

LEFT: The Virginia Museum Theatre staged *Life with Mother* in 1962. Shown above is the original set design by William Ryan, an important member of the staff for twenty-five years. Ryan not only executed memorable sets for the theatre, he was also responsible for some of the museum's most distinctive exhibition installations, including *Greek Gold* (1966), *The World of Shakespeare* (1964) and *Treasures of Tutankhamun* (1963).

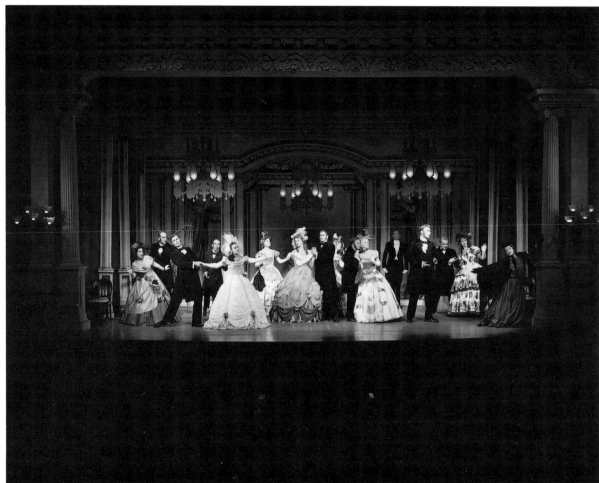

LEFT: William Ryan inspects one of his costumes modeled by a Theatre volunteer before a dress rehearsal at the Virginia Museum.

ABOVE: Staging *The Six Degrees of Crime* during the exhibition *Homefront, 1861* (1961) brought pre-Civil War America alive through costumes, sets, music and dialogue of the period. Frederic S. Hill's moralistic play related with abundant pathos a libertine's steady descent "round by round" on the "ladder of crime."

RIGHT: During intermissions for *The Six Degrees of Crime* actors and actresses circulated among the throng. Some peddled patent medicines, while shrill-voiced ladies extolled the virtues of temperance. Urchins hawked copies of *Harper's Weekly* as a shady-looking figure lurked about, purveying "gen-u-ine" gold bricks to the credulous. All the while, a Salvation Army band brought in for the evening's performance played, much to the delight of theatregoers.

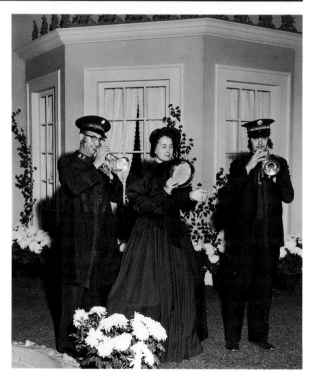

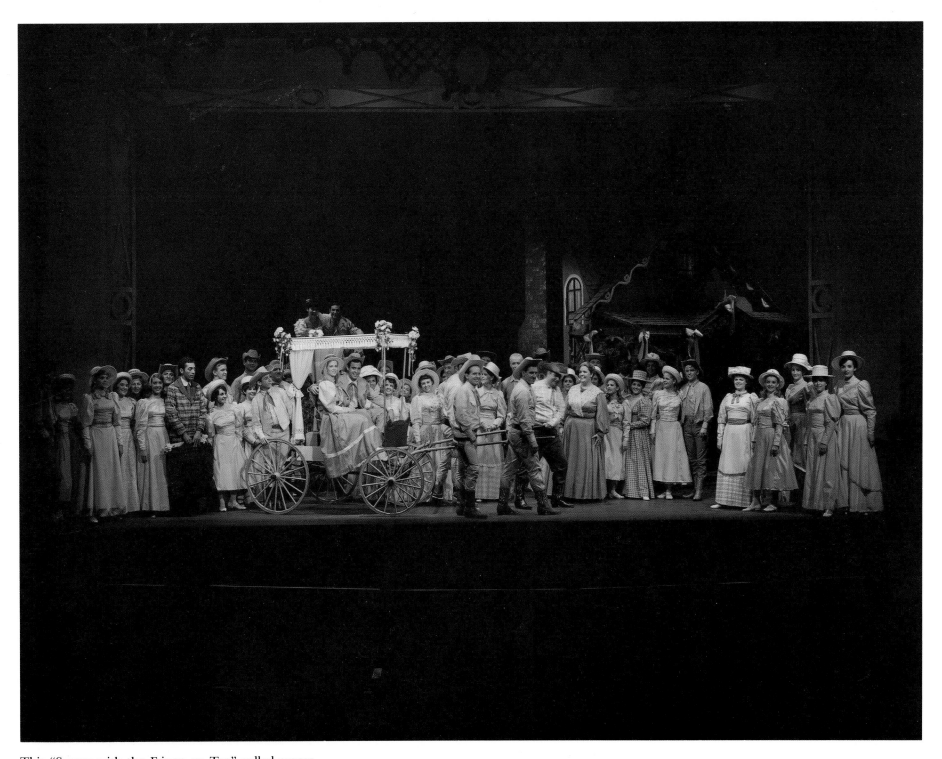

This "Surrey with the Fringe on Top" rolled across the Museum Theatre stage during Rodgers and Hammerstein's unforgettable *Oklahoma!*, directed by staff member James Dyas. John Döepp was the designer of this elaborate production that opened in May of 1967. A chorus of thirty sang such rousing numbers as "Oh, What a Beautiful Mornin'!" and "People Will Say We're in Love."

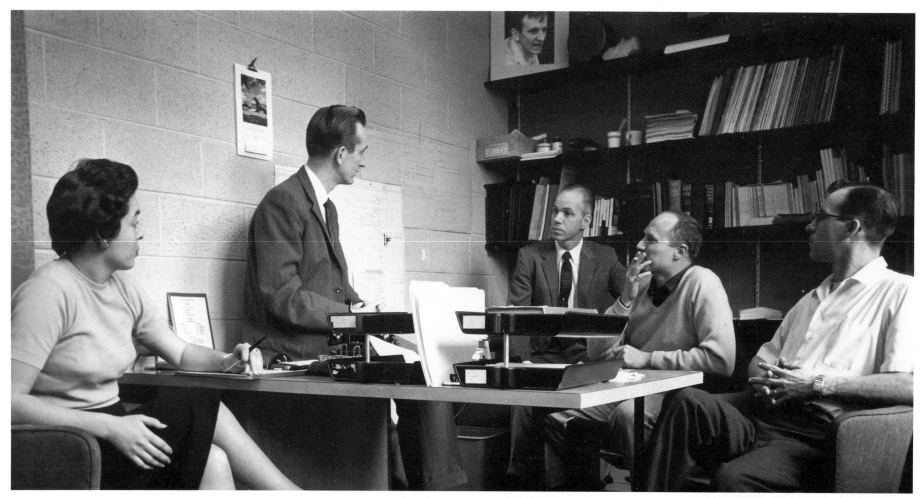

Museum Theatre Director Robert Telford brain-storms with his staff, circa 1962.

Virginia Museum Theatre Director Robert Telford with actress Celeste Holm. Miss Holm served as a judge of one-act plays performed by students partici-pating in the museum's innovative College Drama Festival.

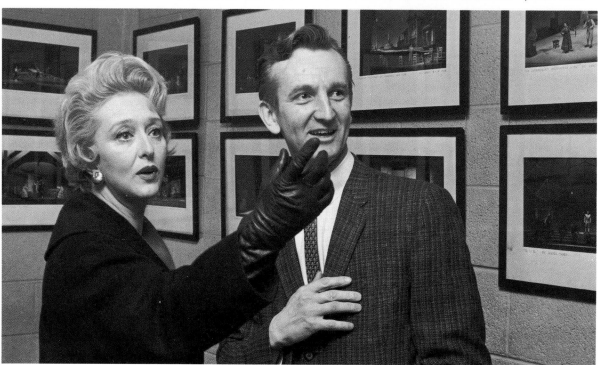

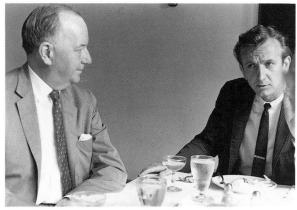

British actor Maurice Evans joins theatre Director Telford for lunch during a break from the Royal Academy of Dramatic Arts auditions, held at the museum in 1965.

During the museum's College Drama Festival, talented students from across the state came to Richmond to sharpen their theatrical skills. Here a Museum Theatre volunteer explains some of the finer points of applying stage make-up. The festival attracted noted professionals including Marc Connelly, Stella Adler and Norris Houghton, who served as judges and critics of the scenes and one-act plays presented by young performers.

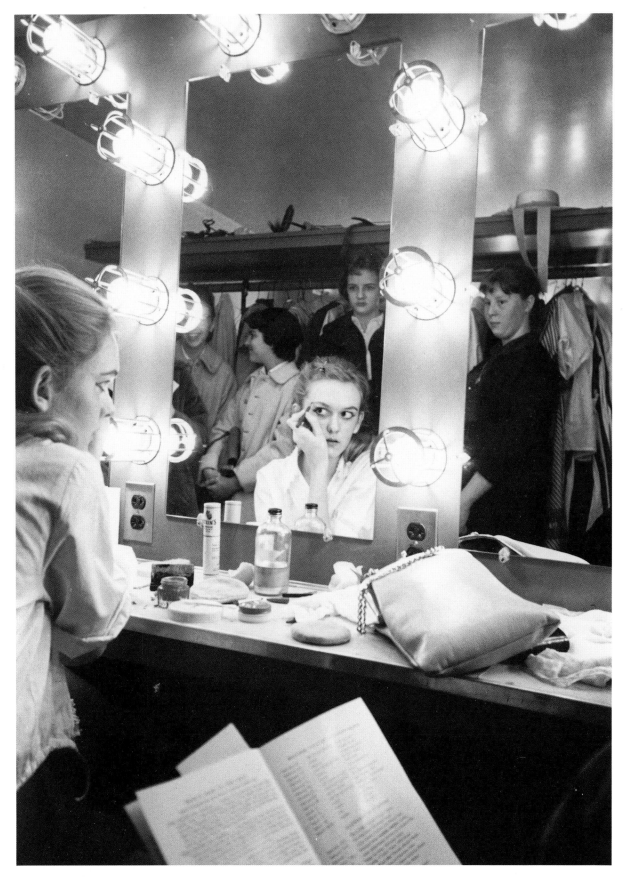

ABOVE: *Designs for the Theatre by Jo Mielziner* (1967) paid hommage to another of Broadway's greatest talents.

LEFT: *Designs for the Theatre by Donald Oenslager* presented a selection of the designer's work displayed in galleries that resembled backstage areas.

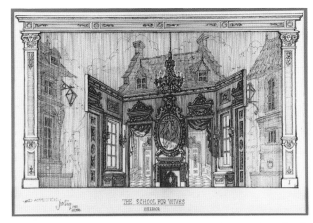

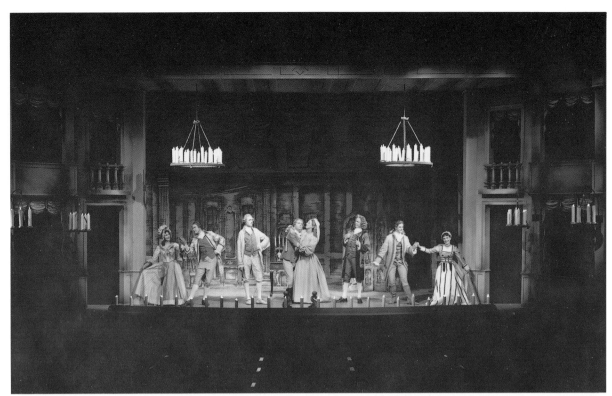

ABOVE: John Döepp's design for a set from *The School for Wives* by Molière, presented at the Virginia Museum in 1967.

RIGHT: Sheridan's *School for Scandal* interpreted *Painting in England*, the 1963 exhibition borrowed from the collection of the Paul Mellons.

BELOW RIGHT: John Doëpp's set for a scene from Richardson and Berney's *Dark of the Moon*, presented at the museum during the 1966–67 season.

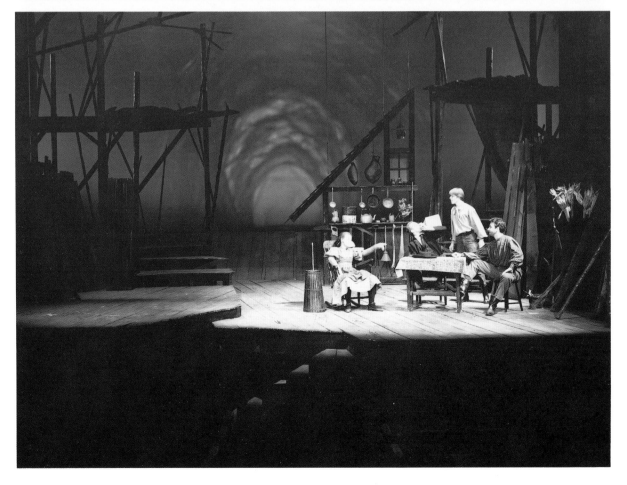

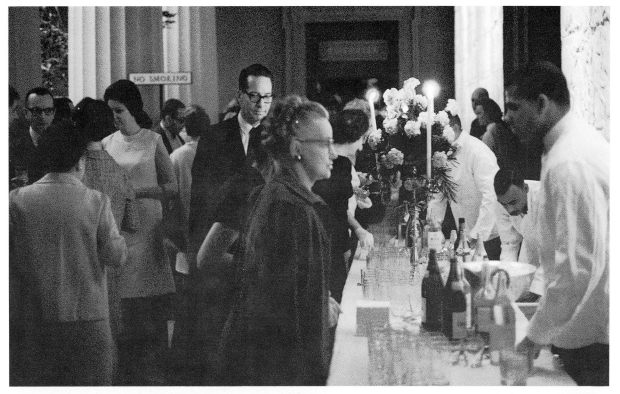

LEFT: The Virginia Museum's "Safari" program brought Confederation members from across the state to enjoy drama, lunch or dinner, and a tour of the galleries. Through this successful program Cheek built larger audiences for the arts, fulfilling the museum's legislative mandate to serve all Virginians. Here refreshments are served to a Safari group in the museum's Mediterranean Court, circa 1965.

ABOVE: Mary Tyler Cheek (third from left) at the opening night for the National Ballet, September 20, 1965. Joining her in the Virginia Museum's Baroque Gallery were Walter S. Robertson, president of the museum (1960–67), Mrs. Polk Guest, Lord Harcourt of Great Britain, and Mrs. Walter Robertson. The National Ballet of Washington was one of four major dance companies that performed at the Museum Theatre in 1965; the others were José Molina Bailes Españoles, Les Grands Ballets Canadiens, and Lucas Hoving and Company.

LEFT: The Museum Theatre stage offered the public more than drama. Concerts by such performers as the Vienna Octet, the Paul Winter Contemporary Consort and Rey de la Torre, were part of a regular schedule of performing arts at the headquarters building. There was also a film series, featuring such classics as *Hiroshima, Mon Amour* and *A Star Is Born*. A dance series was especially popular, with recitals by the Paul Taylor Dance Company, Japan's Hosho No, the Manhattan Festival Ballet and other renowned troupes. Pictured is the Quartetto de Roma, which performed at the museum as part of the Chamber Music Series of 1959–60.

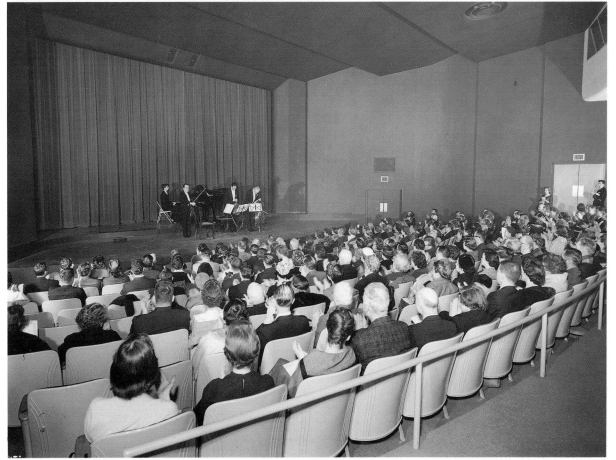

CHAPTER VI

Promoting the Arts for Larger Audiences

Starting in the early 1950s, Miller & Rhoads and Thalhimers, the principal department stores in downtown Richmond, were persuaded to arrange related window displays to announce exhibitions at the Virginia Museum. Shown is a window for *The Aldrich Collection* (1959).

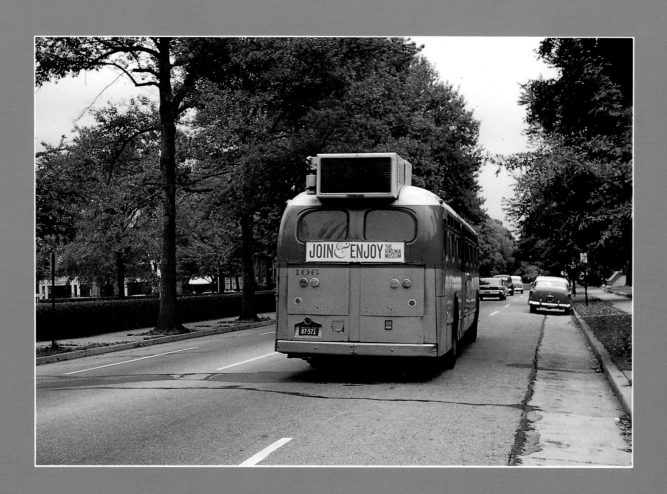

John Cotton Dana once said: "A *good* museum attracts, entertains, arouses curiosity, leads to questioning and thus promotes learning. . . . The Museum can help people only if they use it; they will use it only if they know about it. . . ."

Audience-building was one of Cheek's most important goals. Thus far have been presented the ways with which he moved toward this objective through dramatic installations, through integrating the performing with the static arts, and through taking art to the people via Artmobiles and the Chapters and Affiliates system.

Cheek also employed a wide range of promotional tools to build awareness of the museum among desired audiences, including publicity, advertising, publications, graphics, signage and support organizations.

Few museum professionals at the time anticipated the potential of these tools, particularly public relations. Perry Rathbone, former director of the Museum of Fine Arts in Boston, said: "Leslie was one of the first to use the business techniques we all take for granted now. We [the Boston Museum] never had a public relations department till about 1971 when we recognized the need to broaden support. Leslie recognized the public aspect of the art museum."

Cheek's irrepressible flair for promotion found its first outlet while he was an undergraduate at Harvard and was further developed at William and Mary, and at the Baltimore Museum. His work in Richmond persuaded other museum professionals of both the need for and the propriety of public relations and advertising to promote the arts.

In the 1950s the Virginia Museum began to advertise more aggressively. Cheek coined the slogan "Join & Enjoy," a pithy summons to Virginians to involve themselves with the arts. City buses, billboards, even metered mail bore the catchy slogan.

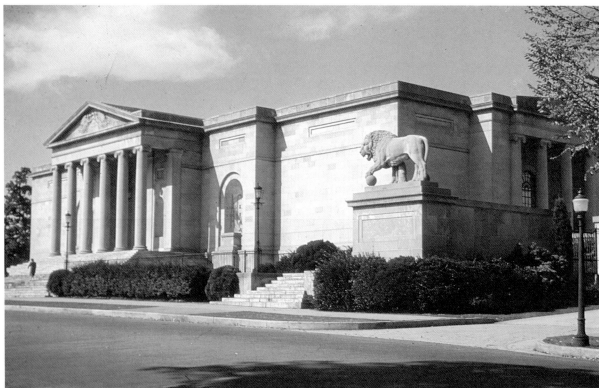

LEFT: An early promotional device at the College of William and Mary. Cheek hired this cart and driver to travel Duke of Gloucester Street in Williamsburg, announcing performances of *The Lying Valet*, staged at Phi Beta Kappa Hall.

ABOVE: Another way to build audiences for the arts was through the use of thematic signs posted on the exteriors of museums. In Baltimore, the young director enticed passersby into his building with eye-catching "teasers" in the decorative niches on the facade of the neo-classical museum. Sometimes these imaginative signs were hung in the portico over the museum's front entrance.

RIGHT: For the 1940 exhibition *Again: Arms and Armor*, the sign was painted a severe military black with letters in the word "Again" dripping red, as if they had been dipped in blood.

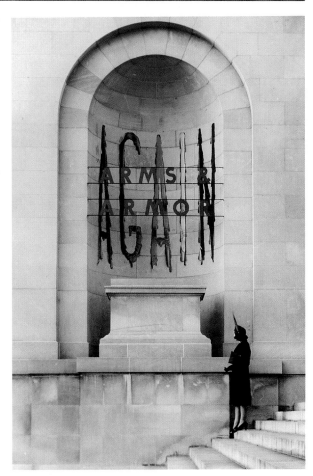

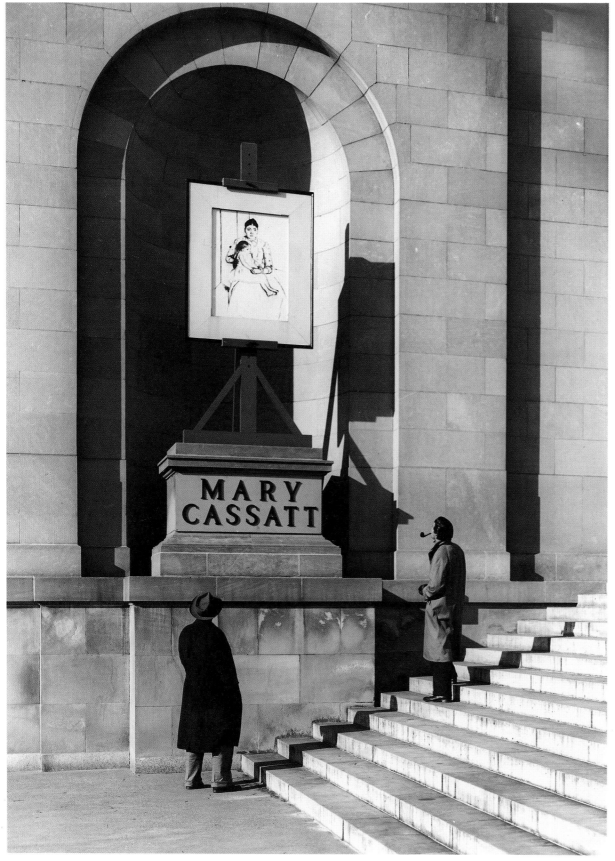

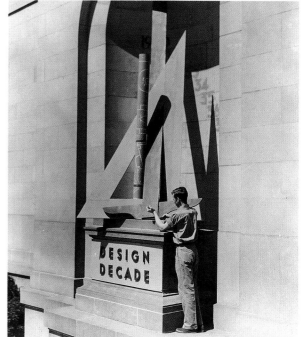

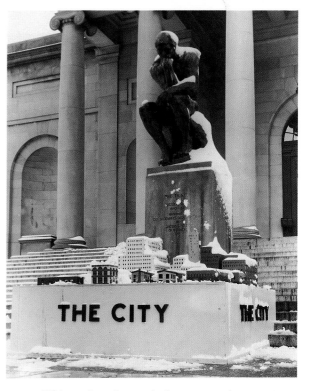

LEFT: This painter's easel drew attention to *Mary Cassatt* (1941). The exhibition honored one of America's greatest artists of the 19th century. **TOP:** An over-sized architect's T-square and triangle announced *Design Decade* (1940). **ABOVE:** To advertise *The City* in 1940, Cheek placed this model of an urban landscape, illuminated with special lighting at night, at the feet of Rodin's *Thinker*.

ABOVE: The sign for *Modern Painting Isms* (1940) comprised a stylized artist's palette suspended above the main entrance to the Baltimore Museum.

RIGHT: *Georgian England* (1941), announced with traditional royal heraldry

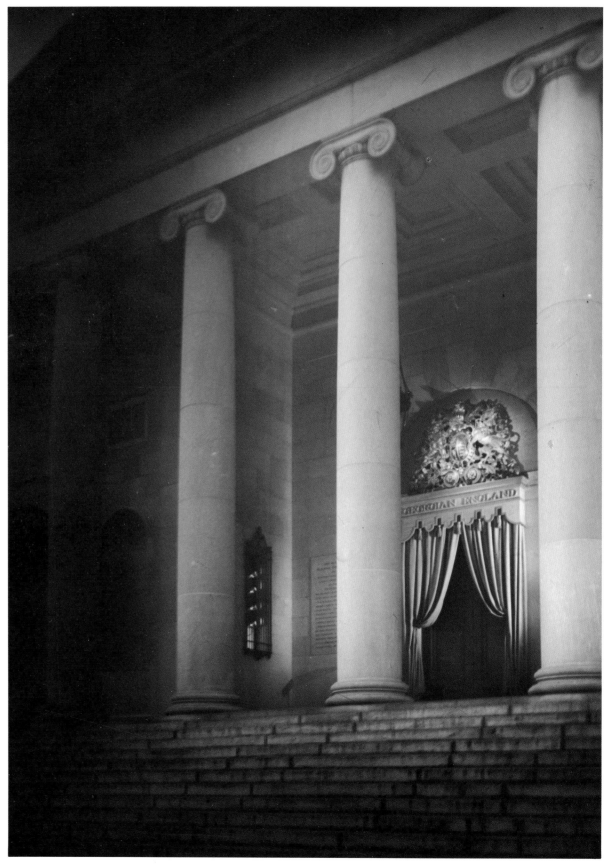

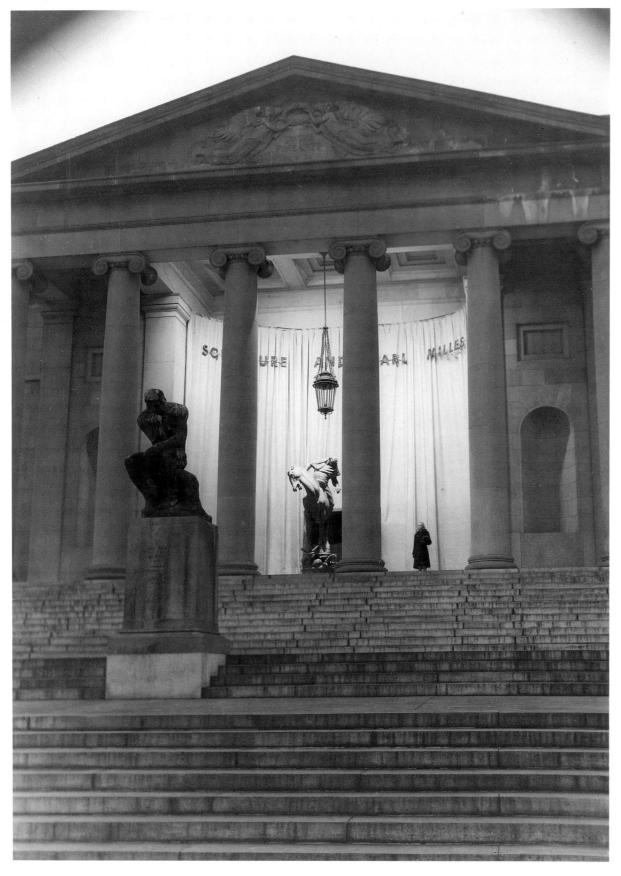

ABOVE: Edward Katz, an actor from *The Six Degrees of Crime*, paraded in front of the Baltimore Museum as well as among the lunch crowd in downtown to announce *Romanticism in America* (1940), the exhibition devoted to Victorian Americana.

LEFT: One of Milles' works greeted visitors entering the museum for *Sculpture and Carl Milles* (1940).

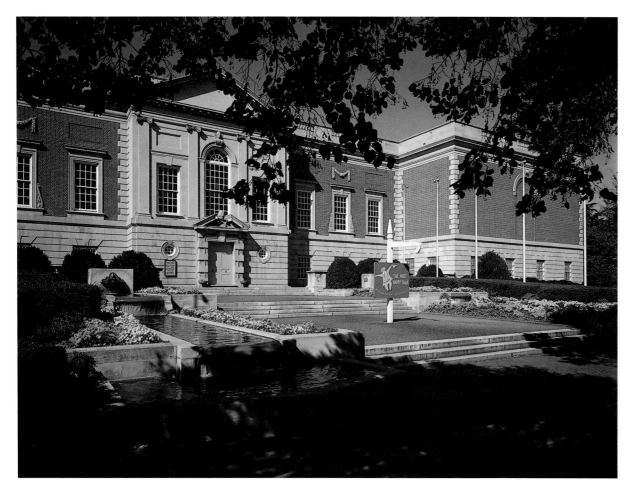

On the wide terrace at the Virginia Museum's Boulevard entrance, Cheek installed a post on which were hung signs announcing loan exhibitions.

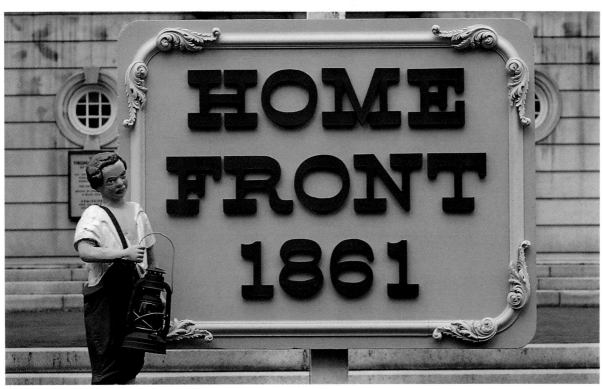

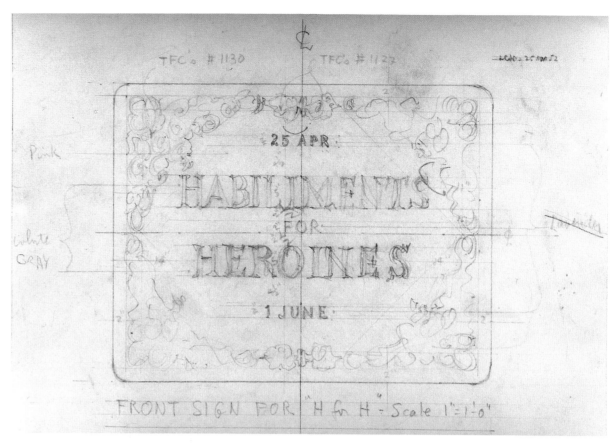

Leslie Cheek's original sketch for the outdoor sign for *Habiliments for Heroines* (1952)

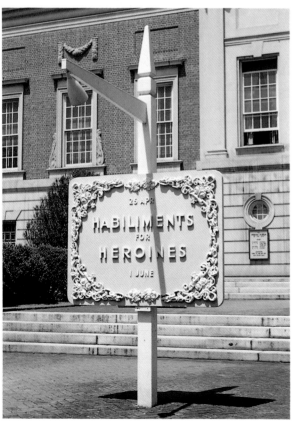

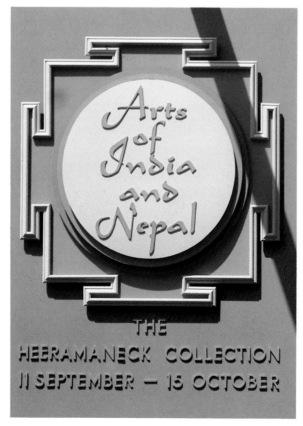

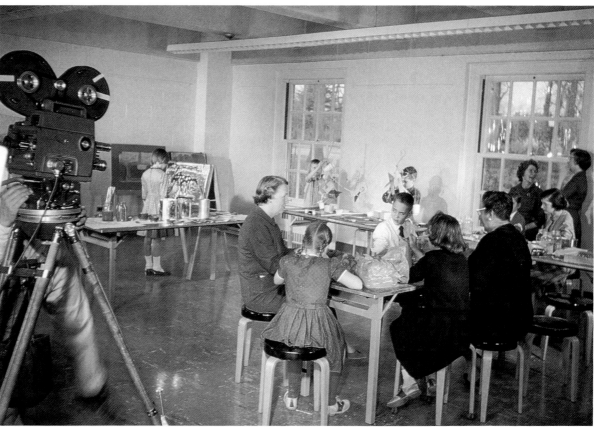

ABOVE LEFT: The Virginia Museum's Public Information Department, started by Cheek in the late 1940s, prepared a 25th anniversary newspaper supplement for dozens of Virginia dailies. Such publicity techniques led to increased membership for, awareness of and interest in the Virginia Museum.

ABOVE: The museum arranged for the production of a color film, *Museum in Action*, narrated by Alistair Cooke. Shown is the shooting of a scene at the museum, under the direction of Richard de Rochemont.

LEFT: Local television news programs broadcast a tour of *Treasures in America* (1961), the exhibition that celebrated the museum's 25th anniversary. *Treasures* honored America's greatest patrons of the arts, including the Rockefellers, Fricks and Vanderbilts.

Bus passengers were exhorted to become involved with the arts.

The Public Information Department was also responsible for one of the museum's greatest media triumphs, an appearance in 1964 on NBC's "Sunday" program. Reporter Aline Saarinen led a nationwide television audience on a tour of *The World of Shakespeare*. The exhibition was also featured in a broadcast made later by more than 200 radio stations affiliated with the NBC network.

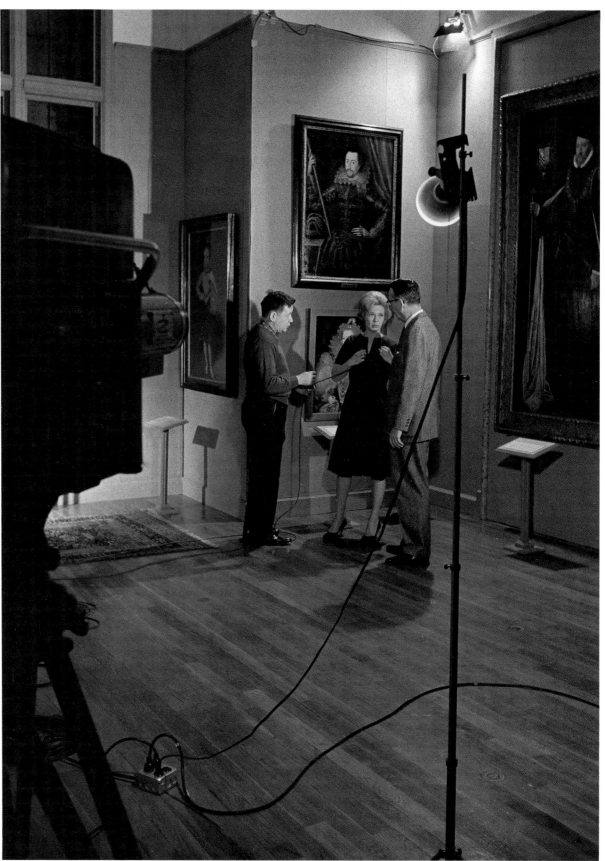

Billboards bore Cheek's catchy slogans.

ABOVE: Cheek was a tireless representative of the Virginia Museum. Here he joins colleagues (left to right) Sherman Lee, director of the Cleveland Museum of Art; Bartlett Hayes, of the Andover Museum; Evan Turner, of the Philadelphia Museum of Art; and James Rorimer, director of the Metropolitan Museum of Art. Meetings like these often led to loans to Virginia Museum exhibitions.

RIGHT: A forceful support group for the Virginia Museum, The Collector's Circle, was organized by Cheek in 1959, and this distinguished organization continues to honor America's leading patrons of the arts. In Cheek's day, the Collectors were annually fêted at a gala black-tie dinner held in the galleries. A "Collector of the Year" was guest speaker; Lessing Rosenwald, Paul Mellon, Vincent Price and Edward Warburg were among those honored.

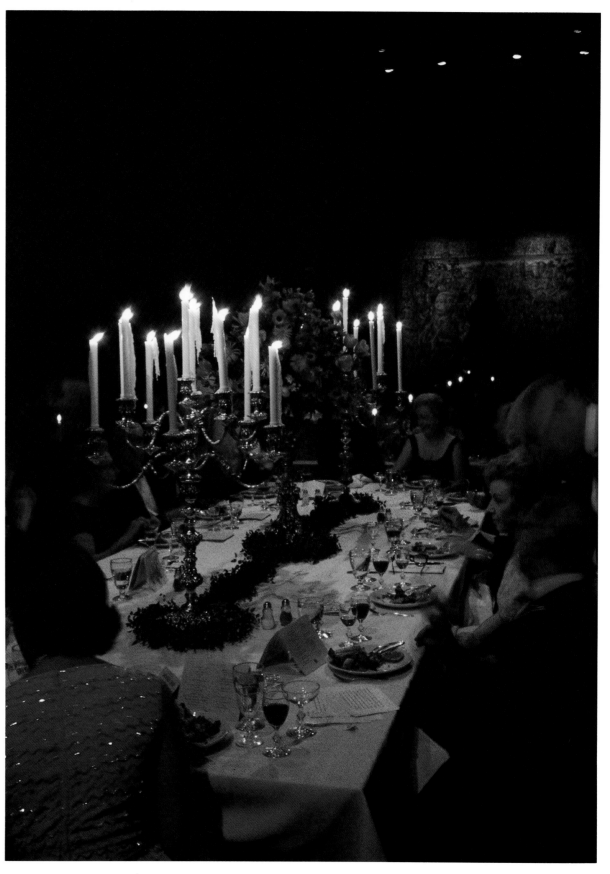

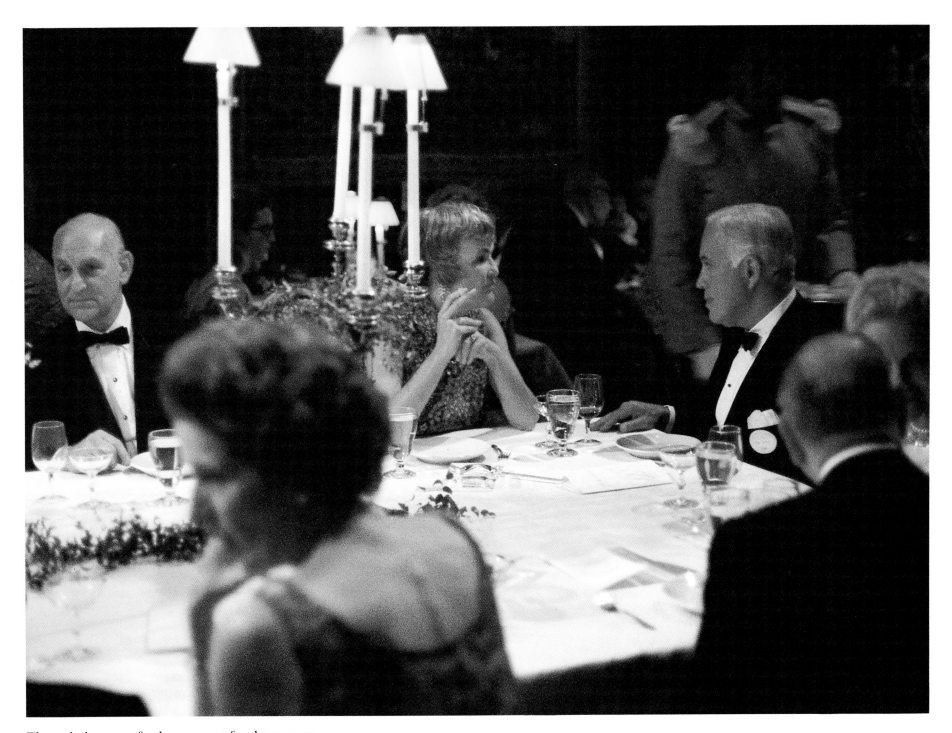

Through the years, further support for the museum has been generously provided by The Fellows, formally established in 1961. Among the projects funded by The Fellows in Cheek's day were a general catalogue of the museum's collections, the orientation theatres, public service announcements for the museum on radio and television, and studies that led to planning for the museum's South Wing expansion. The highlight of The Fellows' annual meetings was an elegant dinner in the galleries.

Concluding Note

Leslie Cheek's legacies to the museum field are defined by the numerous challenges he faced in the different institutions he directed. At the College of William and Mary in Williamsburg he created a Department of Fine Arts, among the first in the South and unique in its attempt to interweave the performing arts with exhibitions of the plastic arts. In Baltimore, he enlarged a city's understanding of art and the role of the art museum in a changing society. In Richmond, he capped his career by fully developing the ideas with which he had experimented elsewhere. His innovations at the Virginia Museum of Fine Arts widened the scope of Virginians' knowledge and appreciation of the arts.

As much as anyone in the twentieth century, Leslie Cheek helped bring to reality the hope that scholar Walter Pach expressed in 1948. "It is not in the art of the collections that [American] museums must differ from those of Europe," Pach wrote, "but in their relationship with the people here." Cheek's people-oriented programming helped transform the American art museum from a preserve of a privileged elite to a cultural center responsive to a democratic society. As a designer dedicated to building larger audiences for the fine arts, he sought practical methods to introduce people to virtually every form of artistic expression. He expanded the conventional spectrum to include such things as city planning and film making, fashion design and architecture. Leslie Cheek's innovations both entertained and instructed, and they undeniably enriched the lives of many by making art museums lively and interesting places.

PART II

PLACES FOR LIVING AND LEARNING

Introduction

"Places for Living and Learning" surveys Leslie Cheek's prolific output as a professional designer and consultant seeking to make his world a more comfortable, beautiful and hospitable place.

Formal training in architecture seems to have been a logical fulfillment for one endowed with a highly developed visual sense. As a boy Cheek had demonstrated a knack for drawing, delighting his parents and friends with sketches and watercolors. His interest in architecture was stimulated during many trips around the world with his parents, where he had firsthand experience with classical, oriental, African, Indian and European environments.

He entered Harvard in 1927, enrolling as an engineering major at his father's suggestion, but his love for the theatre soon lured him from the less congenial field of mathematics. He joined the Dramatic Club and his success as a stage designer moved him to change his field of concentration to the fine arts. Upon graduation he entered the Yale School of Architecture where he strengthened his love of theatre by taking several courses in stage and lighting design, and participating in Drama School productions.

Cheek's years at Yale University coincided with a watershed of change in the teaching of architecture; "modernism" invaded the sacred precincts of the Beaux-Arts. When he arrived in New Haven in 1931, Yale's School of Fine Arts was firmly in the tradition of the École des Beaux-Arts of Paris. This renowned French academy, founded in the 1600s, had produced American architectural giants like Richard Morris Hunt (1828–1895) and Charles McKim (1847–1909), to name but two. Architects whose professional lives were governed by Beaux-Arts principles enjoyed their greatest influence from the 1880s until the advent of the Bauhaus or International Style in the 1930s.

Beaux-Arts architecture emphasized a method of work and a series of design principles rather than any particular style, and these strongly influenced architectural education on both sides of the Atlantic. At its core was the *atelier* system under which problem solving was employed to train aspiring architects. Students were encouraged to devise their own *parti*—the essential scheme or master plan—in producing designs characterized by unity, proportion, scale and balance. They were required to make a comprehensive study of the uses and requirements for a particular building, including interior lighting, circulation of air, convenience and movement of people, fitness of decorative elements, and economy of means. Projects were visualized as a series of spatial volumes through which specators could pass in an orderly progression. Elegant draftsmanship as well as reliance upon classical or historical formulae were crucial ingredients in the Beaux-Arts philosophy.

During his student days at Yale, Cheek received exposure to Beaux-Arts principles through rigorous instruction in such fundamentals as painting, sculpture and life drawing. First-year students labored over *analytiques*, detailed renderings in ink on 3 foot by 4 foot boards that depicted monumental buildings in Rome, Paris or Vienna. Second-year students were assigned more difficult *projets*—such as designs for private estates, factories, and other public buildings—while third and fourth year assignments often called for students to pool talent as members of teams working on designs for competitions, such as the annual Prix de Rome. Seniors rounded out their program by submitting a thesis, judged by the faculty and visiting professionals.

Everett Meeks, who presided as dean of the School of Fine Arts from 1922 to 1947, preserved this traditional approach while at the same time introducing more contemporary influences. By the 1930s it had become apparent that the old methods exemplified by the Beaux-Arts simply could not keep pace with rapid transformations in technology, materials, taste, and corporate and individual wealth. The new age that gave birth to the flying machine and mass-produced, cheaply priced goods, to the automobile and greater leisure time demanded a new, salient architecture, one that was to be influenced by the Constructivists in Russia, the De Stijl movement in Holland and, most importantly, the Bauhaus in Germany.

During the Meeks' regime, the work of architecture students was still being submitted to juries for evaluation. Dean Meeks wisely permitted a new breed of professionals to serve as judges: designers who had made names for themselves with their contemporary work. Wallace Harrison, Normal Bel Geddes and Raymond Hood were among those who accepted the invitation and helped spread the gospel of modernism at Yale. This trio's sleek, streamlined structures captured the pulsating rhythms and quickening energies of the times, and its members were the idols of aspiring architects in Depression-era America. Cheek was thus the product of the cross-currents of his time. The pages that follow catalogue a sampling of projects that reflect this shift in instructional philosophy during the 1930s.

But architectural study was little more than half of his education at Yale. Significantly, Cheek also studied stage design, and among his teachers was Donald Oenslager, designer of many of Broadway's most successful shows. The selection of stage designs on the following pages is drawn from those Cheek prepared for courses at the Yale School of Drama. They clearly illustrate not only his devotion to the theatre; they also disclose many of the techniques he would later employ to great effect in museum contexts. As a stage designer, Cheek had to be skilled at creating convincing illusions, and this talent proved to be immensely useful to him in devising settings that made the arts attractive and approachable for general audiences.

Part I of this study examined the techniques Cheek employed to make museum installations more enjoyable, interesting and informative, focusing to a large extent on methods borrowed from the world of the theatre. This concluding section presents a selection of projects that illustrate the influence the Beaux-Arts school had on Cheek's ability to visualize a project in terms of a comprehensive master plan. This is obvious in many of the Yale *projets* and in his designs for his family's two country houses. Beaux-Arts training was also evident in work when he collaborated in 1965–67 with Robert Stewart to devise a new Entrance Wing for the Virginia Museum. An unusual feature of that ill-fated plan was a sequence of galleries aligned on the museum's long, north-south axis that guided the visitor through human culture, beginning with the earliest artifacts and concluding with contemporary art.

By the same token, modernist influences are plainly visible in Cheek's interior designs for his Williamsburg and Baltimore apartments, as well as for his offices and country houses. Moreover, Cheek is a modernist in another key respect. His obsession with detail is congruent with an enduring faith in the power of good design to solve contemporary social ills.

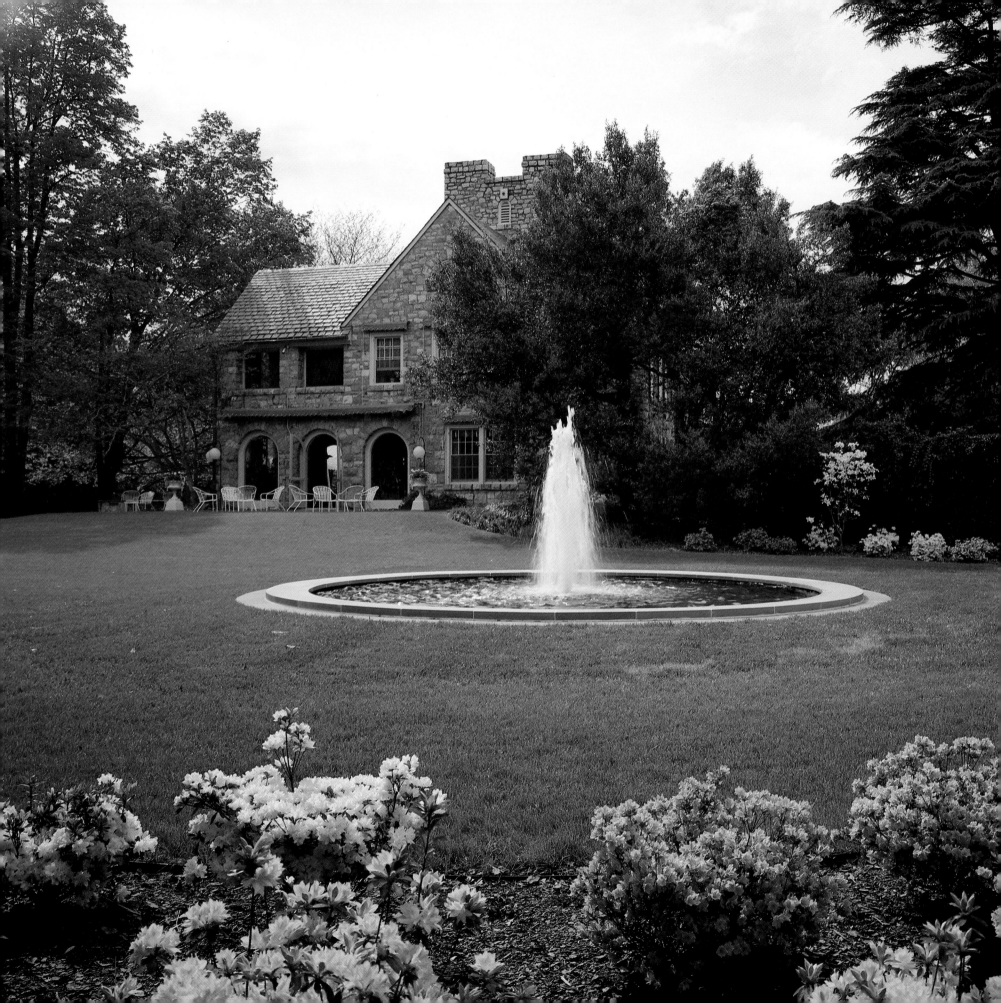

CHAPTER VII

Town Houses

The east facade of the Cheeks' house in Richmond's West End. In the foreground is the Jet Fountain that Leslie installed in 1983.

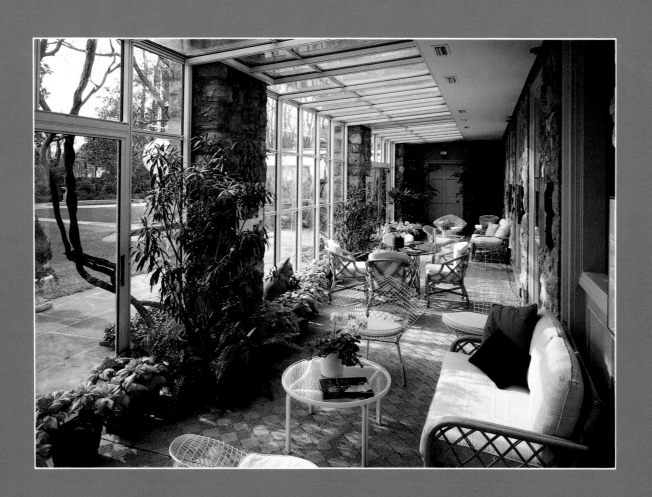

Leslie Cheek grew up in an atmosphere of elegance and abundance made possible by wealth. This privilege, combined with extensive travel and an exceptionally strong visual sense, early produced a love of the style that became a dominant force in all of his work. As he set the pattern for his adult life, he put his mark of tasteful design on everything that he touched, from the tiny restored Kitchen in which he lived in Williamsburg to the ever larger dwellings of his growing family.

Having entered the Yale School of Architecture as a devout follower of the Georgian style, he graduated a confirmed modernist in the mode of the 1930s. The Williamsburg Kitchen, his bachelor quarters from 1935 to 1939, and the apartment in Baltimore, to which he brought his bride in 1939, reflected a new enthusiasm for modernism. Allegiance to Sir John Vanbrugh, Inigo Jones and Sir Christopher Wren was replaced by homage to Frank Lloyd Wright, Norman Bel Geddes and Wallace Harrison. The classical curve yielded to angularity, Chippendale gave way to built-in cabinetwork and the chandelier was supplanted by indirect lighting. With the passage of time, the ardor of the strict modernist mellowed into a more balanced perspective that included appreciation for a variety of styles in their own milieux.

Today Cheek enjoys mixing elements of design from different periods, deriving pleasure from the harmonious combination of works of quality produced by any age or culture. The house of his mature years in Richmond's fashionable West End, where Cheek has lived since 1948, affords an example of this ease in working with both the traditional and the contemporary. Eighteenth century furnishings inhabit rooms adjacent to others filled with Art Deco pieces acquired in the 1930s. Objects from Scandinavia are felicitously combined with others from China and Japan. The total effect is a record of many lives and relationships, a comfortable, stimulating environment, unified by the distinction of line and color that is style.

Warming sunlight bathes the glass-enclosed Galleria at the Cheeks' house in Richmond, Virginia. What had once been an open loggia on the south side of the house is now a season-round gathering place for family and friends.

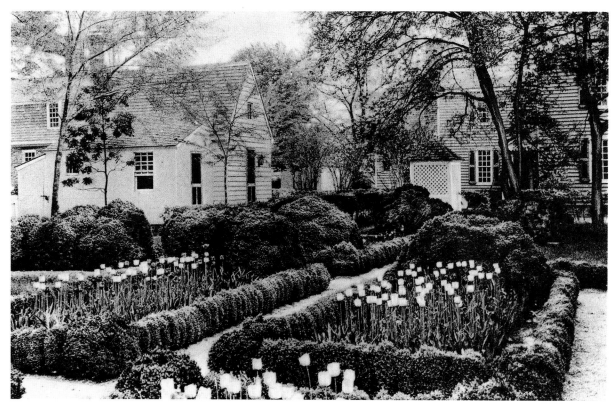

ABOVE AND RIGHT: While a member of the faculty at the College of William and Mary (1935–39), Cheek lived in a small restored Kitchen (the building at left) behind the James Geddy House. He raised eyebrows in the former colonial capital when, with typical panache, he remodelled his living quarters in an uncompromising contemporary style. Williamsburg was agog over the Kitchen. Its Art Deco furnishings and indirect lighting startled townspeople more accustomed to the style of Thomas Chippendale or Robert Adam.

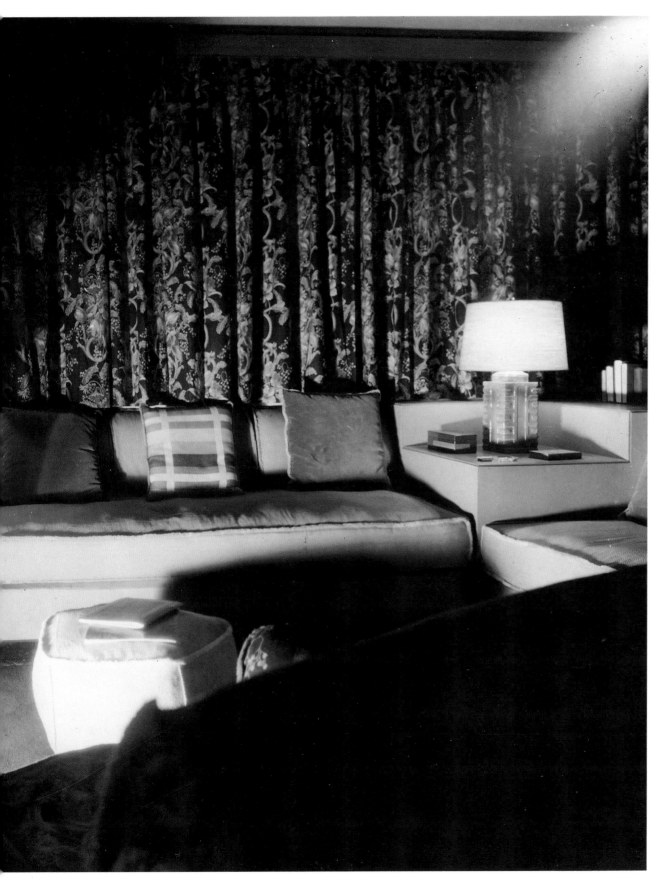

TOP: The Kitchen had a ground floor bedroom with workspace and a small dressing room.

ABOVE: Cheek's Kitchen soon gained a reputation as a place where students and professors from the Fine Arts Department could relax together in an atmosphere of informality. Though some members of the College faculty were offended by such fraternization, Cheek knew from experience the enriching power of such relationships.

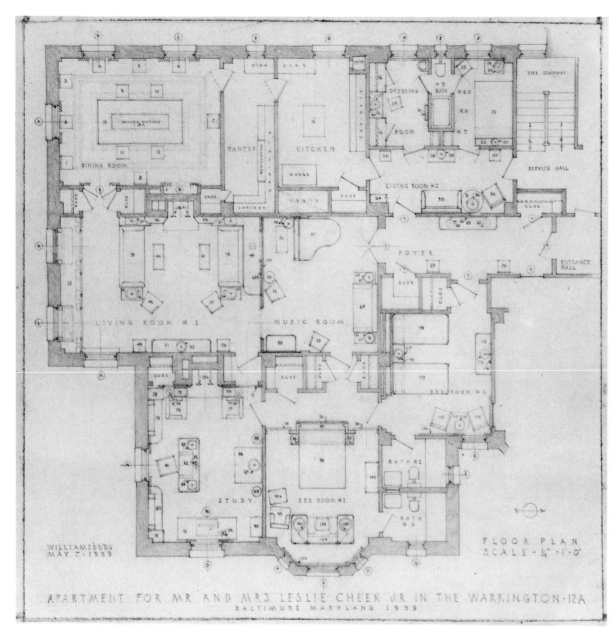

APARTMENT FOR MR AND MRS LESLIE CHEEK JR IN THE WARRINGTON · 12A
BALTIMORE MARYLAND 1939

WILLIAMSBURG
MAY 7 · 1939

FLOOR PLAN
SCALE · ¼" = 1'-0"

ABOVE: Cheek's original furniture layout for the family's 12th floor apartment in Baltimore. The H. Chambers Co. of Baltimore was the contractor for the extensive remodelling project that both delighted and startled Baltimoreans.

RIGHT: The Entrance Hall at the Warrington Apartment, where the Cheeks lived from 1939–42 when Leslie was director of the Baltimore Museum of Art. His new interiors for the apartment were in the then-popular Streamline Moderne style. The cabinet and many other furnishings were designed by Cheek.

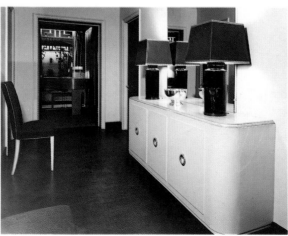

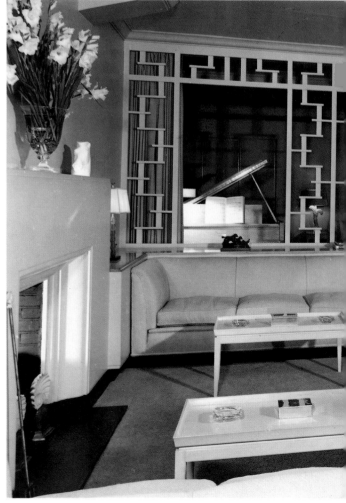

RIGHT: A dazzling Art Deco piano autographed by Steinway, was a wedding present to Leslie and Mary Tyler from Mabel Wood Cheek. Illumination in this and other rooms was accomplished with built-in "Lumiline" lighting strips recessed in the ceiling.

BELOW: Wooden grilles divided the apartment's rather long Living Room. They were later reused in the Sun Room at the Cheeks' Richmond house.

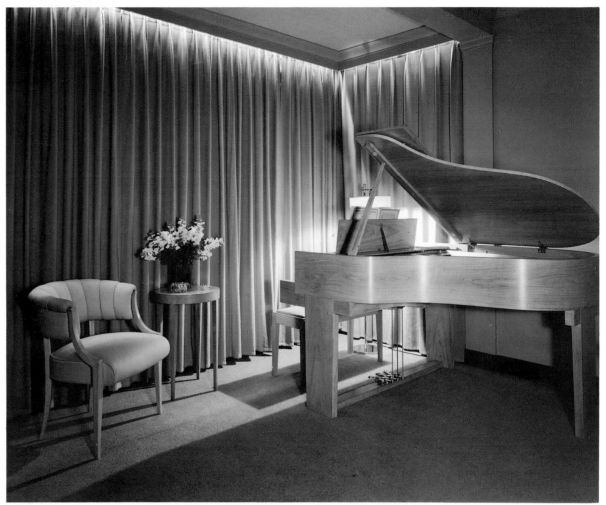

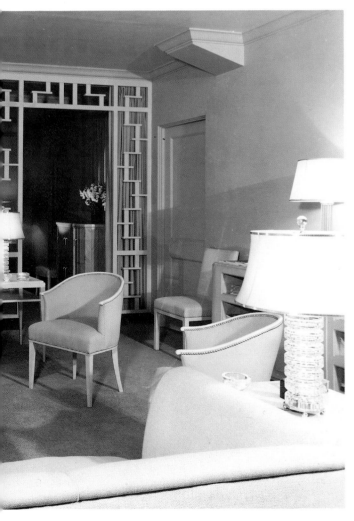

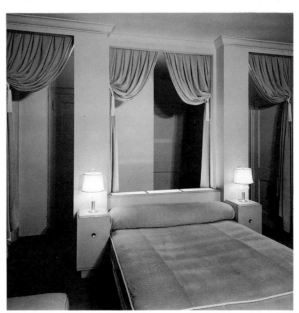

Modern comfort, understatement and simplicity epitomized by the Master Bedroom.

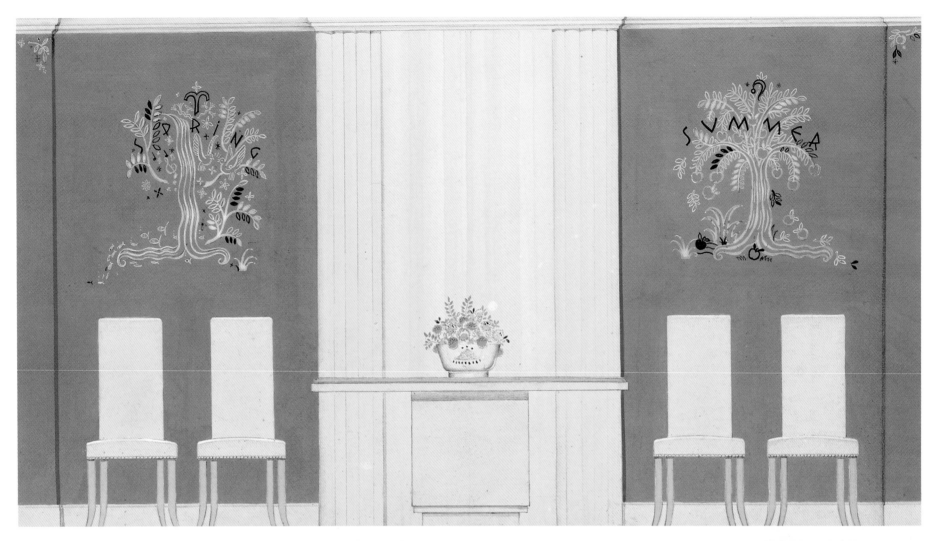

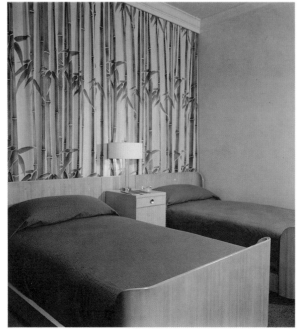

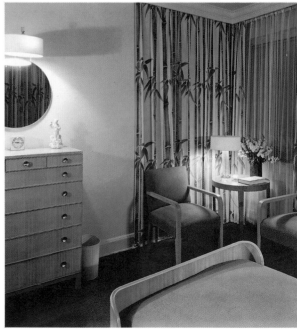

ABOVE: Leonard Haber executed murals of the four seasons to decorate the Dining Room. Haber's color rendering is a sectional view showing the massive 5-foot by 10-foot dining table, which Cheek designed in 1939.

RIGHT: Two views of the Guest Room at the Warrington. The handblocked raw silk draperies were made from material bought by the Cheeks during their honeymoon in Honolulu in June 1939.

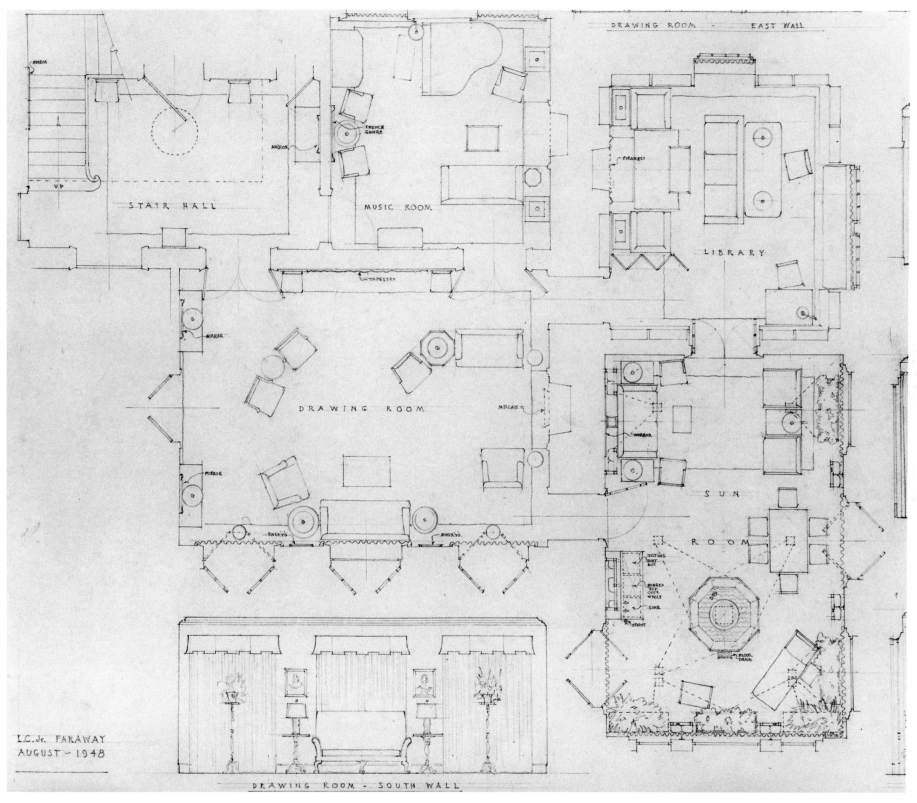

Cheek prepared this furniture layout for his Rich-mond house (partially reproduced here) while on summer vacation in North Carolina (1948). The urn fountain with octagonal base, while an intriguing idea, was never installed in the Sun Room (lower right). Interestingly, some of the furnishings remain to this day in the exact positions indicated on this detailed plan.

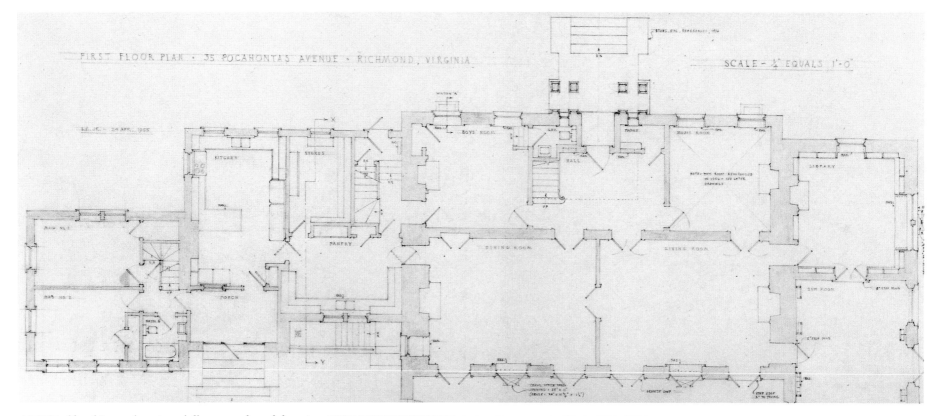

FIRST FLOOR PLAN · 35 POCAHONTAS AVENUE · RICHMOND, VIRGINIA SCALE - ¼" EQUALS 1'-0"

ABOVE: Cheek's tracing (partially reproduced here) of the original floor plan for Pocahontas Avenue (circa 1950), which was designed by W. Duncan Lee of Richmond. Dr. and Mrs. Shelton Horsley built the house in 1919 using stone quarried in western Virginia and shipped east on railroad flatcars.

RIGHT: The front entrance to Pocahontas Avenue that Cheek remodelled in 1955 in a Greek Revival style.

OPPOSITE PAGE: Cheek made this drawing when working on redesigns for the front entrance to the house. The elevation shows the front doorway prior to remodelling. New buff-colored limestone steps, Greek Revival-styled columns, a restyled second storey window, and an enlarged drive and parking court for six automobiles were included in the improvements to the north side of the house.

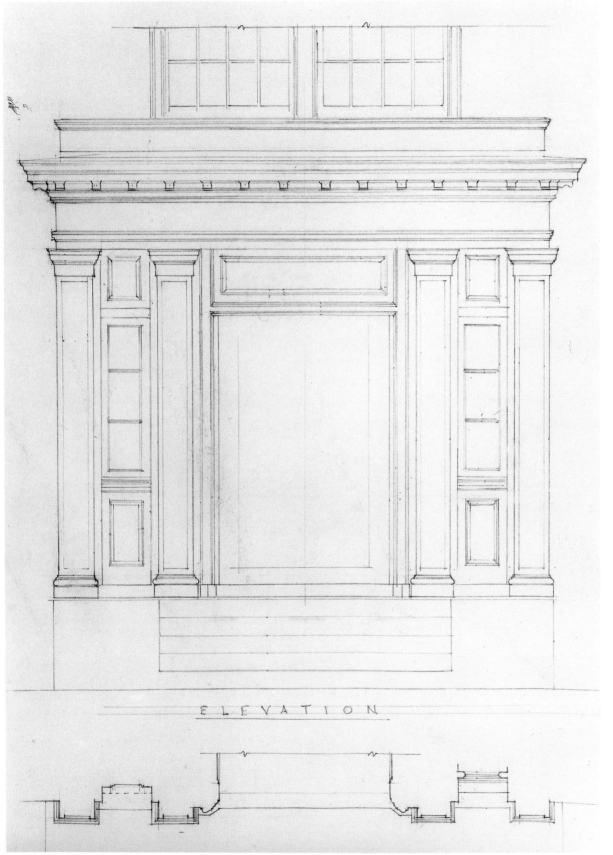

ABOVE: A detail from Cheek's specifications for lanterns, gates and garden walls at Pocahontas Avenue.

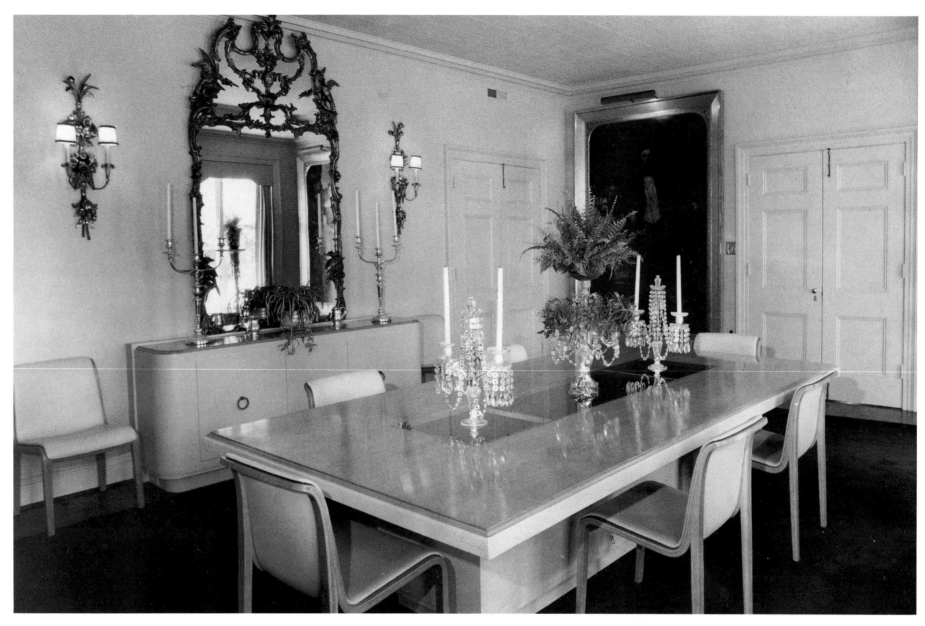

The Dining Room at 4703 Pocahontas Avenue is furnished with Art Deco pieces Cheek designed for the family's apartment in Baltimore. The three glass panels at the center of the table can be removed and wooden panels substituted in a variety of combinations. Tinted gelatin sheets can be slipped between the glass for special occasions, such as Christmas or Thanksgiving. Lights are set in the base on which the table rests so that there are no legs to cause discomfort. The base is lined with black duvetyn to conceal the source of light, which glows through the crystal objects on the tabletop, invariably baffling guests. The portrait, more than seven feet tall, is of William Wallace Warfield, one of Cheek's maternal ancestors. The painting has since been returned to Cheekwood, the former family estate in Nashville.

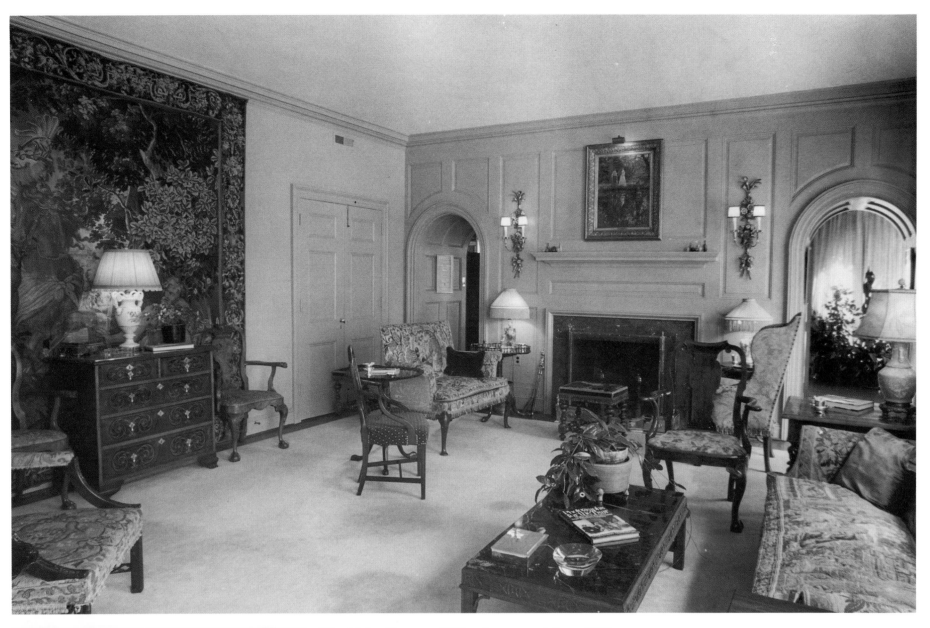

The Living Room at 4703 as it appeared from 1948 until 1985, when many of its furnishings were returned to Cheekwood. Over the mantel is *Lilly Pond* by Gari Melchers (1860–1932). Today, the room—since rechristened the Drawings Room—features many watercolors, drawings and sketches by Cheek.

Friends gather in the Living Room, May 1958, before attending a performance of *Major Barbara* at the Virginia Museum Theatre. Left to right: John Garland Pollard, Jr., Mrs. James A. Shield, Dr. J. Robert Massie, Leslie Cheek, Mrs. Massie. Pollard was president of the museum from 1958 to 1960.

Christmases at Pocahontas Avenue would not be complete without a gaily decorated Fraser Fir, sent to Richmond each year from Skylark Farm in Virginia's Blue Ridge Mountains. Cheek planned the farm as a retirement retreat, but ill health forced him to relinquish it. He and Mary Tyler presented the farm to Washington and Lee University in 1977 in memory of her father, Douglas Southall Freeman.

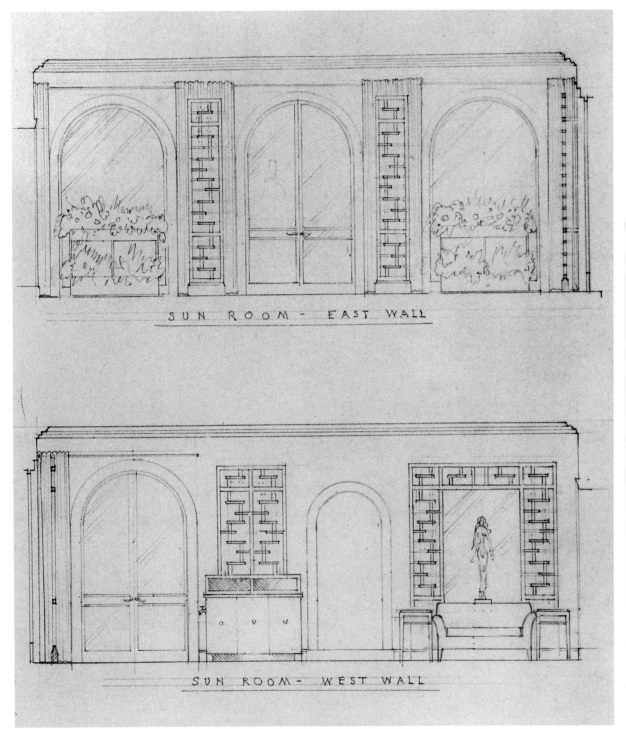

SUN ROOM - EAST WALL

SUN ROOM - WEST WALL

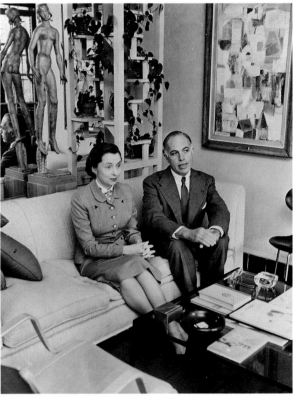

Leslie and Mary Tyler Cheek in the Sun Room in the late 1950s. The bronze figure by Carl Milles was a gift from the sculptor in 1941, shortly after the birth of the Cheeks' first child, Leslie III. *View into Maryland* by American artist Marnye Reinhart hangs at right.

Elevations, interior walls for the Sun Room (1948)

153

RIGHT: A swimming pool was added in 1955. Originally, four nozzles imbedded just above the waterline at opposite ends of the pool sent jets of water arching skyward. The mast with flagpole reflects Cheek's lifelong fascination with banners and ensigns. His extensive collection includes flags from virtually every country in the world.

BELOW: One of Leslie Cheek's conceptual drawings for the pool house (1957). In contrast to the structure that was eventually completed in 1959, this version reveals an enclosed family room for entertaining. Sliding glass doors afforded views of the swimming pool, and designer Florence S. Knoll of New York's Knoll Associates was consulted for the interiors. There would have been a small kitchen, fireplace, state-of-the-art sound system and even a grand piano. The scheme ultimately proved too costly, but the present-day structure in many ways resembles this early plan.

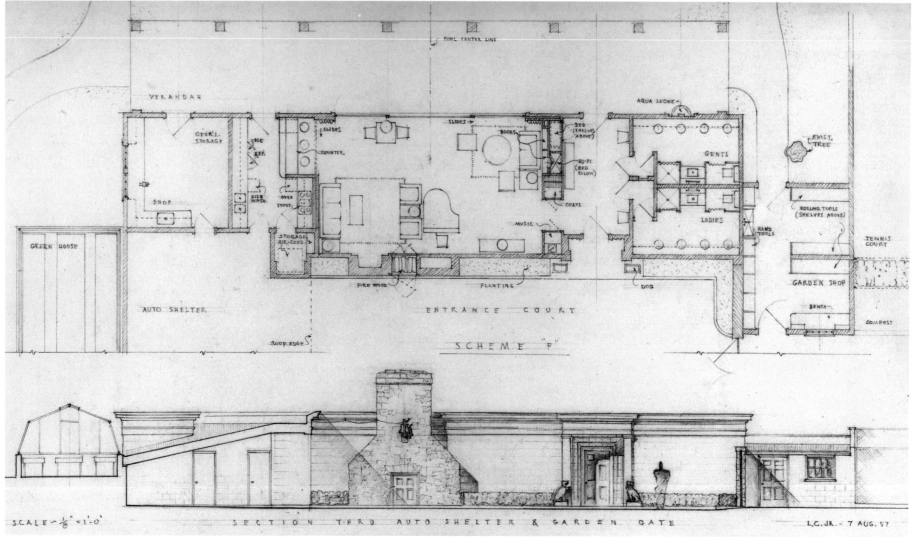

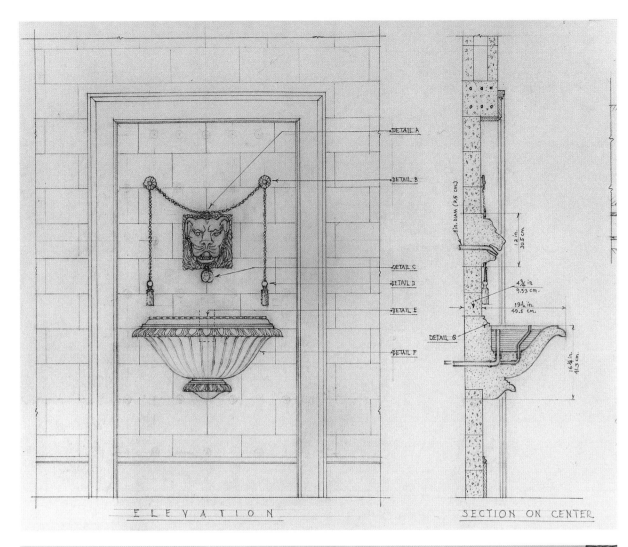

ELEVATION

SECTION ON CENTER

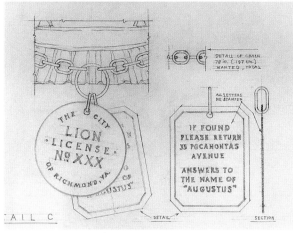

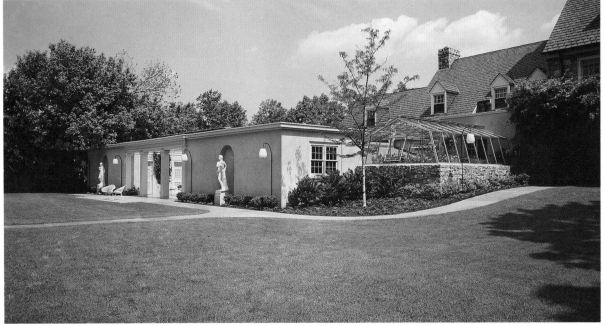

ABOVE LEFT: This 1956 design for a wall fountain was incorporated in the pool house completed some three years later. Cheek's lion bears a bronze, die-stamped license tag—"No. XXX"—that reads: "If found please return to 35 Pocahontas Avenue. Answers to the Name of 'Augustus.'"

LEFT: The pool house viewed from the southeast. This addition, designed by Cheek between 1955 and 1959, includes a greenhouse that provides fresh flowers year-round. Looking through the glass one can see the sloping roof of the garage, which Cheek designed to admit more sunlight for the plants inside the adjacent greenhouse.

155

EAST ELEVATION OF ENTRANCE HALL.

GARLANDS = 1 NO. 8 , 1 NO. 15 , 1 NO. 1 , 1 NO. 22. (M) BOWS = 2 AS FOR L.RM.
CARNATIONS = 16 (8 EACH SIDE) INITIALS OVAL = SAME AS FOR LIB.

25TH ANNIVERSARY DECORATIONS

SCALE = ½" = 1'-0"

L.C.JR. - 30 APR. 64

ELEVATION OF BAR. - 3 WANTED ALIKE

GARLANDS = 3 NOS. 4,5,6 , 3 NO. 16 , 17,18 (M) TOTAL BOWS = 6 AS FOR LIB. TOTAL
CARNATIONS = 60 (10 EA. SIDE) TOTAL INITIALS OVAL = 3 - 15 HORIZ. TOT.

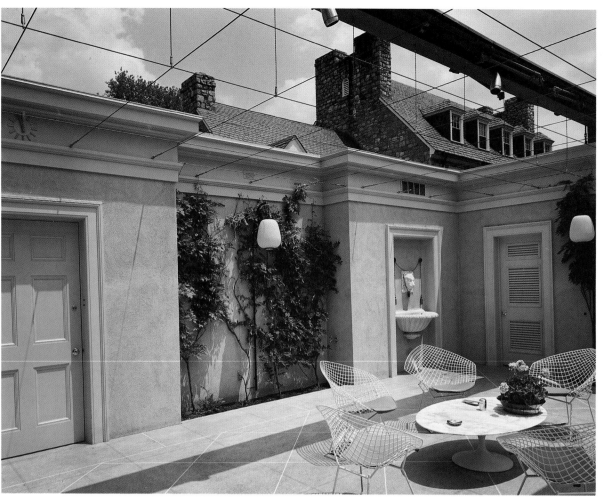

ABOVE LEFT: For the Cheeks' 25th wedding anniversary, a canopied serving area was set up on the south lawn, adjacent to the loggia. The floral garland is crowned with a decorative lozenge bearing the host and hostess' intertwining initials.

LEFT: Specifications for decorative garlands used for the 25th wedding anniversary party (1964).

ABOVE: The pool house loggia. In later years the matrix of wires overhead would support a luxuriant growth of wisteria, rendering unnecessary a mechanically operated protective canopy. The lion fountain bespeaks Cheek's whimsical side. One pull-chain operates a spout for drinking water; the other activates a surprisingly loud leonine roar.

RIGHT: The entrance to the pool house was inspired by the front door to the Franklin Street townhouse of Richmond novelist Ellen Glasgow (1873–1945). The pair of canine sculptures are from Florence, Italy, and prompted Cheek to re-christine the 1959 addition the "Dog House."

Richard Cheek Photo

Dennis McWaters Photo

ABOVE: The Jet Fountain viewed from the South. The 19th century sculpture of *Pandora* by Chauncey Ives (right) was returned to the Virginia Museum in 1987. Noted landscape architect Alfred Geiffert of New York was commissioned by Cheek in the 1950s to design the grounds plan and garden at the Pocahontas Avenue residence. Later, Kenneth Higgins of Richmond was retained to adapt and alter the plan to accommodate the changes that had occurred during the intervening 30 years.

LEFT: This delightful sculpture was originally intended for Skylark Farm. When increasing infirmity forced Cheek to relinquish his mountaintop retreat, he placed this fountain in the garden of his Richmond house.

ABOVE RIGHT: This Martin Condo was built to Cheek's specifications by friend Harry W. Robertson III and was placed on the south lawn in the fall of 1987. The condo's clock keeps accurate time, and every quarter of an hour its "Big Ben" chimes can be heard resounding over an outside audio system.

Richard Cheek Photo

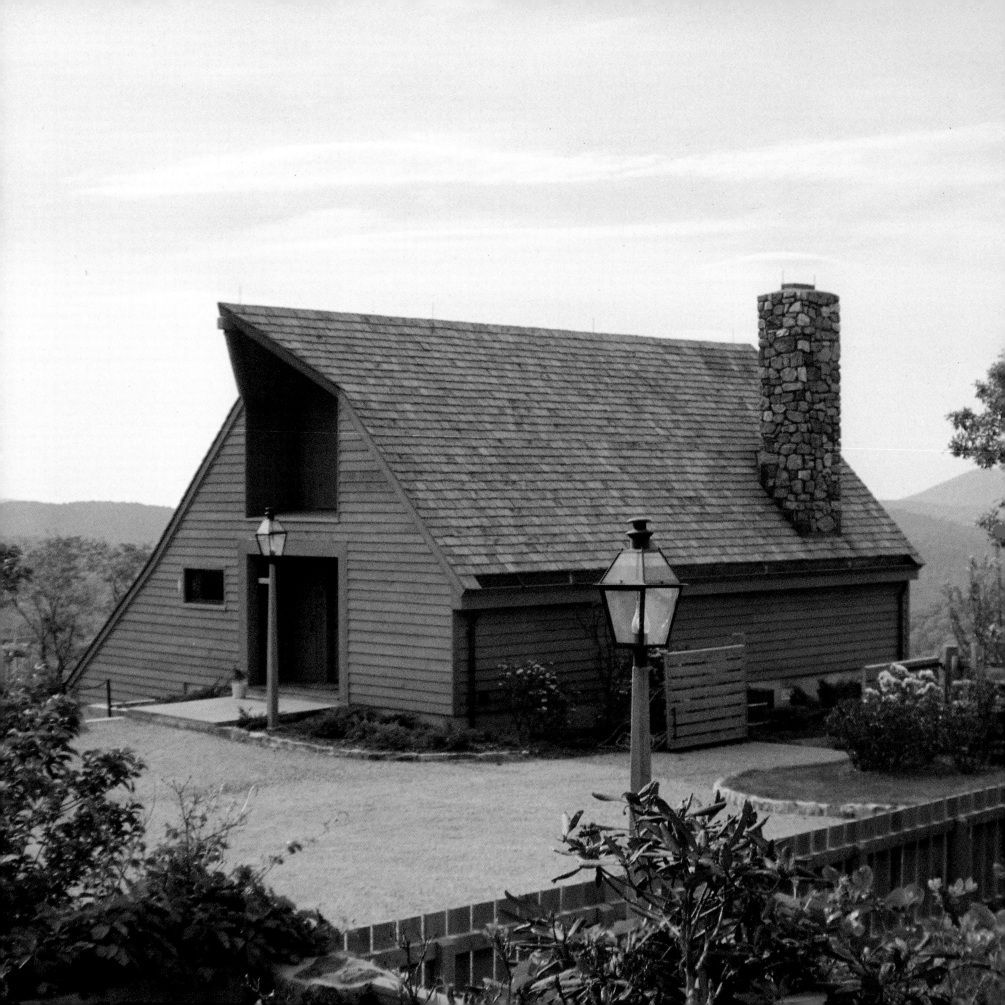

CHAPTER VIII

Country Seats

This dwelling for the resident manager at Skylark Farm was built after the Cheeks decided to make the original Manager's House their permanent home. Cheek envisioned the farm as his home in retirement. Ill health forced him to abandon the project in 1977.

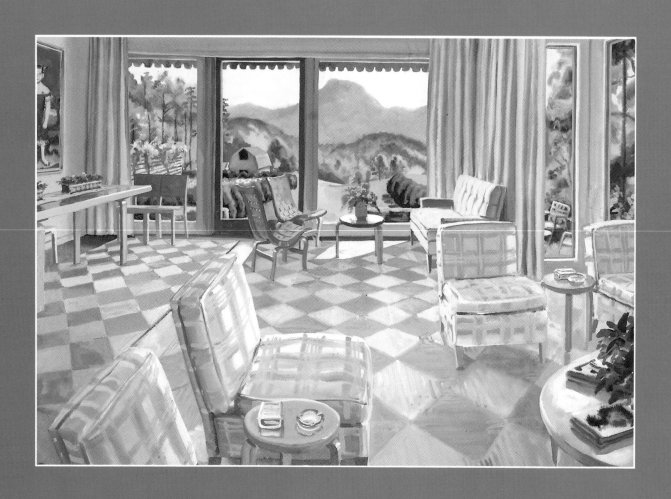

The two country houses presented in this chapter are the only living spaces that are entirely Cheek's own creations. The other places in which he lived as an adult had been designed and built by others; he remodelled them to suit his tastes and needs. Faraway Farm and Skylark Farm freed him to build as he wished, adapting design to locale with an unusual sensitivity to each setting.

Separated by more than thirty years, these two projects reflect a maturing style that discloses much about the personality of their designer. The site for the earlier project in the mountains of North Carolina, surrounded by protective forest, met Cheek's underlying need of establishing a safe haven for his family during World War II. In contrast, Skylark Farm, on which work began in the early 1970s, sits confidently atop a virtually treeless mountaintop in Virginia's Blue Ridge Mountains. Its placement reflects the self-assurance of a man who had reached the pinnacle of professional achievement.

In keeping with his Beaux-Arts training in architecture at Yale, Cheek envisioned these projects as totalities, drawing at the outset comprehensive master plans for each. These schemes guided subsequent work that proceeded in stages over a period of years. In due course Faraway Farm, owned by the Cheeks from 1941 to 1955, evolved to match in virtually every detail the original plan. Mounting costs for upkeep and the long trip from Richmond to Lake Lure, North Carolina, finally forced the growing family to sell the farm. With Skylark, unfortunately, Cheek was compelled by declining health to abandon at midstream his overly ambitious program that called for, among other things, a large, three-and-a-half storey mansion to crown his mountaintop retreat.

Despite the different stages of completion that the two farms attained, each is nevertheless rich with trademarks of Leslie Cheek's career as architect: an unremitting attention to detail, the quest for comfort and convenience, and a yearning for designs that are at once functional and handsome. Both projects were attempts—largely successful—to create self-contained communities. Faraway supplied its own farm and dairy products, as well as its water and electricity. Skylark was to be supported by the cultivation and harvesting of Christmas trees. The openness of Cheek's designs, particularly his use of floor-to-ceiling windows at both farms, dramatize the mountain scenes. The eye is always led outward so that the house becomes one with its surroundings. Both of these houses reflect Cheek at his best in harmonizing structures with their settings through sensitive handling of materials, textures and orientation.

This view of the Living-Dining Room was painted in the late 1940s by David Payne, a friend of the family, and guest at Faraway Farm in mountainous western North Carolina.

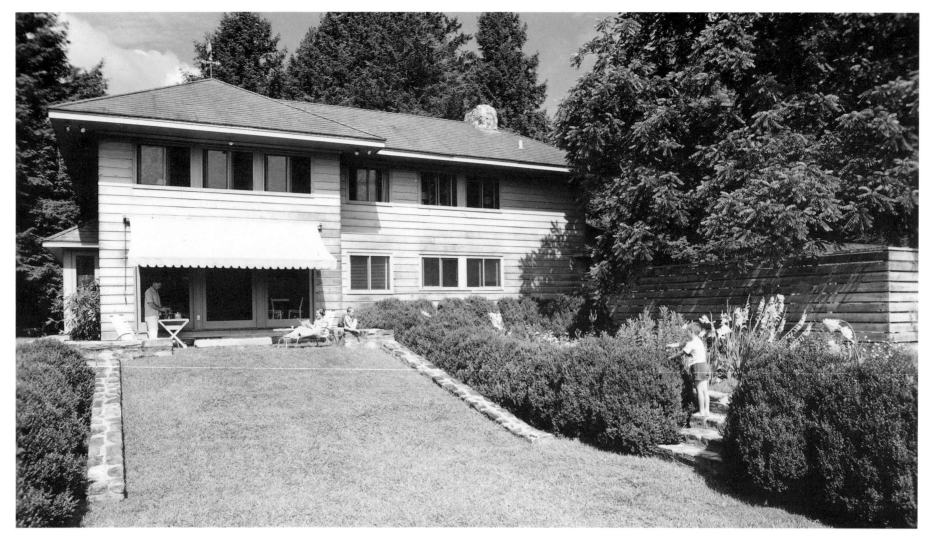

Cheek wistfully refers to Faraway Farm as his "Frank Lloyd Wright house." The wide overhang, the use of materials native to the site, the horizontality of the complex, and the graceful accommodation of land and structure reveal unmistakable Wrightian influences. **ABOVE:** The east facade of the main house at Faraway Farm in Lake Lure, North Carolina. The sloping lawn separating flower and vegetable gardens leads to the barns and upper pasture. **RIGHT:** The west facade of the main house with automobile turn court in the foreground

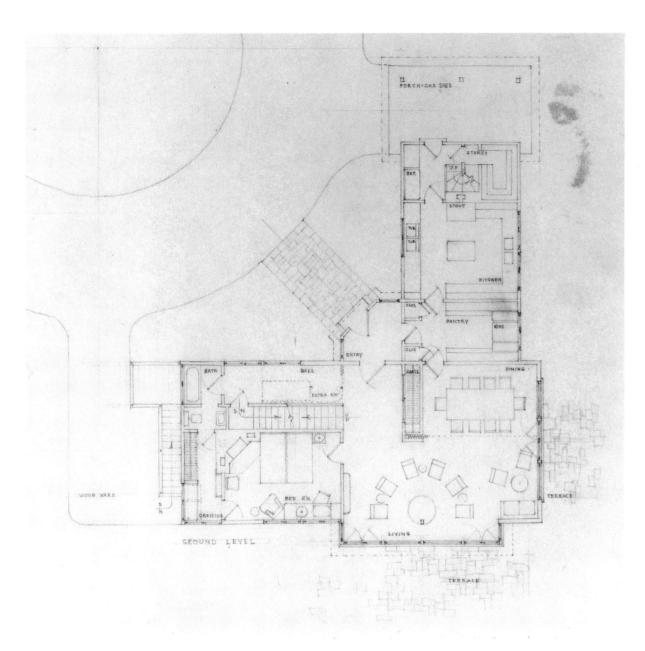

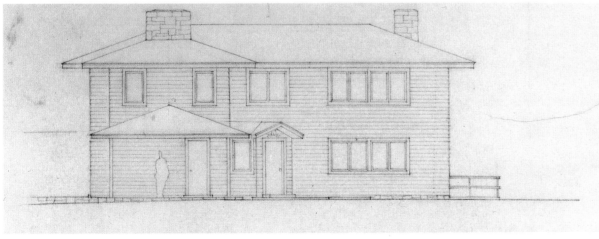

First floor plan and north elevation of the main house
at Faraway Farm (1941)

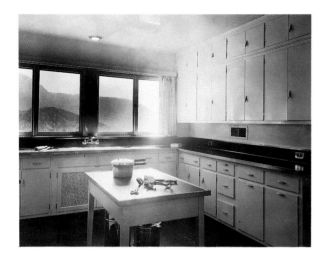

ABOVE: Few kitchens have a view as breathtaking as the one seen through these windows at Faraway Farm. The Cheek family retreat was built in the early 1940s on an isolated mountainside near the village of Lake Lure, North Carolina.

RIGHT: Plan for the upper level (1941)

BELOW RIGHT: The Living-Dining Room. Cheek's choice of furniture for the house was influenced by *Organic Designs in Home Furnishings*, an exhibition circulated by the Museum of Modern Art with contemporary interior designs that he presented at the Baltimore Museum in 1942. It included the work of Charles Eames, Donald Deskey, Alvar Aalto and other prominent designers. The sliding glass doors open onto the terrace overlooking Buffalo Creek.

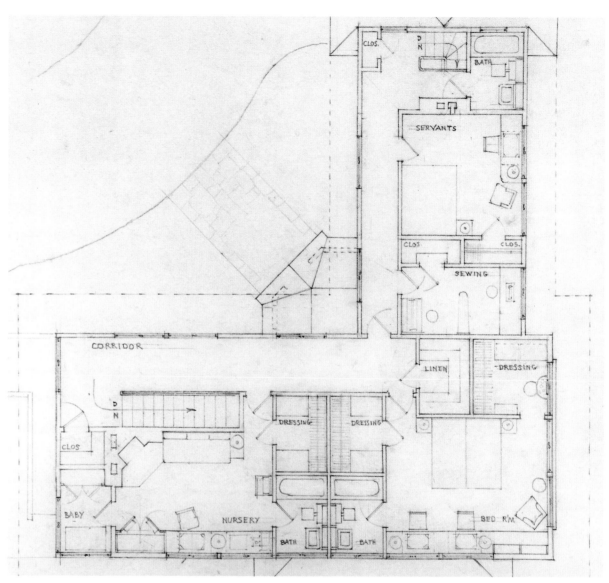

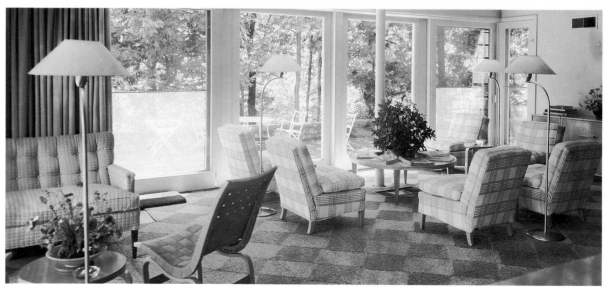

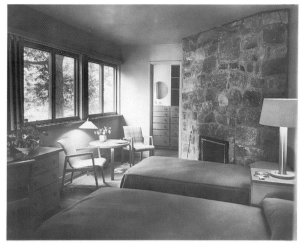

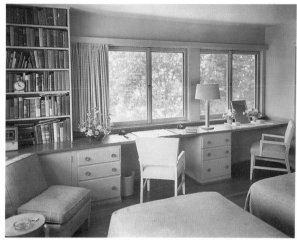

TOP: This first-floor Guest Room served as a cozy family sitting room in cold weather.

ABOVE: The Master Bedroom on the second floor, overlooking Buffalo Creek to the south and over the gardens to Magnolia Mountain to the east.

LEFT: On the south side of the main house this stone terrace overlooked the clear waters of Buffalo Creek, tumbling over large rocks on its way down the mountain to Lake Lure.

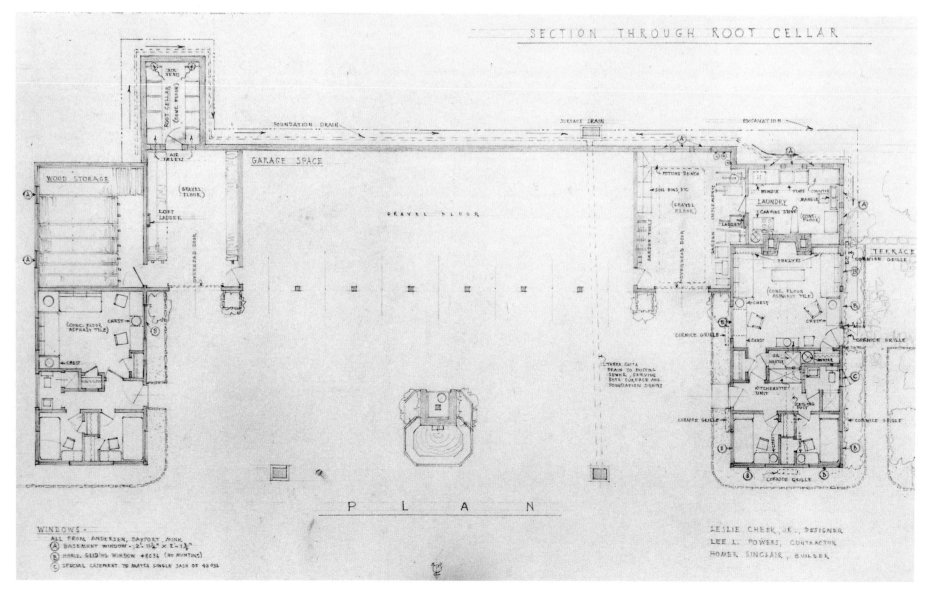

North elevation, guest house (circa 1940). The servant and guest wings are separated by an eight-port vehicle and equipment shed.

Detailed floor plans for servants rooms and guest quarters at Faraway Farm

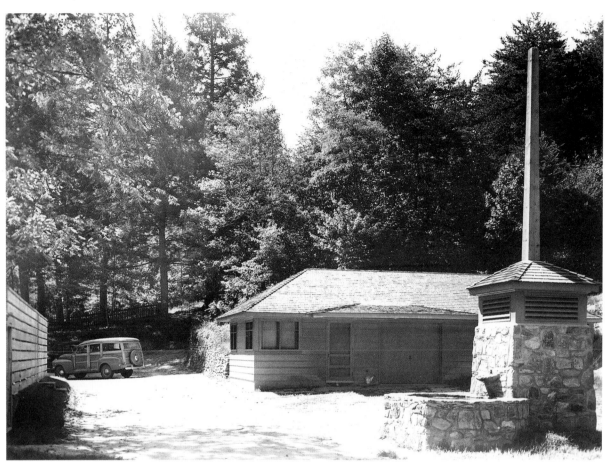

This photograph was taken shortly after the completion of the first phase of the guest house addition at Faraway. Two rooms and bath for servants were later joined by a vehicle shed in an east wing of guest rooms. In the foreground is a gasoline pump cleverly disguised as a water fountain and trough for horses. The main farm house is at left.

This drawing for the gasoline-water pump shows the weather vane with rooster that Mabel Cheek gave Leslie; the decorative finial was never used.

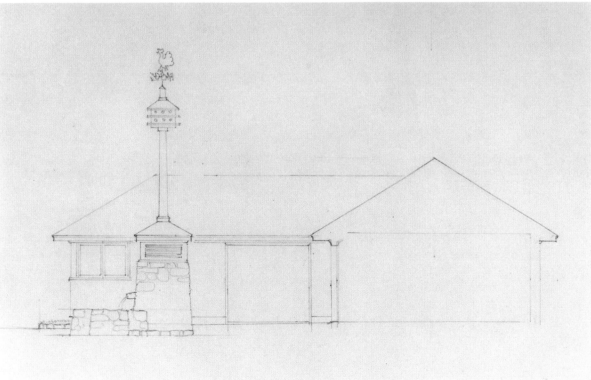

ABOVE: The barn and equipment sheds were east of the main farm house.

RIGHT: The Cheek boathouse on tranquil Lake Lure was the center of family activity in good weather. During her first summer at the farm, Mary Tyler had to travel five miles in the Chris Craft to the town of Lake Lure for milk and to pick up the mail. The tiny shorefront hamlet was the only place she could use a telephone. Faraway Farm had no telephone until 1943, when Leslie and friends laid an insulated cable beneath the Lake.

FAR RIGHT: In 1940 Leslie drew this plan—later abandoned—for a larger Community Beach House.

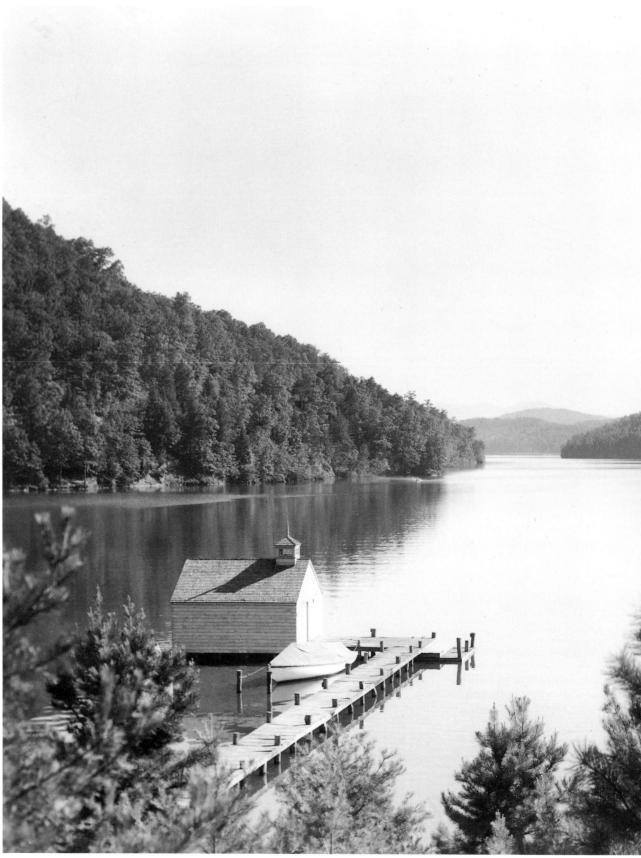

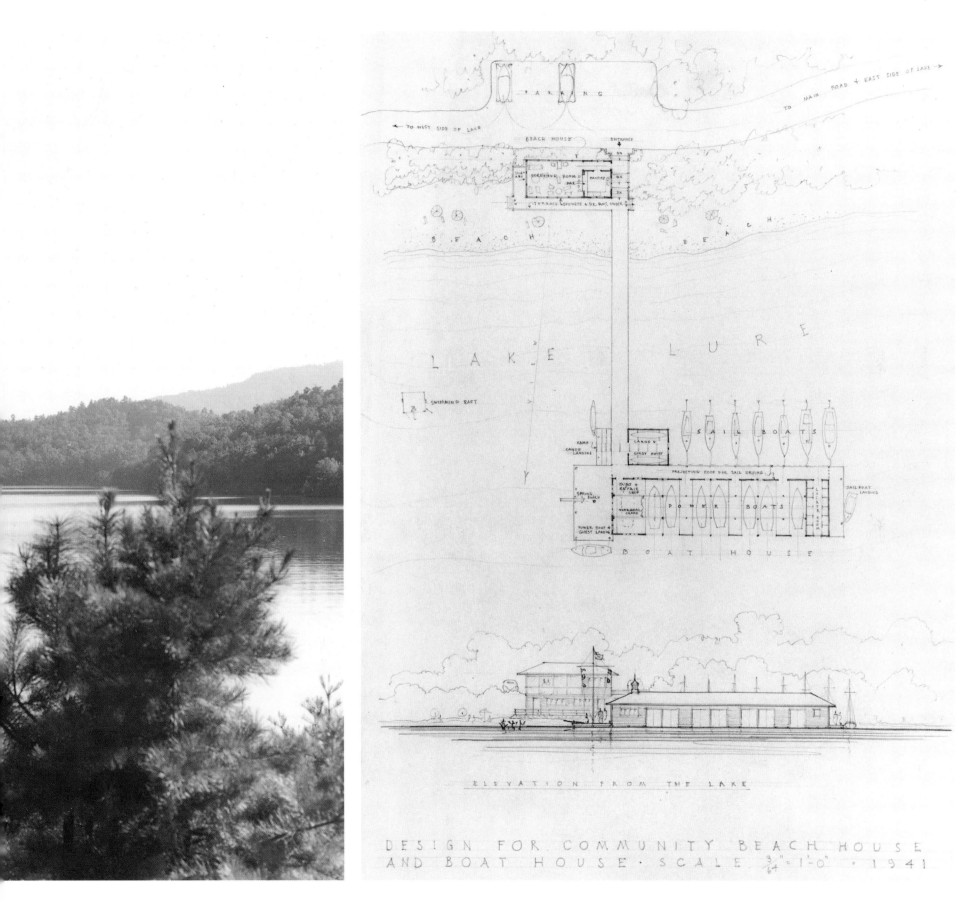

DESIGN FOR COMMUNITY BEACH HOUSE
AND BOAT HOUSE · SCALE 3/64"=1'-0" · 1941

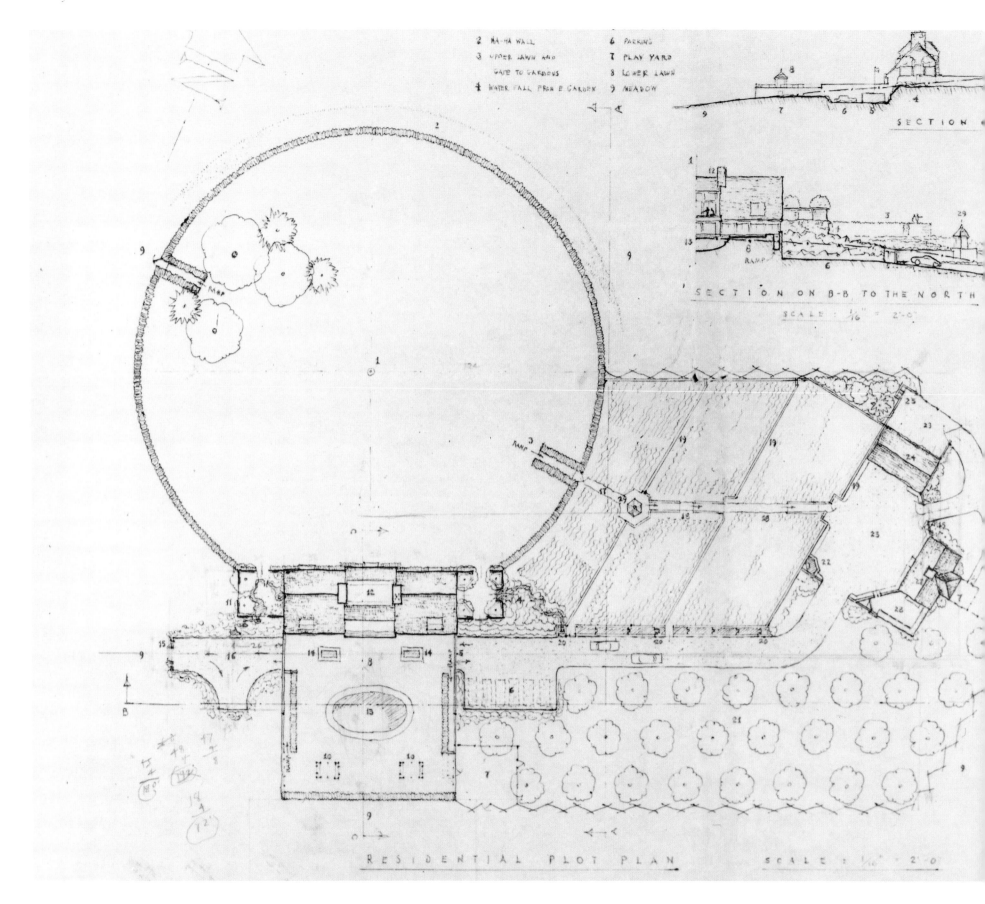

2 HA-HA WALL
3 UPPER LAWN AND
 GATE TO GARDENS
4 WATER FALL FROM E. GARDEN

6 PARKING
7 PLAY YARD
8 LOWER LAWN
9 MEADOW

SECTION

SECTION ON B-B TO THE NORTH

SCALE : 1/16" = 2'-0"

RESIDENTIAL PLOT PLAN

SCALE : 1/16" = 2'-0"

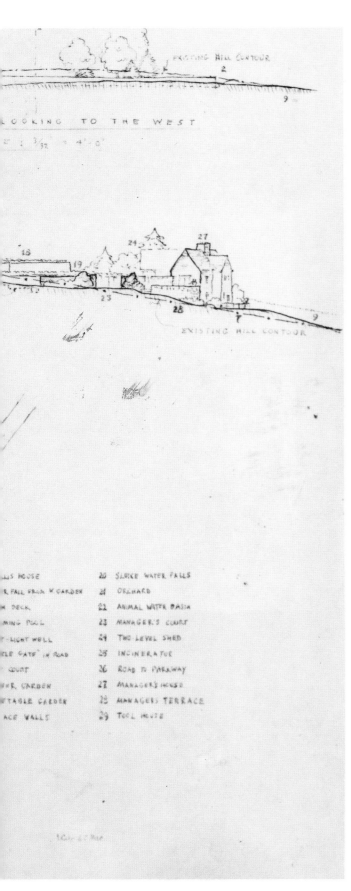

Residential Plot Plan for Skylark Farm (1967). The Manager's House and related service buildings were completed, but the Big House to the west was never built. This large, 3-½ storey house would have dominated "Round Top," the 3,300-foot mountain that is the second-highest point on the farm. From Round Top one can see into Virginia's neighboring states, West Virginia and Tennessee.

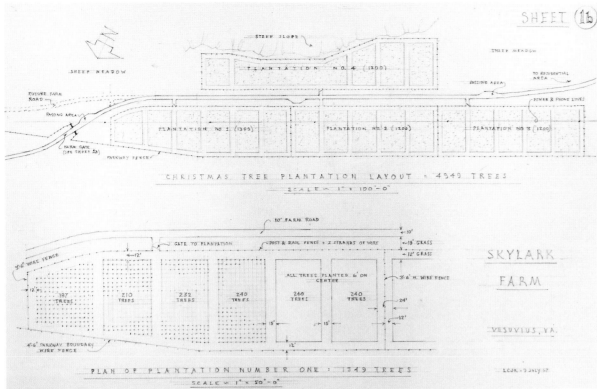

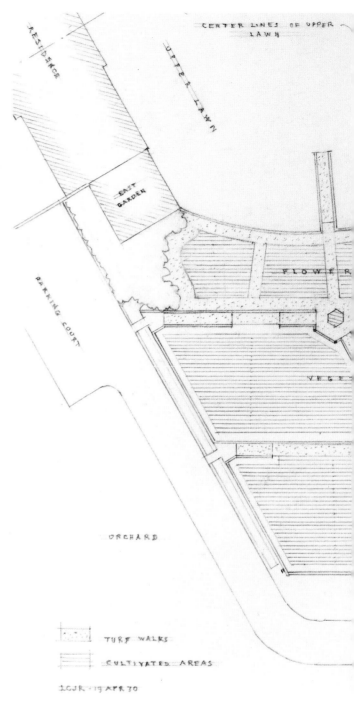

ABOVE: Cheek's layout for Christmas tree plantations at Skylark Farm. Because the farm is some 3,000 feet above sea level, it is ideal for the cultivation of Fraser Fir, a popular tree among consumers.

RIGHT: Cheek's detailed plans called for wooden signs styled after those used by the Park Service on the nearby Blue Ridge Parkway (1969, 1972).

FAR RIGHT: A series of three terraced gardens was to have separated the proposed Big House (upper left) and the Manager's Court complex (lower right). The hexagonal structure between the flower and vegetable gardens was to have been an open-air gazebo topped by a clock (1970). Skylark was to have been completed in two phases. Phase I comprised the Manager's House, the "Tenant's"—or Guest—House, a vehicle shed and stable. Phase II would have seen construction of the Big House. Only the first phase of the project was realized in the early 1970s.

OPPOSITE PAGE: Manager's House, east elevation (1968). When it became necessary to delay indefinitely the building of the Big House, the Manager's House was redesigned for family use. The sloping site readily lent itself to two storeys of family accommodations on the upper west level and to an apartment for the manager on the lower east side.

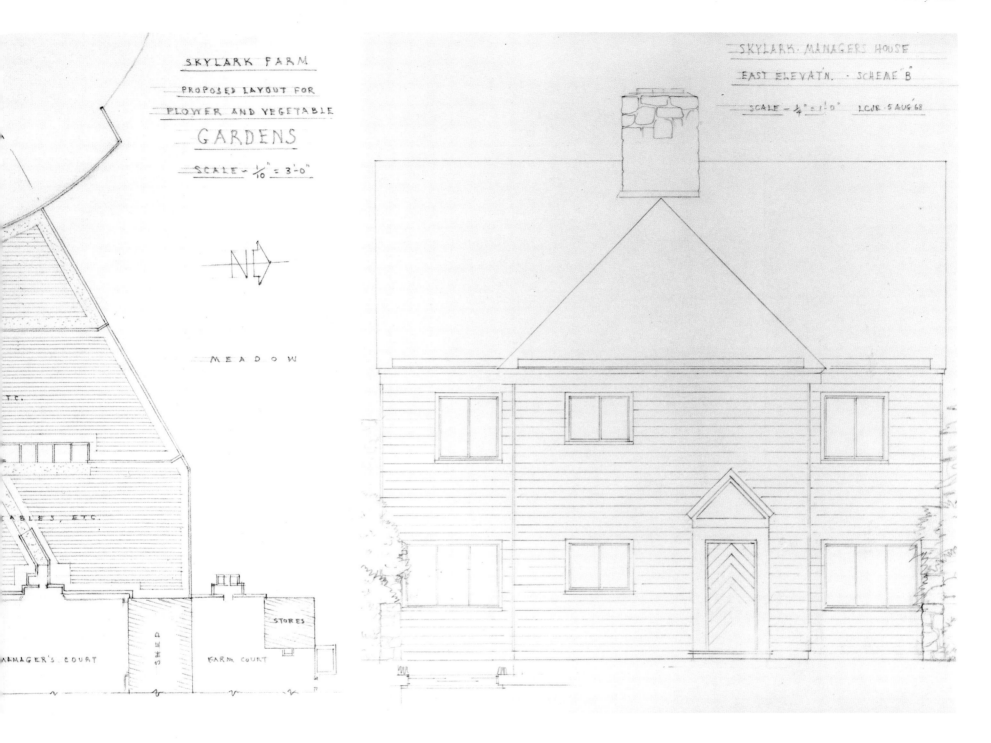

SKYLARK FARM

PROPOSED LAYOUT FOR

FLOWER AND VEGETABLE

GARDENS

SCALE - $\frac{1}{10}$" = 3'-0"

N

MEADOW

STORES

SHED

MANAGER'S COURT

FARM COURT

SKYLARK · MANAGERS HOUSE

EAST ELEVAT'N. · SCHEME 'B'

SCALE - $\frac{1}{4}$" = 1'-0" LCJR · 5 AUG '68

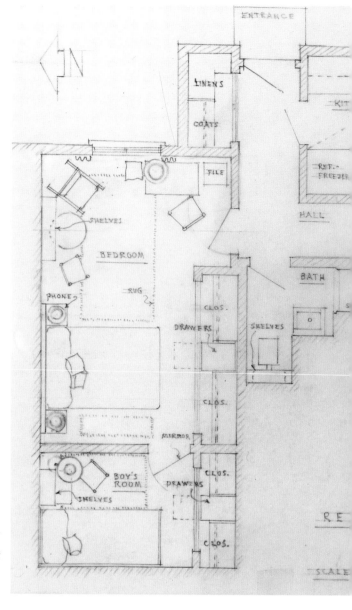

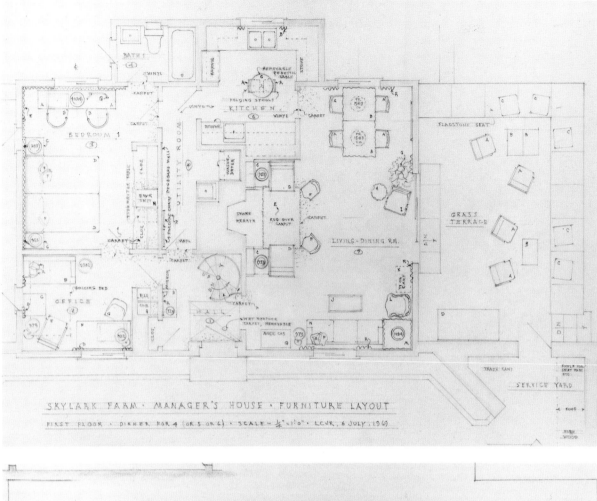

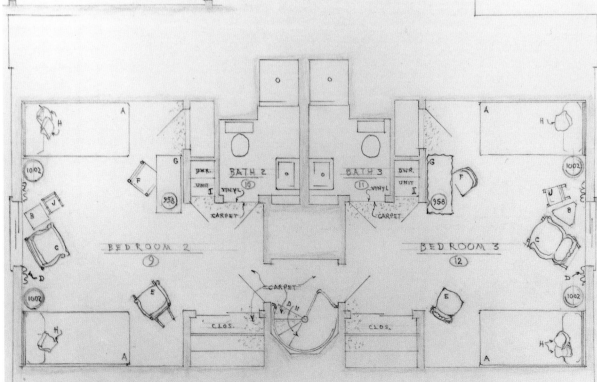

ABOVE LEFT: Cheek's furniture layout for the first floor of the Manager's House (1969)

LEFT: Furniture plans for the two bedrooms on the top or second floor of the Manager's House (1969)

ABOVE: Furniture plans for the Resident Manager's Apartment (1970)

RIGHT: The owners' Kitchen in the Manager's House was provided with special cabinets for keeping meal service on trays (1969). Cheek's design was inspired by food handling methods used on commercial airlines.

FAR RIGHT: The Manager's House at twilight

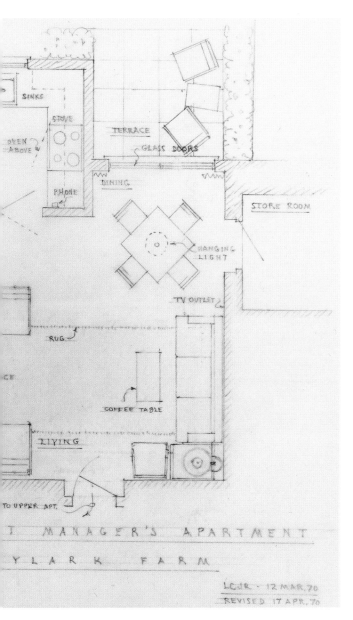

SINKS

STOVE

OVEN ABOVE

PHONE

TERRACE

GLASS DOORS

DINING

STORE ROOM

HANGING LIGHT

TV OUTLET

RUG

COFFEE TABLE

LIVING

TO UPPER APT.

MANAGER'S APARTMENT

YLARK FARM

LCJR · 12 MAR. 70
REVISED 17 APR. 70

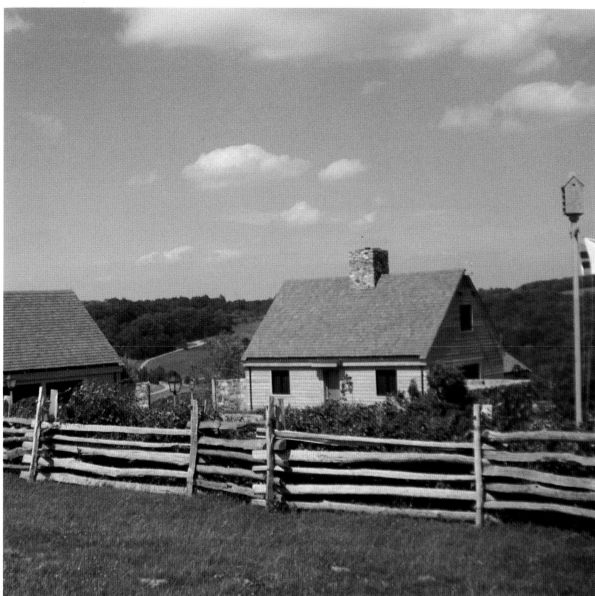

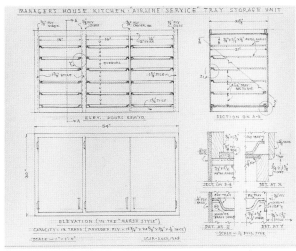

MANAGERS HOUSE KITCHEN "AIRLINE SERVICE" TRAY STORAGE UNIT

ELEV. DOORS REM'VD.

SECTION ON A-A

ELEVATION (IN THE "MARSH STYLE")

SECT. ON B-B

DET. AT X

DET. AT Z

DET. AT Y

CAPACITY: 96 TRAYS (MOULDED PLY. 13¾" x 7⅝" x 7½" x ⅛" THICK)

SCALE = 1" = 1'-0" LCJR · 1 OCT. 1969 SCALE = ⅜ FULL SIZE

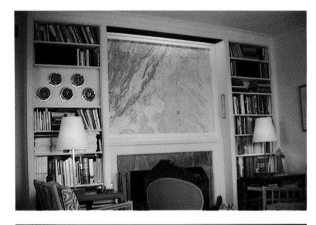

TOP: A contour map of Virginia hangs above the hearth in the Living Room of the Manager's House. The instruments at left indicate outside temperature, barometric pressure, and wind velocity and direction.

ABOVE: The sliding glass door leads from the Living Room to a small terrace on the south side of the Manager's House. A sheltering wall creates a sun-pocket on windy days.

RIGHT: Cheek's sketch with specifications for stone-work in the Living Room on the family's level (1968)

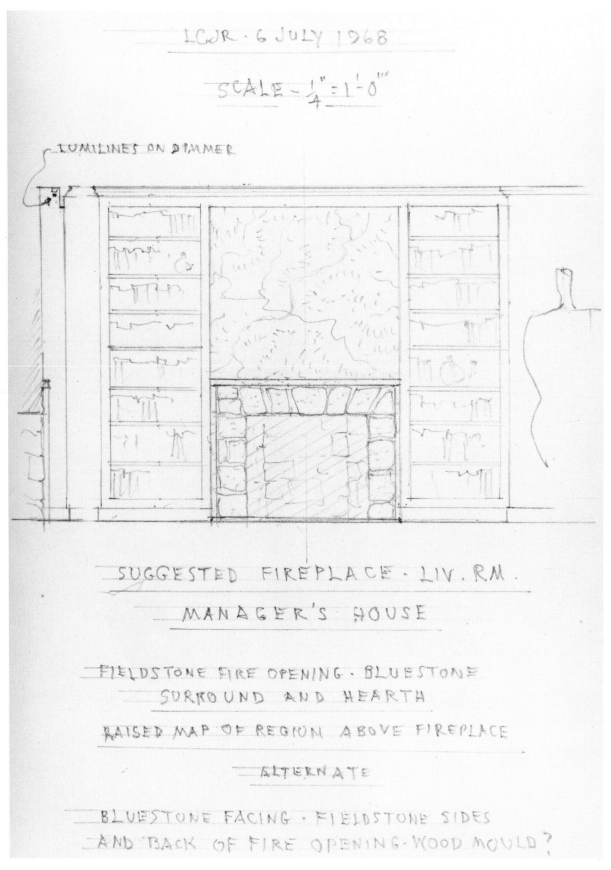

LCJR · 6 JULY 1968

SCALE - $\frac{1}{4}$" = 1'-0"

LUMILINES ON DIMMER

SUGGESTED FIREPLACE · LIV. RM.

MANAGER'S HOUSE

FIELDSTONE FIRE OPENING · BLUESTONE SURROUND AND HEARTH

RAISED MAP OF REGION ABOVE FIREPLACE

ALTERNATE

BLUESTONE FACING · FIELDSTONE SIDES AND BACK OF FIRE OPENING · WOOD MOULD?

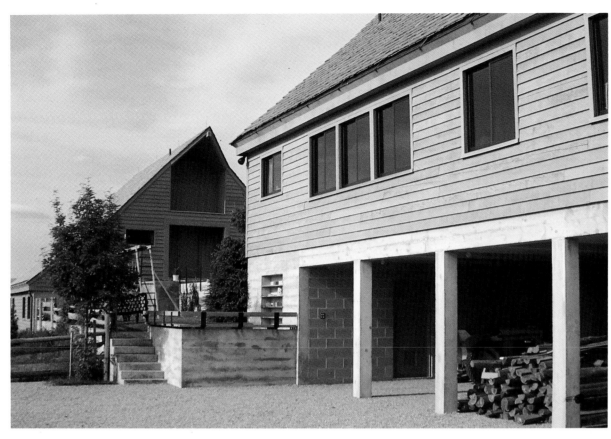

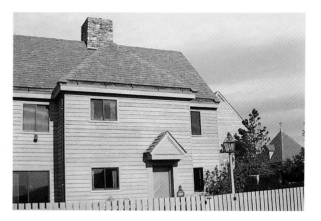

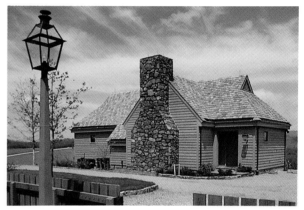

TOP: A view of the Manager's House seen from the southeast

ABOVE: The "Tenant's" (or Guest) House viewed from the west. Washington and Lee University will soon expand this structure to accommodate more comfortably many conferences and seminars.

ABOVE LEFT: The "Tenant's House" (right) with lower level Vehicle Shed. At left is the new Manager's House, the final structure the Cheeks completed when they lived at Skylark Farm.

LEFT: Manager Lowell Humphreys walks toward Round Top where the Big House was to have been built. Behind him are the Vehicle Shed (left) and Manager's House.

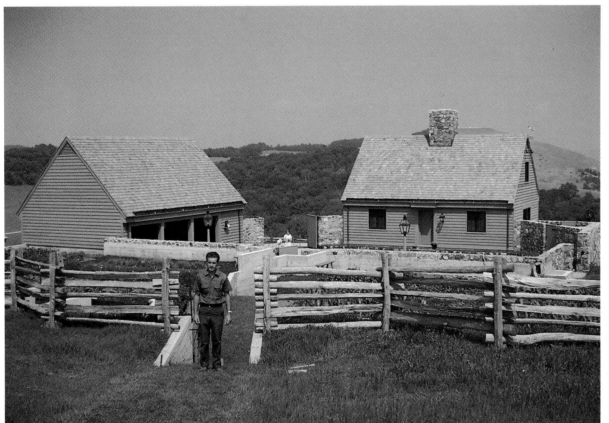

ABOVE: This design for the first-floor sound system in the Manager's House details wiring and locations for stereo speakers (1969).

LEFT: Plans for the Kitchen in the Resident Manager's Apartment (1968)

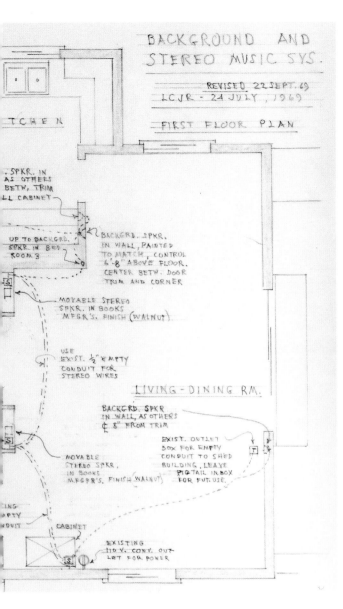

LEFT: East and west elevations, "Tenant's House" (1971). Today, this building—now appropriately called the Guest House—is used regularly for academic conferences and seminars by Washington and Lee University. The Cheeks gave the farm to the University in 1977 in honor of Mrs. Cheek's father, Douglas Southall Freeman.

BELOW: Resolved to hold to his vision of a simple mountain farm, Cheek called the Guest House built in 1971 the "Tenant's House." A sectional drawing for the "Tenant's House" at Skylark Farm (1971). Open space beneath shelters automobiles and equipment.

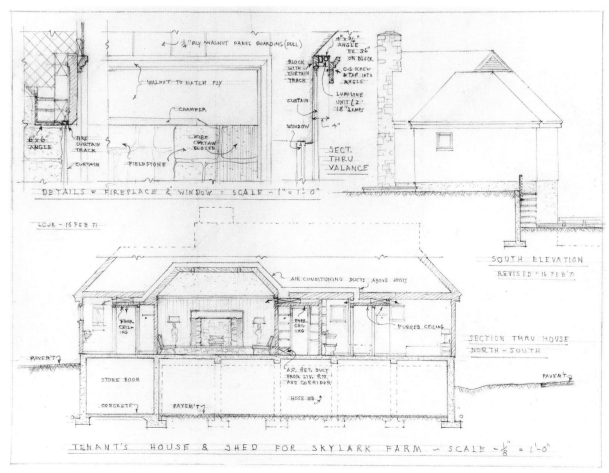

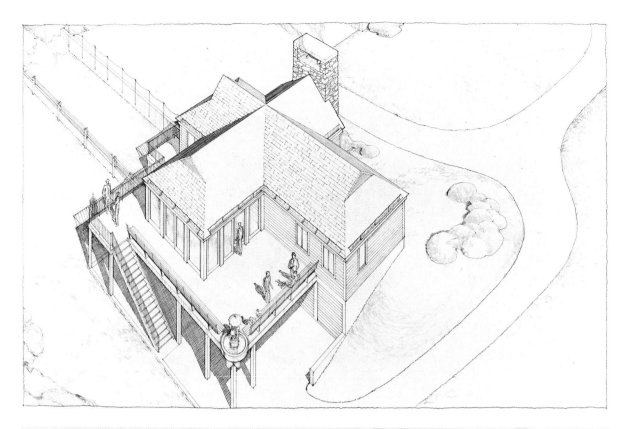

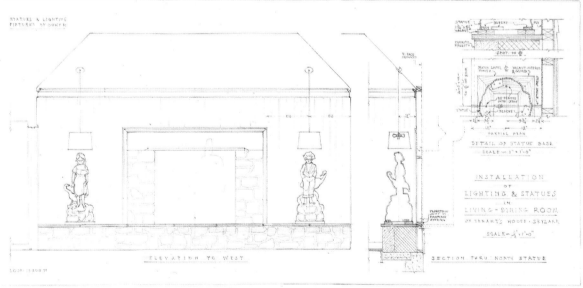

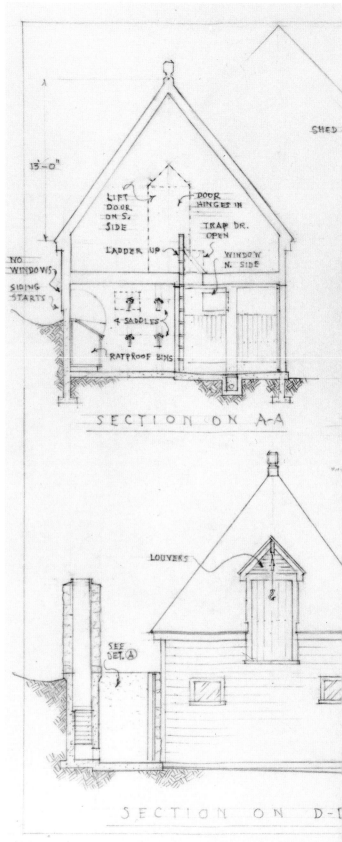

TOP: The "Tenant's House" will be enlarged by Washington and Lee University in the future to include additional meeting space and sleeping quarters. (Rendering by Robert W. Stewart.)

ABOVE: Details for lighting and the placement of sculptures near the hearth in the "Tenant's House" (1971)

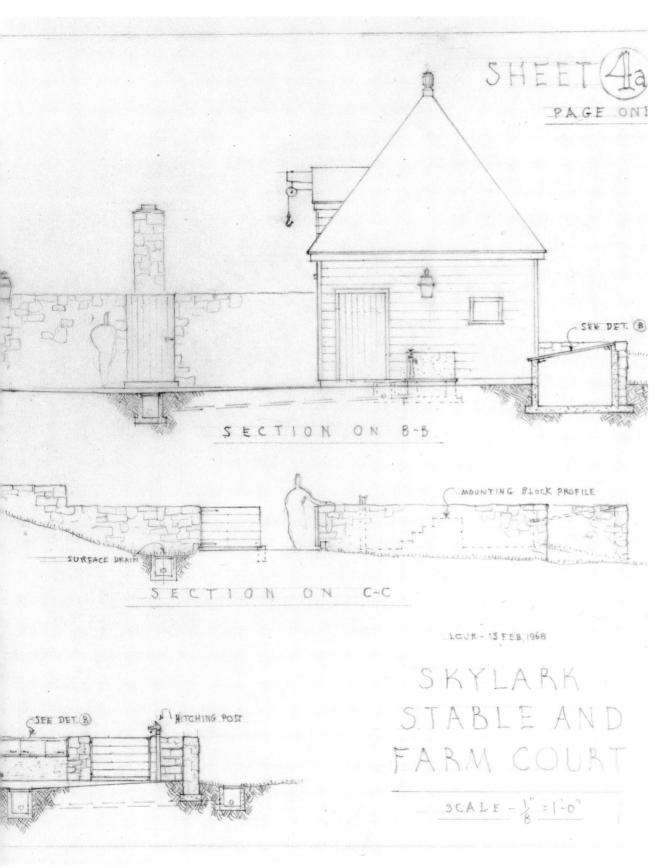

SHEET 4a
PAGE ON1

SECTION ON B-B

MOUNTING BLOCK PROFILE

SURFACE DRAIN

SECTION ON C-C

SEE DET. B

HITCHING POST

LCJR - 13 FEB. 1968

SKYLARK
STABLE AND
FARM COURT

SCALE - $\frac{1}{8}$" = 1'-0"

SEE DET. B

ABOVE: This pencil sketch of a stable for Skylark Farm was executed by Cheek during an ocean voyage. In the late 1960s and early 1970s he spent many quiet hours on these annual trips laboring over drawings for his mountain-top retreat.

LEFT: Sectional drawings for the stable (1968)

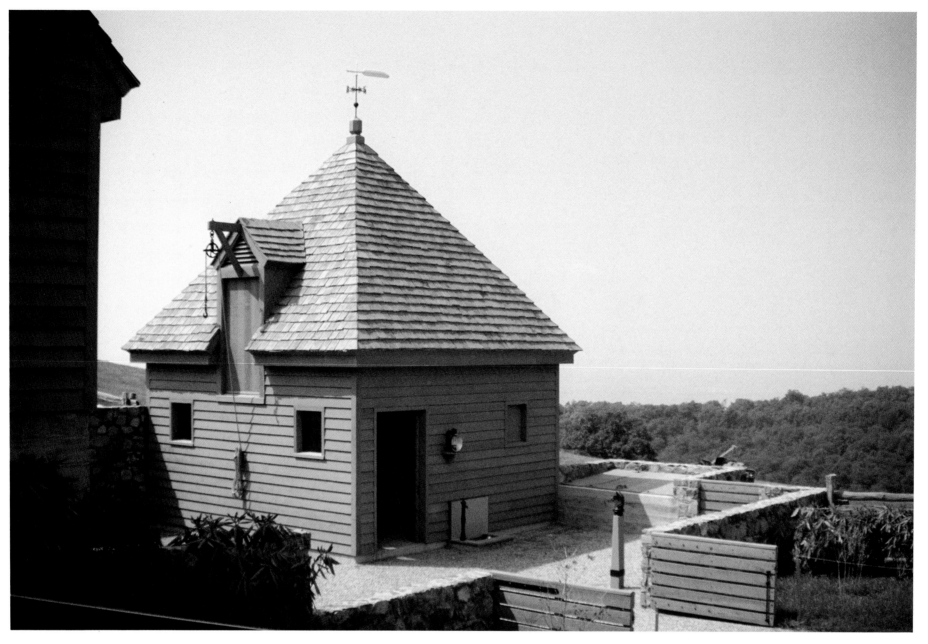

ABOVE: The stable viewed from the southeast

RIGHT: This Martin House with flagpole stands today in the southwest corner of the Manager's Court (1968). Unfortunately, the elevation of the farm is too high for martins, but the bird house remains an amusing finial for the flagpole.

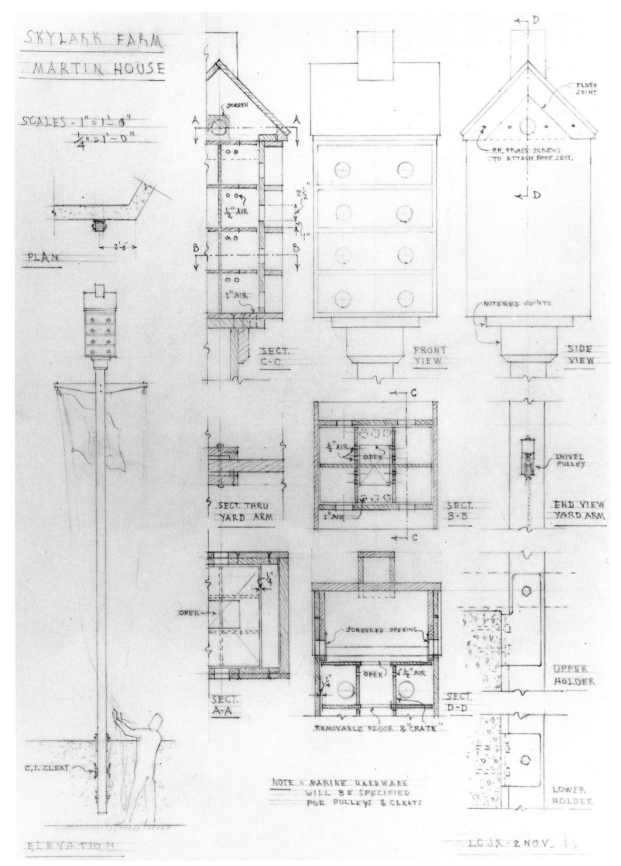

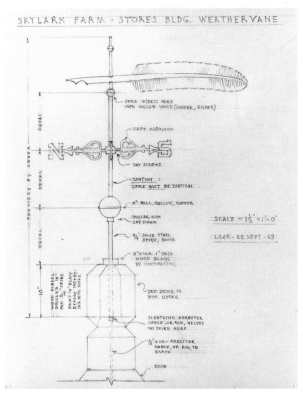

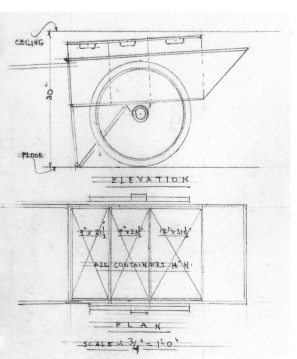

TOP: A weathervane for the Vehicle Shed (1969)

ABOVE: Cheek's drawing of a push cart (1972) for hauling leaves, fieldstones or refuse. These were designed to fit into special storage spaces in the Vehicle Shed.

183

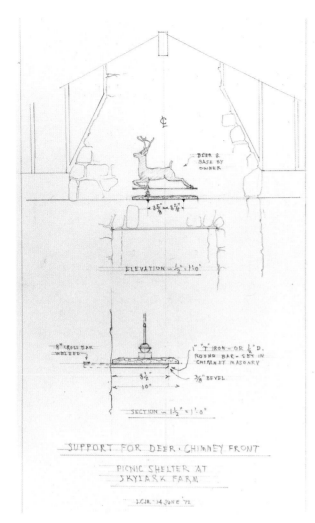

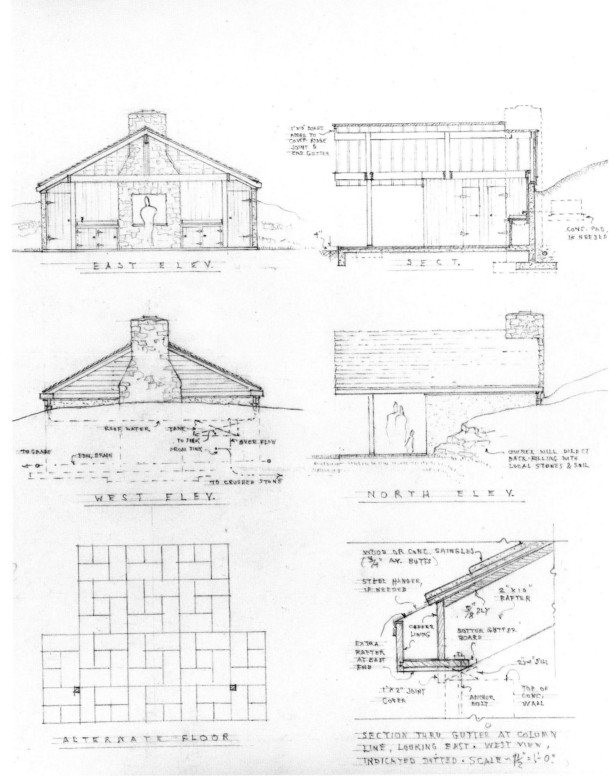

ABOVE: A passion for detail is apparent in Cheek's plan for the hearth with an appropriate deer ornament for the picnic shelter at Skylark (1972).

RIGHT: Plans for a picnic shelter (1971) included specifications for the pattern of floor stones. A tennis court, pond and trails were added when the shelter was built in the early 1970s.

OPPOSITE PAGE: Some of Cheek's preliminary sketches for the Big House (circa 1967)

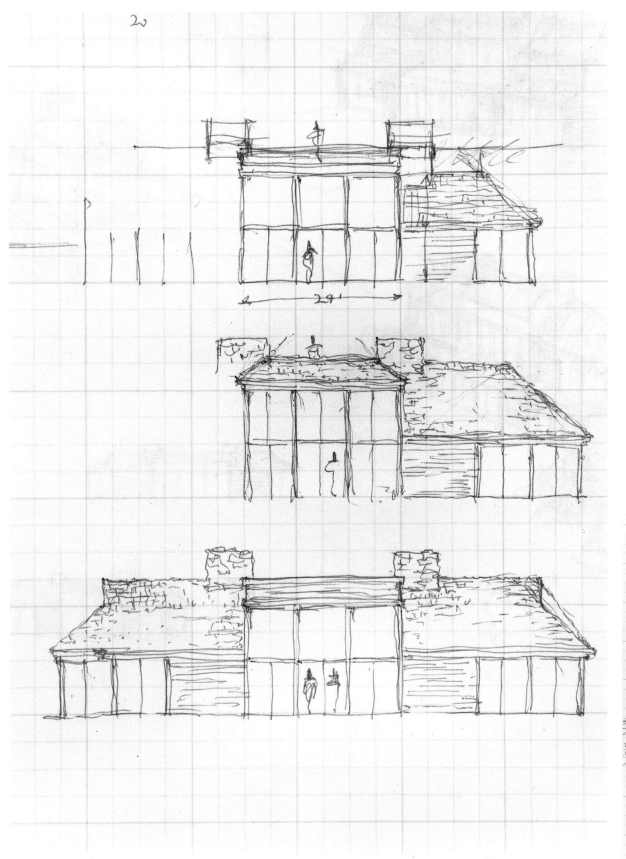

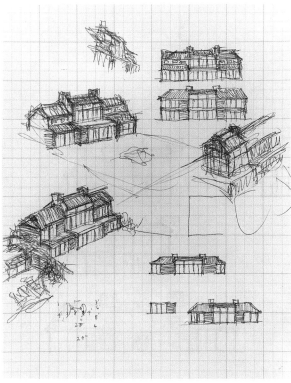

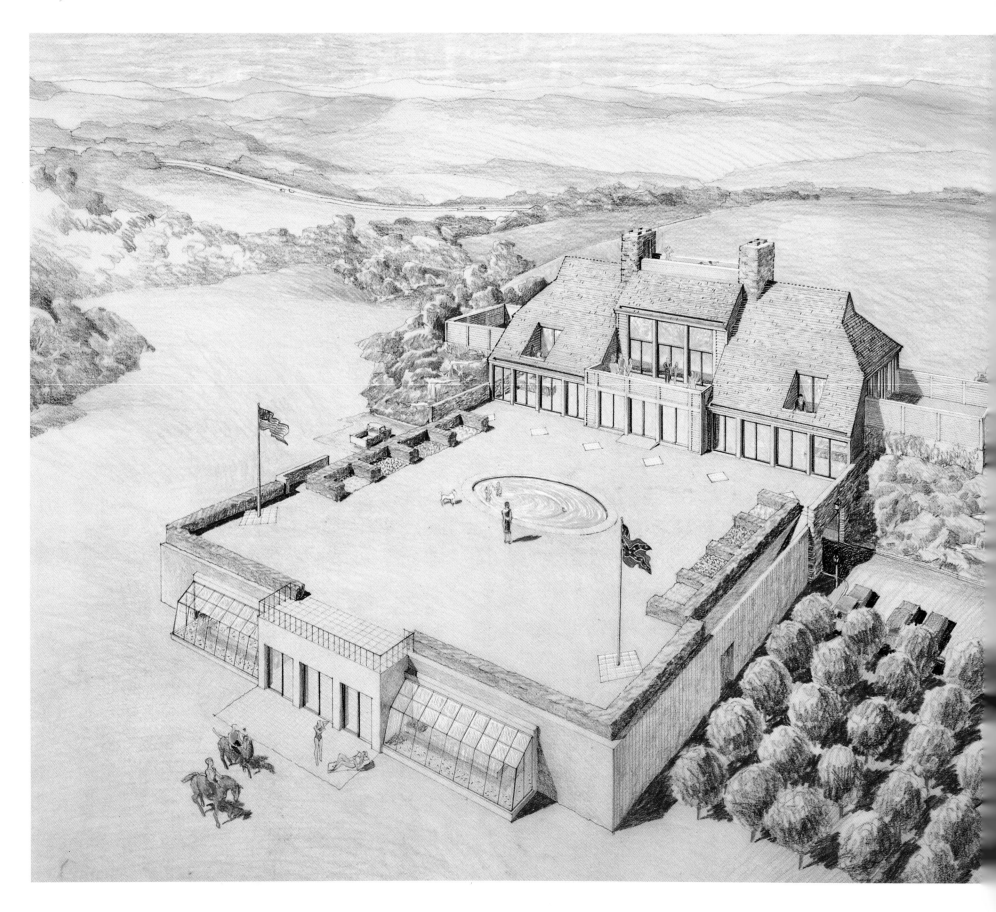

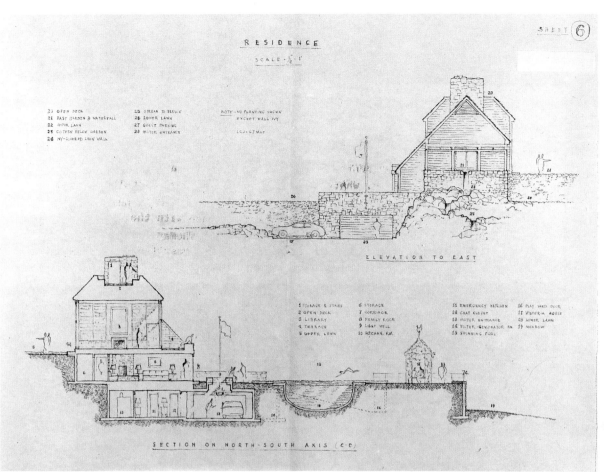

RESIDENCE
SCALE

ELEVATION TO EAST

SECTION ON NORTH-SOUTH AXIS (C-C)

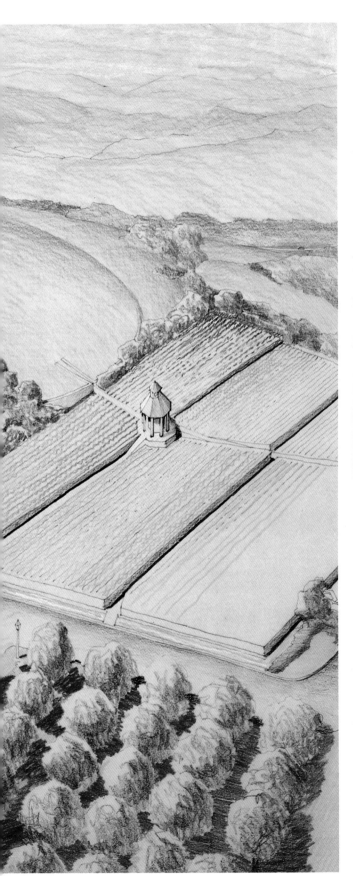

ABOVE: Early plans for the Lower Terrace and Motor Shelter for the Big House (1969). One version included a below-ground pool with ceiling open to the sky. Subsequent plans by Thomas Craven completely enclosed the pool in a glass-walled gallery on the south side of the house.

LEFT: The proposed Big House as seen from the south. The path through the garden (right) was to be an approach to the Manager's Court complex. A swimming pool was to have been in an underground chamber behind the glass in the foreground (center left), protected from the strong winds that swept Cheek's mountaintop retreat. The diamond-shapes set in the South Lawn represent skylights. (Drawing by Robert W. Stewart.)

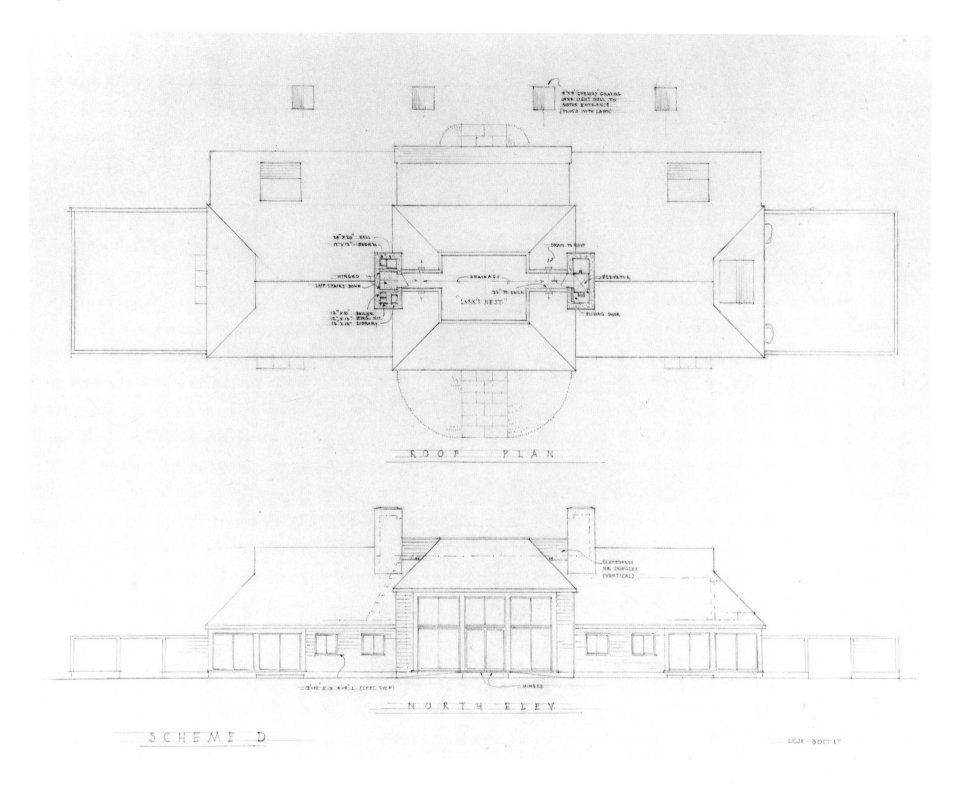

ROOF PLAN

NORTH ELEV

SCHEME D

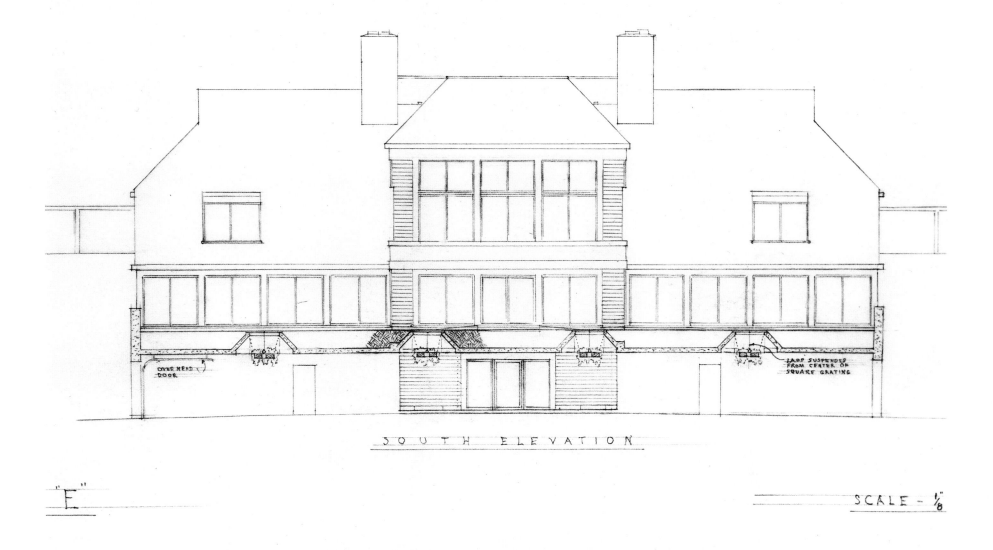

SOUTH ELEVATION

"E"

SCALE - 1/8"

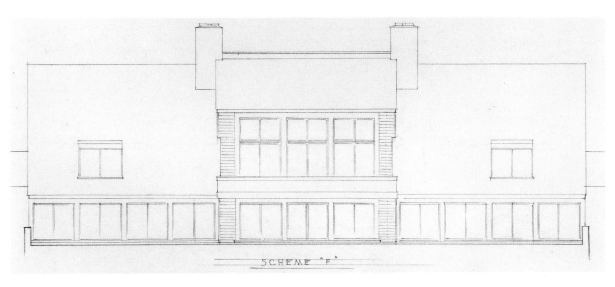

SCHEME "F"

FAR LEFT: "Scheme D" for the Big House was among several versions for the large dwelling that evolved on Cheek's drawing board (1967).

ABOVE: Cheek's "Scheme E" featured a series of octagonal skylights that were to have brightened the below-ground Motor Shelter. In Thomas Craven's modified plans, a second row of identical skylights was placed parallel above an underground swimming pool.

LEFT: "Scheme F," executed a year prior to Cheek's retirement from the Virginia Museum in 1968, appears to have formed the basis for architect Thomas Craven's final designs for the project. Craven's plans would have been followed by contractors had not illness forced Cheek to abandon the Big House.

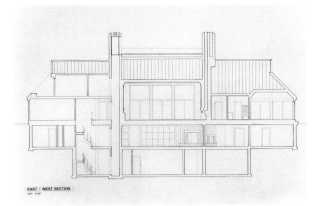

ABOVE AND RIGHT: Sectional views of the Big House by Robert Stewart. A spiral stairway and elevator would have connected the four levels.

BELOW: A sketch for food carts to have been used in the Big House (circa 1970). Meals could have been stored and kept warm in these carts, which would have been wheeled onto the elevator and taken to any room in the Big House.

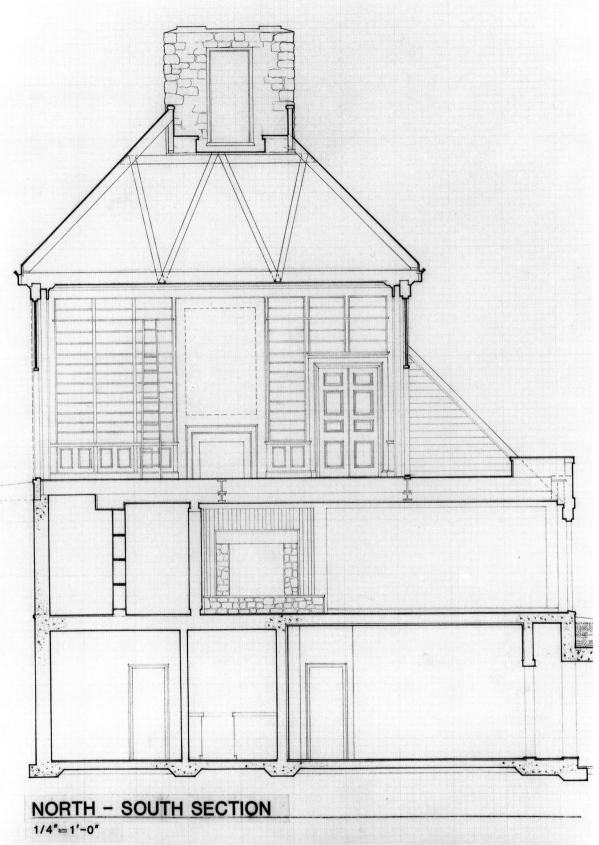

NORTH – SOUTH SECTION

1/4" = 1'-0"

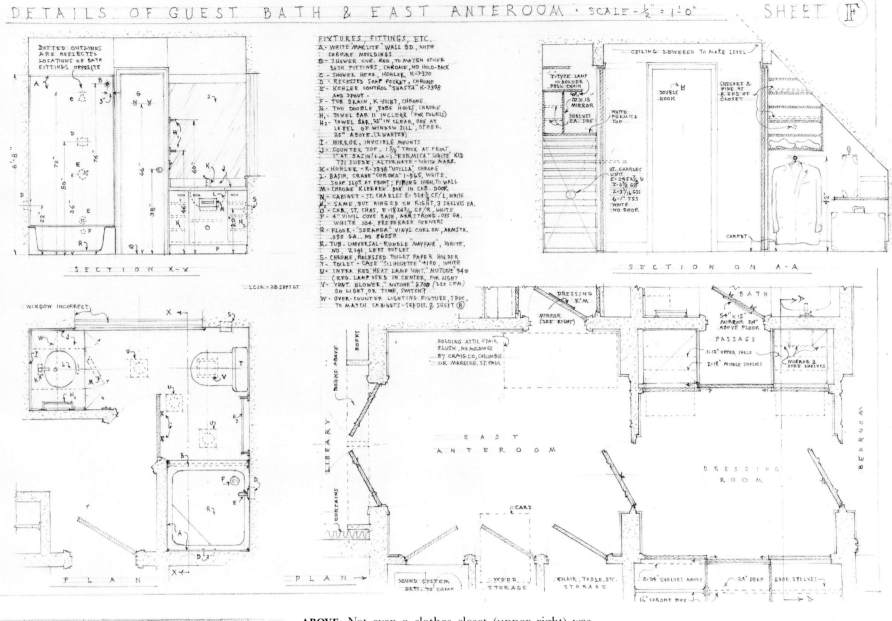

DETAILS OF GUEST BATH & EAST ANTEROOM · SCALE - ½" = 1'-0" SHEET F

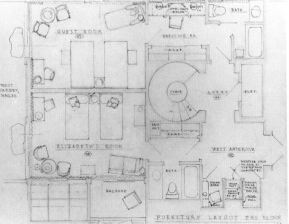

ABOVE: Not even a clothes closet (upper right) was overlooked in the dozens and dozens of plans Cheek prepared for his mountain-top Big House (1967). This storage space would have been part of the Guest Bedroom, in the west wing of the house.

LEFT: An early version of daughter Elizabeth's bedroom and the Guest Room in the west wing of the Big House. Both would have shared a small, Japanese-style garden. The circular stairway was to connect three of the four levels of the house. The doorway at lower right connected the West Anteroom with the high-ceilinged Library.

RIGHT: The Cheeks at Skylark Farm in 1975

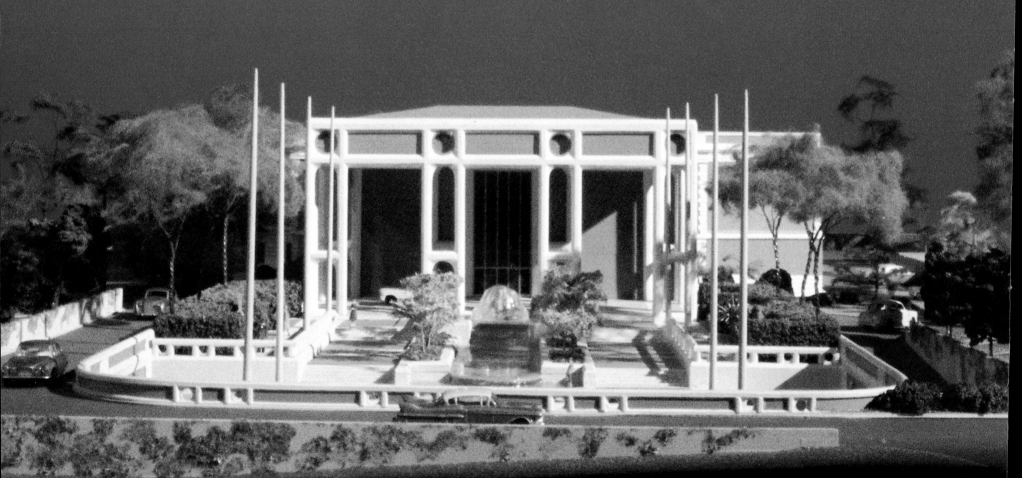

CHAPTER IX

Places for Learning

The north facade of the proposed Entrance Wing at
the Virginia Museum overlooked a sculpture garden
that was to have been placed below grade.

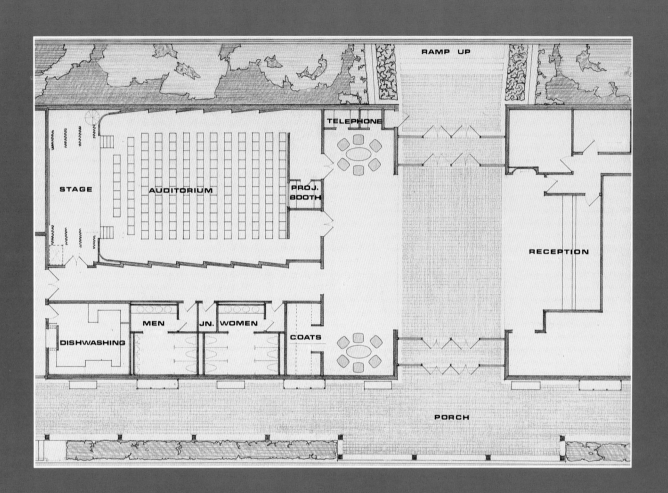

Chapter II discussed the interpretive techniques Cheek employed to give museumgoers brief but informative lessons in art and cultural history. His preoccupation with education helped him transform the art museum from the preserve of a cultured few into a learning place for the general public.

Cheek's pronounced pedagogical bent has found expression in both museum and non-museum settings, though obviously more abundantly in museums. This chapter focuses on a selection of spaces with largely educational functions with which he was associated as either principal designer or consultant. His plans from the mid-1930s for the Fine Arts Department at William and Mary, and for the camouflage training center at Fort Belvoir in World War II constitute straightforward examples of designs for classrooms, studios and lecture halls.

Cheek's work on pavilions at two world's fairs, on visitors' centers at historic sites and on a special exhibition for the Museum of Modern Art are less direct, but nonetheless important, examples of his evolving concept of spaces in which the public could comfortably learn about history, culture and art.

Finally, the additions Cheek and his longtime associate Robert Stewart planned in the 1960s for the Virginia Museum are the consummation of his philosophy of museum management. The esthetically handsome and practical program for the Entrance Wing had as its central feature a reorientation of visitor traffic along a new axis of galleries organized in chronological order. The public was literally to walk through a museum-sized textbook of cultural history. Cheek labored nearly three years on this project only to see his efforts end in frustration and defeat. But the concept was brilliant, as were many of his innovative and often original ideas for places for learning.

In 1972 Cheek was aided by Robert Stewart in formulating plans (a detail from which is shown) for a visitors' center at Shakertown, near Harrodsburg, Kentucky. The plan was never realized due to a shortage of funds.

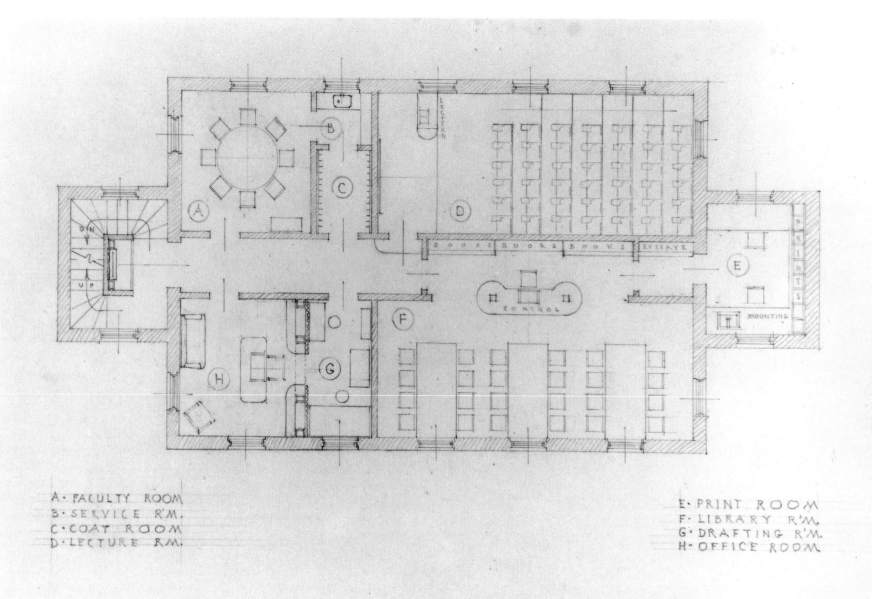

A· FACULTY ROOM
B· SERVICE R'M.
C· COAT ROOM
D· LECTURE R.M.

E· PRINT ROOM
F· LIBRARY R'M.
G· DRAFTING R'M.
H· OFFICE ROOM

° S U G G E S T E D · C H A N G E S ·
° S E C O N D · F L O O R ·
° S C A L E - ⅛" = 1'-0" ·

Cheek's plan for the redesign of the second floor of
the three-storey Taliaferro Building (1935). What had
once been a dormitory was transformed into modern
classrooms, studios and offices.

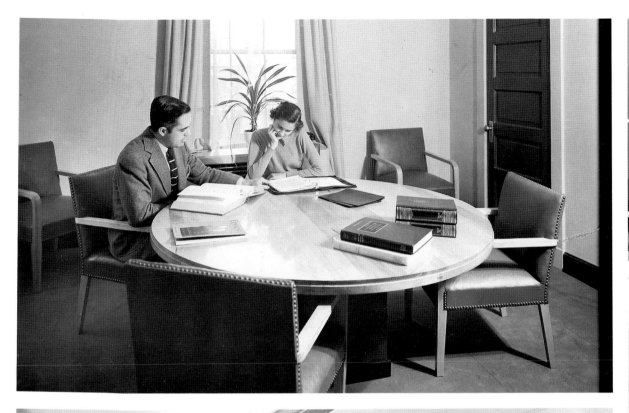

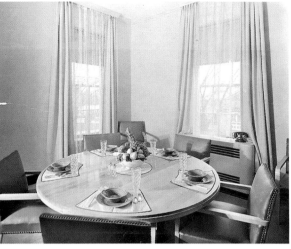

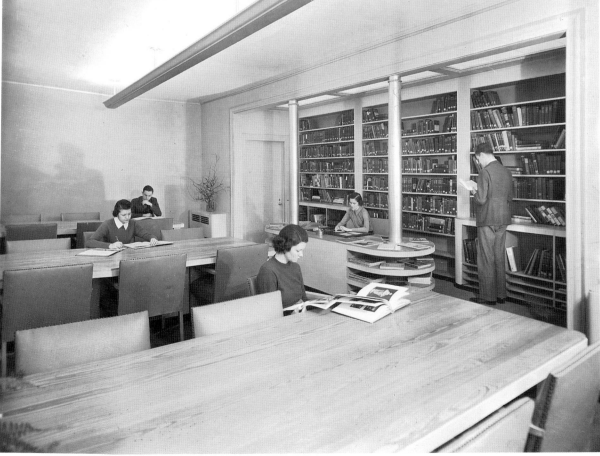

TOP: The Faculty Conference Room was used daily for departmental luncheons as well as for tutoring sessions with students. Keeping the small faculty in constant communication gave the department the special strength of unity.

ABOVE: Design for a polished brass plaque for the Department of Fine Arts, College of William and Mary (1936)

LEFT: The Reading Room in Taliaferro Hall featured recessed, indirect lighting and streamlined styling for desks, bookcases and tables—all startlingly new in recently restored Colonial Williamsburg.

COLLEGE OF WILLIAM AND MARY

IN VIRGINIA

1693 · 1937

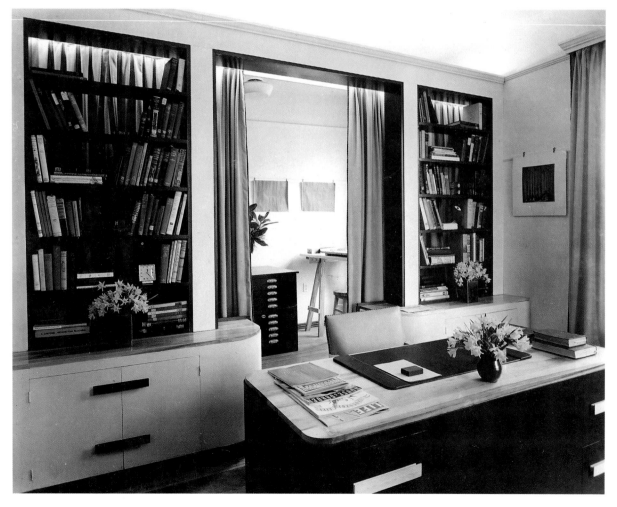

ABOVE LEFT: Leonard Haber, a fellow graduate of Yale whom Cheek brought to Williamsburg, designed this logo in 1937 for the College's new Fine Arts Department. Haber surrounded William and Mary's traditional symbols (center) with those representing drama, music, painting, architecture and sculpture.

LEFT: Cheek's office in the Fine Arts Department

ABOVE AND RIGHT: Edwin Rust's contemporary sculpture decorated the stair well in remodelled Taliaferro Hall. Water cascaded down the three-storey bas-relief into a pool surrounded by plants. Rust and Haber were graduate classmates at Yale University who joined William and Mary's new Fine Arts Department in the mid-1930s at Cheek's invitation.

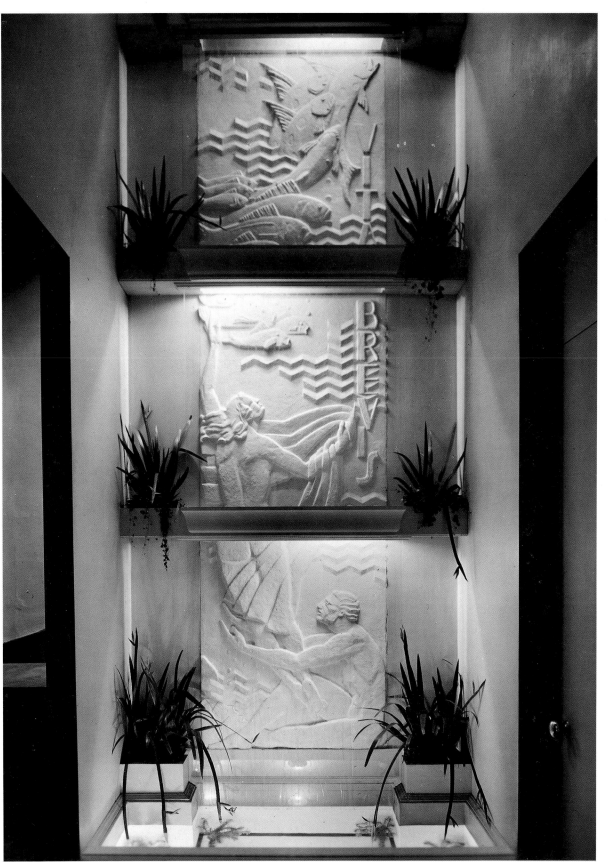

RIGHT: Visitors to the 1939–40 New York World's Fair were served light refreshments in the Virginia Room. Cheek headed the team that designed this contemporary "oasis for the footsore visitor, free from advertisement and noise." Soft beige leather sofas were arranged around Edwin Rust's modern sculpture symbolizing Virginia's rivers. Cheek told an enquiring reporter that the Virginia Room was intended to express "the calm dignity and patrician grace of the Old Dominion . . . to serve Fair visitors by offering a quiet place to wait and rest." In the background are some of the 200-odd large photo albums with information about the Commonwealth's economy, history, geography and culture.

BELOW: The Virginia Room was in the Court of States, occupying the curved space to the left of the central dome and portico. Twenty-two other states were represented at the Fair.

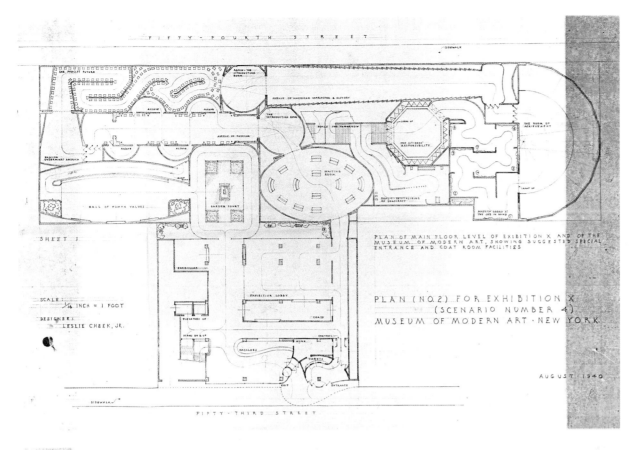

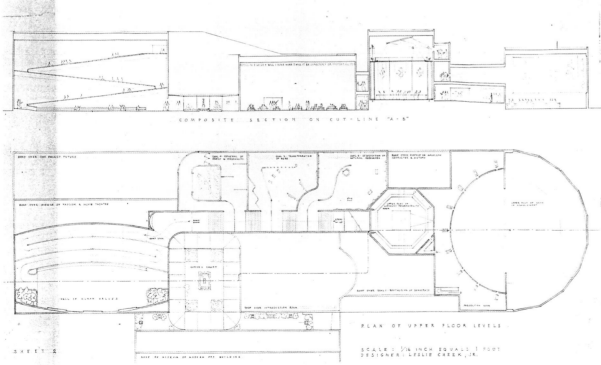

In the summer of 1940 Abby Aldrich Rockefeller (Mrs. John D. Rockefeller, Jr.), a founder of the Museum of Modern Art in New York, telephoned Cheek, who was vacationing in New England. She told him of the urgent need to awaken America to the peril posed to the world by Nazism and Fascism. She asked him to design an exhibition that would rouse the country from its isolationist complacency. Cheek readily accepted and moved temporarily to New York. After shaping his vision of what the "experience," as he called it, should provide, he persuaded Mrs. Rockefeller to invite historian Lewis Mumford and architect Edward Durell Stone to join him. Throughout the summer the three worked on what they eventually named "For Us the Living," a concept so vast that a new building would have been required to house it. It was to be constructed at the Museum of Modern Art on West 53rd Street. Shown are Cheek's plans for two different versions of the projected space, influenced by displays at the 1939 New York World's Fair, especially that of the General Motors Building. The project was abandoned because of its high cost and the fact that America moved rapidly toward involvement in the war.

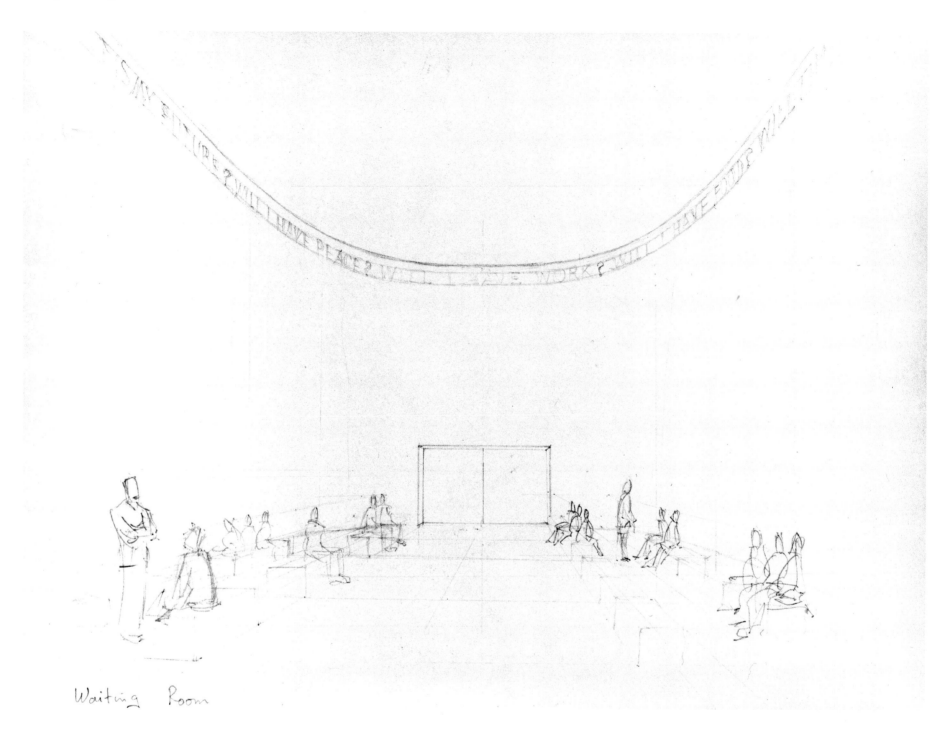

Waiting Room

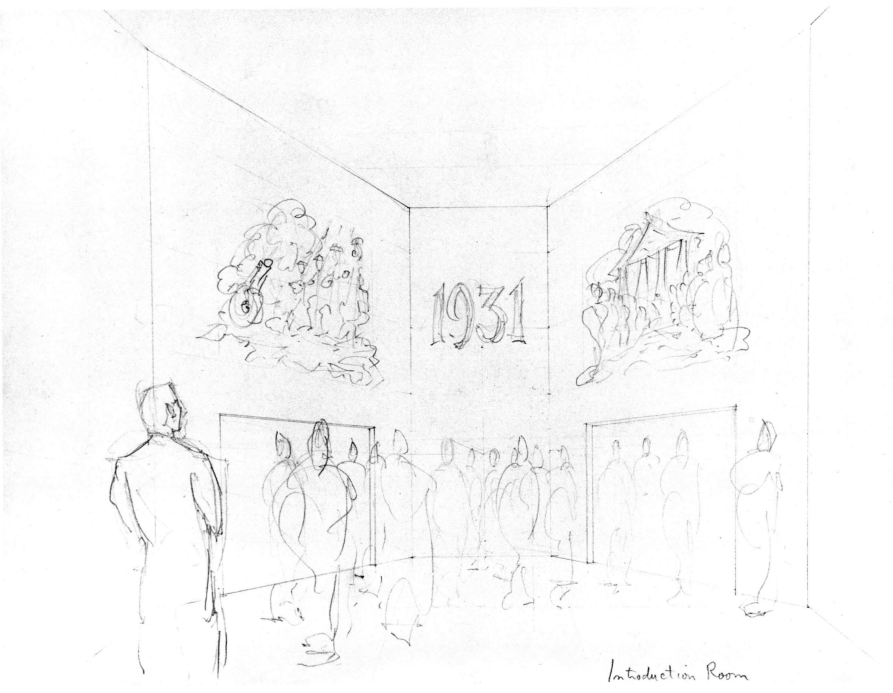

Introduction Room

"For Us the Living" was to be a wholly new and sophisticated propaganda device. The proposed "experience" led visitors through a series of spaces bearing special titles. **LEFT:** *Waiting Room.* Here visitors paused for their turn—in groups of fifty or sixty—to tour the exhibition. Walls and carpet were to be gray, with a frieze overhead in red letters that spelled out some of the questions that were then on the minds of many concerned Americans, e.g., "Will Democracy hold out against Fascism?" and "Will I have a job tomorrow?" After a few moments of quiet reflection here, a voice asked guests to step back from doors which swung open automatically. **ABOVE:** *The Introduction Room.* The slide presentation shown in this room invited visitors to contrast images of life in America and Europe between the crisis years 1925 to 1940. At the end of the slide show a voice boomed out: "Today all of us face a choice. We must choose between democracy and freedom or fascism and slavery." Automated doors then opened and visitors proceeded to the *Avenue of Fascism,* the next part of the experience.

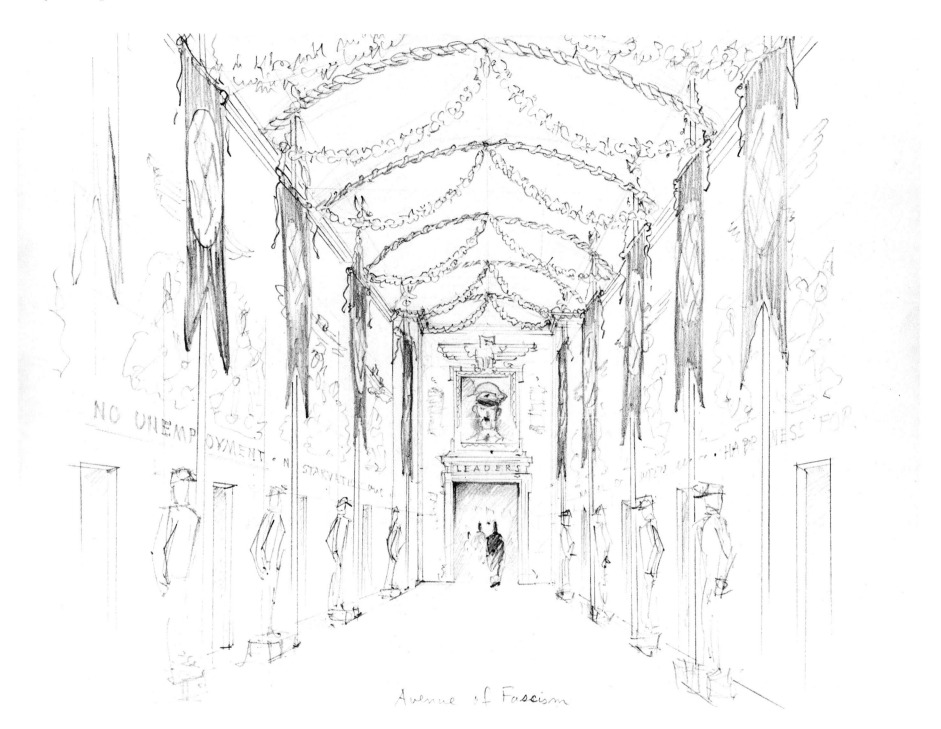

Avenue of Fascism

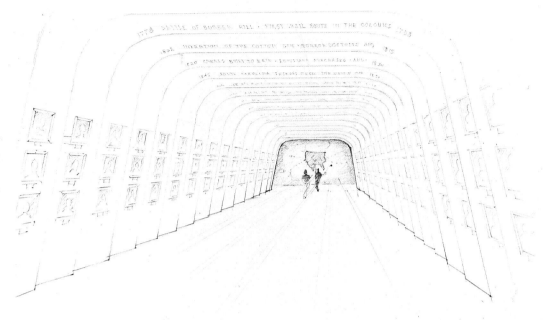

Avenue of American Character + History

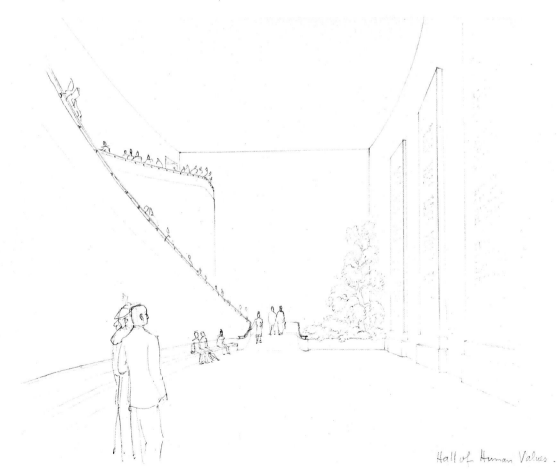

Hall of Human Values.

FAR LEFT: *Avenue of Fascism.* With martial music blaring overhead, visitors entered this hall festooned with Swastikas. Robots dressed as storm troopers lined the room, each raising its arm in the Nazi salute. Visitors passed these menacing figures to enter a theatre with newsreels showing the regimentation of life in Nazi Germany under Adolf Hitler.

TOP LEFT: *Avenue of American Character and History.* This long, narrow room was to be lined on both walls with portraits and biographies of distinguished Americans. Arches divided the space into historic periods, e.g., the first of these bore the label: "1778 Battle of Bunker Hill—First Mail Route in the Colonies—1798." At the far end of the room was an automated map of the United States that indicated patterns of immigration and settlement.

LEFT: *The Hall of Human Values.* The final room in "For Us the Living" challenged the public through statements of eternal human truths and goals for the citizens of, presumably, a more peaceful tomorrow. Visitors could examine and think about these seated on benches or as they rode down an escalator.

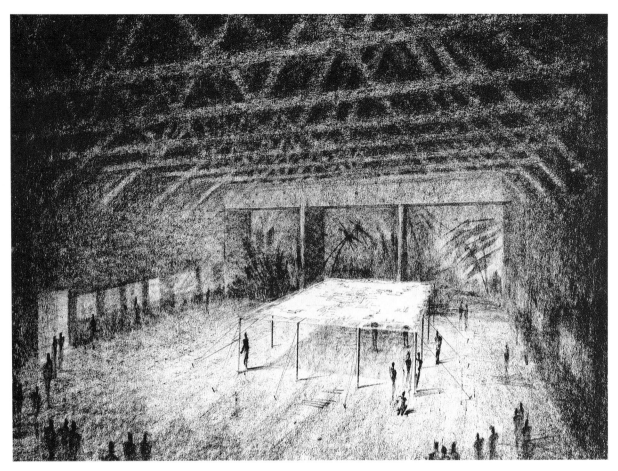

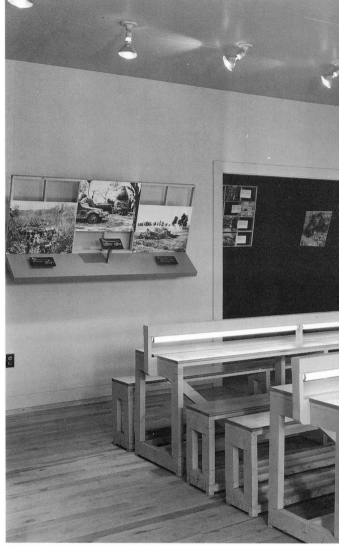

PROPOSED REMODELING OF RIDING HALL FOR CAMOUFLAGE SCHOOL

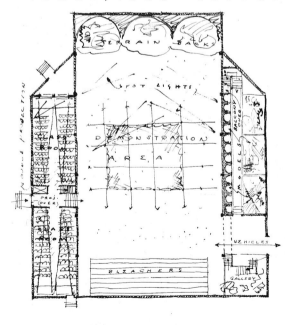

PLAN
SCALE 1" = 20'-0"

ABOVE AND LEFT: Cheek was director of the U.S. Army's Camouflage School at Fort Belvoir, Virginia, during World War II. He designed the remodelling of an abandoned riding hall to include a large "Demonstration Area" for life-sized mock-ups of camouflage techniques. Cheek was a Captain in the Army Corps of Engineers form 1942 to 1944, when he was promoted to the rank of Major and transferred to the Office of Strategic Services (O.S.S.) in Washington, D.C. He served with the O.S.S. until the end of hostilities in 1945.

RIGHT: Eye-catching exterior signage along the railing identifies the camouflage training center at Fort Belvoir, Virginia.

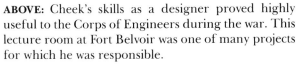

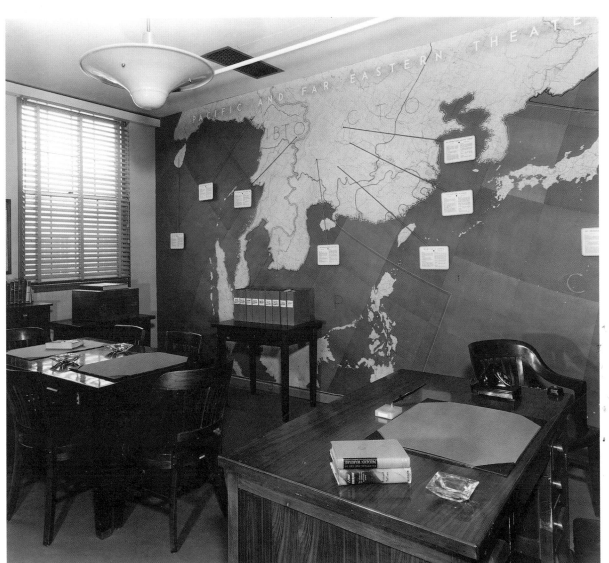

ABOVE: Cheek's skills as a designer proved highly useful to the Corps of Engineers during the war. This lecture room at Fort Belvoir was one of many projects for which he was responsible.

ABOVE RIGHT: The Reports Room for the O.S.S. office in Washington was laid out by Major Cheek. As a member of America's wartime intelligence service, he assisted in the creation of black propaganda to demoralize and confuse enemy forces in Asian and European theatres.

RIGHT: In 1944 while in the O.S.S. Cheek executed designs for the placement of bulletin boards in the U.S. Capitol Building. Congressmen and members of their staffs were to consult the boards, which in these drawings appear as blank rectangles, to get the latest news about the war.

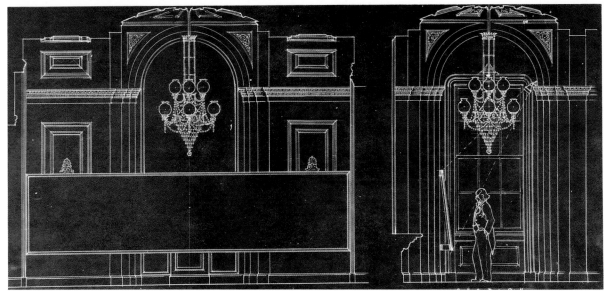

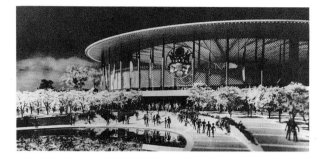

ABOVE: Edward Durell Stone was architect of the circular-shaped U.S. Pavilion at the 1958 Brussels World's Fair. The American display included, among other things, a collection of American folk art that Cheek was asked to install.

RIGHT: Using working drawings of the U.S. Pavilion prepared by chief architect Edward Stone, Cheek executed this plan for the folk art exhibition (1958). Located near one of the building's entrances, the installation consisted of five rooms, each dealing with a particular aspect of American folk and historical art. **FAR RIGHT:** Elevations for the folk art display indicate the spaces for paintings and sculptures, as well as the locations for overhead lighting. Lenders to the exhibition included collector Maxim Karolik, the Whitney Museum and the Abby Aldrich Rockefeller Museum in Williamsburg, Virginia.

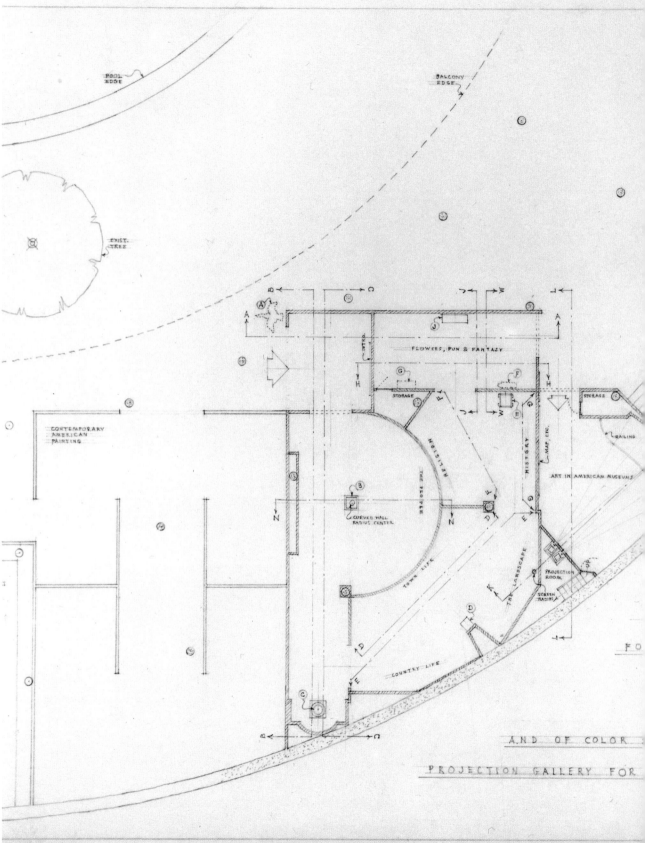

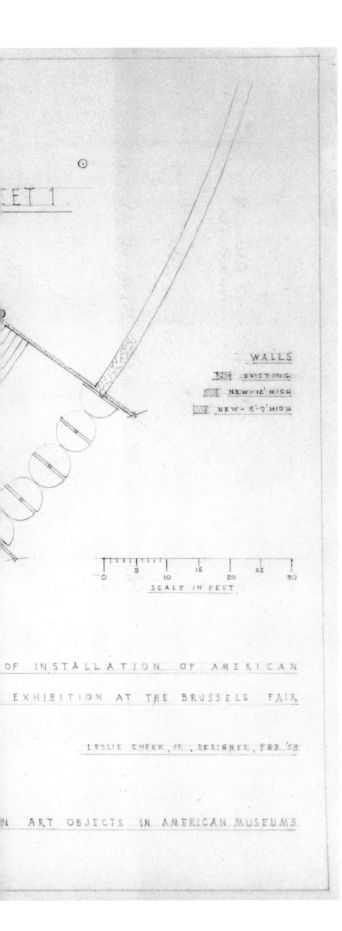

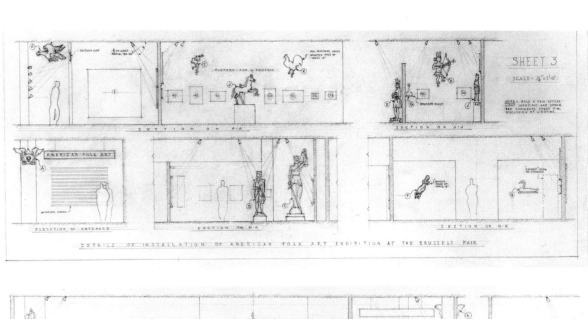

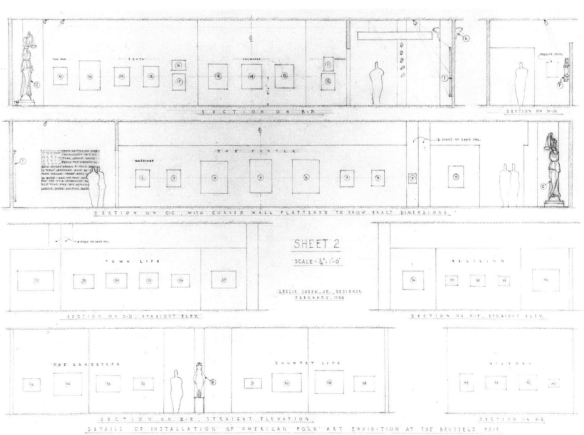

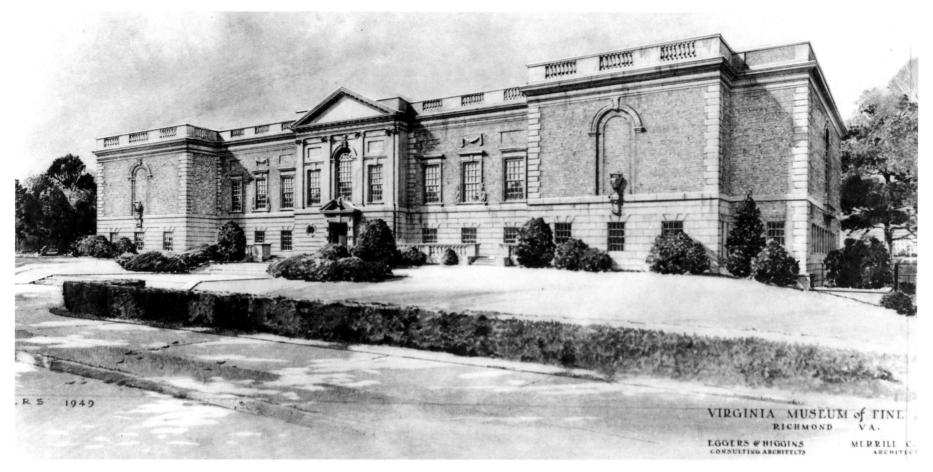

VIRGINIA MUSEUM of FINE
RICHMOND VA.

EGGERS & HIGGINS
CONSULTING ARCHITECTS

MERRILL C.
ARCHITECT

ABOVE: Virginia Museum of Fine Arts. An architect's schematic rendering (circa 1949) showing the original Christopher Wren-inspired headquarters building flanked by two wings to the north and south. These were eventually built with slight modifications. First came the North, or Theatre, Wing (right) completed in 1954, followed by the South Wing in 1970. The proposed Entrance Wing was to have been built as an addition to the existing North Wing.

RIGHT: This concept, which pre-dated Cheek's arrival at the Virginia Museum in 1948, called for a court-yard and surrounding colonnade, perhaps to have been situated at the west side of the building.

GARDEN COURT
VIRGINIA MUSEUM OF FINE ARTS
RICHMOND VA.

Elevation · on · Grove · Avenue.
One-sixteenth inch · one foot

Elevation · on · the · Boulevard.
One-sixteenth inch · one foot

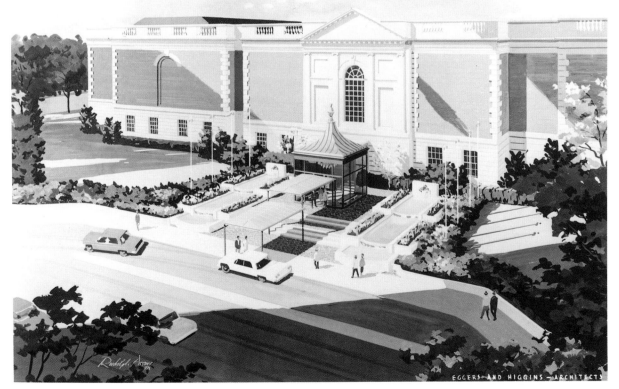

ABOVE: An early scheme for a South Wing dating from the late 1940s. A porte-cochere just off Grove Avenue would have enabled visitors to enter in shelter.

LEFT: This unusual proposal—dating from the early 1960s—called for a glass-enclosed kiosk and canopied walkway at the museum's main entrance. Flanked by the Woodson P. Waddy Fountains, this promenade would have led to the old entrance hall, remodelled by Cheek in 1953–54 to accommodate the Lillian Thomas Pratt Collection of Russian Imperial Jewels.

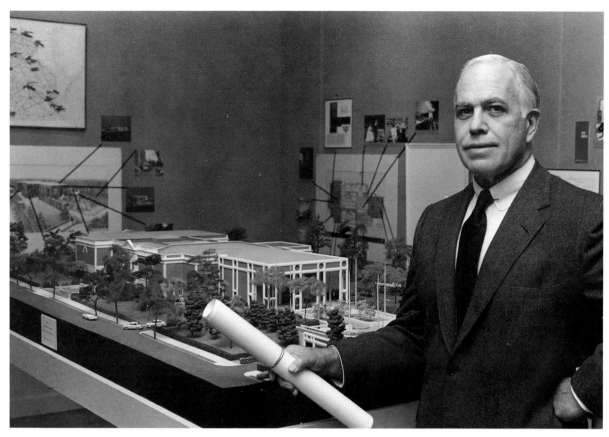

ABOVE: Leslie campaigned across the state to build public support for the proposed Entrance Wing that would have more than doubled the size of the museum. Here he mingles with the audience following a speaking engagement (1965).

BELOW: In 1966 the public had an opportunity to study the proposed additions through two exhibitions: *Art Unseen* traveled across the state while the other, *Building for the Arts,* was shown in Richmond. Here Mrs. Webster Rhoads, Jr., and Mrs. Walter Robertson examine the model at *Building for the Arts.* Their husbands both served as presidents of the museum: Rhoads from 1954 to 1957 and Robertson from 1960 to 1967.

ABOVE: Cheek with the detailed scale model of the Entrance Wing that he and Robert Stewart designed in the mid-1960s. The proposed expansion was intended to provide a new public entrance to the museum. Exhibitions were to have been arranged in chronological order beginning at the Entrance Wing and extending the length of the headquarters building to the new South Wing (far left).

RIGHT: Robert Stewart, a graduate of Yale's School of Architecture, collaborated with Cheek in 1965 through 1967 to design the Virginia Museum's proposed South and Entrance Wings. Behind Stewart are plans for the South Wing, which opened in 1970.

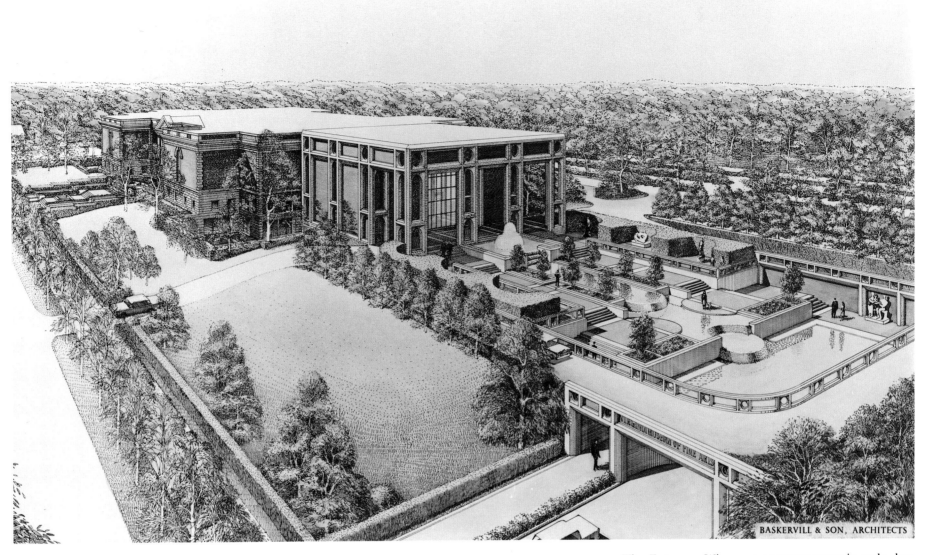

BASKERVILL & SON, ARCHITECTS

The Entrance Wing was contemporary in style, but its design included materials and decorative elements derived from the older Wren-inspired museum building. Robert Stewart's original rendering shows the terraced sculpture garden, fountains and entrance for automobiles turning off North Boulevard. (Drawing by Robert W. Stewart.)

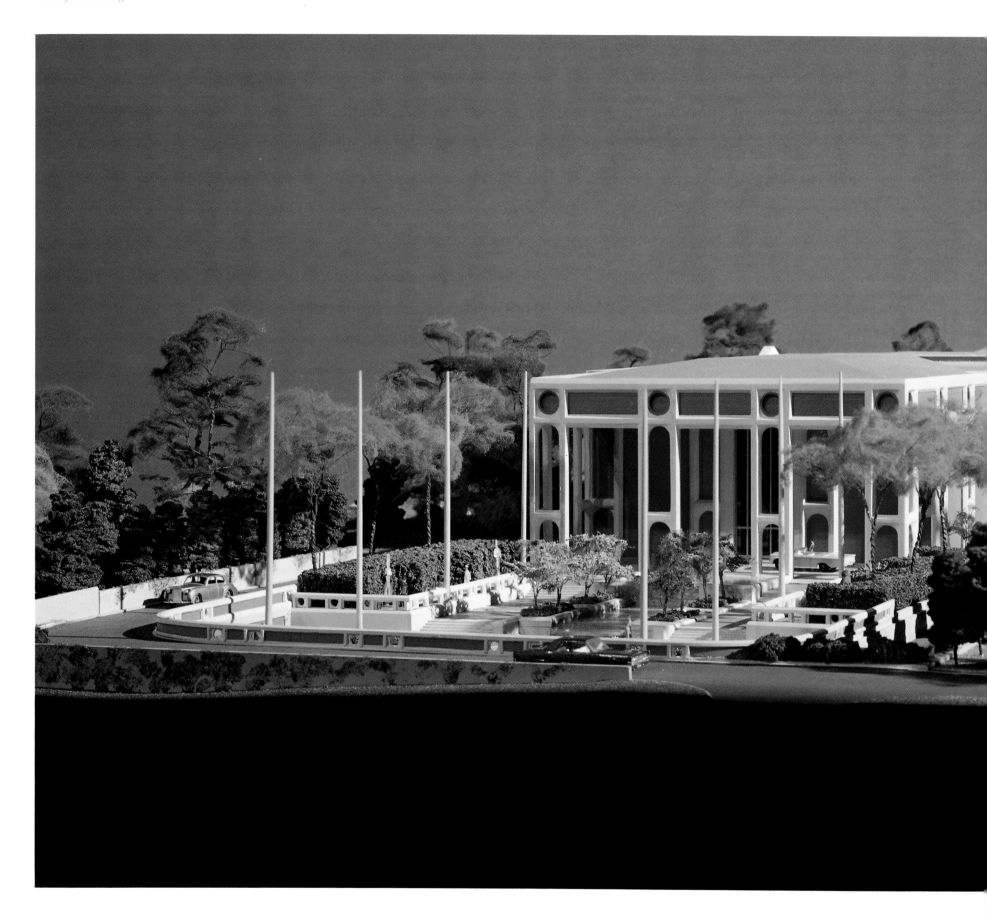

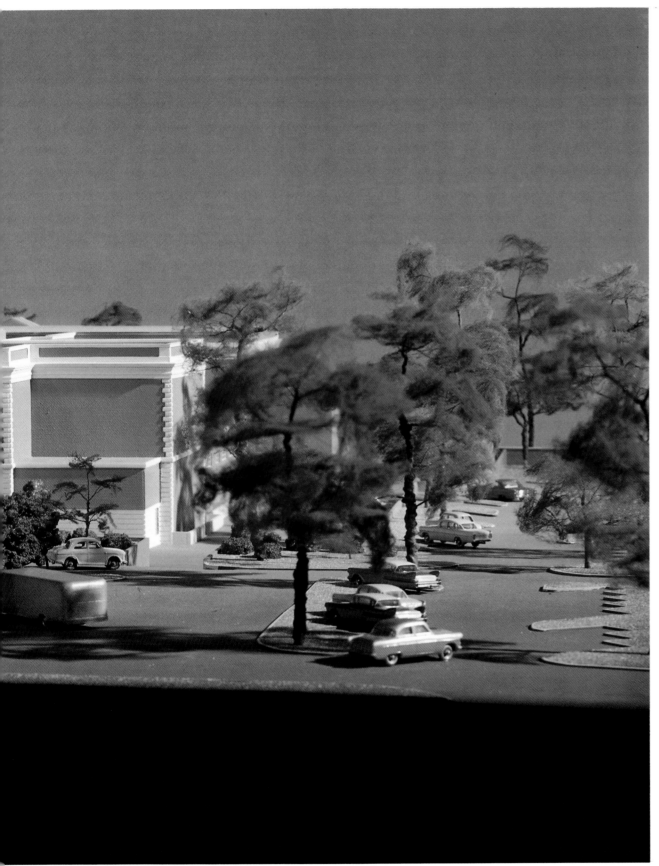

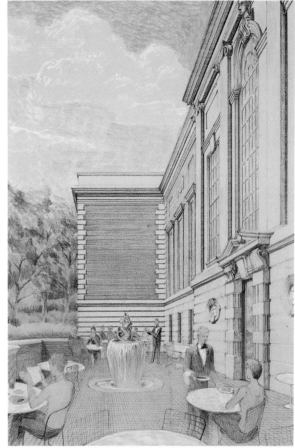

ABOVE: The original entrance to the museum on Richmond's North Boulevard was to be closed under the new plan, with the terrace converted to an outdoor café. The old entrance hall (beyond the door at right) would have continued to display the Fabergé collection, but the main stairway would have been removed to provide additional space for the new public restaurant. (Drawing by Robert W. Stewart.)

LEFT: Between 1965 and 1967 Cheek labored valiantly to win approval for the Entrance Wing, a much-needed expansion for the growing Virginia Museum. The proposed wing, the model for which is shown here, was to have been erected at the north end of the museum, and would have overlooked an elegant sculpture garden.

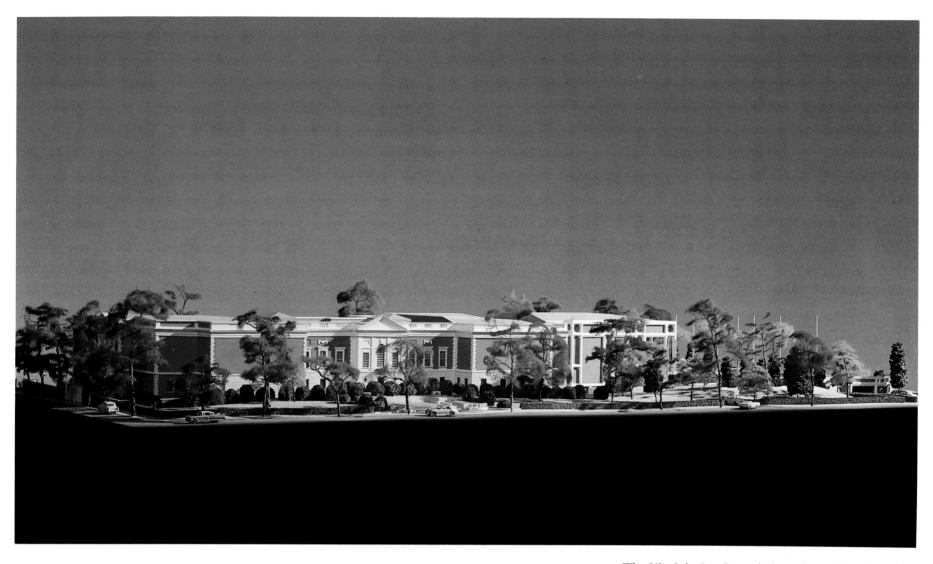

The Virginia Art Commission rejected the design for the Entrance Wing because it found the addition to be out of scale with the original building. This photo of the model taken from the Boulevard or east side of the museum contradicts the Commission's view.

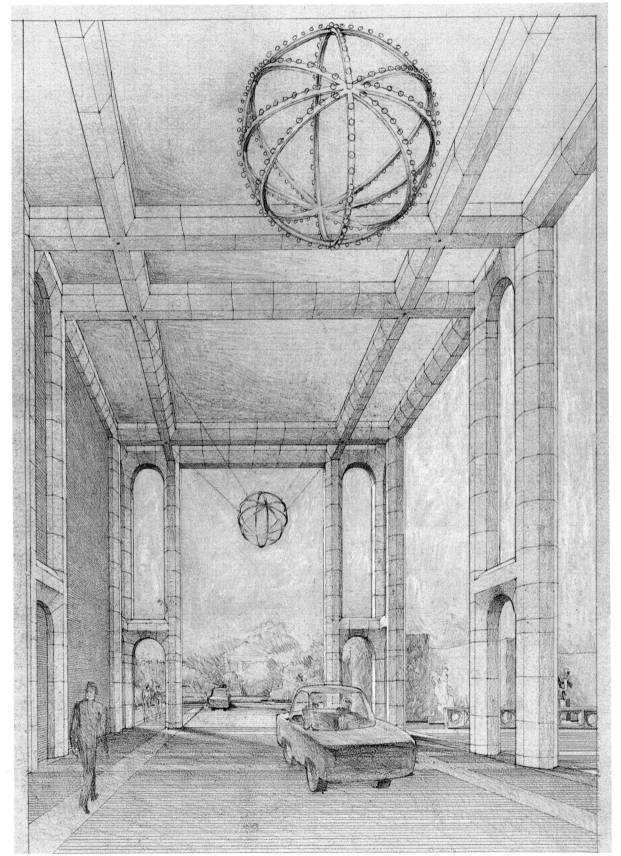

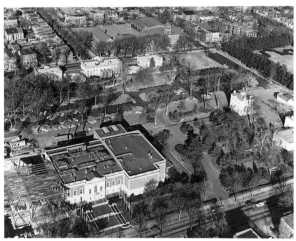

TOP: The fight for the Entrance Wing was waged over the state's airwaves. Fred Haseltine (left), a member of the museum staff, appeared on "Compass," a public interest program broadcast by Norfolk's W.A.V.Y television station.

ABOVE: An aerial view (probably photographed in 1969) shows the South Wing already under construction. Work has not yet begun on the Entrance Wing (slated for the space to the immediate right of the museum) because new plans had to be executed following its rejection by the Virginia Art Commission. In the 1950s Alfred Geiffert designed the parking area, which Cheek insisted be called the "motor park," *not* a "parking lot." Geiffert had been the landscape architect for the National Gallery of Art in Washington, D.C., as well as for the gardens at the Cheeks' Richmond house.

LEFT: A view looking west through the marble portico of the never-built Entrance Wing. (Drawing by Robert W. Stewart.)

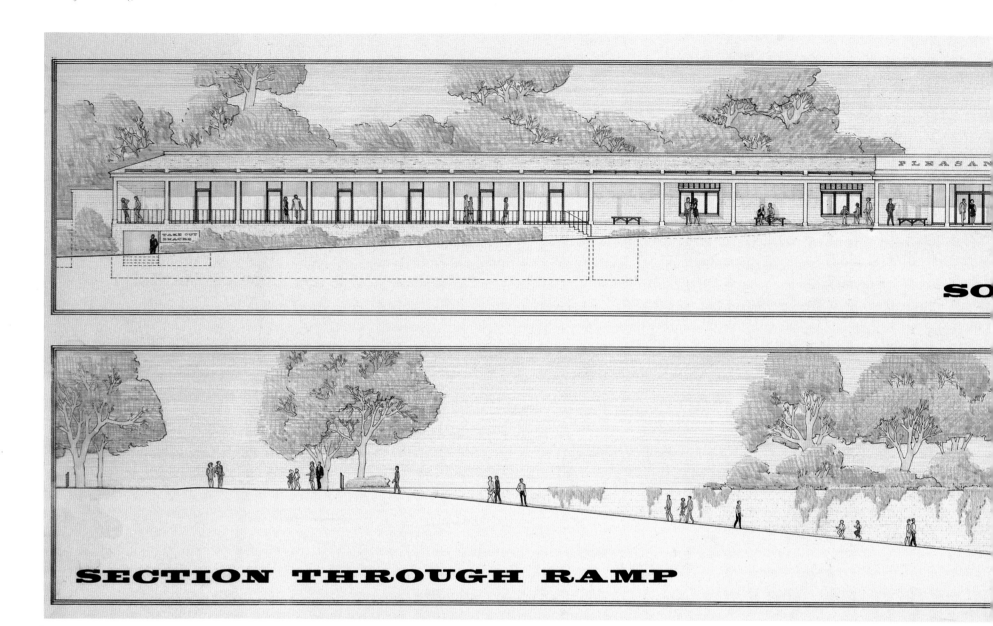

SECTION THROUGH RAMP

ABOVE AND RIGHT: In 1972 Cheek collaborated with Robert Stewart to design this visitors' center for Shakertown at Pleasant Hill, near Harrodsburg, Kentucky. Shakertown recreates the early 19th century lifestyle of the Shakers, a small sect of ascetic Christians who worshipped and farmed in Kentucky from 1805 to 1910. With this plan for a long, low-profiled structure, the two designers wished to avoid intruding on the community's unspoiled surroundings, or detracting from the nearby Federal-period dwellings. The building was to house an information center, gift shop and restaurant. Planting would have concealed an adjacent parking area. Cheek and Stewart's spare style is entirely sympathetic with the simplicity that distinguishes Shaker design.

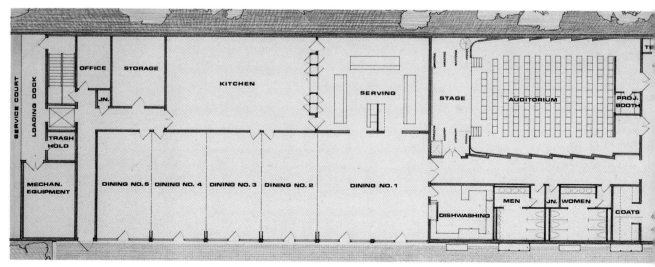

H ELEVATION

PLEASANT HILL

ABOVE: With the aid of designer William Ryan, his associate of many years at the Virginia Museum, Cheek created a reception center for Christ Church, near Irvington, Virginia. The center, located just inside the main entrance to the grounds of the 17th-century church, included an automated slide talk with background information about one of Virginia's most historic houses of worship.

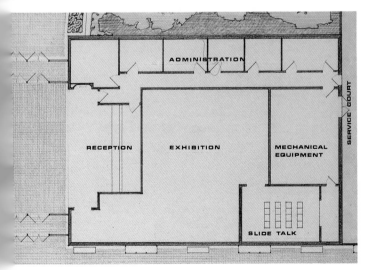

ADMINISTRATION

SERVICE COURT

RECEPTION EXHIBITION MECHANICAL EQUIPMENT

SLIDE TALK

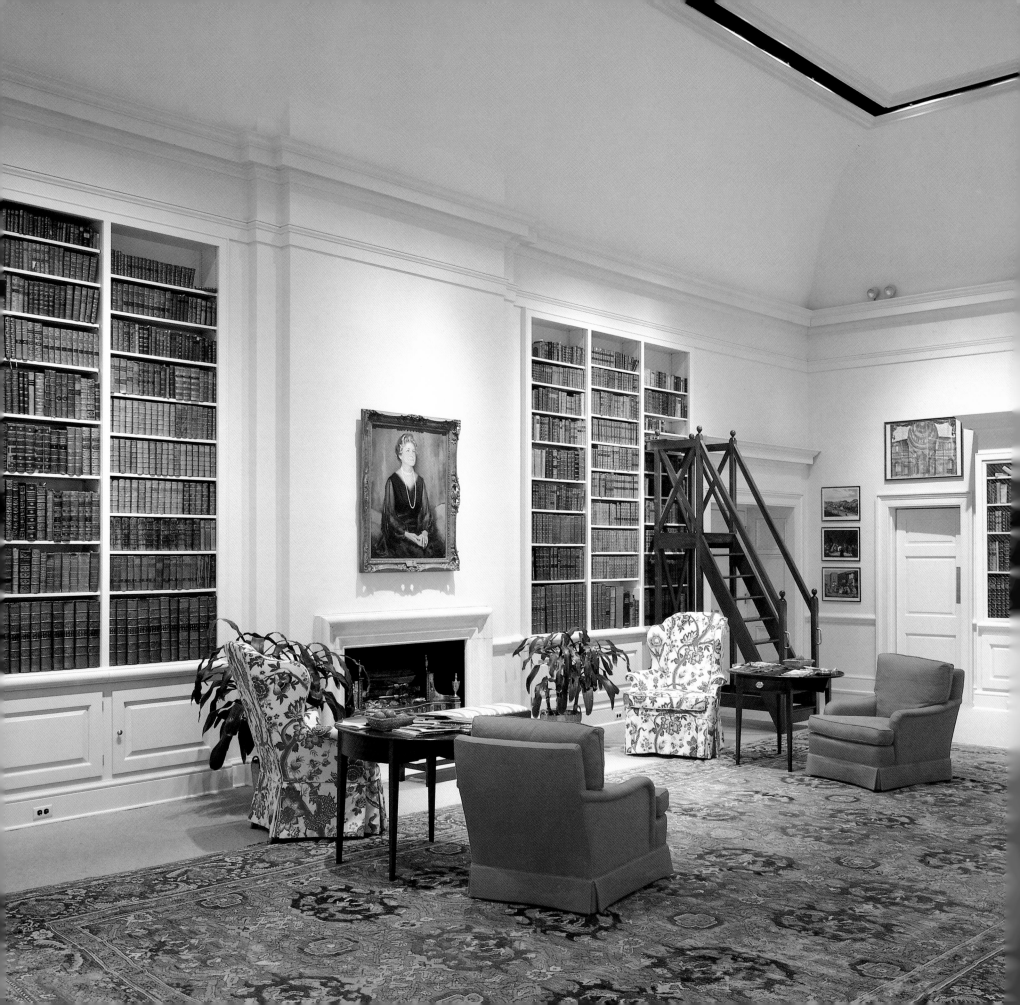

CHAPTER X

Special Projects

The interior of the Jesse Ball du Pont Library at Stratford Hall Plantation. Nancy Lancaster, often called the "Decorator Laureate" of Britain, was then a member of the Board of Directors of the plantation and collaborated with Leslie Cheek in the decoration. Stratford is but one among many projects that have involved Cheek as designer and consultant.

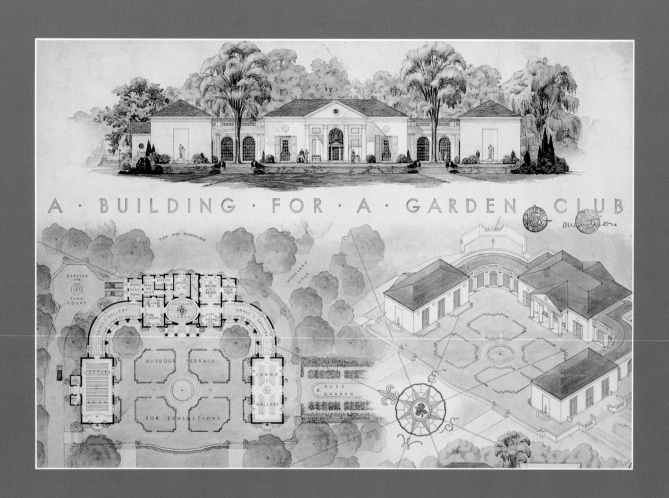

A · BUILDING · FOR · A · GARDEN · CLUB

This chapter gathers a wide range of projects to which Cheek lent his inimitable stamp. They vary from assignments undertaken as a student in architecture school, to consulting work done in adulthood for a number of civic, religious, public and private projects. Together, they illustrate the rich variety of Leslie Cheek's creative work over a sixty year period.

The Yale projects are presented not merely as curiosities, but to show his development as a planner. They clearly disclose the influence of the Beaux-Arts principles, as already discussed. A selection of stage designs is presented to show influences that found full expression later in dramatic, evocative museum settings. For some of the projects reviewed, Cheek was not the designer but a consultant whose opinion was sought by practicing architects who needed his special visual talents.

As he grew older and his arthritic condition worsened, Cheek found it impossible to work at the drawing board he had been using since the 1930s. Instead, he continues to work by explaining precisely what he envisions, leaving the execution to other designers.

The chapter, then, sums up a lifetime of achievement in the design world upon which Leslie Cheek has left a lasting impression.

This skillfully executed *projet* depicts a Garden Club Building (1932). The judges evaluating the plan did not approve the placement of the receiving and unpacking rooms in relation to the overall scheme. Nevertheless, the drawing won a First Mention for Cheek. Assignments such as this sharpened students' skills at the Yale School of Architecture, where Leslie studied from 1931 to 1935.

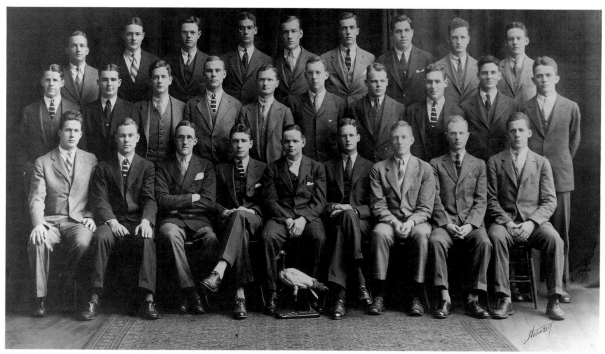

RIGHT: *The Lampoon* editorial board, 1927. In the tradition of Gluyas Williams and Robert Benchley, who had both contributed to the magazine before him, Cheek (top row, third from the right) brought wit and insouciance to his work on *The Lampoon*.

BELOW: A sample of the covers that Cheek designed for Harvard's famous humor magazine *The Lampoon*. The publication's meager budget often forced the fledgling illustrator to work with only two colors. With the "Sportsman Number," however, *The Lampoon* evidently tapped new sources of wealth, and Cheek was invited to design with as many hues as he liked.

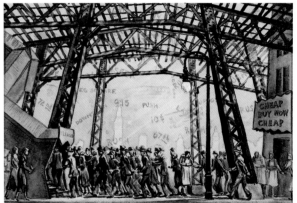

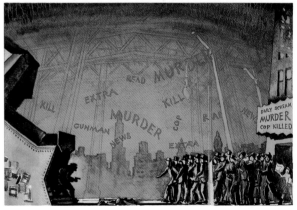

TOP: "Rush Hour," from the play *Elevated in New York* (author unknown), executed circa 1933. Cheek's watercolor and gouache captures the frenetic pace of a big-city crowd racing to catch a commuter train.

ABOVE: "Red Sky," also from *Elevated in New York*

LEFT: Courses in stage design required Cheek to read a wide range of plays, then devise detailed designs for sets, costumes and lighting. He produced this Disney-esque rendering of the "Witch's Glen in the Forest," from Act I of *The Sunken Bell,* by German playwright Gerhart Hauptmann (1862–1946).

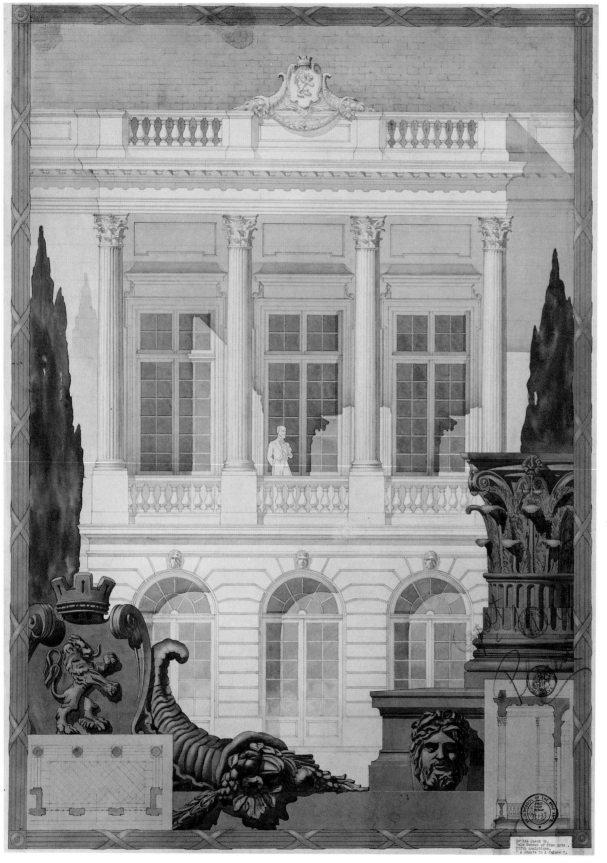

SCALES
FACADE · 3/16 IN=1FT
DETAILS · 3/4 IN=1FT

PLAC

FAR LEFT: This Fifth *Analytique* drawing completed for one of Cheek's first year courses at the Yale School of Architecture (1931) called for making alterations (presumably to the interior) of a pre-existing French or Italian palace to meet the needs of a modern owner. This finely executed drawing of the facade of the 18th century building merited a First Mention.

LEFT: Among Cheek's first year *analytiques* is this detailed rendering of an ornate palace on Paris' *Place de la Concorde* (1931–32). Yale's Beaux-Arts four-year curriculum was a demanding one, and assignments such as this were intended to sharpen students' draftsmanship.

RIGHT: Another *projet* exercise called for the design of a memorial to the patron of a museum (circa 1933). Note the use of lighting, recessed behind the sculpture, intended to evoke reverence and awe, a technique Cheek learned in the stage design courses he took while an architecture student. Years later, his imaginative illumination of galleries and objects in art museums drew both praise and criticism.

BELOW: Cheek produced this elevation for a fabric mill and showroom, a *projet* assigned during his second year in the architecture program at Yale (circa 1933). Clean lines and an absence of classical ornamentation suggest the influence of the Bauhaus.

The Beaux-Arts style finds no purer expression than in Cheek's plan for an architect's combined office and private residence (*projet,* circa 1933). The symmetry of the plan in the style derived from European models, the provision for landscaped gardens and sculptural ornamentation, and the careful rendering attest to Beaux-Arts influences.

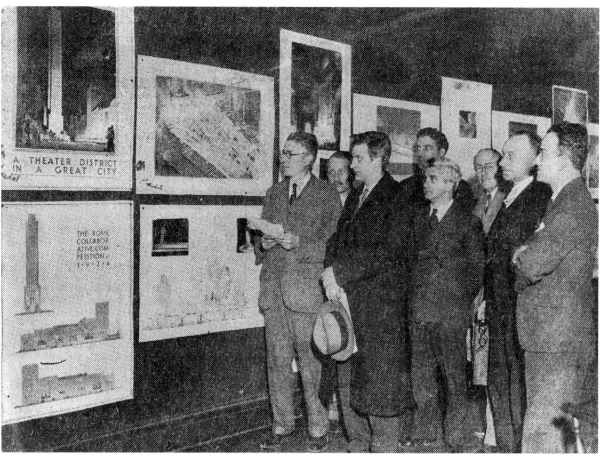

Times Wide World Photo, 1934

Cheek joined with fellow students Leonard Haber, painter, and Raymond G. Barger, sculptor, to enter the 1934 Prix de Rome competition, sponsored by the Association of the Alumni of the American Academy in Rome. The problem involved the treatment of a public square in the center of the famous Times Square theatre district. Cheek determined the distribution of structures, their height, mass and style. Haber designed electric signs and marquees, as well as the illumination of buildings and decorative mosaics to adorn their facades. Barger's responsibility was to determine exterior sculptural ornamentation for both the buildings and for a public plaza or square specified by the competition's organizers. The team placed the plaza in the triangle formed by the confluence of 42nd and 43rd streets, Broadway and Seventh Avenue. **ABOVE RIGHT:** The jury evaluates the Cheek-Haber-Barger designs, displayed at left, which tied for first place with two other teams. **RIGHT:** Illustrated in close-up is a photo Cheek made of his model, showing that the plaza consisted of a five-tiered, landscaped fountain, with water cascading down steps from the water jet toward a collecting pool at 43rd Street.

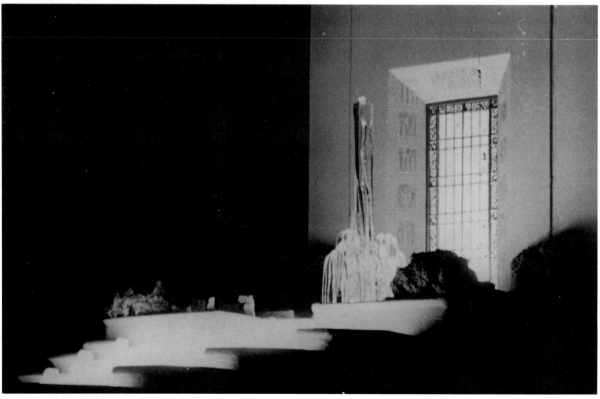

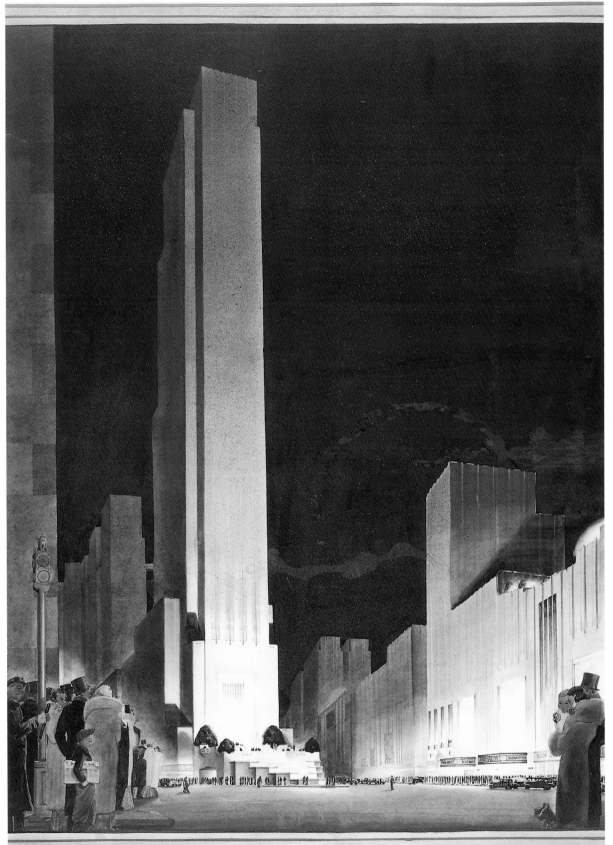

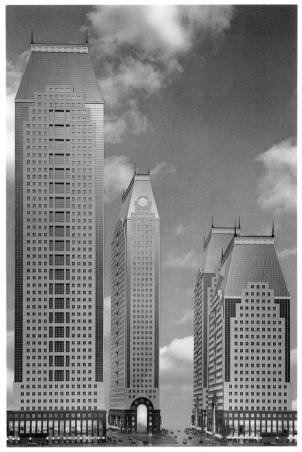

© Nathaniel Lieberman; photo courtesy Park Tower Realty; Johnson-Burgee Architects

LEFT: Leonard Haber's color rendering, obviously influenced by Hugh Ferris, and complete with a well-dressed throng out on the town, shows how Cheek's skyscraper would have appeared as seen from 44th Street. The stepped-back design is clearly suggested by Rockefeller Center. Traffic on 42nd Street, on which the main building fronted, would have been rerouted through a tunnel that passed beneath the public plaza. **ABOVE:** The reader is invited to compare this conception with the architect's model unveiled in 1983 by Times Square Development Associates, a Park Tower/Prudential Joint Venture. This scheme, since abandoned in favor of yet another plan, envisioned Post-Modern styled office and hotel towers, ranging from 31 to 58 storeys, and nine renovated theatres. Perhaps room can be found for the Cheek-Haber-Barger fountain to occupy the triangular area left undeveloped in this view.

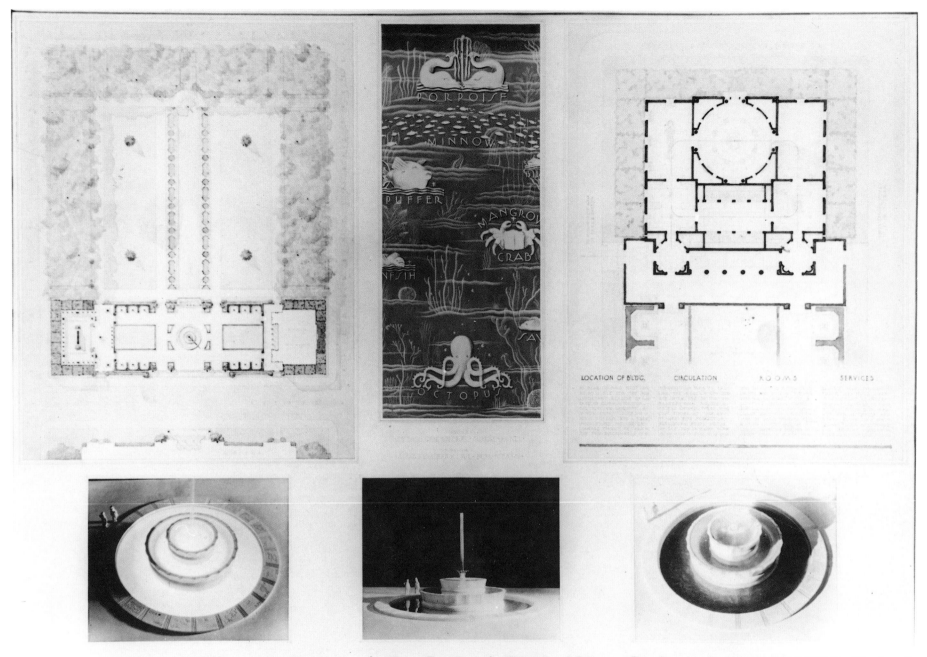

THE ROME COLLABORATIVE COMPETITION

The first prize for the 1934 Prix de Rome Collaborative Competition was $300.00; the problem, a natural history museum in a large city. Instructions specified that the building would occupy an area measuring 700 feet by 600 feet, with total exhibition space of 10,000 square feet, including an outdoor setting for the display of meteorites, totem poles and similar objects. **ABOVE:** The Cheek-Haber-Barger trio teamed up again to produce this design that featured a loggia and external ornamentation including mur-

als, mosaics, and a formal garden. A fountain, its base decorated with sculptures of sea creatures, was at the center of a tree-lined plaza in front of the museum. Similarly, Haber's five murals (one of which is detailed at center) continued the nautical themes. Note Cheek's symmetrical interior layout (top right) for exhibition spaces. Competition judges disapproved the dual entrance. **RIGHT:** This view, drawn as if one were looking through the plaza, shows the fountain in the foreground with the museum building beyond.

Cheek recalls that the design was inspired by the Folger Shakespeare Library in Washington, D.C.

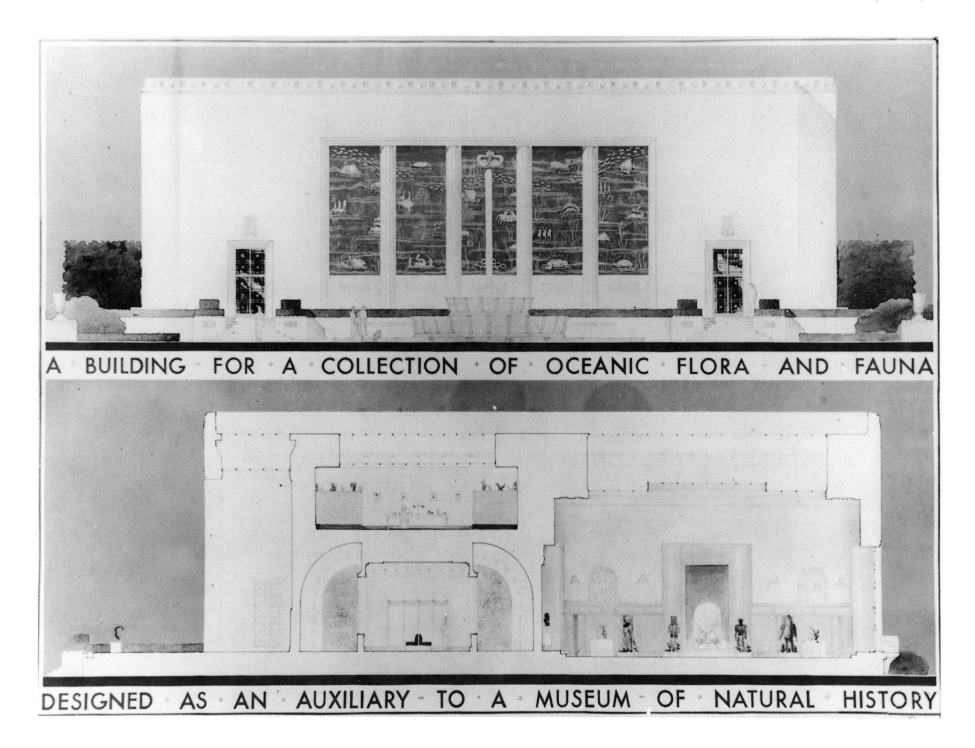

A · BUILDING · FOR · A · COLLECTION · OF · OCEANIC · FLORA · AND · FAUNA

DESIGNED · AS · AN · AUXILIARY · TO · A · MUSEUM · OF · NATURAL · HISTORY

Cheek's 1935 senior thesis topic called for the design of the top ten floors of an 85-storey skyscraper. Having visited the recently completed Rockefeller Center, Cheek decided that his submission would comprise a redesign of the top ten floors of the 70-storey, 850-foot R.C.A. Building. To the young architecture student, the Rainbow Room—on the 65th floor of the R.C.A. tower—was doubtless a magical confection of Art Deco chic and elegance. But he felt it failed to take full advantage of its lofty setting, and he decided that his skyscraper would be crowned with a grander statement. The sectional drawing reveals a spacious Theatre-Restaurant with circular, revolving stage and curved windows (left). The stage, on hydraulic lifts, could be lowered and raised to facilitate the changing of sets. It could also be converted into a revolving dance floor. The restaurant was roughly oval-shaped, with eight tiered levels for dining tables. A Lounge (right) was actually a large curve-roofed greenhouse, its ceiling tall enough to accommodate palm trees and shrubbery. An Entrance Hall (center), complete with enormous chandelier, grand stairway and more window glass, connected the Lounge and Theatre-Restaurant to elevators that conveyed patrons some eighty floors skyward.

·SECTION·THROUG

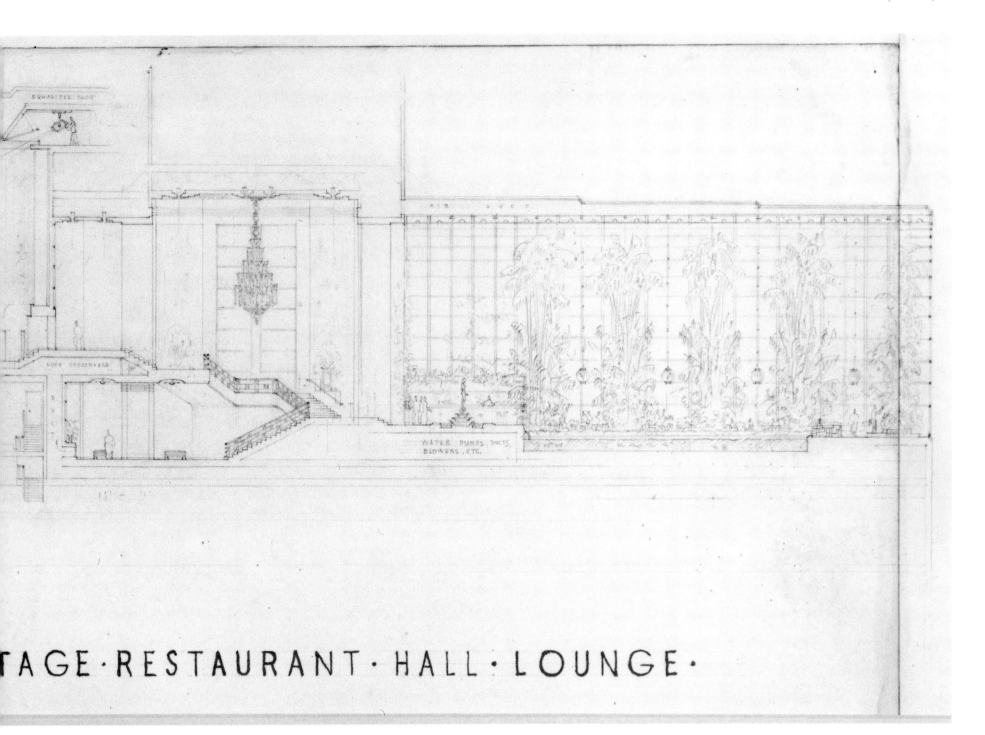

·TAGE·RESTAURANT·HALL·LOUNGE·

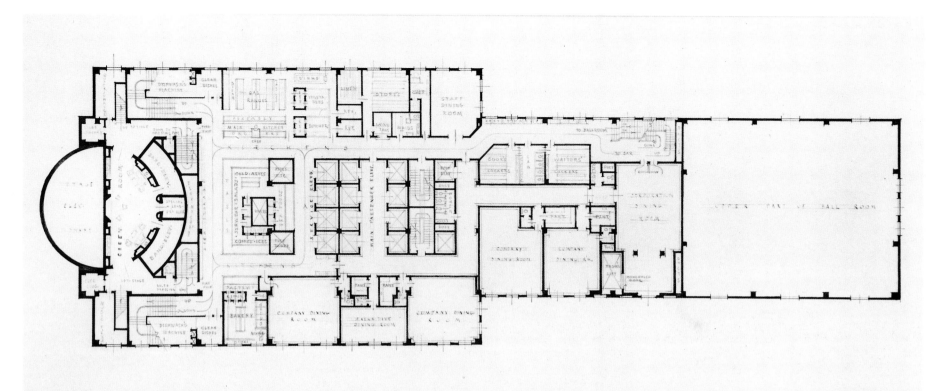

· P L A N · A T · L E V E L · "F" ·

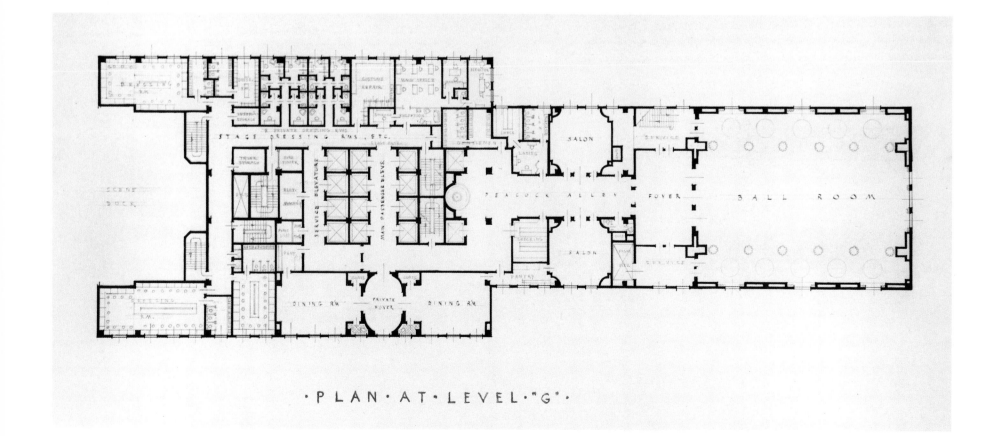

· P L A N · A T · L E V E L · "G" ·

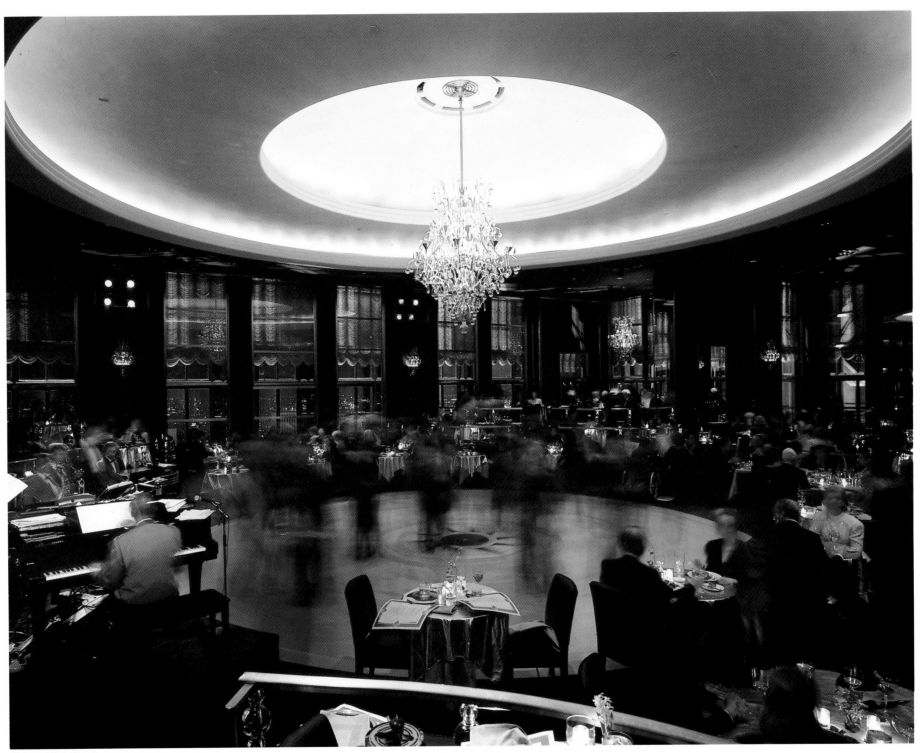

Christopher Little Photo ©

LEFT: Plan at Level F: This floor, beneath the Restaurant, contained the main kitchen, as well as six private dining rooms, dressing rooms for restaurant staff, and an equipment room for the theatre. Plan at Level G: Two private dining rooms, more dressing rooms for performers, space for storage of theatrical costumes and a ballroom occupied this level.

ABOVE: Cheek's Yale thesis, with its more complex articulation, should be compared with the restoration of the Rainbow Room, recently completed at a cost of more than $20 million. Designers Hardy Holzman Pfeiffer Associates have returned much of the white-tie glamour of high society to the 64th and 65th floors of the R.C.A. Building. From crystal-ball balustrades to bronze-rimmed mirrors to aubergine silk wall covering, the 1930s Modernism that inspired original designer Elena B. Schmidt has been brought faithfully and lovingly back to life. Shown is the revolving dance floor at the center of the newly restored Rainbow Room, with the glittering skyline of Manhattan floating beyond.

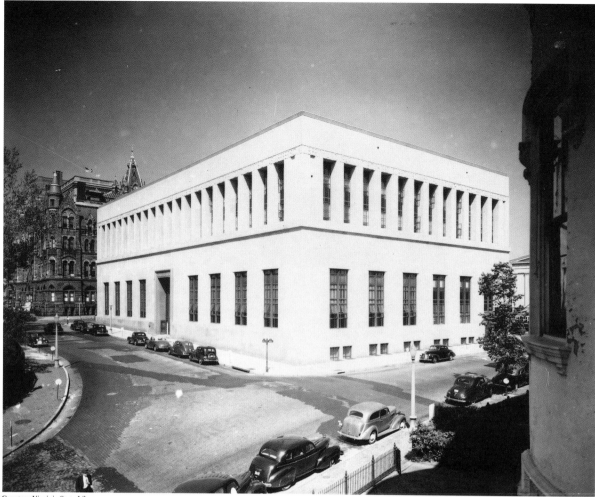

Courtesy Virginia State Library

ABOVE: The modernized Neo-Classical Virginia State Library was completed in 1939, when Cheek was a member of the state's Art Commission. The group adopted Leslie's proposal that Virginia artist Julien Binford execute a mural for the building's finely appointed main entrance hall.

RIGHT: Cheek (second from left) with the winning design for a Stonewall Jackson monument in 1939. New York sculptor Joseph Pollia's entry was judged the best in a competition that involved 80 other entrants. During the late 1930s Cheek was a member of the Virginia Art Commission, a state agency that determined the esthetic suitability of publicly funded projects, among them this statue that now stands in the Manassas Battlefield Park in northern Virginia.

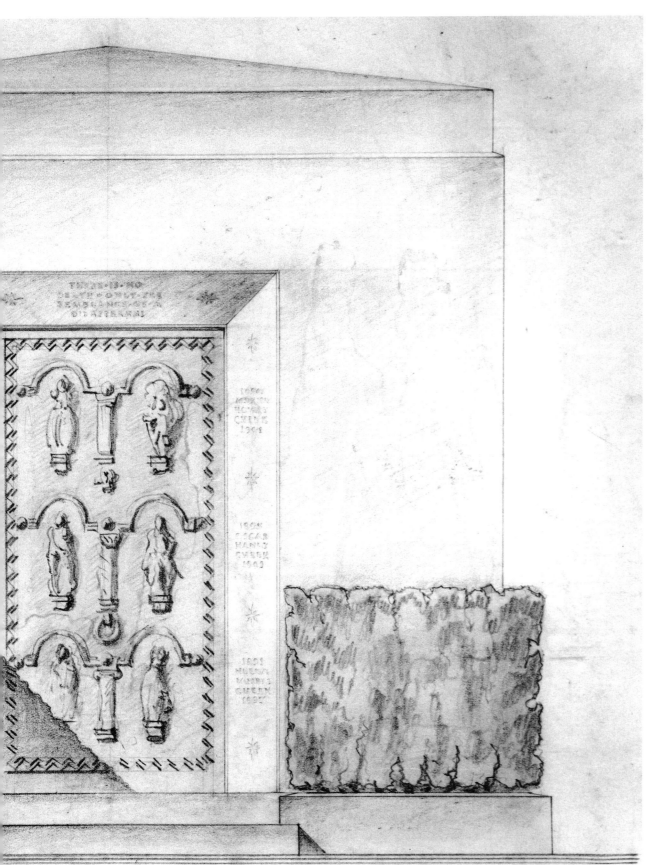

LEFT: An elevation in pencil for the Cheek family mausoleum in Nashville, Tennessee (circa 1946). In the Beaux-Arts manner, Cheek framed the door with stone and bronze decoration executed by sculptor Edwin C. Rust.

BELOW: Cheek was appointed by the Commonwealth as design consultant for the Virginia War Memorial. He suggested to Samuel J. Collins of Staunton, architect for the project, that the names of Virginia's war dead be etched in glass panels. This dignified monument, completed in 1956, overlooks the James River near Richmond's Lee Bridge and includes office space and a small auditorium.

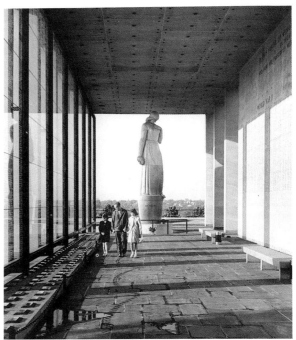

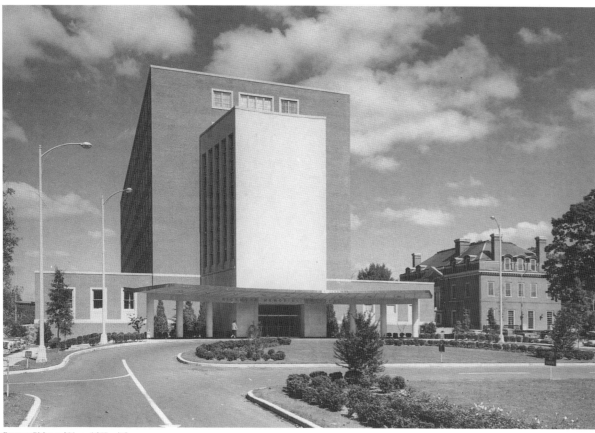

Courtesy Richmond Memorial Hospital

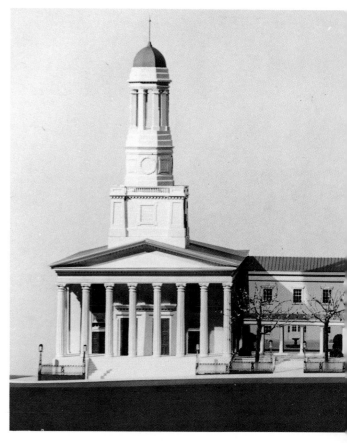

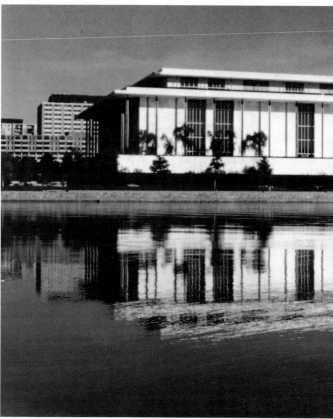

ABOVE: In the late 1950s architect Coleman Baskerville sought Cheek's advice as he was preparing designs for Richmond Memorial Hospital. Cheek proposed an automobile turn court with covered main entrance. He also suggested that each floor of the hospital terminate at a balcony overlooking a high-ceilinged memorial chapel, the white stone projection shown in the photograph.

ABOVE RIGHT: Cheek's suggestion for the expansion of St. Paul's Church in 1960 was a garden court with colonnade to link the 19th century church (left) and a new parish house with underground parking deck. Architect Coleman Baskerville agreed, and the finished design is both practical and appropriate. Before the cast iron fountain was installed, the church lent it to Cheek for *Homefront, 1861,* the exhibition on pre-Civil War culture held at the Virginia Museum.

RIGHT: Throughout the early and mid-1960s the John F. Kennedy Center for the Performing Arts— then only in the planning stages—sought the advice of museum professionals from all over the United States. A programs committee was organized to help chart the Center's future, and Cheek appeared before it in 1966 and again in 1967. He told the committee that the success of the Kennedy Center depended on the establishment of a broad-based program for dance, music and drama that would appeal to many audiences and not just the cultured few. Interestingly, the *New York Times* reported that Cheek was among several who were being considered at the time for the directorship of the Center.

Jack Buxbaum Photo

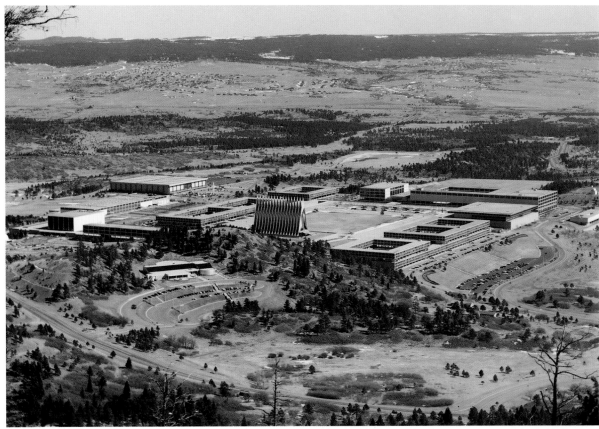

Courtesy U.S. Air Force Academy

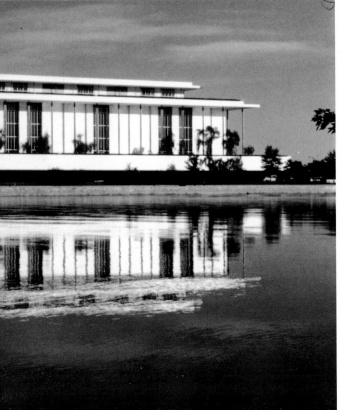

ABOVE: Between 1958 and 1962, Cheek was a member of the Fine Arts Committee of the U.S. Air Force Academy in Colorado. The Committee was responsible for evaluating gifts offered to the Academy that would affect the appearance of the buildings and grounds. These included paintings, sculptures and furnishings. Other members of the committee included John Walker, director of the National Gallery, and Rene d'Harnoncourt of the Museum of Modern Art. The striking Academy complex was designed by Skidmore Owings and Merrill.

RIGHT: In 1959 Cheek, assuming the name "Yasu Stankabitz," created this whimsical sculpture entitled *Who Me?* Welded together from bits of metal he found in a local scrap yard, the sculpture was intended to be a parody of an award that Reynolds Metals Company was then giving outstanding architects. In a mock-ceremony held at Pocahontas Avenue, "Stankabitz" presented his creation to Washington architect David N. Yerkes, a friend of Cheek's since World War II. The affair exemplified Leslie's professed disdain for pomposity and self-importance.

David Yerkes Photo

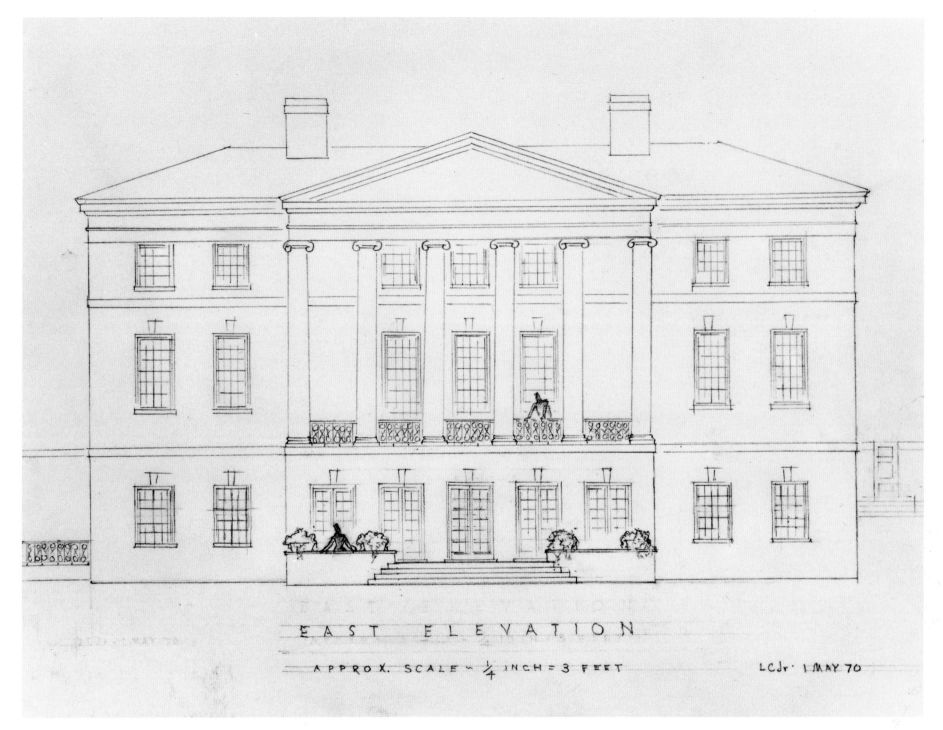

EAST ELEVATION

APPROX. SCALE ~ ¼ INCH = 3 FEET LCJr · 1 MAY 70

ABOVE: While daughter Elizabeth was an undergraduate at Hollins College (1967–1971), Cheek was approached for ideas for a new President's House. In an effort to meet the College's needs at the lowest cost, he suggested that the Administration Building—soon to be abandoned when a new one was completed—be converted to a house of suitable dignity and proportion. **ABOVE RIGHT:** The old building's interiors would have been completely gutted, and private living quarters, as well as guest rooms and spaces for entertaining added. **RIGHT:** The plan called for a garden with a small "Swan Lake" created by damming a nearby creek. Two cast-iron gazebos and a "hump-back" bridge added an appropriate touch of 19th century romanticism. This practical and imaginative solution failed to advance beyond the planning stage.

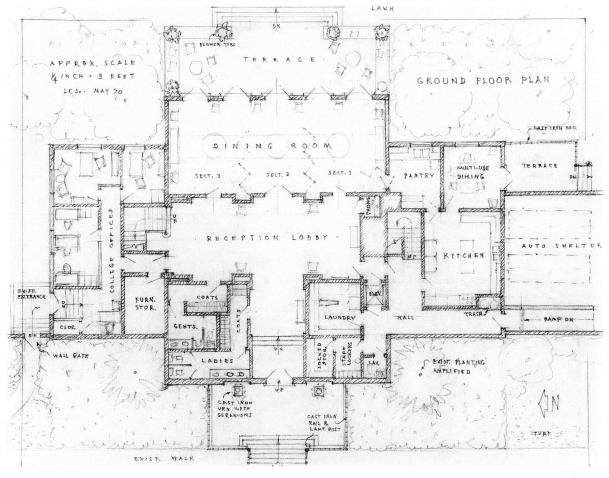

APPROX. SCALE
¼ INCH = 3 FEET
LCJr. MAY 70

GROUND FLOOR PLAN

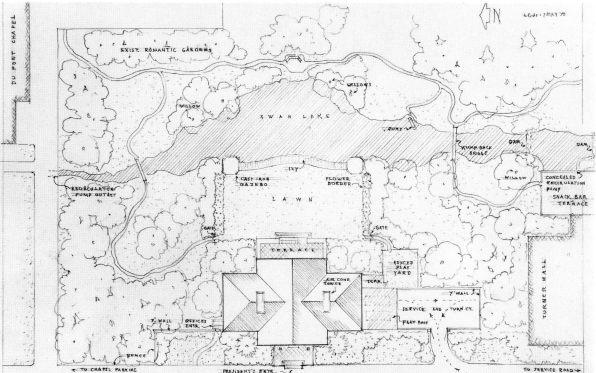

TOP: Through the years Cheek has enjoyed the friendship of many architects, among them Frank Lloyd Wright, Edward Durell Stone, Gordon Bunshaft and Eero Saarinen. In 1968 he was photographed with his friend Philip Johnson (standing right) when WRVA radio dedicated its distinctive Johnson-designed station on Richmond's historic Church Hill.

ABOVE: Cheek with Edward D. and Maria Stone in Newport, Rhode Island, 1962. Stone was the architect of some of the 20th century's most striking buildings, including the U.S. Embassy in New Dehli and the John F. Kennedy Center for the Performing Arts in Washington, D.C.

ABOVE: In 1973–74, Cheek planned the interior of the Richmond Public Library's Special Collections Room. With the aid of Mrs. Martha Davenport, at the time a vice president of the Friends of the Library, Cheek selected Knoll furnishings for the room, which held rare children's books and a series of first editions inscribed by the authors. According to Mrs. Davenport, Cheek, ever conscious of details, even specified the manner in which firewood was to be arranged on the hearth.

RIGHT: Cheek and Robert Stewart collaborated in 1970 to design a Visitors' Center for Stratford Hall Plantation, the historic home of Virginia's Lee family.

FAR RIGHT: Both Leslie and Mary Tyler have been active in the preservation of Stratford Hall Plantation. Leslie fell in love with the historic house when touring the South as an architectural student in the 1930s. (Painting by Harry W. Robertson III.)

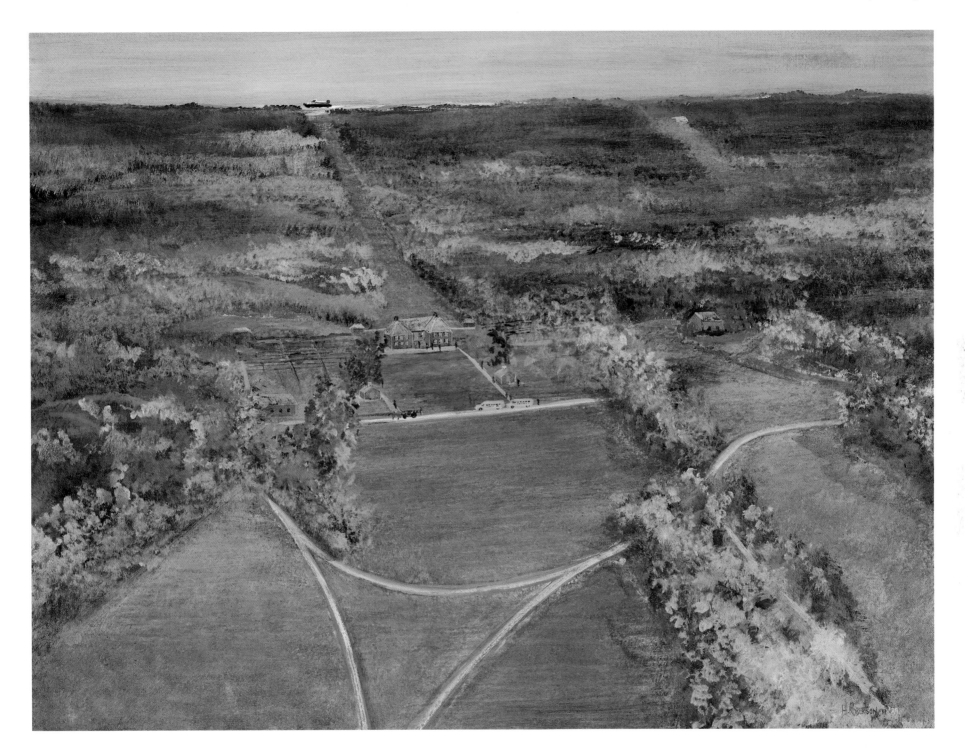

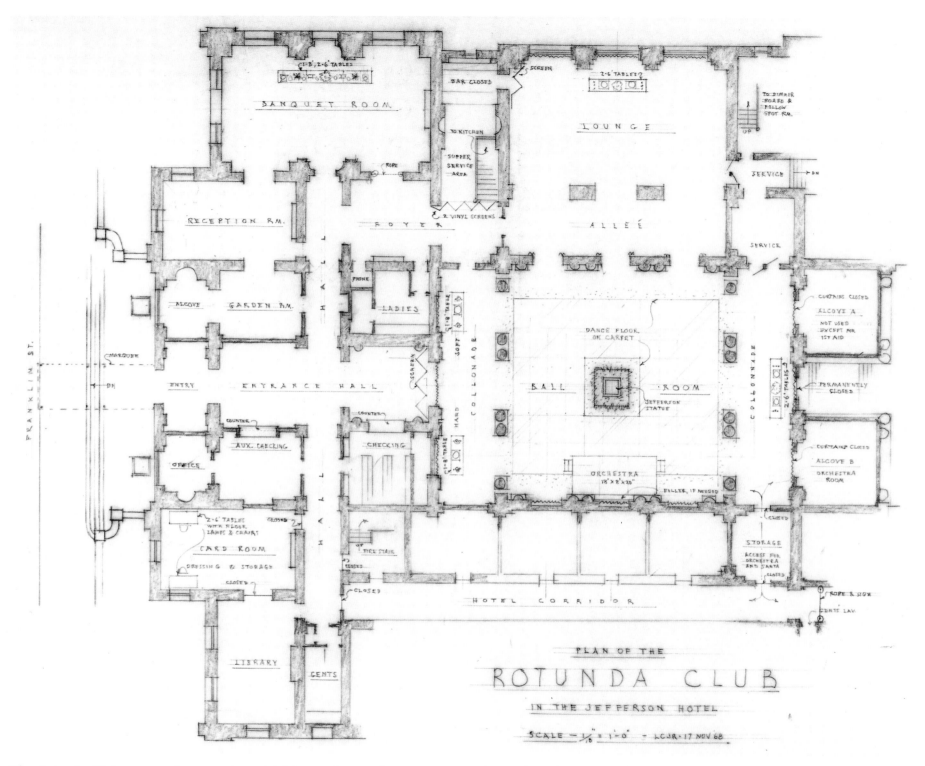

PLAN OF THE

ROTUNDA CLUB

IN THE JEFFERSON HOTEL

SCALE — 1/8" = 1'-0" — LCJR · 17 NOV 68

The Rotunda Club was a private gentlemen's club founded in Richmond shortly after World War II. It leased space until its dissolution in 1977 in the historic Jefferson Hotel designed by Carrère and Hastings. In 1955 the club found its quarters too cramped, and Cheek, a founding member, was put in charge of a major remodelling project. The renovation, which took more than a year to complete and cost $120,000, doubled the club's size to 15,000 square feet. Cheek's plan added several small dining rooms for private parties, a parlour, a billiards room and a library. The most important part of the plan entailed closing off the old Palm Court with its magnificent stairway, and making it the Club's main dining room. Tables and chairs were arranged around Valentine's famous statue of Thomas Jefferson, but these could be removed to convert this space into a ballroom. This was done in December 1968 for Elizabeth Tyler Cheek's debutante ball.

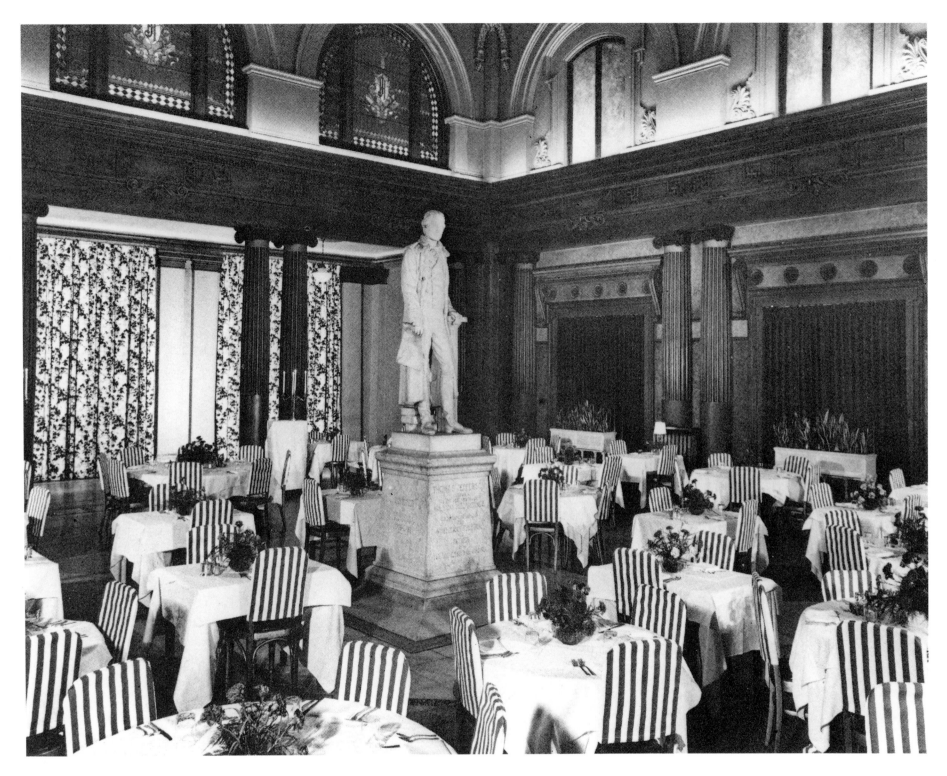

The Rotunda Club's name was inspired by the Palladian building at the focus of Thomas Jefferson's "Academical Village" at the University of Virginia. Appropriately, Edward V. Valentine's sculpture of the third president was at the center of the Club's redecorated Dining Room.

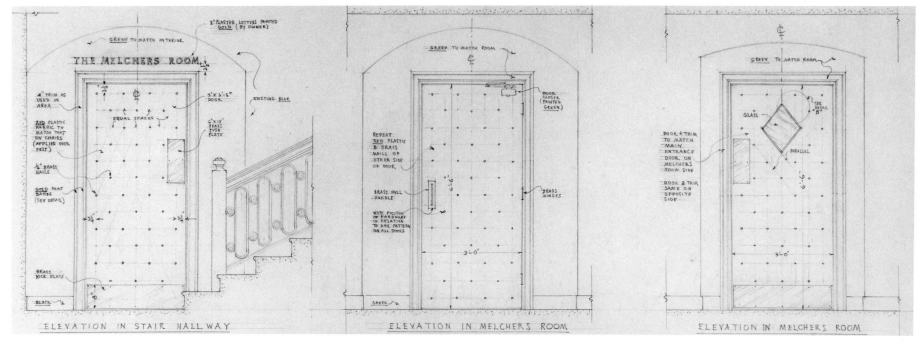

ELEVATION IN STAIR HALLWAY ELEVATION IN MELCHERS ROOM ELEVATION IN MELCHERS ROOM

ABOVE: Cheek's plan for doors to the Rotunda Club's Melchers Room, the men's grill in the basement of the Jefferson Hotel. This room gained notoriety when Cheek arranged for the Virginia Museum to lend several nudes painted by Virginia artist Gari Melchers. Soon after they appeared in 1957, these strikingly realistic paintings touched off a furor among members' wives. After a heated debate, the club discreetly removed the offending works. Today they can be found at Belmont, the Melchers' estate administered as a museum by Mary Washington College in Fredericksburg, Virginia.

RIGHT: Victorian-era urns with flowers appear frequently in interiors by Cheek, as at the former entrance to the Rotunda Club's Dining Room at the Jefferson Hotel.

FAR RIGHT: The Jefferson Hotel, from Franklin Street, as it appeared before its magnificent restoration and reincarnation as the Jefferson-Sheraton in 1985. The grand old hotel was home to Richmond's Rotunda Club for more than 30 years.

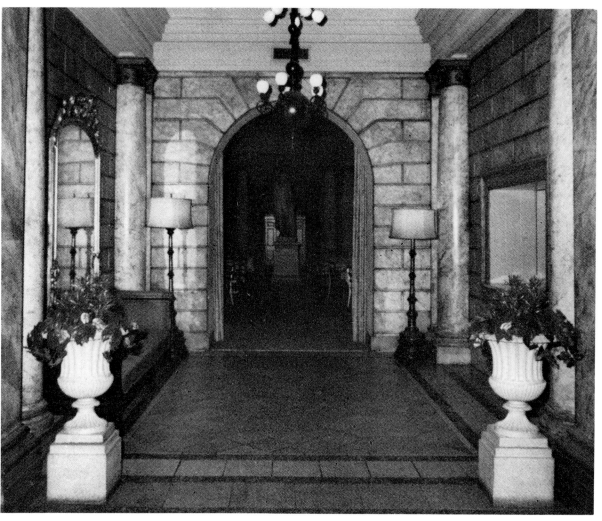

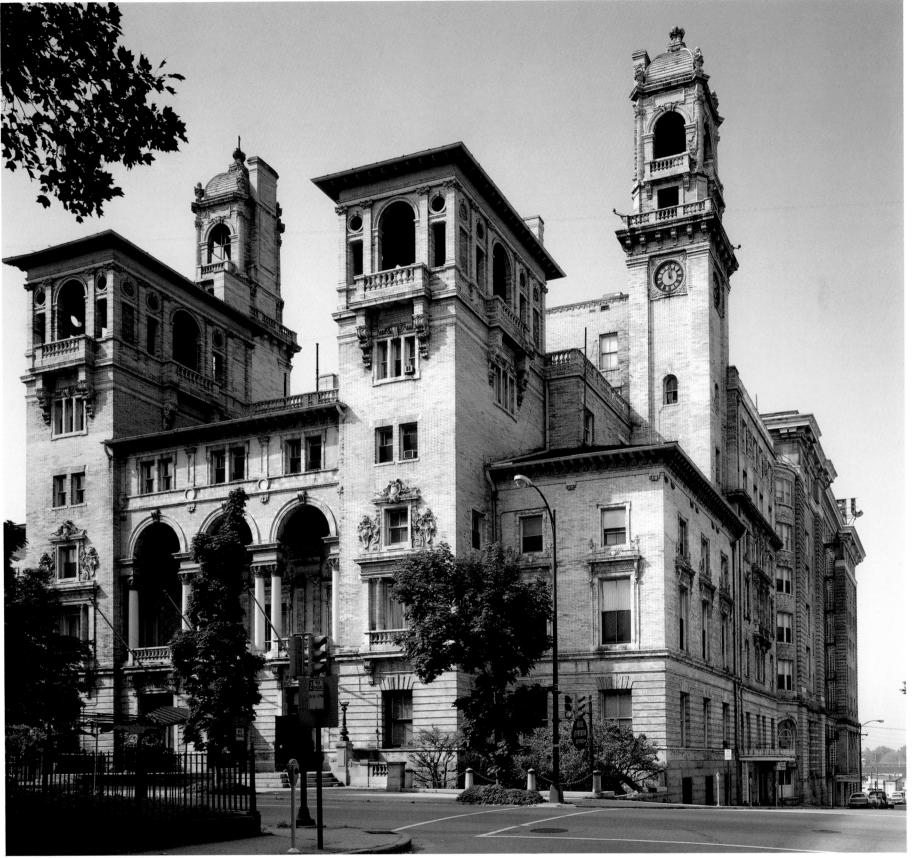

Richard Cheek Photo

Concluding Note

Whether as builder of audiences for the arts, or as designer or consultant for private houses and public spaces, Leslie Cheek has created environments for learning about our past as well as for enjoying the pleasures of family and friends. The enchanting grace and pragmatic simplicity of his designs belie a rigorous approach to resolving stylistic tension. That he has been able to place his personal stamp upon such diverse surroundings bears eloquent testimony to a forceful imagination and a seemingly inexhaustible energy.

Mary Tyler Cheek has often remarked with evident relish that her husband derived no deeper source of satisfaction than when he was seated before his drafting table, his moving pencil giving form to new ideas. In many respects a concept outlined on paper had for Cheek as much palpable reality as mortar, wood, stone and glass. It is indeed our good fortune that so much of his life's work has been realized in three dimensions to both delight our eyes and enrich our appreciation for the beauty of the world in which we live.

Afterword

Leslie Cheek, Jr., is a genius whose natural gifts for design were developed, as if by grand design, to the point that his masterwork lay in transforming a modest museum in Richmond, Virginia, into a cultural force that opened a new chapter in the operation of American museums.

When he was a child in Nashville, his inquisitive mother, Mable Cheek, took him and his sister, Huldah, to see exotic places she read about. One journey was to Confucius' tomb in Northern China, an expedition that required, after they reached Peking, a four-day, 500-mile final leg by box car. "Confucius is buried in a very small town, Tien Fu, under a turtle," her son recalls. "I remember it vividly. The turtle, carved in stone, must be twenty feet long. Rising from the middle of its back is a slab twenty feet high, beautifully engraved with Confucius' achievements."

The excursions lent incredible depth to her son's cultural storehouse. Whatever an exhibition's clime and time, he had a concept with which to stage it. His higher education, beginning in engineering at Harvard, switching mid-course to the arts and finishing with a degree in architecture from Yale, prepared him for the demands of lineal and spatial presentations. Developing at the College of William and Mary the South's first fine arts department, he deepened his understanding for teaching the arts. Rejuvenating the Baltimore Museum of Art confirmed an inclination to audacity in staging exhibitions. He mastered the mechanics of publicity and the art of layout as an editor with *Architectural Forum* and *House Beautiful*.

When Cheek, a dynamo fairly humming with ideas, arrived in Richmond in 1948, the nation's first state-supported art museum had the quietude of a mausoleum. It was born in the Depression as the only frill in Governor John Garland Pollard's administration. Twelve years later Virginia still ranked near the bottom of the forty-eight states in human services, and the museum seemed fated forever to be Oliver Twist at a sparse table.

The Virginia Museum's annual appropriation then was $47,000. Among a dozen employees, five (two design technicians, an associate director, an electrician and a carpenter) mounted the shows Cheek designed. A persisting image of him is at the drawing board late at night, impeccably neat with cuffs turned back twice, his face absorbed in the light of the lamp, as he drafted scale drawings with step-by-step directions for the maintenance crew. "He even told them what size nails to use," recalls former Assistant Director Muriel Christison. "He could take people with no experience in design or even in any kind of cabinet work and train them on the job to produce what he wanted. Museums need two kinds of designers for graphic and three-dimensional design. He did both." Former installation technician I. L. Terrell equates three years with Cheek with a doctorate.

Cheek expected perfection from himself and others. Since he was setting standards with each venture, every particular had to be right as he planned an exhibition and coordinated designs for elegant invitations to previews, a three-dimensional sign out front, and an introductory sign to the gallery. He had immediate impact on the area's printing industry. His sense of proportion is infallible, and an instruction on a proof sheet would have a printer move a line a wafer-thin space up, down or to one side. Recalling his demands for delicate degrees of color, texture and grade of paper, a Richmond printer says: "He knew what he wanted,

and often we lacked the expertise to provide it. One way or another we met specifications." Once, during a trustees meeting, Cheek slipped a memo to business administrator Richard Velz: "Please have someone remove during lunch the trace of a cobweb in the southeast corner of the ceiling."

When he arrived, the collection was meagre. "In a sense we had to pose as a museum," Cheek has said. "We had to make a great to-do over what little we had." Even as he dealt with oncoming waves of exhibitions, he was looking ahead a decade or more, seeking advice, carrying on voluminous correspondence, traveling, and then sharing the vision with staff and trustees. Seizing a mandate to serve the state, he devised a 45-foot Artmobile to carry art everywhere. Viewing sketches for the first gallery-on-wheels, the staff was still taking in its dazzling scope when Cheek remarked that soon three longer ones would be on the road. Heralded by publicity, the mobile gallery drove into Virginia's towns, extended sheltering side panels like the wings of a great bird and displayed explanations about the contents—a medicine show for the arts. Involved in its passage were civic leaders, including wives of members of Virginia's General Assembly. Later, pondering the Virginia Museum's requests for funds, the husbands remembered the Mountain that came to Mahomet.

In fast-waning hours before an exhibition opened, Cheek could be found in Churchillian siren-suit atop a ladder adjusting spotlights. Nearly every Wednesday night the Cheeks entertained visiting artists or lecturers. Handsome and glowing, exhilarated that his staff had met the deadline in grand style, Cheek would be offering humorous comment to those at either side. When an exuberant shaft of wit was just clear enough to reach the entire company, Mary Tyler Cheek, feigning she hadn't heard it, would say in an amused tone, "What was that, Leslie?"—and even as he was replying, defuse it, if need be, with a comment or dismiss it in a delighted peal of laughter that, like a shower of peach petals, distracted the guests from what they thought they had heard. Word of the elegant parties and receptions, and all else about the renaissance in Richmond, circulated in art circles around the nation. As daughter of biographer and *Richmond News Leader* editor Douglas S. Freeman, who interpreted the news and Robert E. Lee and George Washington to Virginians, Mary Tyler gave her husband instant cachet anywhere. In her lovely, courageous person, she fosters progressive causes in the community, which cherishes her for herself. Many insist that Pulitzer-Prize-winning Freeman's finest legacy is his daughter. In public and at home with their wide-spreading family, the Cheeks are a brilliant team.

Cheek is intrepid. Starting a project, he brushes aside any notion of failure. When the museum abandoned a three-judge panel for picking its national painting show, he placed the judging with James Johnson Sweeney of the Museum of Modern Art. Sweeney's choices awakened Richmond to the avant-garde. A furious *Times-Dispatch* columnist, Ross Valentine, opened with a blast at what he deemed the show's decadent, subversive content. That morning a subdued staff was heartened by a smiling Cheek, brimming with delight at the controversy that reached national proportions and brought an almost continuous line to the museum's doors.

The museum's endowment increased multifold under Cheek's ministrations. For tobacco manufacturer Adolph D. Williams, Cheek arranged mini-exhibitions, hanging the object the museum desired alongside an example of the artist's

work borrowed from another museum together with a photograph of the sister museum. A lecture dealt with the artist's background, the painting's significance and why the museum needed it.

"Mr. Williams was a bright man, and we simply had to build his background and his confidence in us," Cheek recalls. "He had something he didn't like. He didn't like cows in pictures. I discovered that when we wished to buy a Dutch picture of cows beside a canal. He never said he didn't like it, but he didn't agree to buy it, and it went straight back to the dealer. I told the dealer, 'Don't ever propose—even if it's the best Dutch painting you ever come across—any more with cows.' Mrs. Williams played a key role. She was on our side, and after they went home, she would put in a word for us. Many objects went to their house first. Then after two or three months, he'd say, 'You can come and get it now.' Sometimes, he would say, 'I may ask for it back.' But he never did." In 1952, Williams bequeathed the Virginia Museum nearly $3 million.

Upon arrival, Cheek began planning a new wing with the most advanced technology: movable walls, lights that could be varied in intensity and scope, and a magnificent theater for staging and filming. Trustee Paul Mellon of Upperville funded the theater's construction, one of many advances he quietly sustained. Working as chairman of the museum's 1960 exhibition *Sport and the Horse*, Mr. Mellon became interested in assembling a premier collection of English paintings, now housed in Yale University's Center for British Art.

As Cheek disclosed plans for the new wing to staffers, one remarked that it would answer the museum's needs forever. Oh, no, Cheek replied serenely, a bird couldn't fly on one wing and soon the museum would need another, and, in time, a third. He was always dreaming, always gazing farther ahead, reaching into the future.

With each expansion, the Virginia Museum added activities: a Collectors' Circle, societies for films, dance, chamber music, a circulating library of work by Virginia artists, and the award-winning magazine *Arts in Virginia*. His instinct for hiring talented artists was evident in seasons of plays that enthralled the community. The museum had become what Cheek had envisioned when he first saw the little Georgian structure: a vast, creative center for all the arts, cross-pollinating, life-enhancing, an oasis for reflection in a society moving at top spin. Visiting museum directors left with new ideas. Civic leaders from around Virginia resolved to seek state aid for starting art centers at home. These bloomed in the Commonwealth in the 1970s and 1980s.

As a child, Cheek spent hours in a workshop over the garage. From blueprints in *Popular Mechanics* magazine he built a detailed model of the "Santa Maria." He persuaded his mother, at her sewing machine, to add stitching to the sails. One of the Cheeks' sons later found it in an attic and brought it down to his room, where it stills plunges along on mythical seas—as does, under full sail, the ever-growing Virginia Museum of Fine Arts, on the course Leslie Cheek set with such clarity and éclat.

GUY FRIDDELL
Norfolk, Virginia

Chronology

October 28, 1908—Leslie Cheek, Jr., born in Nashville, Tennessee.

January 1916—Entered Peabody Demonstration School, Nashville.

Fall 1922—Entered Duncan College Preparatory School, Nashville.

June 1925—Entered first summer session at the Culver Naval School, Culver, Indiana.

May 1926—Graduated from Duncan School and received Scholarship Medal.

Fall 1926—Family began an around-the-world trip that included visits to Japan, China, Cambodia, Egypt, Turkey and France.

Fall 1927—Entered Harvard College, Cambridge, Massachusetts.

Summer 1930—Worked as stage designer with the University Players, Falmouth, Massachusetts.

June 1931—Graduated from Harvard, Magna Cum Laude.

Summer 1931—Taught free-hand drawing, Lake Forest Academy, Lake Forest, Illinois.

Fall 1931—Entered the Yale School of Architecture, Yale University, New Haven, Connecticut.

April 1934—Designed sets for play, *Names in Bronze,* Yale School of Drama.

Spring 1935—Submitted Senior Thesis, "Above It All" to the Yale School of Architecture.

June 1935—Graduated with honors from the Yale School of Fine Arts.

Fall 1935—Employed as an instructor in art history by the College of William and Mary, Williamsburg, Virginia.

Fall 1936—Named head of the Department of Fine Arts at William and Mary.

Winter 1938–1939—Worked on designs for *Virginia Room* pavilion for the 1939–40 New York World's Fair.

Spring 1939—Named Director of the Baltimore Museum of Art, Baltimore, Maryland.

June 3, 1939—Married to Mary Tyler Freeman of Richmond, Virginia.

Summer 1939—Honeymoon to western United States, Hawaii and New York.

June 1940—Exhibition *Romanticism in America* opened at the Baltimore Museum of Art.

Summer 1940—Designed *For Us the Living* exhibition for the Museum of Modern Art in New York with Edward Durell Stone, Alfred Barr and Lewis Mumford.

Fall 1940—Appointed Trustee, American Federation of Arts, Washington, D.C.

December 12, 1940—First child, Leslie Cheek, III, born in Richmond, Virginia.

Winter 1940–Spring 1941—Searched for safe haven for family in mountains of Tennessee and North Carolina.

January 1941—Exhibition *The City* opened at the Baltimore Museum of Art.

Summer 1941—Purchased land to be site for Faraway Farm, Lake Lure, North Carolina.

Spring 1942—Tendered resignation from Baltimore Museum of Art and entered United States Army Corps of Engineers, Fort Belvoir, Virginia.

Fall 1942—Appointed head of Camouflage Training Section, School of Engineers, Fort Belvoir.

January 26, 1943—Second child, Douglas Freeman Cheek, born in Richmond, Virginia.

Spring 1944—Transferred to Office of Strategic Services, Washington, D.C.

June 1945—Honorably discharged from the Army.

Summer 1945—Appointed Associate Editor, *Architectural Forum,* New York, New York.

Summer 1945—Moved with family to 1035 Fifth Avenue, New York.

October 24, 1945—Third child, Richard Warfield Cheek, born in Richmond, Virginia.

Spring 1946—Appointed Architectural Editor, *House Beautiful,* New York.

Fall 1947—Appointed to the Yale Council, New Haven, Connecticut (served until 1954).

Spring 1948—Named Director of the Virginia Museum of Fine Arts, Richmond, Virginia.

Summer 1948—Purchased *4703* Pocahontas Avenue residence and began remodelling house to accommodate growing family.

June 11, 1949—Birth of fourth child, Elizabeth Tyler Cheek, Richmond, Virginia.

January 1950 — Exhibition *Healy's Sitters* opened at the Virginia Museum of Fine Arts.

January 1952—Exhibition *Furniture of the Old South* opened at the Virginia Museum of Fine Arts.

April 1952—Exhibition *Habiliments for Heroines* opened at the Virginia Museum of Fine Arts.

October 1953—Dedicated Artmobile I with the traveling exhibition *The Little Dutch Masters.*

January 1954—Exhibition *Design in Scandinavia* opened at the Virginia Museum of Fine Arts.

Fall 1954—North Wing of the Virginia Museum opened to the public.

December 1954—Fabergé installation in the Entrance Hall of the Virginia Museum opened to the public.

Spring 1955—Sold Faraway Farm.

Fall 1955—First play, *High Tor,* opened at the Virginia Museum Theatre.

October 1955—Doctor of Fine Arts degree conferred by the University of Richmond, Richmond, Virginia.

June 1956—Attended Harvard's 25th Reunion for the Class of 1931.

January 1957—Exhibition *The Tastemakers* opened at the Virginia Museum of Fine Arts.

February 1958—Visited Brussels, Belgium to supervise the installation of the Folk Art Exhibit in the U.S. Pavilion at the Brussels World's Fair.

February 1958—Submitted resignation as Director of the Virginia Museum, but was persuaded to withdraw it by the Board of Trustees.

Spring 1958—Appointed to the Fine Arts Committee of the United States Air Force Academy, Colorado Springs, Colorado (served until 1962).

Spring 1959—Defeated in election to be Overseer of Harvard University.

May 1959—Designed and began construction of Pool House at Richmond house.

April 1960—Exhibition *Sport and the Horse* opened at the Virginia Museum of Fine Arts.

April 1960—Support organization, The Fellows, formally organized by the Virginia Museum of Fine Arts.

April 1961—Egyptian Gallery opened at the Virginia Museum of Fine Arts

January 1964—Exhibition *The World of Shakespeare* opened at the Virginia Museum of Fine Arts.

June 1964—Celebrated 25th Wedding Anniversary, Richmond, Virginia.

Spring 1966—Appointed to the United States Fine Arts Commission, U.N.E.S.C.O., Washington, D.C.

Fall 1966—Awarded Thomas Jefferson Citation for Public Service by the Old Dominion Chapter of the Public Relations Society of America, Richmond, Virginia.

October 1966—Initiated land purchases (three tracts) in Nelson County, Virginia, future site of Skylark Farm.

February 1967—Cheek formally tendered his resignation to the Virginia Museum's Board of Trustees and search for successor was undertaken by the Board.

Spring 1967—Doctor of Fine Arts degree conferred by the College of William and Mary.

September 1968—Ends tenure as Director of the Virginia Museum.

May 1969—Presented with Special Award by the Virginia Chamber of Commerce.

July 1970—Leslie and Mary Tyler Cheek moved into the completed Manager's House at Skylark Farm.

Spring 1977—Awarded Patron of the Arts degree and medal by the Virginia Museum of Fine Arts.

July 1977—Presented Skylark Farm to Washington and Lee University in honor of Douglas Southall Freeman.

Fall 1978—Underwent spinal surgery, Jefferson Medical College Hospital, Philadelphia, Pennsylvania.

November 1979—Presented with Governor's Award for the Arts, Richmond, Virginia.

March 1981—Received Annual Award from the Federated Arts Council of Richmond, Virginia.

Spring 1981—Cheek Guest House dedicated at Stratford Hall Plantation, Stratford, Virginia.

September 1981—Attended special presentation, *A Sentimental Evening,* Virginia Museum Theatre.

December 1981—Presented George Washington Award by the Virginia Chapter of the American Society of Interior Designers, Williamsburg, Virginia.

Spring 1983—Jet Fountain dedicated at Richmond House.

June 1983—Doctor of Fine Arts degree conferred by Washington and Lee University, Lexington, Virginia.

February 1984—Attended Charter Day ceremonies with Mary Tyler at the College of William and Mary.

Summer 1985—Completed "Galleria" on loggia of Richmond house.

September 1985—Received the Architectural Medal for Virginia Service Award, Virginia Chapter of the American Institute of Architects, Norfolk, Virginia.

December 1985—Exhibition *Cheek and the Arts* opened at the Muscarelle Museum of Art, College of William and Mary.

October 23, 1987—*The Cheek Gallery in Honor of Leslie Cheek, Jr.,* dedicated in the Phase II addition of the Muscarelle Museum of Art.

November 1987—The first *Leslie Cheek Award* is presented by the Muscarelle Museum of Art to designers Gaillard F. Ravenel II, and Mark A. Leithauser, both with the National Gallery of Art, Washington, D.C.

December 1987—The first *Leslie Cheek, Jr., Medallion* awarded to the late Morton Thalhimer.

May 1988—Doctor of Human Letters degree conferred by Virginia Union University, Richmond, Virginia.

November 1988—The second *Leslie Cheek Award* is given to designer Florence S. Bassett.

February 1989—Virginia House of Delegates adopted Senate Joint Resolution No. 221 expressing the Commonwealth's appreciation for Leslie Cheek's contributions to the arts.

June 1989—Celebrated 50th Wedding Anniversary, Richmond, Virginia.

November 1989—The third *Leslie Cheek Award* is given to architect Philip Johnson.

February 1990—Attended ceremonies at Virginia Museum's Renaissance Gallery at which plaque honoring Director Cheek was unveiled.

Bibliography

BOOKS:

G. Donald Adams, *Museum Public Relations* (Nashville, TN: American Association for State and Local History, 1983).

T. R. Adams, *The Civic Value of Museums* (NY: American Association for Adult Education, 1937).

Edward P. Alexander, *Museums in Motion: An Introduction to the History and Functions of Museums* (Nashville: American Association for State and Local History, 1979).

American Association of Museums, *Museums for a New Century* (Washington, DC: A.A.M., 1984).

A. H. Arnason, *History of Modern Art*, 3rd ed. (NY: Abrams, 1986).

Paul Baker, *Richard Morris Hunt* (Cambridge: MIT, 1980).

Alan Balfour, *Rockefeller Center: Architecture as Theatre* (NY: McGraw-Hill, 1978).

Sarah H. Boutelle, *Julia Morgan, Architect* (NY: Abbeville, 1988).

Samuel Cauman, *The Living Museum, Experiences of an Art Historian and Museum Director: Alexander Dorner* (NY: New York University Press, 1958).

John C. Dana, *A Plan for a New Museum* (Woodstock, VT: Elm Tree Press, 1920).

Joseph Dreiss, *Gari Melchers: His Work in the Belmont Collection* (Charlottesville, VA: University of Virginia Press, 1984).

Henry Dreyfuss, *Designing for People* (NY: Simon and Schuster, 1955).

Exhibition Techniques (NY: Museum of Science and Industry, 1940).

Cyril Harris, ed., *Historic Architecture Sourcebook* (NY: McGraw-Hill, 1977).

Kenneth Hudson, *Museums of Influence* (NY: Cambridge University Press, 1987).

International Council of Museums, *The Museum in the Service of Man: Today and Tomorrow* (Paris: I.C.O.M., 1972).

Martin Kaplan, ed., *Harvard Lampoon Centennial Celebration* (Boston: Little Brown, 1973).

Walter Kilham, Jr., *Raymond Hood, Architect* (NY: Architectural Book Publishing Co., 1973).

Carol Krinsky, *Gordon Bunshaft of Skidmore Owings and Merrill* (Cambridge: MIT, 1988).

Jo Mielziner, *Shapes of Our Theatre* (NY: Charles Potter, 1970).

Walter Pach, *The Art Museum in America* (NY: Pantheon, 1948).

Museum of Modern Art, *The Museum of Modern Art* (NY: Abrams, 1984).

The Organization of Museums: Practical Advice (Paris: U.N.E.S.C.O., 1960).

Grace F. Ramsey, *Educational Work in Museums of the United States* (NY: H. W. Wilson, 1938).

Leland Roth, *McKim, Mead and White, Architects* (NY: Harper and Row, 1983).

Parke Rouse, Jr., *Living by Design: Leslie Cheek and the Arts* (Williamsburg, VA: Alumni Society of the College of William and Mary, 1985).

Michael Sorkin, *Hardy Holzman Pfeiffer* (NY: Granada, 1981).

Susan Stern, ed., *The Architecture of Richard Morris Hunt* (Chicago: University of Chicago).

David Stevens, ed., *Ten Talents in the American Theatre* (Norman, OK: University of Oklahoma Press, 1957).

Edward Durell Stone, *Evolution of an Architect* (NY: Horizon, 1962).

Richard Wilson, *McKim, Mead and White: Architects* (NY: Rizzoli, 1983).

Alma S. Wittlin, *The Museum: Its History and Its Tasks in Education* (London: Routledge and Kegan Paul Ltd., 1949).

———, *Museums: In Search of a Useable Future* (Cambridge: MIT, 1970).

Doreen Yarwood, *Encyclopedia of Architecture* (London: Batsford, 1985).

EXHIBITION CATALOGUES:

A Century of Baltimore Collecting (Baltimore Museum of Art [BMA], 1940).

Sculpture and Carl Milles (BMA, 1940).

Scenery for Cinema (BMA, 1942).

Healy's Sitters (Virginia Museum of Fine Arts [VMFA], 1950).

Design in Scandinavia (VMFA, 1954).

The Aldrich Collection (VMFA, 1959).

Handbook of the Lillian Thomas Pratt Collection of Russian Imperial Jewels (VMFA, 1954).

Masterpieces of American Silver (VMFA, 1960).

Sport and the Horse (VMFA, 1960).

Treasures in America (VMFA, 1961)

The American Victorian (Washington, DC: Smithsonian Institution, 1961).

Drawings from the Donald Oenslager Collection (Minneapolis: Minneapolis Institute of Arts, 1963).

Two Volumes, *Painting in England* (VMFA, 1963).

Twentieth Century Engineering (NY: Museum of Modern Art, 1964).

The World of Shakespeare (VMFA and the Detroit Institute of Arts, 1964).

Master Prints from the Rosenwald Collection (VMFA, 1965).

European Art in the Virginia Museum (VMFA, 1966).

Ancient Art in the Virginia Museum (VMFA, 1973).

Fabergé (VMFA, 1976).

Index